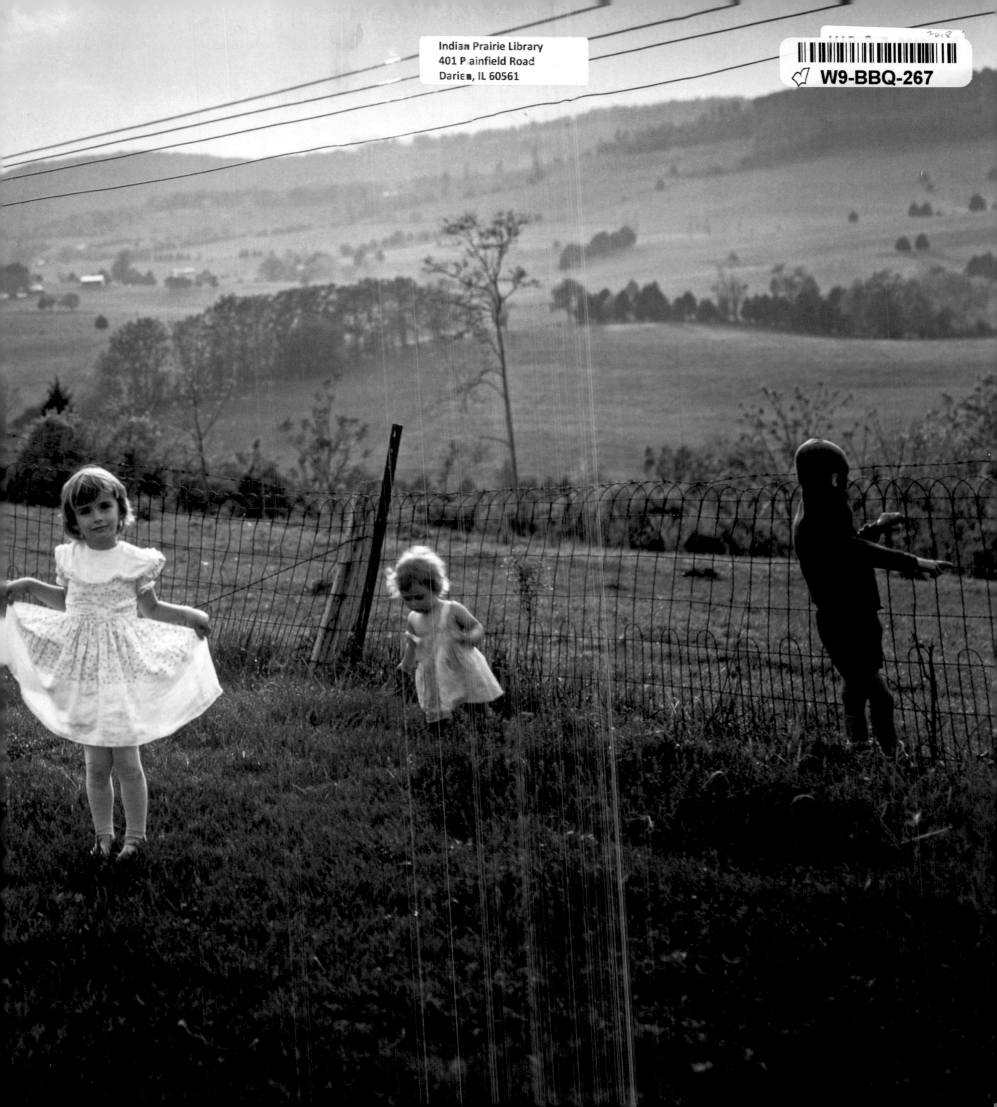

SALLY MANN *a thousand crossings*

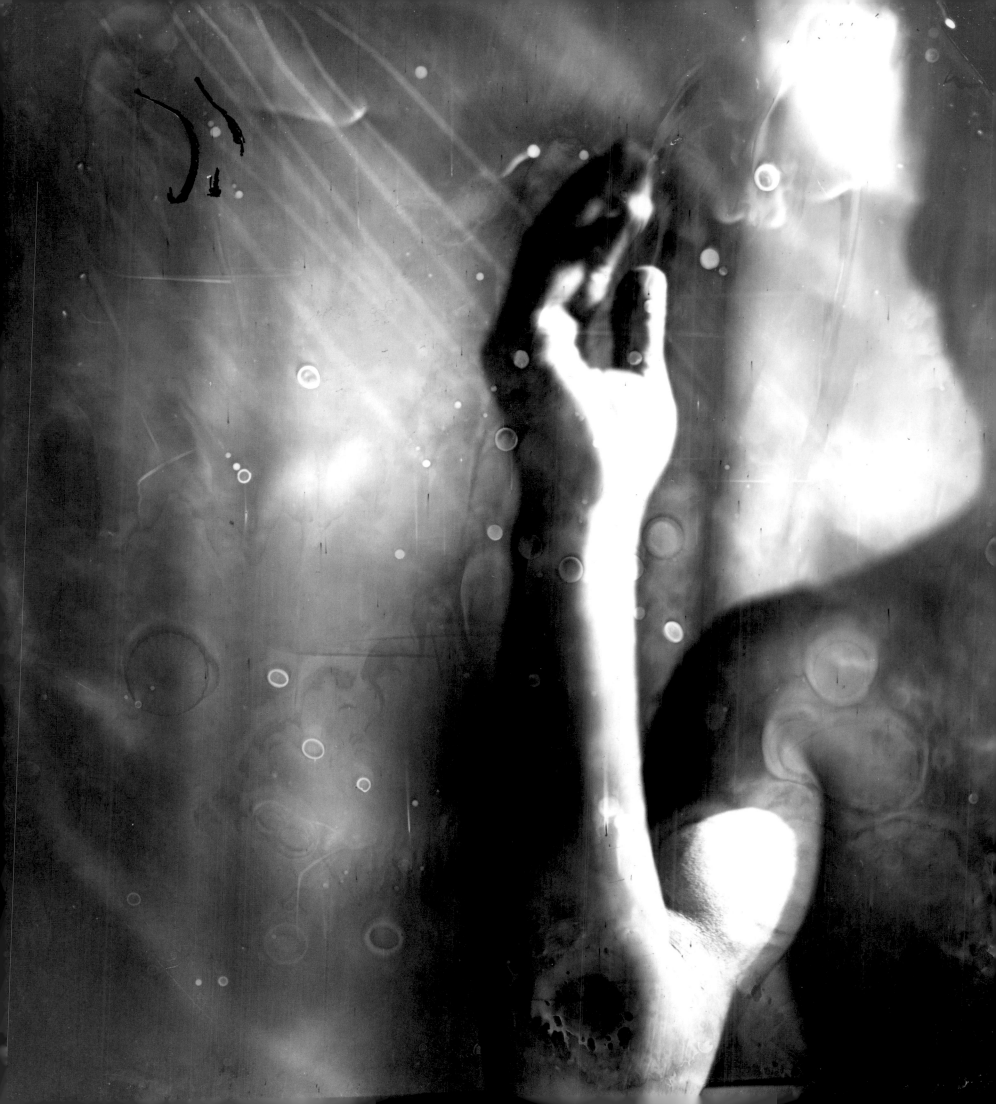

You see

it's neither pride, nor gravity but love

that pulls us back down to the world.

…

The soul makes a thousand crossings, the heart, just one.

JOHN GLENDAY, 2009

SARAH GREENOUGH AND SARAH KENNEL

with essays by HILTON ALS, MALCOLM DANIEL, AND DREW GILPIN FAUST

NATIONAL GALLERY OF ART, WASHINGTON

PEABODY ESSEX MUSEUM, SALEM, MASSACHUSETTS

ABRAMS, NEW YORK

SALLY MANN *a thousand crossings*

The exhibition is organized by the National Gallery of Art, Washington, and Peabody Essex Museum, Salem, Massachusetts.

The exhibition in Washington is supported by a generous grant from the Trellis Fund.

Additional support is provided by Sally Engelhard Pingree and The Charles Engelhard Foundation.

Support for this exhibition is also kindly provided by Wes and Kate Mitchell.

The exhibition in Salem is supported by a generous grant from the Robert Mapplethorpe Foundation.

Additional support is provided by Carolyn and Peter S. Lynch and the Lynch Foundation and the East India Marine Associates of the Peabody Essex Museum.

This publication was made possible by the Joseph M. and Barbara Cohen Foundation. Additional funding was kindly provided by Peter D. Edwards and Rose Gutfeld.

Exhibition dates

National Gallery of Art, Washington
March 4–May 28, 2018

Peabody Essex Museum, Salem, MA
June 30–September 23, 2018

The J. Paul Getty Museum, Los Angeles
November 20, 2018–February 10, 2019

The Museum of Fine Arts, Houston
March 3–May 27, 2019

Jeu de Paume, Paris
June 17–September 22, 2019

High Museum of Art, Atlanta
October 19, 2019–January 12, 2020

Produced by the Publishing Office, National Gallery of Art, Washington, www.nga.gov

Chris Vogel *deputy publisher and production manager*

Edited by Julie Warnement *senior editor*
Designed by Margaret Bauer, Washington, DC

Sara Sanders-Buell *image manager*
John Long *print and digital production associate*
Mariah Shay *production assistant*
Katie Brennan *assistant editor*

Typeset in Adobe Caslon and Benton Sans and printed on Phoenix Motion Xantur
Printed in the United States by Brilliant Graphics, Exton, Pennsylvania
10 9 8 7 6 5 4 3 2 1

Library of Congress Control Number: 2017945093
ISBN 978-1-4197-2903-4 (cloth)
ISBN 978-1-4197-3213-3 (limited edition)

Published in association with
Abrams
195 Broadway
New York, NY 10007
abramsbooks.com

Illustration details

Endsheets: *Easter Dress* (front, pl. 2) and *The Turn* (back, pl. 115); page 2: *Semaphore* (pl. 109); pages 4–5: *Battlefields, Manassas (Veins)* (pl. 33); page 8: *Deep South, Untitled (Fontainebleau)* (pl. 24); page 12: *Deep South, Untitled (Three Drips)* (pl. 25); page 16: *Untitled (Self-Portrait)* (pl. 104); pages 56–57: *Last Light* (pl. 10); page 84: *Jessie Bites* (pl. 13); pages 108–109: *Deep South, Untitled (Bridge on Tallahatchie)* (pl. 30); page 124: *Battlefields, Antietam (Trenches)* (pl. 43); pages 140–141: *Battlefields, Cold Harbor (Battle)* (pl. 40); page 158: *St. Paul United Methodist* (pl. 65); pages 172–173: *Asbury United Methodist* (pl. 68); page 242: *Blackwater 9* (pl. 44); pages 256–257: *Ponder Heart* (pl. 110); page 282: Zoë Lepiano, *Mann at St. Paul African Methodist Episcopal*, 2015, courtesy of the artist; page 296: *The Two Virginias #1* (pl. 86); page 310: *Blackwater 32* (pl. 57); page 320: *St. Paul African Methodist Episcopal* (pl. 69).

CONTENTS

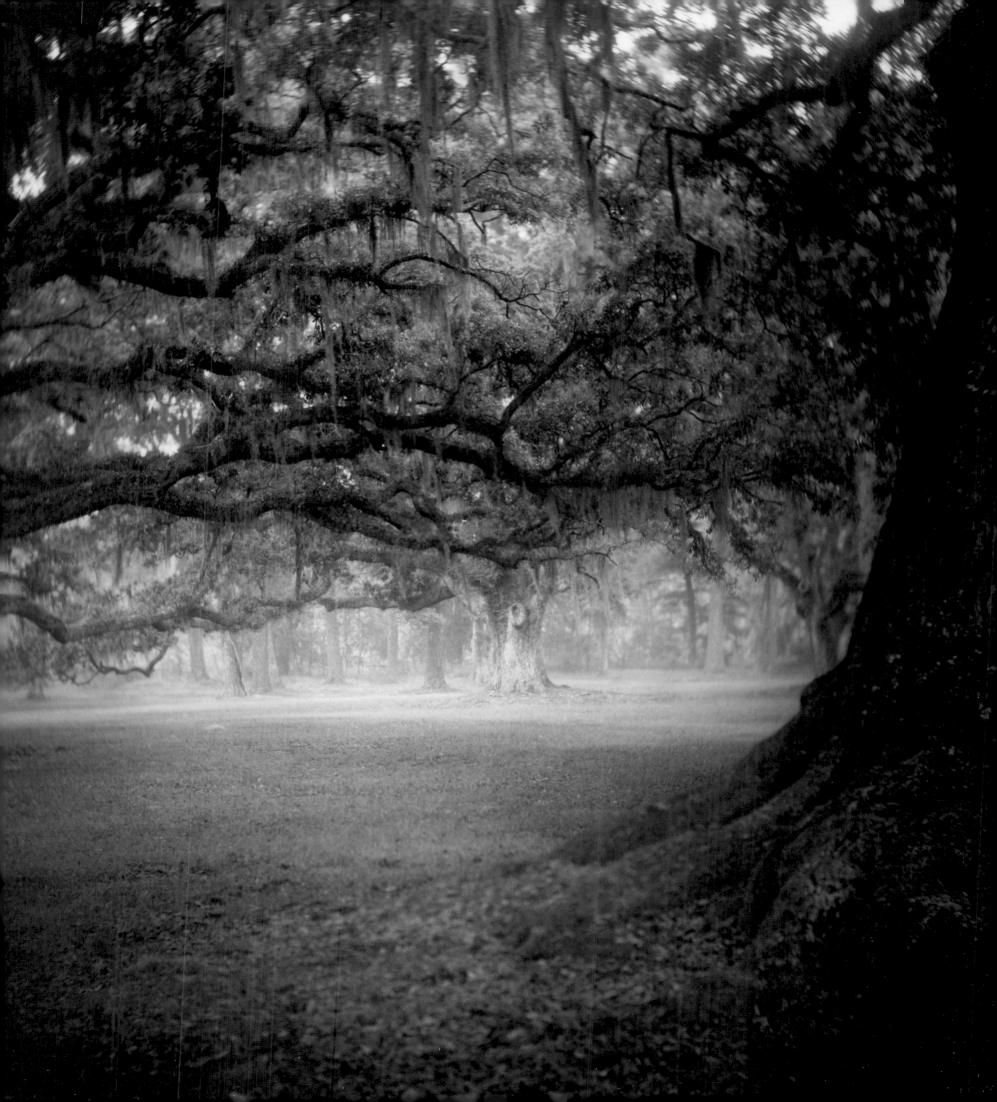

DIRECTORS' FOREWORD

For more than forty years, Sally Mann has made experimental, elegiac, and hauntingly beautiful photographs that explore the overarching themes of existence: memory, desire, death, the bonds of family, and nature's magisterial indifference to human endeavor. What unites this broad body of work—including figure studies, landscapes, and architectural views—is that it is all bred of a place, the American South. Fully immersed in its literary and visual culture, Mann, who is a native of Lexington, Virginia, has long written about what it means to live in the South and to be identified as a southerner. Using her deep love of this place and her knowledge of its fraught heritage, she asks powerful, provocative questions—about history, identity, race, and religion—that reverberate across geographic and national boundaries. *Sally Mann: A Thousand Crossings* explores how Mann's relationship with this land has shaped her work and how the legacy of the South—as both homeland and graveyard, refuge and battleground—continues to inform American identity and experience.

The exhibition takes its title from John Glenday's poem "Landscape with Flying Man," in which the Scottish author, like Mann in her photographs, asserts the power of love to bind us inextricably to a person or a place. "You see / it's neither pride, nor gravity but love / that pulls us back down to the world. / Love furnishes the wings, and that same love / will watch over us as we drown. / The soul makes a thousand crossings, the heart, just one." The title *Sally Mann: A Thousand Crossings* thus indicates not only her willingness to acknowledge the power of love but also her commitment to gain ever deeper insight through her art into herself, her family, her native land, and its troubled history.

Jointly organized by the National Gallery of Art and the Peabody Essex Museum, this exhibition is the first major traveling show of this celebrated artist to cover such a wide spectrum of Mann's photographs—from pictures of her family made in the 1980s to her studies of the landscape and the legacy of slavery made in the last decade. The accompanying

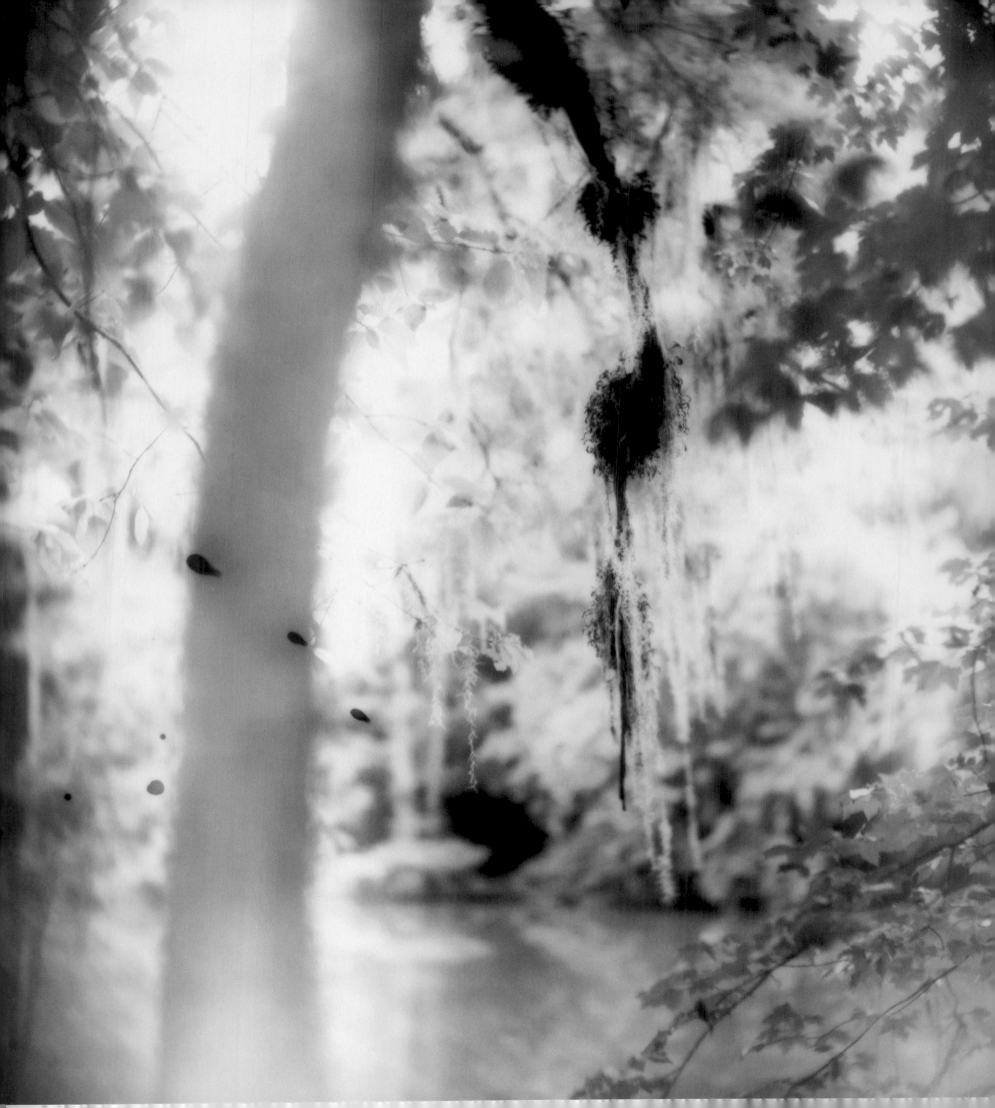

PREFACE

The seeds of this exhibition were planted in 2014, when we undertook a review of the photographs from the Corcoran Gallery of Art after it was dissolved and its collections placed under the stewardship of the National Gallery of Art. Among the Corcoran's works that would greatly expand the depth and breadth of the National Gallery's collections were twenty-five photographs by Sally Mann, made from the mid-1970s to the early 2000s. With the acquisition of this work, the National Gallery became one of the largest public repositories of Mann's photographs in the country. Our interest in mounting an exhibition of Mann's art deepened when we realized that despite her immense talent and prominence (in 2001 she was dubbed America's Best Photographer by *Time* magazine), the full range of Mann's work had not yet received sufficient and widespread scholarly and critical attention. Two ambitious projects — the Corcoran's 2004 exhibition *What Remains* and the Virginia Museum of Fine Art's 2010 *Sally Mann: The Flesh and The Spirit* — offered significant presentations of her work, but only the former traveled beyond the organizing institution and only the latter was accompanied by a multi-authored, scholarly catalogue.

For much of her career, Mann has seemed both a part of her time and separated from it. Like many other photographers from the 1980s and early 1990s, she was fascinated with domestic life in her early work. Yet her poignantly beautiful photographs of her family, which are the source of her initial fame, lack the cool irony or detached objectivity of works by many of her contemporaries. Mann refuted the treacly stereotypes of childhood, offering instead often unsettling visions of its complexity, including intimations of violence and sensuality. Their publication in her 1992 book *Immediate Family* and the ensuing controversy over the depiction of child nudity in it thrust Mann and her family into the spotlight. This unexpected notoriety only further cemented the fiercely independent and stubbornly local artist's decision to continue to live and work in her hometown of Lexington, Virginia — her chief source of inspiration, though one far from the centers of the art world.

The distinctive and changing nature of Mann's photography in the mid-to-late 1990s also set her apart from many of her peers. At a moment when many other photographers were shifting from analogue to digital technologies and creating vibrant large-scale color prints, Mann turned to photography's past, investigating the visual and metaphorical potential of using older equipment and processes. And where many photographers were working in a highly conceptual vein to interrogate the nature of photographic reality, Mann alternatively mined the medium's ability to create meaning and to explore the larger questions of existence through the crucible of personal experience. As we look back on the evolution of her work from the vantage point of 2018, Mann's use of nineteenth-century processes and her emphasis on subjective experience appear prophetic. In the past decade alone, numerous exhibitions have been devoted to contemporary photographers working with so-called alternative photographic processes, such as the tintype and the collodion negative. Disenchanted with the dominance of digital techniques, these artists have embraced the aleatoric qualities of chemically based, older processes in order to infuse greater meaning and emotion into their work.

But Mann's timeliness is equally evident in the themes and subjects she has probed in her art—memory, history, identity, culture, and race—and explored further in her award-winning memoir *Hold Still*, published in 2015. It makes clear the profound importance that the South—rich in literary and artistic traditions, but troubled in history—has had in shaping both the person she is and the art she creates. Entitled *Sally Mann: A Thousand Crossings*, our exhibition and this accompanying catalogue strive to present the scope of Mann's art over the past four decades and to reveal the consistency and power of her vision, grounded in the evocation of the South as a point of personal origin, a lost paradise, and a place that has borne witness to extreme violence and historical trauma.

Unafraid to ask big questions, Mann is an artist who oscillates between the intimate and the epic, the local and the universal. These qualities guided us in the organization of the exhibition, which opens with a presentation of the family pictures Mann created between 1985 and 1994 and juxtaposes well-known photographs from *Immediate Family* and others from this period in order to offer a more nuanced view and stress the generative function of place in their creation. The exhibition then follows the path Mann herself charted, as she moved away from the family to explore the southern landscape and create effulgent and languid pictures infused with a sense of profound mystery and longing. Traveling farther south to Georgia, Alabama, Louisiana, and Mississippi, Mann sought out what she called "the radical light of the American South"[1]—perceived as if in a dream—and the vestiges of the past, including the ruins of Windsor Mansion, one of the largest antebellum plantation houses, and the site on the banks of the Tallahatchie River where Emmett Till's brutalized body had been recovered. Increasingly drawn to the violent histories that lay beneath the alluring beauty of the southern landscape, Mann began to photograph Civil War battlefields in 2000, trying to conjure in her photographs the immensity of the bloody and tragic conflict whose fraught legacy continues to shape American identity and culture. In these pictures, which constitute the third section of our exhibition, she discovered that she could elicit a wide range of suggestive photographic effects—including light flares, fogging, streaks, and blurs—that serve as metaphors for the South as the site of memory, defeat, ruin, and tentative rebirth. In contemplating death, the passage of time, and the treachery of memory, Mann returned once again to photographing her family. These works—the subject of the last section of our show—feature spectral portraits of her children's faces, probing photographs that explore the disease-weakened body of her husband Larry, and haunting self-portraits that intimate her own mortality.

The exhibition also presents Mann's newest and most ambitious subject to date: the legacy of slavery and racism in the American South. In crepuscular, even apocalyptic, tintypes made along rivers in and near Virginia's Great Dismal Swamp, and

in ethereal, light-infused pictures of local nineteenth-century African American churches, Mann explored how both slavery and the struggle for freedom have marked the physical and cultural landscape of her home. Although she had begun to address these issues during her earlier photography trips in the Deep South, the process of writing the prestigious Massey Lectures for Harvard (delivered in 2011) and *Hold Still* led her to interrogate them more fully. Race had not only marked the region physically and spiritually, but also shaped the most intimate bonds within her own family. In particular, she looked back more critically at her relationship with Virginia "Gee-Gee" Carter. One of the people whom Mann knew best and loved unreservedly, Gee-Gee was an African American woman who had worked for Mann's parents for more than fifty years. As Mann revisited the importance of Gee-Gee in her life, she began to recognize not only how profoundly racial and economic oppression had shaped Gee-Gee's experiences, but also the enormity of "all that I had not seen, had not known, and had not asked."[2]

She then began to explore other unspoken but trenchant racial divisions that had marked her youth and shaped her interactions. African American men, for example, had remained largely unseen by her in the most important ways. Inspired by the desire to cross the "seemingly untraversable chasm of race,"[3] she made her first attempts to photograph African American men in 2006. The project gained momentum in 2009 when she encountered the choreographer Bill T. Jones' production *Fondly Do We Hope…Fervently Do We Pray*, a groundbreaking work that reflects on the legacy of Abraham Lincoln. Mann was struck in particular by how Jones celebrated the power and beauty of the African American male body, even as he lamented and condemned the histories of racism and slavery that have subjected it to so much stereotyping and projection. In her photographs, Mann attended to the nuances of individual men with care, while she also considered the histories of oppression and struggle that continue to impact the lives of many African Americans and people of color. Deliberately ambiguous and infused with a sense

of emotion and grace, the photographs seem to slip in and out of time, offering no clear resolution to the historically fraught nature of these staged encounters but posing many questions about both limits and possibilities.

The events of the last few years—the deaths of unarmed black men at the hands of law enforcement officers, the desecration of black churches, and the rise of white supremacist movements—make reflecting on the legacies of slavery and racism more urgent and timely than ever. Yet this charged atmosphere has also drawn greater scrutiny to representations of the experiences of African Americans, especially by white artists, and to the responsibilities inherent in presenting racially and politically charged art. We are grateful to the many scholars, curators, and artists who shared their insights about presenting challenging art with sensitivity and with care, and who encouraged us to present an inclusive dialogue about this complex subject, which remains so central to American life.

On August 12, 2017, as we were finalizing the selection of objects for this exhibition, violence erupted at a white supremacist rally in Charlottesville, Virginia, leading to many injuries and one fatality. More than 150 years after the end of the Civil War, a protest sparked in part by the city's decision to remove a statue of the Confederate general Robert E. Lee from a public park ended in death. As we look for clarity in this moment of deep uncertainty, divisiveness, and conflict, we may find in Mann's art—part hope, part lament—one way to cross the chasm.

Sarah Greenough and Sarah Kennel

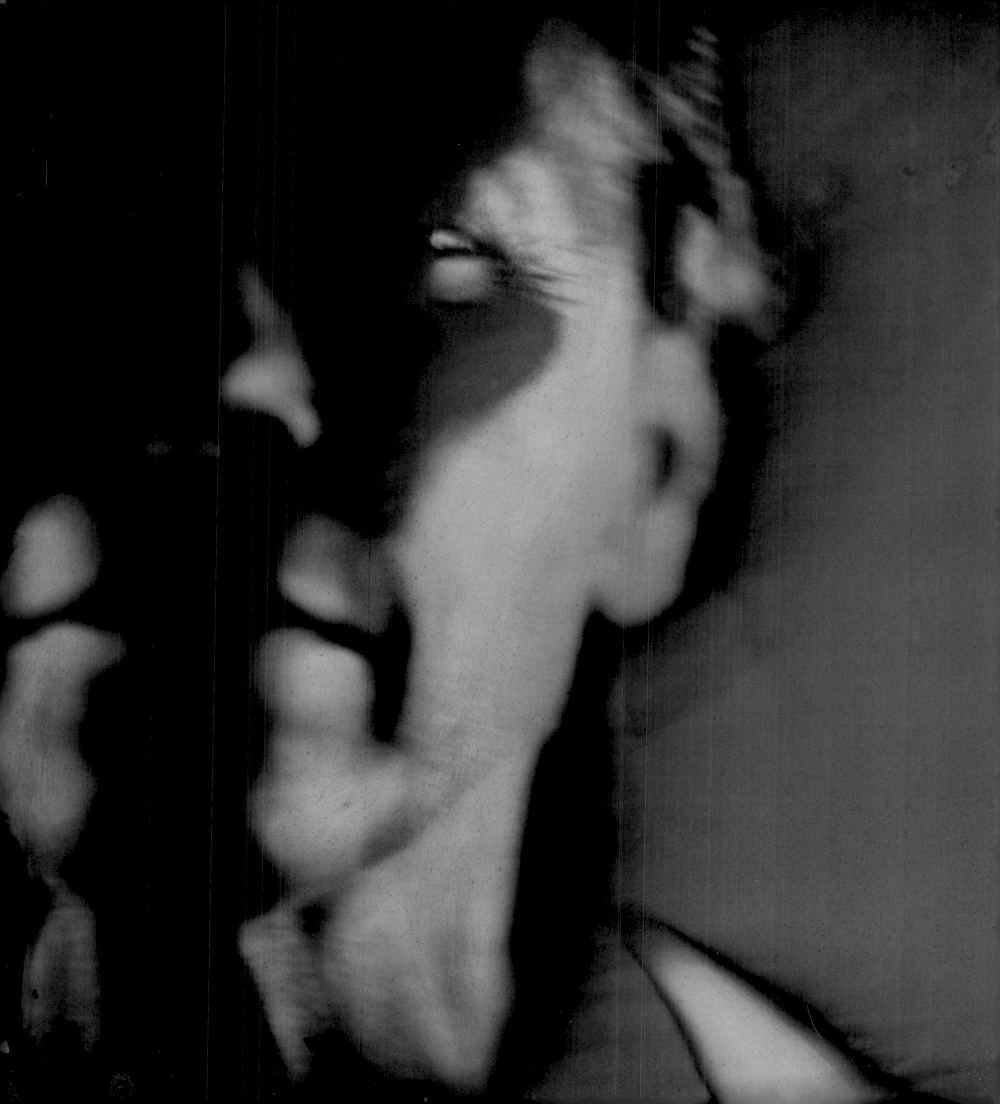

Writing with Photographs: Sally Mann's Ode to the South, 1969–2017 **SARAH GREENOUGH**

Faulkner, Poe, Wordsworth, Pound — all those authors inform my photography
and my photographs sing their words back to them.

SALLY MANN, 2007

In September 1997, the Edwynn Houk Gallery in New York City opened an exhibition of photographs by Sally Mann titled *Mother Land: Recent Landscapes of Georgia and Virginia*. The show, like the book that accompanied it, included two groups of pictures, all made in the previous four years with each group, at first glance, radically different from the other. Those made in Virginia are of the rolling hills, rivers, and vine-encrusted forests near Mann's family home in Lexington (pls. 22, 23, 28). Dark and dense, they shimmer with a palpable atmosphere that softens the outlines of the undulating mounds and underbrush, and lends a moisture-laden weight to the deep shadows. They are carefully yet simply seen, exuding a sense of deep familiarity, as if they are the result of years of looking and thinking. Those made in Georgia are largely of nondescript buildings and empty fields and seem as if the photographer had encountered an entirely foreign land. Made with high contrast Ortho film and antique, often damaged lenses, they are printed in a completely different key. Bright and even blasted in appearance, as if the sun had caused a conflagration in the sky, they adhere to few traditional notions of beauty. Like those shown in her next exhibition at the Houk Gallery in 1999, which depict scenes in Louisiana and Mississippi, the *Mother Land* pictures display evidence of damage to the negatives' emulsion with blobs and scratches as well as streaks of light caused by the faulty lenses. All of these effects intensify the otherworldly character of the tea-toned prints and recall nineteenth-century photographs. Whereas the Virginia pictures are redolent of personal connections, those made in Georgia, Louisiana, and Mississippi allude to a larger national history of war, death, suffering, and injustice (pls. 25, 26, 29–32). But in their exploration of pictorial extremes — the inky, almost Ad Reinhardt–like blackness of the impenetrable Virginian woods or the blinding light of the desolate Georgian sky — both groups of pictures explore the limits of legibility and intelligibility, as if they seek to extract knowledge and meaning by looking into the void.[1]

These photographs—transcendent yet tremulous, bold but bleak—succinctly express the transitional nature of Mann's art at the time. With no people in sight, they were a significant departure for the fiercely independent photographer who for the past several years had been embroiled in controversy around her earlier body of work, *Immediate Family*. Made between 1985 and 1992, the photographs in *Immediate Family* depict Mann's three young children—Emmett, Jessie, and Virginia—occasionally nude and sometimes accompanied by her husband, Larry, and friends at the family's remote summer cabin on the Maury River in Virginia. Fully exploiting photography's rich descriptive capabilities, the lush pictures show the typical pastimes of childhood (swimming, dressing up, reading the funnies, vamping for the camera) as well as the minor incidents of everyday life (nosebleeds, bug bites, cuts and scrapes). Intimate but devoid of sentimentality, they speak of languid, unstructured summer days spent outside in the intense heat and humidity of the South. Yet with their seductive tones and occasionally provocative imagery, they are also startling, psychologically charged, and infused with darker undercurrents—latent sexuality, injury, and even death. The exhibition of some family pictures in the late 1980s and the publication of *Immediate Family* in 1992 swept Mann up in the culture wars of the 1990s and the national debate about child pornography, motherhood, government support of the arts, and censorship that tore through an increasingly polarized society. Supporters were quick to champion the refreshing honesty of her vision, noting that it was an "accurate…and a welcome corrective to familiar notions of youth as a time of unalloyed sweetness and innocence," and they praised *Immediate Family* as "one of the great photograph books of our time… a singularly powerful evocation of childhood from within and without."[2] But critics as diverse as Pat Robertson of the Christian Broadcasting Network and Raymond Sokolov of the *Wall Street Journal* condemned it, deploring the "selling of photographs of children in their nakedness" as "an exploitation of the parental role," and questioning whether federal funds should

be used to support the creation of such work, even though Mann received no government grants to make these photographs.[3]

Often described as fearless, crackling with intelligence, and endowed with an innate belief in personal liberty and a mother's instinctive defense of her family, Mann was nevertheless "blindsided by the controversy."[4] In the early 1990s, she slowly turned from photographing her family to recording the landscape behind them, explaining to a friend in 1994 that

the kids seem to be disappearing from the image, receding into the landscape.….As I thought about making a picture with a child in it, I came to be seduced by the landscape first of all, and then I would find a way to place the subject in it…rather than the other way around. In a certain way I was ambushed by the landscapes, they overwhelmed and commandeered my Family Pictures aesthetic![5]

Yet supporters and critics alike were perplexed in the late 1990s by her new photographs. Some praised them as "deeply romantic, poignant, often beautiful."[6] Applauding their daring originality, others perceptively recognized how easy it would be for Mann to continue to photograph her children and commended her for not falling into the trap of endlessly repeating the same kind of pictures.[7] Knowing of the threat of legal prosecution faced by some photographers at the time, some wondered if she had been censored or so chastened and scarred by her previous experiences that she had succumbed to self-censorship.[8] Still others, realizing that her children were now teenagers, questioned whether they had balked and refused to perform for her camera.[9] Some saw her new dark elegiac pictures as mourning the loss of her children's youth or even as "sentimental…coy, overwrought and empty."[10] Hilton Als in a perceptive but critical review in the *New Yorker* chided Mann for being "too obsessed with the South's picture-postcard 'terrible beauty.'… Rather than enjoying one of photography's most liberating qualities, its freedom from language, Mann begs for verbalization." He concluded, "she wants to be a mythologizer, a Faulkner of the lens."[11]

Mann may well have agreed, at least in part, with Als' assessment. From the beginning of her career, she has laid claim to her southern heritage and asserted that what makes her work southern is her "obsession with place, with family, with both the personal and the social past, the susceptibility to myth, the love of this light which is all our own, and the readiness to experiment with dosages of romance that would be fatal to most late twentieth-century artists."[12] But she has also been equally clear that literature has been just as important to her art, noting that she has "always had to reconcile wanting to be a writer and wanting to be a photographer."[13] With no siblings close in age and two self-absorbed parents, she was an avid reader as a child and imbibed both her father's belief that television was "not just stupid but possibly evil" and her mother's "utter devotion to…the selling of book-loving—and her belief that books and reading mattered, mattered more than getting home at suppertime to be there with a casserole between her oven mitts: That devotion was passed to me almost intravenously."[14] As she also freely admitted, she was never trained as a photographer but stumbled into the profession. Beyond one course and a few workshops, she, unlike so many other artists of her generation, did not study photography in college or university nor did she attend art school. Instead, she received a master's degree in creative writing from Hollins College and only became a photographer in the early 1970s because it was easier than writing and she was able to find a job working as a photographer for a local university. Moreover, she never sought to create an art that was free from language: joining her literary tastes with her aesthetic vision, she explained that the "two sensibilities, the visual and the verbal, have always been linked for me—in fact, while reading a particularly evocative passage I will imagine what the photograph I'd take of that scene would look like, even with burning and dodging notes."[15] In 2007 she told an interviewer that he had "nailed it" when he described her pictures of the Deep South as "'writing with photography.'…The landscapes come as close to 'writing with photography' as anything I have made," she insisted.[16] As she noted in her 2015 award-winning memoir *Hold Still* (written over the course of several years), the "inherent relationship between my writing and photography has never been clearer to me than it is now. The early poetic language and my later elegiac landscapes each served as primary, repeating threads running through my life, the warp and woof of memory and desire." She concluded, "If I couldn't do justice with words and certainly not the 'just the facts, ma'am' kind, I tried with my camera, composing silver poems of tone and undertow, the imagery saturated still with the words of authors I read in my teenage years—Faulkner, Whitman, Merwin, and Rilke. Many of my (poem-)photographs would sing those words, heady with beauty, ponderous with loss, right back to them."[17]

Yet her love of literature and poetry did more than just inform her imagery: it also permeated both the means she explored to create her art and her aspirations for it. Although she embraced a medium—photography—that for much of its existence has been inextricably linked to the reproduction of reality, she has never aspired to documentary exactitude in her pictures but has always sought to do more than simply record what she sees. Part of a generation of photographers who came to maturity in the 1970s and explored a more directorial and fictional approach to the medium, she has—from her first pictures made in the late 1960s to those made nearly fifty years later—skirted the border between fact and fiction, between the real and the imagined. By staging tableaus, altering and manipulating her negatives, and courting the vagaries of chance, she has repeatedly inserted herself between her subject and its expression. Recognizing that the power of fiction to speak to the human condition lies in its proximity to—as well as its distance from—the world, she has consistently deconstructed familiar vistas in order to posit new ways of seeing the everyday; in recent years, in referring to the more illusory nature of existence, she has also even created alternate realms, imagining events as they might have transpired.[18] In striving to infuse the universal into the specific, she has drawn inspiration from the lyricism of William Wordsworth, the darkly romantic and gothic tales of Edgar Allan Poe, the

sweeping epics of Walt Whitman, the mysticism of Rainer Maria Rilke, and the experimental, often provocative vision of William Faulkner, Ezra Pound, or W. S. Merwin, among many other authors. With her deep love of literature in all of its many forms and her rich understanding of the power of narrative and metaphor, she has recognized how her pictures can take on the psychological intensity and moral ambiguity of a short story, the nuanced complexity and immersive emotional sweep of a novel, the seductive but allusive power of a poem, and the lyric resonance and exalted cultural significance of an epic verse. This has been her aim: to construct "silver poems of tone and undertow," elegies to both the fraught heritage of her southern homeland, with its history, identity, race, and religion, and to the overarching themes of existence — the bonds of family, memory, desire, and death.[19]

Short Stories and Novels

We are spinning a story of what it is to grow up. It is a complicated story and sometimes we try to take on grand themes: anger, love, death. sensuality. and beauty. But we tell it all without fear and without shame.

SALLY MANN, 1992

Sally Munger Mann was born on May 1, 1951, in Lexington, Virginia — in a hospital that was once the home of the fearless Stonewall Jackson — and she has lived there almost her entire life. A small town with a population of just under six thousand in 1950, Lexington is at the southern end of the Shenandoah Valley, fabled for its natural beauty and hailed by Southern loyalists as the breadbasket of the Confederacy during the Civil War. Spared much of the devastation suffered by other Virginian towns during the war, Lexington is rich in history and tradition and proud of its past. Founded in 1778, it is also home to Washington and Lee University and the Virginia Military Institute. While some

might use these facts to assert a deep southern heritage, Mann does not: "Daddy was a character, from a Dallas family with some oil and real estate money. At the age of twenty-six, he went around the world on his motorcycle, taking along a tuxedo. Mom was from Boston, a very poor New England girl with gallons of blue blood running through her. All the different values that those two areas embody were strong in each of them."[20] Mann's parents were not only outsiders in a small, close-knit southern town but also eccentrics, tolerated and commended for their many contributions but perceived as different. Mann's mother, Elizabeth, worked for progressive causes and ran the bookstore at Washington and Lee University, importing writers such as Truman Capote and Betty Friedan to enlighten the local community. But she was distant, reserved, and confused by her daughter's passionate, headlong embrace of life. Her father, Robert, was a physician who was fascinated — even obsessed, as Mann herself has said — with death and the way it has been portrayed throughout the history of art. An avid gardener, he moved his family in 1952 to Boxerwood (fig. 1), an overgrown backwoods near Lexington where he eventually planted more than twelve thousand rare and exotic trees and shrubs. A man of many accomplishments and immense drive, he was also an amateur artist who bought art (Wassily Kandinsky in the 1930s and Cy Twombly in the 1950s) and loved to create often sexually provocative sculptures that he installed in his house and garden, much to the horror of his genteel southern neighbors and the annoyance of his wife.[21] Although Mann came to adore his strongly held beliefs, unconventionality, and irreverence, he remained something of a paradox to her and her siblings: courtly but also satiric and self-indulgent, an atheist but also a moralist, and a "fearsome" man whose "protective reserve had kept even his own children at arm's length."[22]

Raised "in a household that cared very little for children," Mann read copiously, cavorted around the family's property, often alone, often nude, and often on the back of her favorite horse, Khalifa.[23] This "lonely child" was saved by the nurturing presence

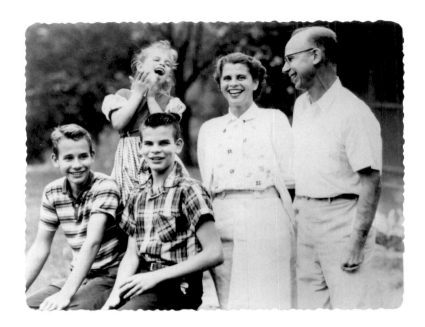

of Virginia "Gee-Gee" Carter, an African American woman who worked for the family for fifty years, and was, Mann asserted, the "best mother a child could want."[24] As an adult, Mann struggled with the "fundamental paradox of the South: that a white elite, determined to segregate the two races in public, based their stunningly intimate domestic arrangements on an erasure of that segregation in private." And she questioned whether "the feelings exchanged between two individuals so hypocritically divided [could] ever have been honest, untainted by guilt or resentment." Her answer: "I think so. Cat-whacked and earnest, I am one of those who insist that such a relationship existed for me. I loved Gee-Gee the way other people love their parents, and no matter how many historical demons stalked that relationship, I know that Gee-Gee loved me back."[25] However, as she admitted in *Hold Still*, with the obliviousness of a child it never occurred to her at the time to wonder why Gee-Gee did not eat with the family or use the bathroom when they went on long drives or how she managed to take care of her own family of six children after working twelve-hour days or how she was able to send all of them to boarding school (because the state provided only elementary education to African Americans) and to college. And as she confessed in her memoir, she did know that there was a difference between her and "the best mother a child could want": as she dug deeply into her memories, she painfully recalled the embarrassment she felt when Gee-Gee picked her up at school and her fear that classmates would think Gee-Gee was her mother.[26]

If Mann saw few racial boundaries inhibiting her love of Gee-Gee, others at the time were far less generous. Mann came to maturity during two of the most tumultuous decades in Virginia's history in the twentieth century. She was three years old on May 17, 1954, when the United States Supreme Court ruled in the landmark case of *Brown v. Board of Education* that "in the field of public education the doctrine of 'separate but equal' has no place." She was four when the Supreme Court ruled the following year in what has come to be known as *Brown II* that desegregation must proceed "with all deliberate speed," vague wording that allowed segregationists time to organize resistance. And she was still only four when Virginia senator Harry F. Byrd, Sr., took up that challenge and announced on February 25, 1956, the policy that came to be known as Massive Resistance. This group of laws was designed to prevent the integration of schools by creating a Pupil Placement Board with the power to assign students to particular schools and by awarding tuition grants to those who did not want to attend integrated ones. It also included a law that cut off state funds and closed any school that attempted to integrate. Mann was seven in September 1958 when the federal government ordered the desegregation of many schools in the state, including those in nearby Warren County, a little over one hundred miles to the north. She was still seven in January 1959 when Governor James Lindsay Almond, Jr., disobeyed the order and closed them, and when simultaneous rulings by Virginia's highest court and a federal court rejected the legislative underpinnings of Massive Resistance and ordered the schools to be reopened and desegregated. While these verdicts allowed thirteen-year-old Betty Ann Kilby and other African

1 / Robert Munger, Munger family Christmas card, c. 1958, courtesy of Sally Mann

Americans to attend Warren County High School, they did nothing to mitigate the fear she felt "with the gunshots constantly being fired at the house, crosses burned in the yard, bloody sheet on the mailbox, the farm animals mutilated and the constant threatening phone calls."[27] And Mann was thirteen and fourteen in 1964 and 1965 when the Civil Rights Act and the Elementary and Secondary Education Act were passed, denying federal funds to schools deemed to be resisting integration. Although these laws would gradually bring about significant changes, when they were enacted a large number of white families in Virginia were either sending their children to private schools or to public ones in the mostly white suburbs.[28]

Both of Mann's parents and her brother Chris supported civil rights: her mother collected five hundred signatures from Lexington residents to end a poll tax designed to keep African Americans from voting in Virginia and Chris participated in sit-ins, where he was kicked, shot at, arrested, and jailed seventeen times, causing great alarm within the family. But Mann, still an adolescent, was more interested in boys, parties, and cars than race, inequity, and politics, and in 1966 she, like her brothers before her—and so many other white Virginian children at the time—was sent to boarding school. When she first arrived at the Putney School in Vermont—a 1930s-era progressive institution with a rigorous academic program and a requirement that students contribute to the life of the community by working on a farm and in the cafeteria—she was a fish out of water. Surrounded by the sophisticated children of East Coast doctors, lawyers, intellectuals, and artists (Robert Frank's children, Pablo and Andrea, were students in the late 1960s and early 1970s), she discovered that her "currency was worthless." Pining for the South, she wrote long, elegiac, and often overwrought poems as she came to recognize that "the seasons, the sky and the soil" of the South "are within me." Slowly, though, she learned a new kind of tender: "creativity, intellect, artistic ability, scholarship, political awareness, and most important, cool emotional reserve."[29] She also learned photography. In April 1969, shortly before her graduation, she developed her first roll of film shot a few weeks earlier in Virginia with a 35mm Leica III camera her father had given her. She excitedly wrote her parents:

I have just returned triumphant from the darkroom. The best photographer in the school helped me develop my film and both he and I were absolutely ecstatic with the results. A lot of the pictures were of patterns of boards, textures of peeling paint on walls and old farm machinery. But their composition and depth and focus were all really good. I am absolutely frantic with…happiness and pride.…It's all rather unbelievable and perhaps a total fluke, but really very exciting anyway. God![30]

With no television and "highbrow" parents who subscribed only to the *Atlantic* and the *New Yorker*, though much later relenting and allowing the more pedestrian *Life* magazine to enter their doors, Mann largely understood photography in 1969 through what she had seen in Edward Steichen's best-selling, highly influential, if sentimental book *The Family of Man*, based on his 1955 exhibition of the same title. He was unafraid to "think big" and grapple with the meaning of life, and his sequence of photographs prized emotion over intellect and told a compelling, uplifting narrative of the common humanity of all people: for Mann it was "an eye-opener."[31] Yet now she discovered that the very act of making photographs could be equally revelatory—and controversial. Her second roll of film, shot later that spring, consisted of pictures of two friends, a boy and a girl, lying nude in a grove of trees in emulation of Wynn Bullock's *Child in Forest*, 1951, reproduced in *The Family of Man*.[32] Although they reminded Mann of a "teenage *Dejeuner sur l'Herbe*," they elicited a different response from others: soon after Putney's photography teacher found them, she was called into the headmaster's office and chastised for "inappropriate subject matter" and sexual misconduct.[33]

If, at this point, Mann had gone to art school or perhaps one of a number of universities, or even if she had moved to New York City or Los Angeles, she may well have turned into a different

photographer, possibly one more engaged with conceptual art, the impact of the media on identity and culture, or the effects of suburban expansion on the natural landscape — all practices and themes that intrigued many other young photographers in the highly experimental art scene of the 1970s. But, with her firm commitment to make her home in the South and her passions for reading, writing, and photography, she followed an alternative course. She continued to pursue her literary interests, majoring in literature at Hollins College and graduating summa cum laude with a bachelor of arts degree in 1974 and with a master's degree in writing in 1975. Her thesis consisted of an analysis of Pound's experiences in a Pisa prison camp and a piece of creative writing titled "Early Pictures," her first attempt to merge the visual and the verbal.[34] Like so many other authors before and since, she was inspired to write by two photographs: one of a man (her new husband, Larry Mann), flanked by two hounds and standing in a clearing with overhanging boughs; the other of a woman (by a nineteenth-century photographer), dressed in lace, with "molten eyes…that lunged toward the lens." In both poetry and prose, she used the pictures as a springboard to tell a story of a badly mismatched couple, one happy in "the saddle of the humped mountain" and one longing for her urbane life in Philadelphia.[35]

At the same time Mann continued to explore her nascent love for photography. In 1971 when she was enrolled in Bennington College she took a class in photography with Norman Seeff, who had achieved acclaim for his photographs of rock musicians. Later that same year, she and Larry traveled to Europe, where she studied photography at the Praestegaard Film School in Denmark and at the Aegean School of Fine Arts on the Greek island of Páros while she simultaneously studied with the British poet Lee Harwood. When she returned to the United States in 1972 she took advantage of the numerous photography workshops that had blossomed in the 1960s and 1970s. During these years when photography was still finding its place in university and art school curriculums, workshops — like camera clubs in the past — provided important educational opportu-

nities for many photographers, giving them useful technical instruction and a sense of community, as well as infusing them with the often high-minded beliefs of their founders.[36] Usually only a few weeks long, workshops were also less of a commitment than colleges or universities and less expensive, which suited both Mann's pocketbook and her emerging eclectic aesthetic — she could sample various approaches and concepts, picking those that proved helpful while rejecting the rest. She also benefited from the growing interest in the history of photography and the many photography exhibitions mounted in large and small museums around the country in the 1970s, as well as the proliferation of books on the medium by photographers, curators, and scholars. These, too, introduced her to the history and diversity of the medium, and enabled her to construct a vital and innovative practice far from a major urban setting.

In 1973 Mann attended the newly established Apeiron Workshop in Millerton, New York, which offered classes with a wide variety of photographers, such as Paul Caponigro, Linda Connor, and Judy Dater, as well as George Tice, with whom she studied. Founded by Peter Schlessinger, it was based on the principles of Minor White, who espoused Alfred Stieglitz's idea that a photograph could be a visual metaphor for an idea or state of being — "the function of camera work, when treated as a treasure, is to invoke the *invisible* within the visible" — as well as more basic prescriptions, "use the camera to see the *familiar* things: 'stay at home, don't go to the cemetery.'"[37] That same year she also attended the Ansel Adams Yosemite Workshop in California. One of the oldest workshops in the country, it was founded in 1955 by the charismatic photographer to provide students with the tools they needed to critically evaluate their photographs as well as technical lessons on previsualization, the zone system (his method to achieve correct exposure and development), and good printing techniques.[38] With his outsized personality and grand photographs celebrating the glories of the American West, Adams was at the height of his fame in the early 1970s, honored with a major retrospective at the Metropolitan

Museum of Art in New York in 1974 and the Presidential Medal of Freedom in 1980. Coupling his own shrewd marketing skills with advice from dealers and consultants, he had also become one of the few fine art photographers to support himself by selling his pictures, and thus proved to be an alluring role model for many younger photographers. Adams' impact on Mann's early landscape photographs made around her home in Lexington is obvious: he influenced her choice of subject matter and compositional strategies, encouraged her to observe the natural world in a calculated, deliberate manner, and instilled in her a deep love of the craft of photography, particularly the nuances that could be extracted from a black-and-white print (figs. 2, 3). But the differences between their work are telling too. Even though she had started to use a larger 5 × 7 inch view camera as advocated by Adams, her pictures are softer, more suggestive, and less emphatic than those by the older photographer, more concerned with an eastern and specifically southern quality of light, more focused on the fragile nature of the vistas in front of her camera, and more suggestive of the human presence within the land. She was also inspired by Adams' assistant at the time, Ted Orland, whom she later credited with being one of her early mentors.[39] Together they formed the Image Continuum, a group of six photographers who shared their work and ideas through their self-published journal. Although Orland's pictures, as he himself later admitted, "remained straight Adamsonian landscapes for years," Mann respected his levelheaded understanding of the commitment and tenacity it took to become a creative artist and valued his friendship and wit.[40] They exchanged letters for several years in which Mann revealed her struggles to gain gallery representation ("a nightmare...a living hell...the most degrading experiences I've ever had"), her concern that she was artistically "digging a grave" for herself by staying in Virginia, and her hope that a "healthy balance" could exist "between the artistic tensions and the fundamental order" of home and family.[41]

If serendipity favors those who are both fortunate and receptive, primed by hard work and ambition but open to new

2 / Ansel Adams **Rock and Grass, Moraine Lake, Sequoia National Park, California** c. 1932, National Gallery of Art, Washington, Gift of Virginia B. Adams

3 / Mann **Sensible Hole** 1972–1973, National Gallery of Art, Washington, Corcoran Collection (Gift of Greg MacGregor Malcolm in memory of Peter Malcolm)

ideas and approaches, then Mann was perfectly poised to recognize the importance of the seventy-five-hundred glass plate negatives by the nineteenth-century photographer Michael Miley that she discovered in the attic of the journalism building at Washington and Lee University late in the summer of 1973. Enrolled at nearby Hollins College, she and Larry were living in Lexington and starting to carve out a life for themselves. To help pay the bills, she had gotten a part-time job, albeit a pedestrian one, with the university taking photographs of its sports teams, student activities, buildings, and even its sewage-treatment plant. Miley, who was best known for his portrait of Robert E. Lee astride his horse Traveller, had learned to photograph during the Civil War, fashioning a good business for himself by making pictures of soldiers to send back home to their loved ones. After the war, he set up a studio, the Stonewall Art Gallery, in Lexington, where for much of the rest of the nineteenth century he, too, photographed the classes and athletic teams at both Washington and Lee, and the Virginia Military Institute. But the dusty negatives that Mann discovered in that attic contained many unexpected subjects interspersed among the nameless portraits, including the buildings and town of Lexington, the rivers and hills around the village, and even the remote stretch of river on a farm that Mann's father had bought many years earlier and where she had spent much of her childhood. And they were made using a photographic process entirely different from the one that she knew: Miley's negatives were made not on plastic-based film bought from the store with the convenience demanded by twentieth-century practitioners, but on glass plates that the photographer himself had coated with a sticky substance called collodion and then, working in complete darkness, sensitized with silver nitrate. Mann spent more than two years carefully cleaning the negatives, which ranged in size from 2 × 3 to 16 × 20 inches, and then catalogued and printed more than one thousand of them. In the process she learned a great deal about the difficulty and beauty of earlier photographic processes and the different ways in which they articulate light, form, and space; about

the ways a larger, heavier camera encouraged a different kind of seeing, one not dependent on spontaneity and speed but on a careful, deliberate recognition of the importance of the thing being photographed; about the history of her hometown, the look of the land, the city, and its people before the advent of the twentieth century; and about the power of photography to make the past a vital force in the present. But most of all she learned about the commitment of an artist to his practice and to his people, his place, his culture, and his history. And she realized that if she too dedicated herself to her homeland and to a deep exploration of her craft, she need not move to New York, like so many other young photographers, but could remain in Lexington and create art, like Miley's, that could speak across time and space and might even clarify, for her, "the deposits of my existence."[42] These were but the first of many lessons that Mann would glean from Miley's photographs, for in the years to come, often at moments of transition in her art, she would repeatedly cycle back to his pictures, using them as touchstones and extracting, each time, new insights from them.

With a voracious, if eclectic, visual appetite and a growing self-confidence, Mann began to draw on many other diverse influences as her circle of friends within the photography community expanded. In the 1970s she acknowledged that she had learned much from Connor, who taught her to be attentive to the way light could infuse a scene with a timeless, ethereal wonder, while Caponigro focused her attention on the mystery of the natural world, and Tice, through the example of his own work, "taught [her] to print," as she said.[43] In 1974 she saw an exhibition of photographs by Nancy Rexroth at the Jefferson Place Gallery in Washington, DC. Finding Adams' zone system too rigid and stifling, Rexroth had begun to use a Diana camera in 1969 that was originally marketed as an inexpensive novelty to be given away at carnivals or sold for the nominal sum of $1.98. (With an amusing lack of fuss, the instruction sheet told users to "look through the viewfinder and compose the picture. Then press the shutter slowly downwards. The picture is taken."[44])

Prone to light leaks, the cheap plastic lens produced softly focused, often vignetted, dreamlike pictures, while the imprecise viewfinder gave them a loose, spontaneous quality that Rexroth believed captured "feelings [like] something you might see faintly in the background of a photograph" (fig. 4).[45] Rexroth also mastered the complicated platinum printing process, prized by late nineteenth- and early twentieth-century pictorialists for its subtle, rich tonal range and rediscovered by many photographers in the 1960s and 1970s, including Irving Penn and Tice, among others.

When Mann saw Rexroth's photographs, she suddenly recognized that she could abandon her "Ansel Adams landscape mode" and depict the world in an entirely different way.[46] Using an 8 x 10 inch camera that someone had given her (not a small Diana), she began to make photographs of the construction of the Lewis Law Building at Washington and Lee (fig. 5). Turning her back on the implied documentary realism of Adams and the notion that a photograph was a transparent window on the world, she began to insert herself between her subject and its expression. In order to transform this pedestrian scene, she put on what Connor called her "photography eyes," and sought "the sensibility that allows for ecstatic vision."[47] She also used some of the strategies she had learned in her creative writing classes and searched for visual means that would allow her to develop character, setting, time, theme, voice, and tone. She decided to work at twilight or even at night when the busy activity of the day had been temporarily abandoned and she discovered that if her pictures were slightly out of focus, like Rexroth's, she could intensify their emotive qualities. Drawing on the compositional lessons she had learned from Paul Outerbridge, she used the limited tonal range of her nighttime views to lend them an abstract, chiaroscuro quality.[48] By using extremely long exposure times—twenty minutes or more—she found that the light seemed to emanate from the objects and not be reflected off them. Moreover, because her lens did not fully cover the image area and she used a cut-down toilet-paper roll to shade it and block peripheral light, her pictures, again like Rexroth's,

4 / Nancy Rexroth **My Mother, Pennsville, Ohio** 1970, courtesy of the artist and Weinstein Gallery

5 / Mann **Untitled, Lewis Law** 1974–1976, courtesy of the artist

have a centrifugal feeling to them, as if they are sucking the viewer into a whirlpool.

Inspired by both Miley and Rexroth, Mann also realized that she need not be bound to the black-and-white gelatin silver prints of the Adams school but could instead explore the history of the photographic medium and exploit the flexibility of its many different techniques. In the 1970s she began to make platinum prints in order to reveal what she described as "the translucence of light and fragility of form."[49] Becoming more sophisticated and sure, she responded to nude studies by earlier male photographers, such as Stieglitz and Edward Weston, and made a series of close-up photographs of the human body (figs. 6, 7). Like them, she used the nuanced and expanded tonal range of platinum paper to convey a delicate, supple, and sensual quality; and, like them, she pushed the forms right up to the front of the picture plane, rejecting any interest in individuality to transform the body into an exquisitely rendered still life.[50] Yet she updated the work of her predecessors—and slyly winked at them—by photographing Larry's buttocks draped with a delicately feminine gauze held in place by his decidedly masculine hand.

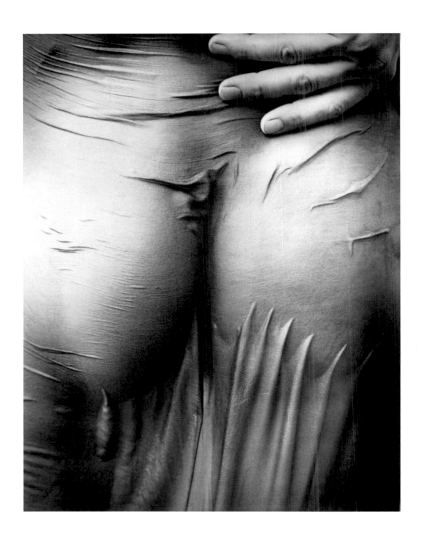

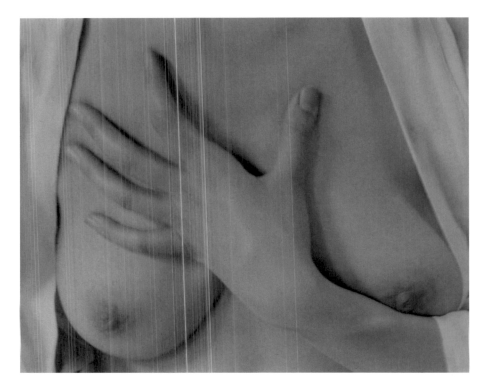

6 / Mann **Untitled, Platinum** 1978–1980, courtesy of the artist

7 / Alfred Stieglitz **Georgia O'Keeffe — Hand and Breasts** 1919, National Gallery of Art, Washington, Alfred Stieglitz Collection

Mann summarized these early investigations in *Second Sight*, a book of photographs published in 1983, in which she again sought to merge the verbal and the visual. The title is drawn from Theodore Roethke's poem "The Pure Fury," where he explores the notion of an ecstatic unity with the cosmos: "Morning, I saw the world with second sight, / As if all things had died, and rose again. / I touched the stones, and they had my own skin."[51] Yet it also alludes to Ralph Waldo Emerson's belief that the imagination infuses the natural world with symbolic importance: "Whilst common sense looks at things or visible Nature as real and final facts, poetry, or the imagination which dictates it, is a second sight, looking through these, and using them as types or words for thoughts which they signify."[52] As Mann sought to emphasize how she looked through the natural world with a second sight to reveal the larger concepts behind the final facts, she divided her book into four sections—early landscape photographs; abstractions, including the Lewis Law pictures; portraits of women; and platinum prints—and prefaced each one with a short poem written by her. The poems speak of her connection to the land around her—"the extravagant geode: my past. / Where all my life / by the one river, the upper field, / or the blue mountains— / the one place"—and her desire to recover "the small truths: the local. / This much is not sentimental: / To evoke and clarify the deposits, / their grace so fragile, so various."[53] By declaring herself both a poet and a photographer in *Second Sight*, Mann aligned herself with many other artists of the 1960s and 1970s who incorporated words into their photographs—from more traditional photographers like Robert Frank, Duane Michals, and Jim Goldberg to conceptual ones such as Vito Acconci, Barbara Kruger, or Sophie Calle, among many others. However, the book as a whole does not convey a unified vision and seems instead to consist of separate, unrelated chapters. And, as Mann herself admitted later in the 1980s, the photographs remain decorative—"there's no message—it's all just decadence…decadence and indulgence."[54]

Mann's life and art changed profoundly and permanently in the late 1970s and early 1980s when she and Larry had three

8 / Ted Orland **From Darkroom to Diapers: Life on the Home Front** 1980, courtesy of the artist

9 / Emmet Gowin **Edith, Newtown (Pennsylvania)** 1974, courtesy of Pace/MacGill Gallery

children in quick succession: Emmett, 1979; Jessie, 1981; and Virginia, 1985 (fig. 8). The all-consuming love she felt for them, coupled with a newfound sense of responsibility and the pressing reality of providing care, turned her focus away from the abstract, the ethereal, or the poetic to the present—more specifically, to the people around her. "Having children…expanded the parameters beyond the decorative [and] opened up the tender as well as a political (in its broadest sense) side to my work," she observed a few years later.[55] As she explored how to merge the decorative with opinion, "without the loss of grace or luminance," and create "visual stories" that made "people think," she looked to the work of her friend and mentor Emmet Gowin.[56] Born in nearby Danville, Virginia, Gowin had discovered his muse in 1964 when he married Edith Morris, who was "born about a year and a mile" away from him. As he "entered into a family freshly different" from his own, he determined to pay attention in his photographs "to the body and personality that agreed out of love to reveal itself."[57] Throughout the 1960s and early 1970s, he made quietly insightful, poetic pictures of Edith and her extended family: often employing fecund symbols—split watermelons, tubers, and dense encircling foliage—and often using an 8 × 10 inch camera with a lens intended for a smaller one, which produced a vignetted picture (fig. 9). Showing the connections of people to one another and their home, his photographs reveal a place that is both ordinary yet charged, where daily events are infused with mystery and myth. Devoid of sentimentality yet deeply intimate, they seek to disclose, in Gowin's words, the "secret, unrecognized dimension in the commonplace."[58]

In the early 1980s—"in the odd hours…between jobs and diapers"—Mann began to merge the emotional insight of Gowin with the cool-eyed precision of Adams in a series of photographs of adolescent girls.[59] She had previously photographed women, mainly her friends around Lexington, but here she turned her focus exclusively to twelve-year-olds on the cusp between childhood and adulthood. She published the pictures in a 1988 book titled *At Twelve*, with an introduction by Ann Beattie,

and interspersed them with short descriptive texts that recount the circumstances around their creation.[60] Mann's texts reveal how carefully she staged the pictures. On finding a potential subject, she met with the parents to secure their and their child's permission and then spent a considerable amount of time getting to know the girl, selecting the setting, and finally posing the photograph. Although many have an air of casual spontaneity, as if they were snapshots taken with a small handheld camera, all were made with her cumbersome 8 × 10 inch camera, better

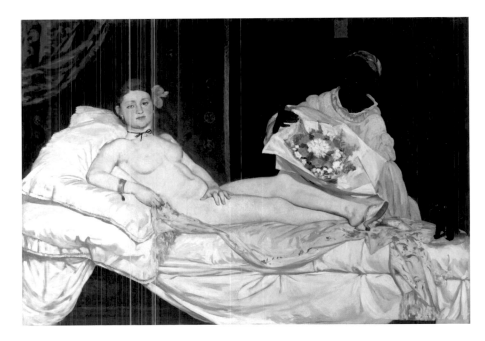

suited to photographing rocks and trees than the fluid movements and fleeting expressions of a child. Yet these large, sharply focused negatives yielded pictures dense with details—each element concisely seen and lushly described, and each one rich in meaning. Many show the budding sexuality of the girls and present them in the process of coming to terms with their femininity and womanhood, sometimes with an ineffable wistfulness. Often, like Édouard Manet's *Olympia*, they gaze at the viewer with a profound sense of self-knowledge (fig. 10). One girl, sprawled across a chair under the trees, reveals her youthfulness in quiet

10 / Édouard Manet *Olympia* 1863, Musée d'Orsay, Paris

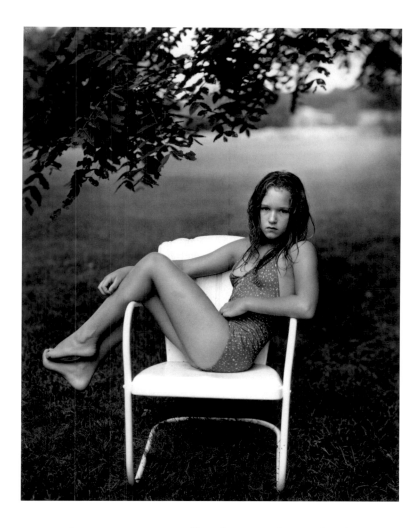

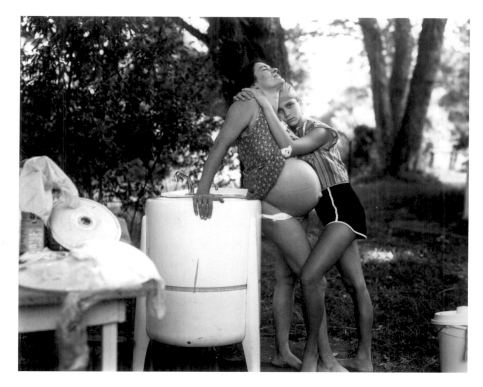

ways—the nervous gesture of her fingers picking at her leg or the curl of her toes, for example—while the twist of her body, the drape of her legs, and even the very rendition of nature itself all speak of her emerging sexuality (fig. 11). Others show the girls' interactions with their families. One depicts Mann's friend Leslie—her naked, pregnant belly protruding like a giant water balloon ready to burst—as she stands outside in the oppressive humidity of a Virginia summer. Wearing an expression, as Mann wrote, of "resignation, ambivalence, and determination," Leslie leans back on an abandoned washing machine, as if signaling the hours of drudgery that lie ahead, while her daughter, calling to

mind a lanky fawn, wraps her arms and legs around her mother.[61] Looking directly at the camera, the girl has a startling air of empathy and sadness, perhaps in recognition of her own past and future (fig. 12). With carefully constructed, unflinchingly seen pictures, *At Twelve* reads like a collection of finely honed short stories on the human condition. Replete with details and ambiguity, questions posed and left unanswered, each photograph, like a short story, focuses on a self-contained moment or incident in a child's life and provides "a glimpse into another country," as John Updike wrote of the genre, "an occasion for surprise, an excuse for wisdom, and an argument for charity."[62]

It is often said that short stories are apprenticeships for authors, a genre they must master before venturing on to longer, more ambitious, and experimental narratives. Mann made that leap in 1985 when she began to photograph her children. She drew on everything she had learned to date—from her Adams-like landscapes and haunted architectural views to her elegant

11 / Mann **Juliet in White Chair** 1983–1985, courtesy of the artist
12 / Mann **Jenny and Leslie, 8 Months Pregnant** 1983–1985, courtesy of the artist

figural studies and incisive portraits, as well as her deep knowledge of the history of photography and painting—and constructed a grand narrative, published in 1992 as *Immediate Family*, that was as ambitious and accomplished as it was controversial. (For further discussion, see Sarah Kennel's essay in this volume.) The story it tells is a layered and complex one, though fundamentally about a specific place—her family's four-hundred-acre farm nestled in a horseshoe bend on the Maury River. Mann's first words in the introduction to *Immediate Family* signal its significance: "The place is important; the time is summer. It's any summer, but the place is home and the people here are my family" (pl. 1).[63] The story is also about the Edenic life the family enjoyed there: the long days and nights spent swimming, playing, and being together with no electricity or running water and far removed from the intrusions of late twentieth-century life. And the story is about Mann's own history with the place: it is about her father who bought the land and built the cabin, her mother and her grandmother Jessie who made the Easter dress that Mann's own daughter Jessie proudly displayed one warm

spring day; and it is about her beloved Gee-Gee whose heavy, wrinkled arms and legs appear in several pictures in marked contrast to the supple, sensuous vitality of Mann's young children (pls. 2, 85). The story is also about the oppressive heat of the place, its refulgent light, and its pristine, timeless natural beauty (pls. 6, 9). As she sought to render these qualities, Mann looked back to Miley's photographs of this very place, taken a hundred years earlier, noting how he used the vortex created by the twisting river, the trees, and their dark, cool, mysterious reflection in the water as a way to draw viewers into the composition, giving them a palpable sense of the feel and even the smell of the place and the quality of life it engendered (fig. 13; pls. 1, 19, 20). And she noted too how he had exploited the moisture-laden, radiant light streaking through the dense overhanging foliage, how it obliterated some forms in his pictures with its intensity while it illuminated others with an ethereal glow (fig. 14; pls. 6, 9).

Once again, Mann carefully defined the parameters of the project. She primarily photographed her children during the summer at the farm and spent the winters printing the pictures

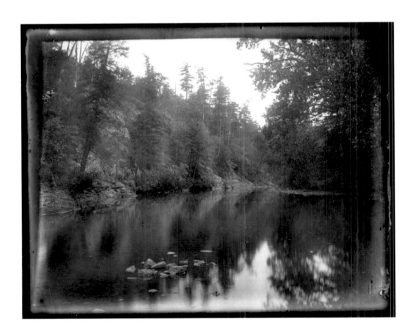

13 / Michael Miley **Untitled** c. 1890s courtesy of Sally Mann

14 / Michael Miley **Untitled** c. 1890s courtesy of Sally Mann

in between her daily life as a busy mother. Once again, she mainly used her 8 × 10 inch view camera, even though the subject matter seemed to cry out for a smaller format. Once again, she posed many of the pictures, often re-creating scenes she had previously observed but fine-tuning details to intensify her results. And once again, she was dependent on the complete cooperation of her subjects, not only to hold their poses for the long exposures but also to perfect through repeated trial and error their expressions and thus the meaning she wanted to convey. Even more than the twelve-year-old girls she had photographed earlier, her children were true collaborators. She explained: "Sometimes I have an idea, usually based on something I've seen them do…when it's convenient, I'll arrange the scene and let the kids work back into it.…The final image more often than not is significantly affected by the children's interpretations or contributions. Remember, these are very independent, strong-willed, sophisticated children who know a lot about how they want the pictures to look."[64] They also quickly learned what scenes intrigued their mother: in 1992 eleven-year-old Jessie said, "I know what my mom likes sometimes, so I point it out to her."[65] As Mann continued: "They have been involved in the creative process since infancy. At times, it is difficult to say exactly who makes the pictures. Some are gifts to me from my children: gifts that come in a moment as fleeting as the touch of an angel's wing."[66]

The angels did grace many of these photographs, for they are as sure and telling, as layered and nuanced, as the greatest pictures of domestic life, revealing Mann's extraordinary ability to infuse the everyday with mythic significance. Some are grand tableaus with a nineteenth-century feel in both their command of a complex pictorial space and their sprawling narratives. *The Ditch,* for example, shows Emmett, his arms and legs bent under his body, tightly wedged in a muddy channel in between a glowing body of water in the foreground and the darker river behind (pl. 8). Although the allusions to birth, the river of life, and the passage from an ethereal inner world to a mysterious outer one,

are obvious, Mann transformed the scene into a dreamlike world by drawing on lessons learned from Gowin and her own innovative use of focus. Vignetting the picture, she created a swirling whirlpool that distorts, blurs, and darkens the people standing on the periphery, transforming them into eerie apparitions witnessing Emmett's fraught rite of passage into the outer world. The centrifugal pull of the composition sucks the viewer into its maelstrom where the eye finally rests on Emmett's face, the only thing in focus in the picture. *Easter Dress* is another picture that seems on the verge of spiraling out of control (pl. 2). Again, all of the peripheral figures—Emmett, Virginia, an older man, and even a dog—are blurred, twisting and turning in different directions around Jessie who, like Emmett in *The Ditch*, anchors the picture in her glowing white dress, as if speaking to the centrality of children in all life. As multilayered—and literary—as any Pre-Raphaelite painting, *Blowing Bubbles* uses similar tools and strategies, and with its abandoned toys and soap bubbles drifting through an empty frame alludes to the fleeting and fragile nature of both childhood and art (pl. 4). Mann also printed these photographs at 20 × 24 inches: much bigger than her earlier 8 x 10 inch platinum prints, they create an immersive experience for her viewers, enveloping them in the scenes, the stories, and the lush sensuality.

Others are less sprawling in their scope but no less powerful in their evocation of the grand themes of life—"anger, love, death, sensuality, and beauty," as Mann noted in the introduction to the book.[67] Several draw on her rich knowledge of the history of photography. In *Jessie Bites* (pl. 13), for example, she looked to the toughness of Diane Arbus and her ability to express raw emotion, as in *Child with toy hand grenade in Central Park, N.Y.C.,* 1962.[68] Re-creating the bite marks that Jessie had made earlier, she stiffly entwined her arm with her daughter's and posed her to elicit a defiant expression, suggesting that Jessie's anger raged long after the incident had transpired. In *Cherry Tomatoes* or *Last Light*—pictures like so many others in the book that are filled with sentiment but no sentimentality—she looked to earlier

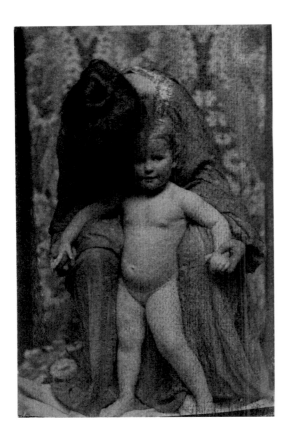

photographers such as Harry Callahan or Gertrude Käsebier, noting the way they had expressed the deep sensuality of the love that exists between parent and child (fig. 15; pls. 7, 10). While in other pictures, Mann acknowledged Gowin's ability to allude to the love of siblings who are able to spend endless hours together, devising ways to entertain themselves at any time and in any situation (fig. 16), even when, as in *Gorjus*, threatened by a dog (pl. 3). *The Two Virginias #4* speaks to a different kind of love that skips generations and defies race (pl. 85). It depicts Mann's youngest daughter, Virginia, lost in a deep sleep on the lap of her namesake, Gee-Gee. Merging old and young, past and present, black and white, Mann wove the picture together through the depiction of the long white tendrils of Gee-Gee's hair and their upraised arms, frozen in midair as if they were jointly conducting

an unseen orchestra in their dreams. Once again, through her use of selective focus, Mann draws attention to Gee-Gee's crippled arthritic hand on the left as it reaches up and is bathed in light, as if blessed by the divine.

This is a story about the grand themes of family life often told from a child's point of view—the pure, ecstatic delight siblings have in mastering a balancing act in the warm summer sunlight, as in *River Dance*, for example, or the joy in making the perfect dive, as in *Jessie at Nine* (pls. 16, 19). But it also expresses those emotions that reside more exclusively with parents. Showing parenthood to be a delicate balance between profound love and gut-wrenching fear, *The Alligator's Approach*, for example, speaks of every parent's dread of imminent, unforeseen danger and the need to be constantly vigilant, even in paradise; the *Bloody Nose*

alludes to concerns about injury and the almost instinctive desire to protect a child from pain and suffering; while *Emmett Floating* broaches the unspeakable horror of the death of a child (pls. 6, 17, 11). The very strength and emotional honesty of these pictures and the conflicted feelings and responses they provoke in viewers — from aching love, fear, and protectiveness to the beguiling, even alluring nature of the children themselves — shake many viewers to the core, just as they did Mann herself. Recognizing that photography was a way to not only preserve a moment in time but also understand it more fully, she wrote: "The more I look at the life of the children, the more enigmatic and fraught with danger and loss their lives become." Mann explained: "Photographing my children in those quirky, often emotionally charged moments has helped me to acknowledge and resolve some of the inherent contradictions between the idea or image of motherhood and the reality."[69]

Few photographers before or since have made such a nuanced, multifaceted picture of childhood, one that addresses it both from the child's and the adult's point of view; few have so successfully transformed their pictures into visual metaphors that address life's grand themes; and few have faced such a barrage of criticism. In 1992, the same year that *Immediate Family* was released, the conservative political commentator Patrick Buchanan used his address to the Republican National Convention in Houston to declare that "the culture wars" were a battle for "the soul of America. [They] are as critical to the kind of nation we will one day be as was the Cold War itself." They are "about who we are…what we believe…what we stand for as Americans."[70] In the wake of the profound and tumultuous changes that had occurred in American society since the 1960s, it was a battle about abortion, affirmative action, creationism, evolution, feminism, homosexuality, and school prayer, but the arts and the question of censorship, pornography, and government support were also front and center. In 1989, conservatives such as Senator Jesse Helms had been angered when Andres Serrano's photograph of a crucifix suspended in his own urine, *Piss Christ*,

was exhibited in Virginia by the Southeastern Center for Contemporary Art. This organization, using funds from the National Endowment for the Arts, had awarded grants to Serrano and nine other artists.[71] That same year, the Corcoran Gallery of Art in Washington ignited a firestorm when it canceled its planned presentation of *Robert Mapplethorpe: The Perfect Moment*, an exhibition that some thought contained pornographic photographs. Organized by the Institute of Contemporary Art in Philadelphia, it too had received a grant from the National Endowment for the Arts. The cancelation sparked a national debate about whether taxpayer dollars should support art some considered obscene and whether art was a form of free speech and thus protected under the First Amendment. While *Immediate Family* was swept into this maelstrom, its reception was also clouded by several highly publicized cases of child sexual abuse in the 1980s, including one involving the McMartin Preschool in Manhattan, California, which had riveted national attention from 1983, when charges were first filed, until 1990, when the final defendant was acquitted. The rising number of reported cases of child abuse in the 1970s and 1980s may also be seen as symptomatic of the anxieties provoked by changing concepts about the role of women, their growing presence in the workplace, and the need for a better system of day care. Moreover, with the divorce rate, the number of openly homosexual and interracial couples, and the advocacy for gay marriage all increasing, the definition of the family and family values was fiercely debated in the 1980s and 1990s.[72]

In this charged climate, reactions to Mann's family photographs were swift, often harsh, and came from all sides. While many in the art world praised the beauty and originality of the photographs, others remained deeply skeptical.[73] "It May Be Art," a headline in the *San Diego Tribune* read, "but What about the Kids?"[74] Some reviewers missed Mann's art historical references: she had titled one of her early pictures of Jessie's bug-bitten face *Damaged Child* after Dorothea Lange's earlier picture of the same title, but confusing a photograph with documentary evidence, they questioned whether her children had

been abused, while others suggested that she had aestheticized the issue of child abuse.[75] Not realizing that many of the photographs were carefully staged and forgetting that they represented only one fraction of a second—one expression extracted from the flow of time—a few critics suggested that the children looked mean and nasty.[76] But many more found—and still find—the nudity of the children particularly offensive and troublesome. Questions were raised about the very morality of the photographs and the photographer herself: could the children freely give consent when the photographer was their parent; were the pictures exploitative; did they sexualize the children, putting them and other children at risk; and had Mann abdicated a gender-biased notion of a mother's role as protector of her children?[77] Mann's titles unintentionally added fuel to the fire: she called a picture of Jessie standing nude on a table and bathed in a magical light *The Perfect Tomato* (page 99, fig. 11) because a tomato was the only thing in focus in the picture, not realizing that it was slang for a girl or woman. She titled a picture of Emmett standing in the river *The Last Time Emmett Modeled Nude* because the early fall photography session required many takes and this image represents the final one, not because he objected to the practice (pl. 20).[78] Mann's children quickly came to her defense. Displaying an astute understanding of photography, they recognized, even at a young age, that the pictures were just that—pictures not reality. They also noted—then and now—that they were willing participants and that when Mann questioned whether she should publish the photographs in the early 1990s, they were the ones who insisted she do so.[79] Before the publication of *Immediate Family*, the children had seen a psychologist, who declared them happy and well-adjusted. Yet they all—the children, Mann herself, and Larry—were unprepared for the response the book provoked: the media attention, the critical press reviews, and even the stalkers. Their lives would never be the same.

Poems, Metaphors, and Encoded, Half-Forgotten Clues

I dined with Legrandin on the terrace of his house, by moonlight. "There is a charming quality, is there not," he said to me, "in this silence; for hearts that are wounded, as mine is, a novelist, whom you will read in time to come, claims there is no remedy but silence and shadow. And see you this, my boy, there comes in all lives a time, toward which you still have far to go, when the weary eyes can endure but one kind of light, the light which a fine evening like this prepares for us in the stillroom of darkness, when the ears can listen to no music save what the moonlight breathes through the flute of silence."

MARCEL PROUST, 1934

Since my place and its story were givens, it remained for me to find those metaphors; encoded, half-forgotten clues within the southern landscape.

SALLY MANN, 2015

When clockmakers fabricate the intricate workings of their machines, they often leave punches or scratches, called witness marks, providing clues for those who later repair them on how to fit the pieces back together. Artists leave their own sort of witness marks that in retrospect give evidence of their future course. Sally Mann did just that in the late 1980s and early 1990s when she depicted the dark brooding landscape in *The Last Time Emmett Modeled Nude* nearly subsuming her son or showed children eating on the grass in *Picnic* before a raging conflagration in the background (pl. 21). As she turned her attention from photographing her children to the landscape around her home in Lexington in the early 1990s, she was exhilarated by a newfound sense of freedom and challenged by a new set of aesthetic problems.[80] Experimenting widely and boldly, she radically altered not only the scope of her practice but also the issues her art addressed. For the first time in more than a decade, she was working alone without models and without the natural magnetism

they brought to a picture. And unlike her children—who talked back, adding their own suggestions on how to make her pictures—her new subject, the landscape, was mute, intractable, sometimes inscrutable, and entirely unresponsive to her direction. At first she photographed the land around the farm, the upper fields and edge of the woods that she knew so well and that offered a "profligate physical beauty," as she wrote, that was so easy to find in her homeland (pls. 22, 28). Seeking what she termed "the radical light of the American South," as well as the "silence and shadow" of Proust, she worked in the early morning or late afternoon hours when the light was suffused with humidity and "the landscape appears to soften before your eyes and becomes seductively vague, as if inadequately summoned up by some shiftless creator casually neglectful of the detail."[81] Especially when she recorded more distant views, as in *Blue Hills*, she utilized the soft vignetting of her lens to intensify both the sense of looking and her personal connection to the land, thus creating the impression that she was standing on a rise, hand cupped against her forehead, surveying the vista unfurling before her eyes (pl. 22). By composing the scene out of bands of tone, not detail, she infused a Wordsworthian sense of the sublime into it, as nature and her imagination transformed the heavy, dense lines of the trees and rolling hills into an ocean of waves receding into the background. Some pictures verge on pure abstraction and emotion, such as *Upper Field*, as ribbons of cool, dark tones rise to meet a glowing light (pl. 28). But she also searched for scenes that were "uncompelling," where she could not immediately see what there was to photograph, like a mound of damp mud, rock, and scruffy brush in *Niall's River* (pl. 23).[82] Such vistas, she said, were "teasingly slow to give up [their] secret," but she found them surprisingly seductive because they assumed "the unassertiveness of the peripheral. These are the places and things most of us drive by unseeing, scenes of Southern dejection we'd contemplate only if our car broke down and left us by the verdant roadside."[83] The more photographs she made, the more she came to realize, as she wrote to a friend in 1994, that "if the family

pictures are flashes of the finite, these landscapes offer them residence in the languid tableaux of the durable."[84]

As she began to reexplore the landscape, she also renewed her friendship with Twombly. Although he was born in Lexington and knew her parents, he had lived in Rome and Gaeta, Italy, for many years. In 1993 he moved back to Lexington, where he spent part of almost every year until his death in 2011. As an artist who drew heavily on literature, myth, and cultural memory, creating pictorial metaphors that explored the grand narratives of the Western tradition, and one who merged the visual and the verbal through his scrawls on his canvases, he was a welcome and influential companion for Mann. Since his student days at Black Mountain College in 1951 and 1952, he had also been an active photographer and in 1993 published the first of many books of his photographs.[85] Twombly's softly focused, tremulous photographs depict his everyday world—flowers, trees, an open window, his studio—"the little things that hardly anyone sees,"

17 / Cy Twombly **Robert Rauschenberg Combine Material, Fulton Street Studio, NYC** 1954,
courtesy Archives Fondazione Nicola Del Roscio

as Rilke (whom both Twombly and Mann greatly admired) wrote in his *Letters to a Young Poet:*

If you will cling to Nature, to the simple in Nature, to the little things that hardly anyone sees, and that can so unexpectedly become big and beyond measuring; if you have this love of inconsiderable things and seek quite simply, as one who serves, to win the confidence of what seems poor: then everything will become easier, more coherent and somehow more conciliatory for you, not in your intellect, perhaps, which lags marveling behind, but in your inmost consciousness, waking and cognizance.[86]

Twombly's ability to infuse his unassertive subjects with personal meaning and a sense of the fragility of time resonated with Mann, but so too did his casual "Brancusi-like freedom of interpretation," as she wrote; his use of light, particularly the way he allowed it to transform both color and form into abstraction and pure energy; and his ability to make "profound even the most mundane of junk heaps" (fig. 17).[87]

She carried these lessons with her as she ventured into Georgia in 1996. As part of Atlanta's celebration of the 1996 Olympics, she received the inaugural commission for the High Museum of Art's *Picturing the South* photography series. Seeking to create works that were as "unhurried and as profound" as possible, she once again looked to Miley and got, as she later explained, "far more than I bargained for. His pictures completely changed the direction of my work for the next fifteen years" (fig. 18).[88] She was dazzled by aspects of his collodion negatives that Miley himself may well have considered flaws—the white flare around their edges, their subtle solarization (a reversal of tone caused by overexposure), and the way some areas of the negative had an unnatural clarity while others were out of focus. She found that she could approximate these effects by using Ortho film, a high-contrast, extremely sharp, fine-grained film usually used for offset lithography. It worked for her, though, because its slow speed allowed her to use an antique lens that had no shutter or aperture, was held together with tape, and let in a huge

amount of hard-to-control light. Although her earlier family pictures had required a technique so precise as to "out-Ansel the most meticulous Adams," she discovered that a more slapdash approach using old, diluted print developer worked better with Ortho, even enabling her to bring out middle tones, if desired. In addition, Ortho could be developed under a safelight, so that puttering like a chef in the kitchen, she could add a little of this, a little of that, and cook until done. Best of all, she was "having fun again, just like those first months with my father's Leica."[89]

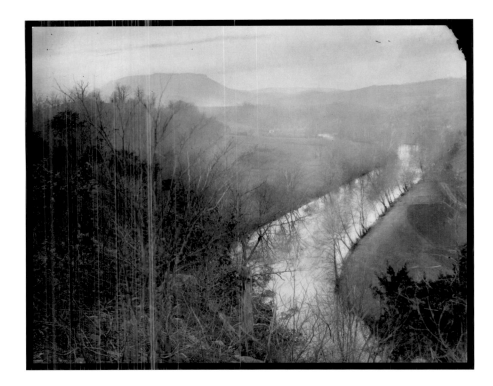

When she traveled through Georgia, she discovered a different world from the one she had depicted in Virginia; this new place was infused with a sense not of a personal, private history but a more conflicted, public, and national one that had inscribed itself on the present landscape. As she wrestled with this new land, she drew on her deep knowledge of both the history of photography and the history of the South, particularly the Civil

18 / Michael Miley **Untitled** c. 1890s, courtesy of Sally Mann

War, and searched for the "inconsiderable things," as Rilke noted, that expressed this past. She was drawn to empty fields littered with logs or low-slung buildings that recall Civil War photographs by Alexander Gardner, Timothy O'Sullivan, or George Barnard: not their celebrated pictures of the dead on the battlefield, but more mundane ones that are charged with a sense of human action on the land yet leave viewers wondering about the nature of the events that transpired there (fig. 19). These earlier photographs intrigued her with their inconsequential yet redolent subject matter, as well as their Twombly-like freedom of interpretation—the rough nature of their exposures and the bleached character of their prints, all of which imparted a sense of time, history, and the past.

She returned to the Deep South in 1998 on the first of several trips that had profound consequences for her art. Guided not by intellect but by "inmost consciousness, waking and cognizance," as Rilke had advised, she traveled to Alabama, Louisiana, and Mississippi "within a nimbus of goodwill," as she later remarked, "like some Nabokovian state of grace, pure and sweet."[90] The morning after she had met a couple at a lecture in Mississippi and accepted their offer to stay at their family home, she awoke to find a magnificent tree outside the back door (pl. 29). Recalling the nineteenth-century French photographer Gustave Le Gray's *Beech Tree* (fig. 20), she made no attempt to picture the tree in the larger context of the yard and field behind it or even to depict its branches or crown. Instead, focusing directly on its trunk and roots, she constructed a portrait of it as a "silent witness" to another age and revealed the landscape as a vessel for memory.[91] While Le Gray's tree possesses the same solemnity, ineffable sadness, and even wisdom as Mann's, his appears as a ghostly apparition rising off the ground, about to take leave of this world, while hers is firmly rooted in the earth and the present, its scar evidence of its past, near mortal, wound and its survival. Le Gray's photographs informed other pictures Mann made on this trip. Although *Fontainebleau* was named after a state park on the shores of Lake Pontchartrain, north of

19 / George Barnard **Scene of General McPherson's Death** 1864–1865, from *Photographic Views of Sherman's Campaign* (New York, 1866), The Museum of Modern Art, New York, Acquired by exchange with the Library of Congress

20 / Gustave Le Gray **Beech Tree, Forest of Fontainebleau** c. 1856, National Gallery of Art, Washington, Patrons' Permanent Fund

New Orleans, and not the forest in France where Le Gray made many of his most famous photographs, Mann, like her French predecessor, used the dense overhanging boughs, their branches thickly entwined with kudzu and other vines, to weave the picture together (fig. 21; pl. 24). Like Le Gray, she lured viewers from that tangled uncertain canopy in the foreground to a brightly lit field in the background, enticing them from darkness to light, complexity to simplicity, confusion to clarity.

Borrowing freely and shamelessly from the past, Mann also began to use the same wet collodion process that Miley and countless nineteenth-century photographers had employed to make their negatives. (For further discussion, see Malcolm Daniel's essay in this volume.) Although messy, complicated, fraught with difficulties, and made with potentially explosive materials, it significantly altered her art, expanding and complicating the freewheeling experimentation she had begun with Ortho film. She received sound training in the process in 1997 from Mark and France Scully Osterman, two photographers who had resurrected and mastered the wet collodion technique in the late 1980s. Although she came to appreciate the almost ceremonial aspect of creating a collodion wet plate, she realized as she experimented that it was "the flaws I like." She had always been open to serendipity, eagerly embracing the fleeting glance of a teenage girl, the unexpected gestures of her children, the light flares, uneven focus, and spatial ambiguity caused by her camera and lenses. But now chance became a determining element in the creation of her art and she found herself praying to "the angel of uncertainty" to bestow on her plates "essential peculiarities, persuasive consequence, intrigue, drama, and allegory."[92] Before exposing a negative, she playfully admonished herself: "Please don't…totally screw it up, but still if you do, screw it up enough to make it interesting."[93] Thus, if the Ostermans or nineteenth-century manuals advised her to polish the glass carefully, she did not, causing pits, spots, and comet-like streaks in her prints, as in *Concrete Grave*; if they directed her to pour the collodion slowly and evenly over the entire plate, she did not, creating bands and pools, as in *Valentine Windsor*; and if they cautioned her to handle the edges of the negative with care to avoid damaging the fragile emulsion, she did not, welcoming the losses and cracks, as in *Concrete Grave* (pls. 31, 26).

Her embrace of collodion, though, propelled another, even more significant consequence. Once she started to use a nineteenth-century method of making her negatives, along with a nineteenth-century camera and lenses, she was able to more fully understand, integrate, and play with nineteenth-century pictorial vision in her late twentieth-century art. Today, more than 175 years after the birth of photography, it is hard to remember that this medium marked not only a marvelous new way to capture the image of nature but also the construction of an entirely original pictorial language, one characterized by, among other things, seemingly arbitrary compositions; random cropping; a stretching, flattening or layering of space; and a dependence on the unpredictable interaction of light, form, and chemicals. Earlier photographers learned to exploit this new language,

21 / Gustave Le Gray **Tree, Forest of Fontainebleau** c. 1856, The Museum of Fine Arts, Houston, Museum purchase funded by the Brown Foundation Accessions Endowment Fund, The Manfred Heiting Collection

and Mann did so too. Thus, in pictures such as *Three Drips* she played with oddly placed objects such as the tree in the extreme foreground—something any earlier self-respecting painter would have omitted—in order to highlight photography's peculiar and uncritical acceptance of everything in front of the lens and to convey a sense of immediacy, as if viewers too are wading through the underbrush and discovering this scene (pl. 25). In *Stick* she explored the same kind of mirrored reflection that had intrigued Carleton E. Watkins or Eadweard Muybridge, as well as others, but she deftly played with the reflection. Bisecting the stick in multiple spots (at the line of the water and trees in the background, at the line of the water itself in the foreground, and by a bright highlight on the water in between), she made it difficult to discern where reality stops and illusion begins (pl. 27). And in *Valentine Windsor* and *Three Drips* she exploited the way an intense light can both define and obliterate forms, as well as collodion's overly sensitive rendition of blue light (all attributes that nineteenth-century photographers wrestled with in their pictures), creating photographs where reality itself seems to be dissolving before one's eyes. Further updating and complicating the experience of these pictures, she printed them much larger than any of her earlier photographs—40 × 50 inches—giving them an enveloping, immersive quality unknown in her earlier art and in most nineteenth-century photographs as well.

Her trips to the Deep South, and especially Mississippi, prompted other conceptual revelations that reverberated in her art for years to come: "I had come south looking not so much for the scars of the Civil War, but for something even more fundamental and, paradoxically, elusive." As she absorbed the region's poverty and inequality, as well as the sense of oppression, pain, loss, decay, and even death that seemed to permeate the very air, she realized she had plunged into "the heart of the country, but it's such a flawed heart."[94]

I was improbably enough listening to Joseph Conrad's Heart of Darkness *on tape. Though a world apart from Africa, it was impossible for me not to think of the misery extracted at every turn in those roads, just as it had been impossible for Marlow to paddle up the Congo unaware of the "groves of death" lying within the shadows along the riverbank. For me, the Deep South was haunted by the souls of the millions of African Americans who built that part of the country with their hands and with the sweat and blood of their backs.*[95]

Seeking to get the earth "to give up its ghosts," she lingered near Money, Mississippi, the town where fourteen-year-old Emmett Till, an African American from Chicago, was kidnapped and murdered in 1955 after allegedly flirting with a white woman.[96] Like so many others, Mann had been haunted by the accounts of his death since her own childhood and had named her firstborn child Emmett. Marrying her horror with the larger national one, she retraced Till's route on the evening of his death, creating several photographs in homage to the young man. One, *Bridge on Tallahatchie* (pl. 30), depicts the Black Bayou Bridge in Glendora, Mississippi, the place where some believe Till's naked, mutilated body was thrown into the river with the heavy fan of a cotton gin lashed around his waist. It is an odd picture. Showing a picturesque country bridge nestled in the background and spanning a placid river, it is the kind of scene that might grace the walls of the local chamber of commerce. Yet in the foreground a skeletal branch reaches in from the left like the scrawny-fingered hand of death, and just below it a seemingly careless chemical streak evokes a teardrop moving through the emulsion. At once ordinary but charged, beautiful but horrific, the image embodies the very paradox of the South itself.

Guided by a friend, Mann then trekked through dense underbrush to the site where they believed Till's body was discovered. When she got there she was "disappointed by the humdrum, backwashy scene before me. How could a place so weighted with historical pain appear to be so *ordinary?*"[97] Nevertheless, she persisted and, drawing on everything she had learned, especially Twombly's ability to make the humdrum

profound, she created *Emmett Till River Bank* (pl. 32).[98] It, too, is a picture slow to give up its secrets. She positioned her camera almost directly in front of the opening in the brush where Till's body was pulled from the water, focusing attention on a gash in the earth, an open wound-like form. She shot into the sun, allowing it to flood the heinous scene with light, in knowing defiance of Kodak's rule and perhaps mindful of Martin Luther King's admonition: "Darkness cannot drive out darkness; only light can do that. Hate cannot drive out hate; only love can do that."[99] As in her Lewis Law photographs or some of her Virginia landscapes, she eliminated all detail, transforming the scene into abstract bands of tone and emotion, thus reducing it to its most elemental state—earth and water, light and air. Merging her technique with her vision, she used her faulty, too-short lens and hastily coated her collodion plate, but she prevented the light-sensitive solution from flowing evenly into the corners. Giving a sense both of the macro and the micro, the specific and the universal, the vignetted image appears as if seen through the lens of time. Mann may well have looked back in time to a similar photograph, *The Ditch,* of her son, Emmett, lying by another river. Whereas sentinels preside over her child as he moves into the river of life, there are no protectors for Emmett Till at this site on the Tallahatchie River: it is as empty, barren, and utterly devoid of humanity in this photograph as it was in 1955.

She made one more photograph near Money that may also allude to Till, *Concrete Grave.* In it, an oddly human-shaped concrete coffin seems casually placed underneath a giant tree. Mann's companion told her that it was a common practice in the area to bury people in concrete graves on top of the earth. Mann herself saw the picture as "emblematic of the plucky, undiminished South, a no-frills monument to the intractability of the overworked soil and the practical, impoverished, generous people who have long tried to wring a living from it."[100] Yet for many this concrete grave, which forever sealed the identity of its occupant, cannot help but recall Emmett Till's own open coffin, which laid bare for all time the depravity of the crime committed against him.

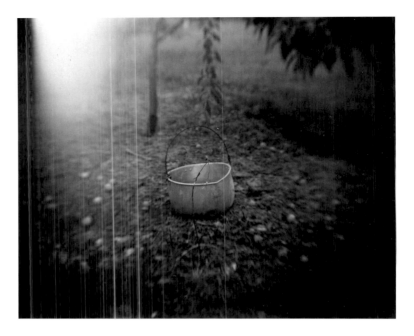

In the late 1990s several other projects and events focused Mann's attention on the nature of death more generally. Like her father, she had been fascinated with the subject for many years and his death in 1988 and Gee-Gee's in 1994 renewed her interest. In 1995 she was commissioned by the Corcoran Gallery of Art to make photographs for an exhibition titled *Hospice: A Photographic Inquiry.* Unlike the other artists in the exhibition, she used her photographs not as agents of memory—that is, as objects to remember the dying—but as acts of the imagination. She spent several months traveling around Lexington with a hospice nurse and meeting patients in an effort to determine "what exactly it is that *matters* to the dying person."[101] Pairing words and pictures, she sought to suggest what the patients might see or feel in their final days, depicting the places of most significance to them, such as the ocean, or even more random, mundane scenes, such as views from their windows that were, as she said, the "touchstones [of] their very world" (fig. 22).[102] As the daughter of a doctor, she also analyzed the nature of death more objectively, even clinically, in 2000. Fascinated with the question of what happens to the physical body after death (and perhaps remembering Poe's

gruesome story *Berenice,* where a man unearths his wife's body and removes her teeth), she exhumed her beloved greyhound, Eva, fourteen months after burial to see how the earth had affected the carcass. In addition, in September of that same year she was commissioned by the *New York Times Magazine* to photograph corpses that were donated to the University of Tennessee Forensic Anthropology Center and deposited on the grounds.[103] There at the Body Farm, as it is known, she, like the university's scientists, studied the ways in which human flesh decays under different conditions—left in the open air, hidden under debris, submerged in water, or wrapped in plastic.

But her focus suddenly changed on December 8, 2000, when a convicted sex offender escaped from the police and fled onto Mann's farm. Warned by a frantic call from Larry, she watched as the convict ran across a field near her house and helicopters and police cars descended on her property. Cowering in a bank of trees near her home, the young man, not much older than her son at the time, fatally wounded himself during a shootout with the police. Later in the day, after the police cars, television crews, and the man's grieving mother had left, Mann approached the spot where he had died. As she stared at a dark pool of blood on the frozen ground—the only evidence of his demise—"it shrank perceptibly, forming a brief meniscus before leveling off again, as if the earth had taken a delicate sip."[104] At that instant, she later recalled, "the whole question changed from 'what does the earth do to a dead body?' to 'what does a dead body do to the earth?'"[105] She wondered:

Death had left for me its imperishable mark on an ordinary copse of trees in my front yard. Never again would I look out of my kitchen window at that lone cedar on the prow of the hickory forest in the same way as I had before.... But would a stranger, coming upon it, say, a century later, somehow sense the sad, lost secret of the place, the sanctity of this death-inflected soil?[106]

She sought to answer this question in a series of photographs of Civil War battlefields made between 2001 and 2003.

(See Drew Gilpin Faust's essay in this volume for further discussion.) She visited Antietam, Appomattox, Chancellorsville, Cold Harbor, Fredericksburg, Manassas, Spotsylvania, and the Wilderness, all within easy striking distance of Lexington and all sites of some of the most horrific battles of the war with more than 165,000 Union and Confederate casualties. Once inside the protected areas of the National Parks, she found that many of the battlefields remain largely unchanged, their earthworks and trenches still visible under the swelling mounds of grass, their fiercely contested stonewalls still standing (pl. 43). Drawing inspiration from her Deep South photographs and her work on the hospice project, she knew—as had Shelby Foote when he wrote his novel *Shiloh*—that the only way to convey the latent energy that lingers in a site charged with historical suffering was through an act of the imagination and fiction. She photographed the "commonplace…mongrel-like, scrubby…orphan corners" of the battlefields during the day, often under the hot sun and surrounded by gnats and busloads of tourists.[107] But her pictures bear no evidence of the present or the ordinary—their dark, ominous tones instead suggesting that all were taken in the twilight hours or during conflagrations so horrendous that the light of the sun was all but obliterated. Mimicking the view of a dying soldier, she positioned her camera close to the ground, tilted it to capture a high horizon line, and selectively focused on one spot in the composition—a tree glimmering in the background of *Antietam (Trenches),* a picket fence in *Antietam (Black Sun),* or a stand of corn in *Antietam (Cornfield)* (pls. 43, 38, 36). Often, too, she punctuated these penumbral vistas with eerie, hard-to-define spots of light. These devices draw viewers into the composition, giving them points of reference around which to decipher the scene, but they also suggest the things a soldier might have seen before closing his eyes for the last time. She drew on the tropes first noted by Civil War photographers as well as the soldiers themselves when they sought to describe the shocking loss of life. At Antietam, where Robert E. Lee and George B. McClellan led opposing forces into battle in the single bloodiest day in the

nation's history, she depicted the cornfields: there, as Union officer Joseph Hooker remembered, "every stalk of corn in the northern and greater part of the field was cut as closely as could have been done with a knife, and the slain lay in rows precisely as they had stood in their ranks a few moments before." And at the Battle of the Wilderness, where the densely wooded, nearly impenetrable terrain prompted hand-to-hand combat and the artillery fire felled men and trees alike, she, like an unknown photographer in 1864, focused on a blasted young tree, severed long before its prime (fig. 23; pls. 36, 41).[108]

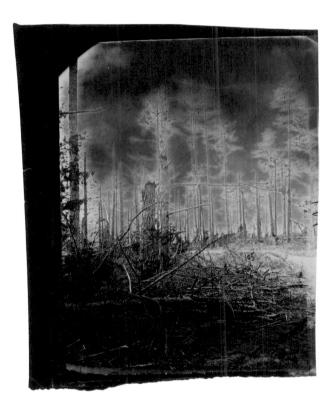

Just as important, she dug deeply into the expressive potential of her technique in order to reveal the landscape as a vessel for memory. Seeking not what was seen but what was invisible and felt—those intangible and ineffable traces of emotions and experiences that linger in the land—she used riptides of collodion

in several as if to suggest not only the inferno rising from the ground at Antietam or tearing through the sky above Fredericksburg, rending heaven and earth, but also the pain forever exuding from these tormented places (pls. 36, 37). In some photographs, bullets seem to fly, while in others shrapnel rains down, as if the conflict still raged; in yet more, smoke seems to emerge from the ground, as if the earth were ceaselessly smoldering in the battle's aftermath (pls. 40, 33, 35). The distressed nature of the plates themselves with their torn, cracked, and peeling emulsion, and the irregular focus of the pictures with their hazy, obscure passages serve to intensify the sense of violence that occurred at these sites.[109] Only a few, such as *Trenches,* are relatively untouched by physical distress. Yet with its unnatural forms, ethereal light, and cenotaphic tree marking the sacred ground, it too is infused with a pervasive sense of loss and death. In all of these pictures, as she pushed her technique to the limits of legibility, her compositions became more abstract, painterly, and darker than they had ever been before, lodging deep in one's memory like half-forgotten dreams, whose meaning and resonance must be extracted.[110] But they also shed the characteristics usually associated with photographs, becoming less literal, descriptive, and didactic; less connected to reality as it is usually seen; and less rooted in a specific time. As they grow more elusive and allusive, more open to imaginative interpretation, they become richly expressive of human experience and emotion. Further removing them from traditional expectations of glossy black-and-white photographs, she added texture and grit by coating them with a varnish made with diatomaceous earth (the fossilized remains of tiny, aquatic organisms called diatoms). These works thus mimic the cyclical nature of life itself, echo the funeral service in the Book of Common Prayer—earth to earth, ashes to ashes, dust to dust—and are composed of the very soil they depict. All of these elements combine to create photographs with an otherworldly presence. She intensified this spectral sense in her 2003 book *What Remains* by pairing some of her pictures of Antietam with lines from Whitman's "Pensive on Her Dead Gazing, I Heard

23 / Possibly by Alexander Gardner **The Wilderness Battlefield** 1865–1867, The Metropolitan Museum of Art, New York, Gilman Collection, Purchase, The Horace W. Goldsmith Foundation Gift, through Joyce and Robert Menschel

the Mother of All," an elegy written at the end of the war: "Absorb them well O my earth, she cried, I charge you lose not my sons, Lose not an atom."[III] In so doing, Mann conclusively answered her question, "does the earth remember?…Is there a numinous presence of death in these now placid battlefields, these places of stilled time?"[112]

Mann's book *What Remains*, however, seeks to do more than show how the land could become a metaphor for human violence. Including several different groups of pictures, it searches for an answer to the question its title poses: what remains after death? The book begins with several photographs of Eva's skin and bones, carefully arranged and simply depicted. "Like a little lost language," as Mann noted, "that had to be deciphered," they are simultaneously poignant but macabre, redolent yet inscrutable (fig. 24).[113] Next are photographs from the Body Farm: they are gruesome, often shocking pictures of decaying corpses, but

they are also distanced and aestheticized, as the silvery tones of the collodion wet plate negatives, coupled with a soft focus, transform the putrid flesh into sculptural masses, while the flaws in her processing augment and complicate an understanding of the decomposition of the bodies themselves. Following them are several more literal and descriptive pictures of the stand of trees on Mann's farm where the convict died. Quiet and contemplative, they show that the only visible evidence of the events that transpired on that day are the police tape and the tire tracks in the grass. Next are several photographs of the battlefields at Antietam, followed by the final suite of pictures, close-up portraits of Mann's now grown children (pls. 100–103). They are the pivotal point of the book. Made with her children lying flat on a plank beneath her large camera (see page 292, fig. 12), they show only their eyes, noses, and mouths. Illuminated with a pale diffuse light and softly focused, these pictures are like fragments of classical sculpture, imbued with both an ethereal serenity and a sense of inner reflection. With details of their faces — their gossamer eyelashes or lustrous lips — floating in and out of focus, Mann created a telling metaphor for the inability of photography and memory itself to firmly fix an image of reality. The photographs are sequenced so that the images grow paler, less distinct, the children's eyes close, and their expressions relax, as if lost in sleep or evanescing into Proust's "silence and shadow." Although they inevitably call to mind Victorian post-mortem photographs of children, they also reveal Mann's fascination with the fragility and transience of life and clarify the larger theme of the book — memory, love, and loss. She made this patently clear in the quotations she selected for the book: she put an excerpt from Jacques-Bénigne Bossuet's "On Death, a Sermon," in which he wrote that nature "cannot for long allow us that scrap of matter she has lent" before the photographs of Eva; she placed Galway Kinnell's poem "The Quick and the Dead," in which he lamented the unnatural process of preserving human bodies with "formaldehyde and salts [that prevent] the crawling of new life out of the old" before the Body Farm

24 / Mann **Untitled, Eva** 2000–2001, National Gallery of Art, Washington, Corcoran Collection (Gift of Sally Mann)

pictures; she put a passage of her own writing on the events of December 8, 2000, before her photographs of the hillock where the suicide occurred; and she intermingled her photographs of Antietam with Whitman's "Pensive on Her Dead Gazing." It is, though, an excerpt from Pound's Canto 81, placed among the photographs of her children, that answers the question posed by her title:

> What thou lovest well remains,
> the rest is dross
> What thou lov'st well shall not be
> reft from thee.[114]

These words, no doubt, took on even greater meaning in June 2016 when Larry and Sally Mann's son, Emmett, died, a victim of schizophrenia.

Elegies on American Life and Love

In 2006 Sally Mann embarked on her most ambitious and fraught subject to date—the legacy and landscape of slavery and racism. As an outspoken but thoughtful artist who had embraced the South as her theme for more than forty years, she was destined to explore "the brooding omnipresence of American history—race, and more precisely, slavery," as the legal scholar Sanford Levinson defined it, yet its challenges were daunting.[115] She had first begun to think about it in the late 1960s at the Putney School when her liberal northern teachers started to enlighten her about the complexities of race and religion, the atrocities of slavery, and the depravity of the racism that still pervaded American society. After her green-eyed African American teacher, Jeff Campbell, gave her Faulkner's *Absalom, Absalom!*, she could never again see the world "in quite the same way":

Faulkner threw wide the door of my ignorant childhood, and the future, the heartbroken future filled with the hitherto unasked questions, strolled easefully in. It wounded me, then and there, with the great sadness and tragedy of our American life, with the truth of all that I had not seen, had not known, and had not asked.[116]

Faulkner's "The Bear" widened her eyes further: "Don't you see? Don't you see? This whole land, the whole South, is cursed, and all of us who derive from it, whom it ever suckled, white and black both, lie under the curse."[117] However, it was only after she had explored the other great themes that she had long defined as the domain of a southern artist—family, place, and history; time, memory, love, and loss—that she tackled the "paradoxical refusal" of the South "to own up to the horrors of slavery while glorifying the past of which it was a crucial element."[118]

She began to consider how to address slavery and racism in her art during her trips to the Deep South in the late 1990s when she photographed the Mississippi delta and the scenes related to Emmett Till's murder. They made her realize that she wanted to create pictures "about the rivers of blood, of tears, and of sweat that Africans poured into the dark soil of their thankless new home."[119] Merging her process with her vision, she initially sought to show how the body itself could hold the scars of not only a personal but cultural past. But she found that the "historically dishonest and slippery social ground" upon which she established her encounter with her models made "every emotion, every gesture, suspect." And she wondered how she could expect "to establish a relationship of trust, communicate my uncommunicable needs, reconcile four hundred years of racial conflict, and make a good picture all in one session."[120] Slowly, though, she came to realize that her studies were just one stanza in a larger poem, a more complex and inclusive epic that drew on her experience of her native land and its people to allude to the pain of slavery and the legacy of racism. Striving to reach across the "seemingly untraversable divide between the races," she wanted to address not only the "rivers of blood" African Americans had poured into this land, but the perils they had faced, the courage they had displayed, and the paths they had created for salvation.

Because of the clear, self-imposed parameters, this work could be seen as a form of performance art: an intense period during which the relationship that obtains between sitter and photographer both informs and becomes the art. Our different ages and gender deepen the transaction, but the social constructs of race, culture, age, background, and life experience contribute to the Gordian nature of the knotty moment. It is an intense time, probably for both of us, certainly for me.[135]

The resulting photographs are infused with a sense of both dance and performance as Mann and her subjects seem to circle around one another, wordlessly assessing their respective roles and coming to know one another in a far more intimate way than traditional portraiture often allows. As she probed her own blindness and silence, as well as the painful lesson Gee-Gee had taught her long ago "that contact with a black man could be dangerous," she explored what kind of intimacy might now be possible with someone of a different race. Seeking to create a picture that was "aesthetically resonant in some universal way and worth the risk [the model] takes in making himself so vulnerable," she tried to establish "such a level of trust as to attenuate, if only for that short time, our racial past."[136]

In some of the studies of monumental heads, the proximity of the photographer and the subject is indicative of a close communion between them, as if each dropped the barriers that had once separated them, even if only momentarily (pl. 54). But history and memory are also present and they complicate the pictures, provoking varied responses. Some seem to be subtle homages to the African American men and women of Mann's youth who had reached across the divide to enlighten her. While acknowledging her debt to Jones, *Men, Janssen* (pl. 52) recalls Mann's loving descriptions of Gee-Gee's overpowering presence, her chest endowed with the "ageless sculptural proportions of the working-woman," her nails "glowing like pale beacons at the tips of the fingers," or even "the long-nailed fingers" of her Putney teacher Campbell, whose "forefinger yellowed from pipe-tamping,

placed *Absalom, Absalom* like a sacerdotal biscuit in my palm."[137] Yet others, with the minimal nature of their dress and surroundings, are also ambiguous and—as they slip in and out of time—open to different interpretations. Both beautiful and disturbing, some, as John Stauffer noted, chillingly connect the legacy of slavery to the racism of today, gesturing to both the Middle Passage and the countless African American men who have been and are incarcerated (pl. 53).[138] And still more can be seen as transcendent: one man, who turns away from the photographer, towers above his murky surroundings, his dark body sharply etched by a bright background that seems ringed by flames, as if he were rising like a phoenix from the ashes or even a black Christ, a liberator and an emblem for African American freedom (pl. 64).

Mann realized that these photographs were a fraught undertaking, not only because of the intimacy she hoped to establish, but also because she was a privileged white southern woman gazing at an African American man. She knows that in this highly charged time the larger question of who has the moral authority to speak about the atrocities and experience of slavery is a fiercely contested issue. And she is keenly aware that the representation of African American men by white artists has a long and troubled history, riddled with dehumanizing and exploitative stereotypes and objectification. As the art historian Huey Copeland recently remarked, "the 'black male' is a perennial site of fear and projection, policing and pathology, contestation and coalition."[139] Moreover, as Mann pointed out, "exploitation lies at the root of every great portrait," no matter the sex or race of its creator or subject, thus "the simplest picture of another person is ethically complex, and…compromised right from the git-go."[140] Even within this challenging constellation, she understands that these pictures of African American men "when considered in historical perspective, are unsettling." Yet, after more than forty years of using her photographs to address complicated issues of personal and cultural memory, she also firmly believes that "art can afford the kindest crucible of association, and within its ardent issue

lies a grace that both transcends and tenders understanding." She did not conceive of these photographs as an attempt to speak broadly about the African American experience; rather, she wished to address the complex and charged racial experience that shaped her life, and to "find out who those black men were that I encountered in my childhood, men that I never really saw, never really knew, except through Gee-Gee's eyes or the perspective of a racist society." They were an effort to "find the human being within the stylized, memory-inflected, racially edged, and often-inaccurate historical burden I carry."

She has titled the series as a whole—the photographs of rivers, African American churches, Gee-Gee, and African American men—*Abide with Me* and woven the pictures together like a long elegiac poem with passages of deep lament, sorrow, and solace. Infused with a sense of penitence, empathy, and faith, with a recognition of a long and complicated history, and with the need to construct a better future, the title draws on the multiple meanings of the word *abide*—to accept, comply, or act in accordance; to be unable to tolerate; to wait, stay, or remain steadfast; to endure; to dwell. The title also brings to mind the Christian hymn "Abide with Me"—a prayer to God to remain present throughout life's trials and death—and it aims to be a "transformative expression of love, affirmation, and hope." Begun at the dawn of Barack Obama's presidency when the possibility of racial reckoning and reconciliation seemed more than a distant dream and completed in the wake of the killings and racial unrest in Ferguson, Baltimore, Dallas, Charleston, Charlottesville, and too many other cities and towns across the country, *Abide with Me* is not only an elegy to four hundred years of cruelty and intolerance but also a hopeful and very personal cry from one artist for greater understanding and compassion:

But even if these image-making sessions can't bridge the seemingly untraversable chasm of race in the American South, and of course they can't, they still offer an oblique way for me to express my belated thanks to Hamoo, Smothers, and Ernestine's nephew. These men,

and many others, suffered the ignorance and arrogance of my youth, and reached across that divide when they needn't have, gestures that required forbearance and courage that I was too blind to recognize at the time. Now, on my studio porch, I both reveal and invite vulnerability, gently, I hope, teasing open the doorway to trust, a doorway that leads from an immutable past to a future that neither Gee-Gee nor I would ever have imagined.[141]

Mann once remarked that death was "the sculptor of the ravishing landscape" she saw every day on her farm, "the terrible mother, the damp creator of life, by whom we are one day devoured"; it was also the sculptor of two recent series of photographs, reflections on her life, her love, and her family.[142] Several events prompted her continued examination of death and mortality in the mid-2000s and her return to the locus of the family, a constant nexus from which she has derived strength for more than forty years. In 2006 she had a severe riding accident—her horse, suffering a burst aneurysm, fell and stomped on her before collapsing and dying. Once mobile, she was determined to work. Unable to lift her heavy 15 × 13½ inch view camera, she set it up in a fixed position and repeatedly photographed herself standing in front of a black backdrop. Using very long exposure times, she made close-up portraits of her face, much as she had recorded her children a few years earlier. She had created only a few self-portraits before then. In one, made in 1974 after she and Larry had returned to Lexington from their European travels, she depicted herself standing in a bathroom, clutching her shirt and gazing into the lens, lips half parted, with a model-like seduction of the camera (fig. 28). Upending this earlier picture, the later photographs made between 2006 and 2012 reveal a very different woman, someone who is not looking hopefully to her future but warily confronting her own aging and death (pl. 104). She made these pictures as ambrotypes—direct positive images made by coating collodion on thick black glass—and again used the very physicality of her process to add an immediacy to her art and carry the weight of her metaphors. As the collodion flakes and

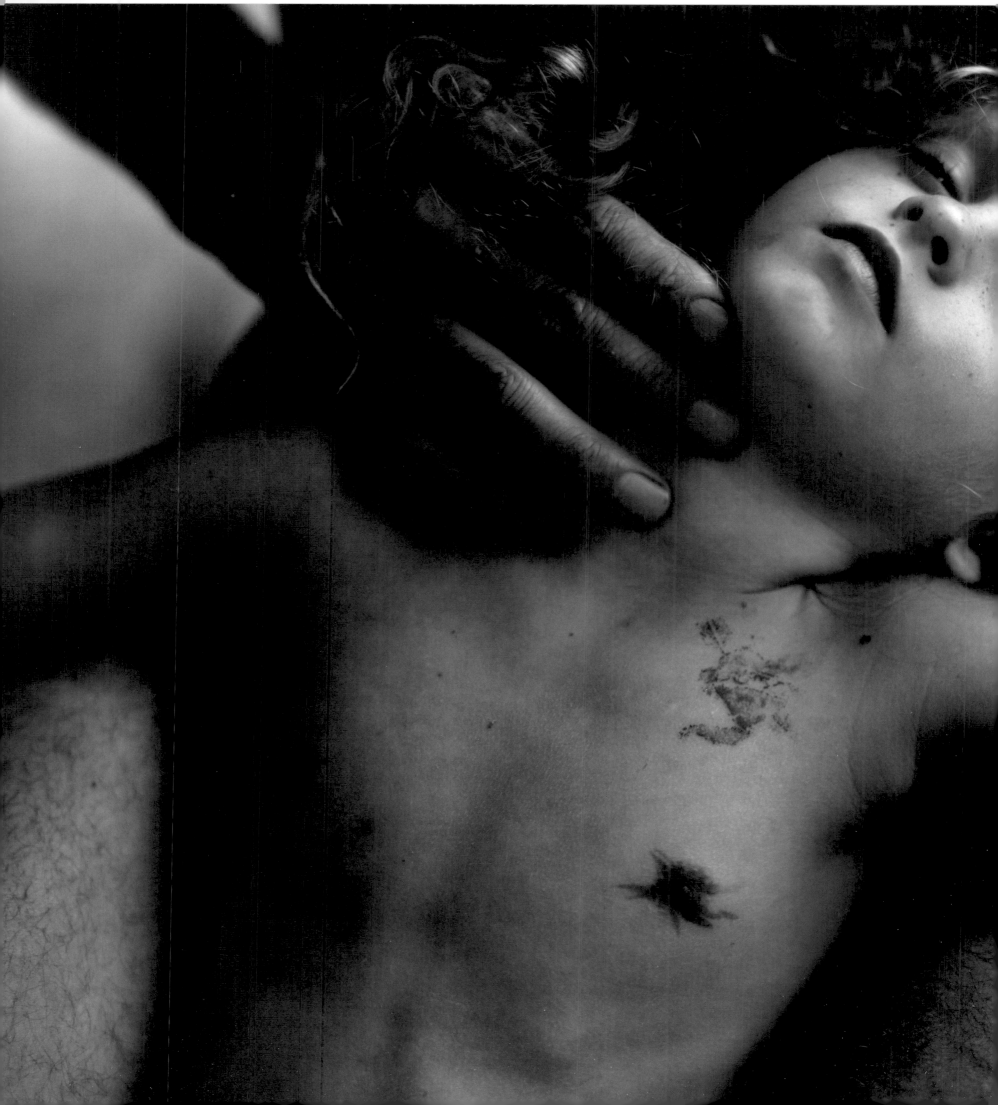

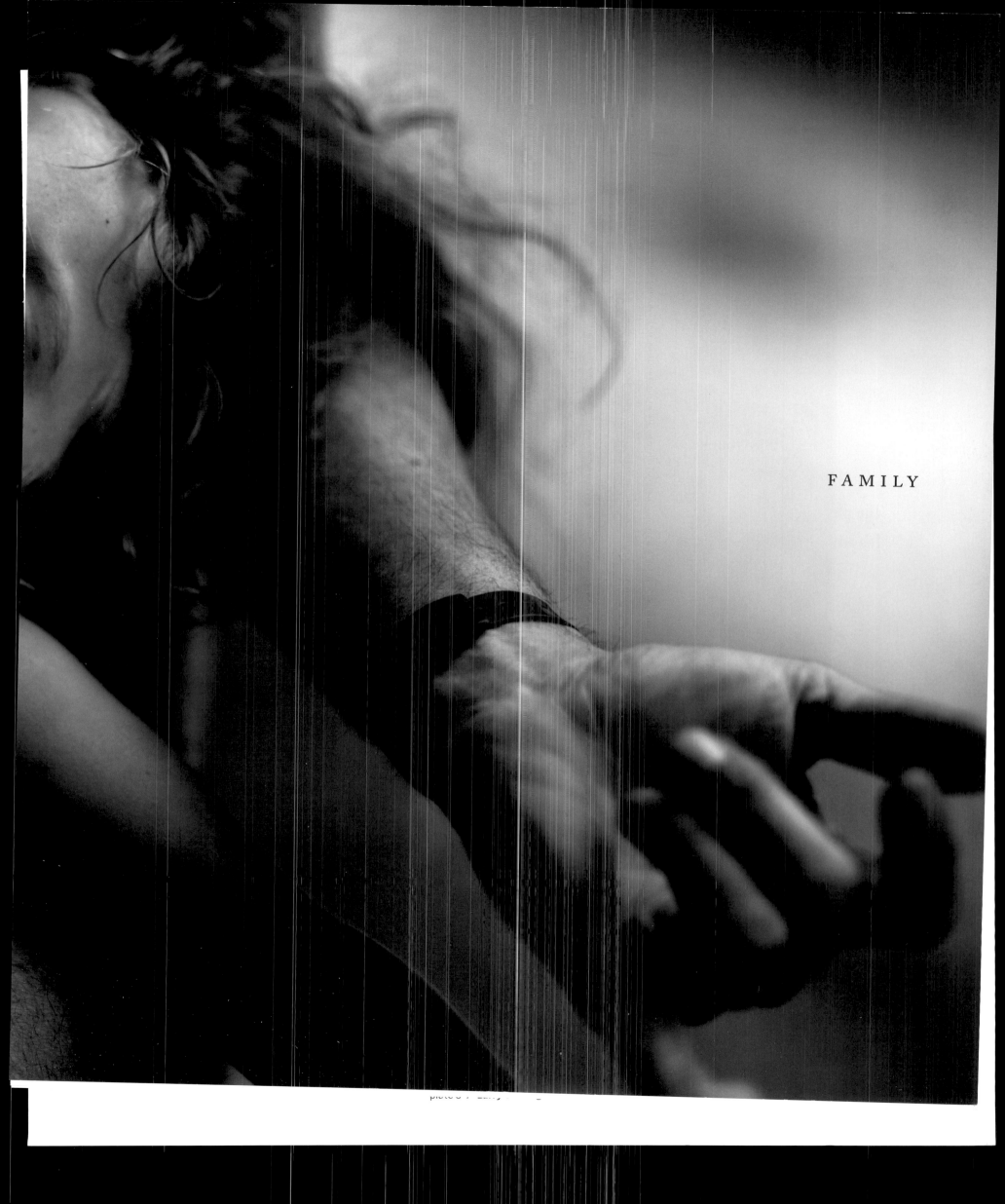

FAMILY

photos by Larry

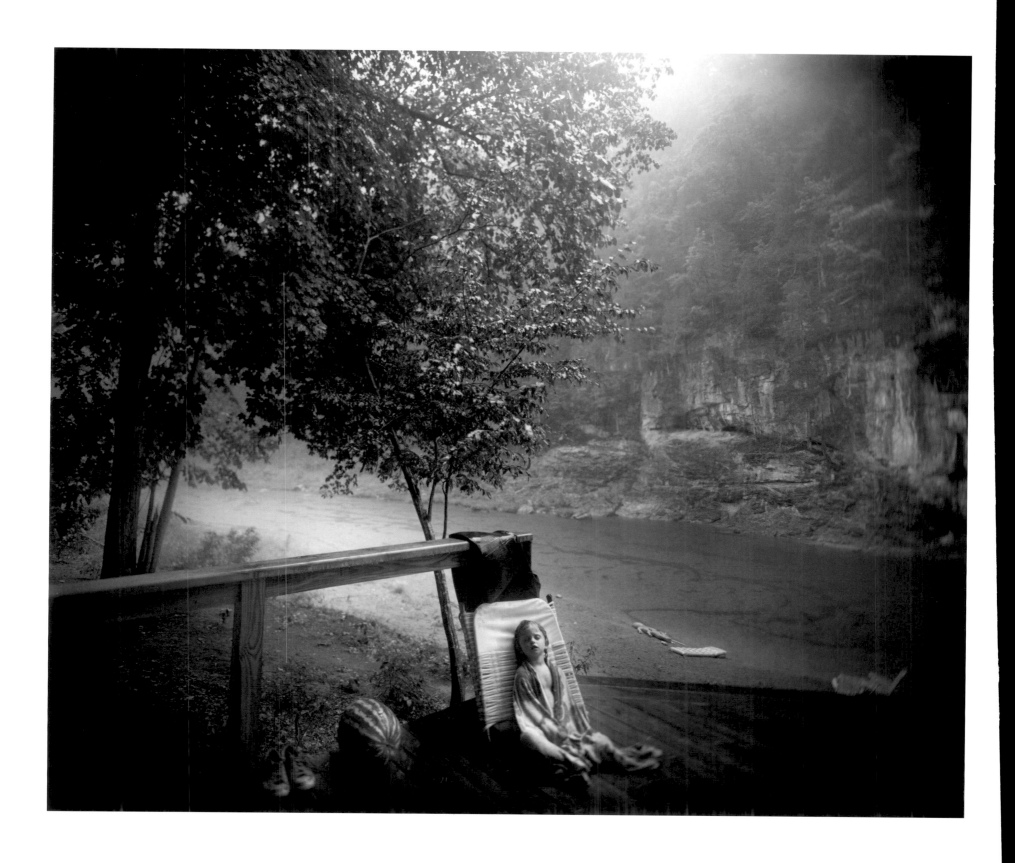

plate 6 / **The Alligator's Approach** 1988

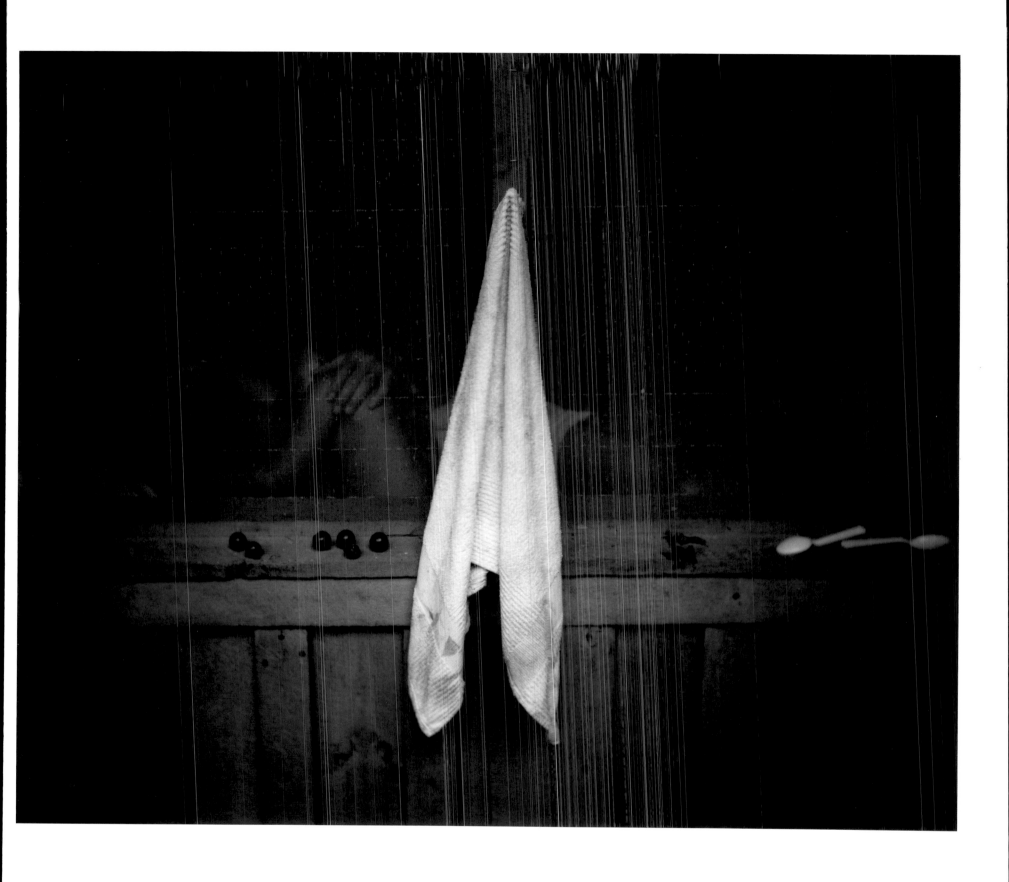

plate 7 / **Cherry Tomatoes** 1991

plate 15 / **Bean's Bottom** 1991

We are spinning a story of what it is to grow up. It is a complicated story and sometimes we try to take on grand themes: anger, love, death, sensuality, and beauty. But we tell it all without fear and without shame.

SALLY MANN, 1992

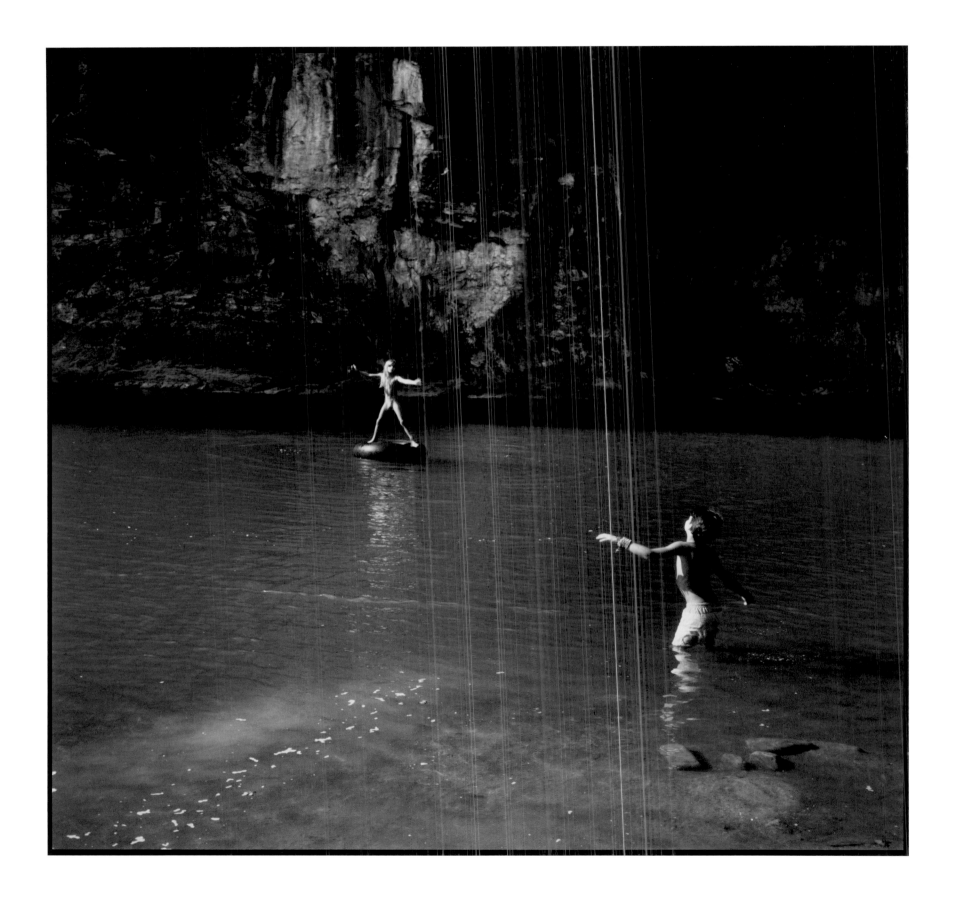

plate 15 / **River Dance** 1991

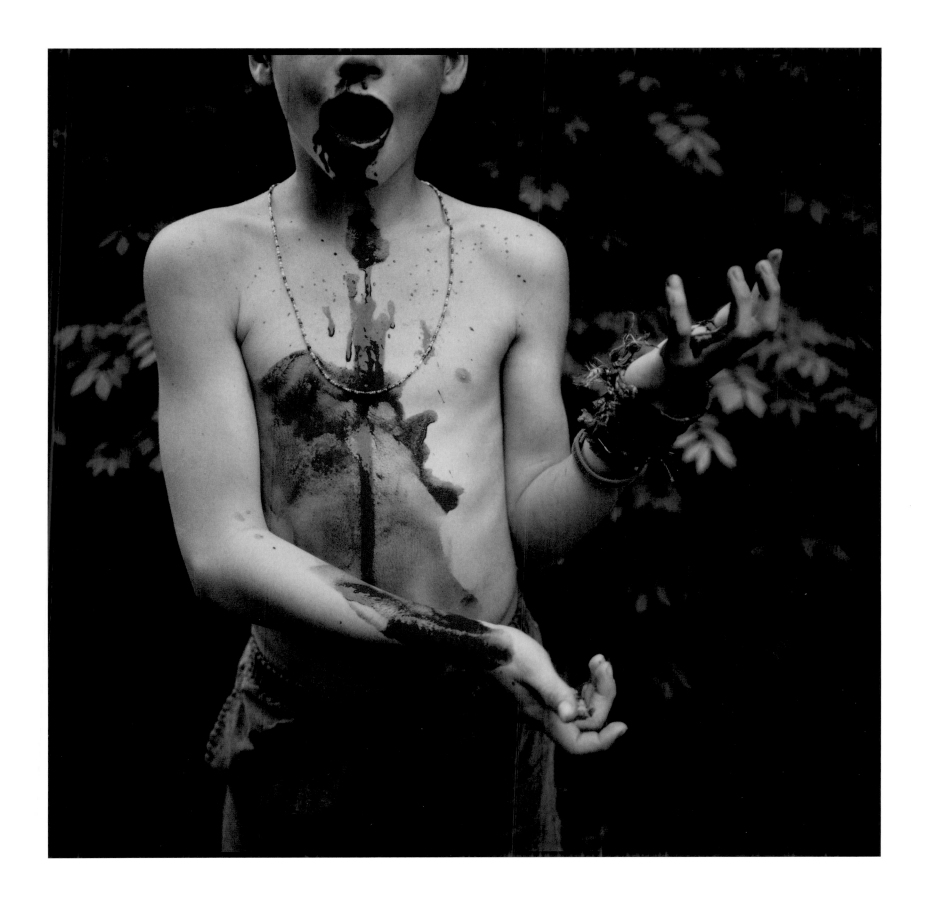

plate 17 / **Bloody Nose** 1991

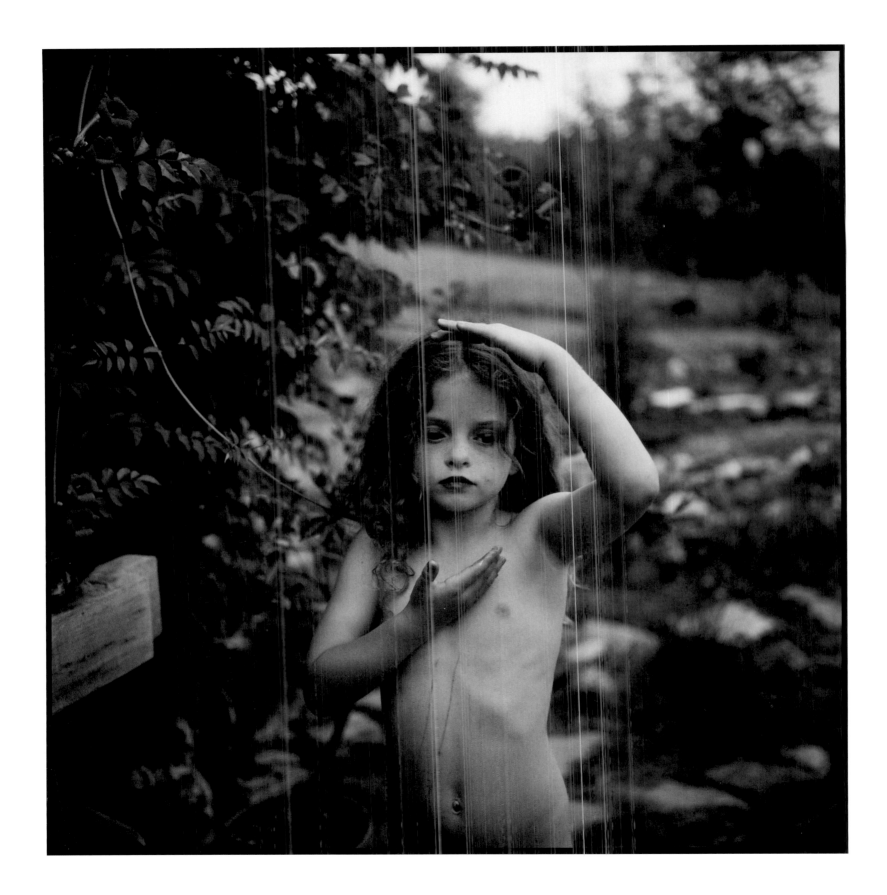

plate 18 / **Trumpet Flowers** 1991

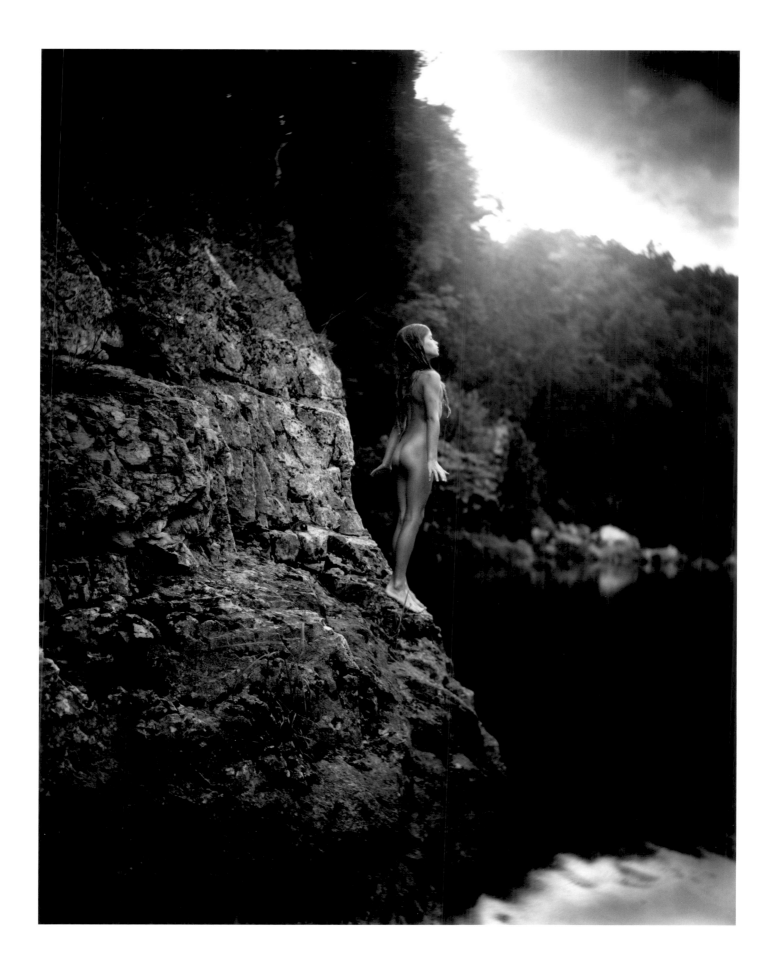

plate 19 / **Jessie at Nine** 1991

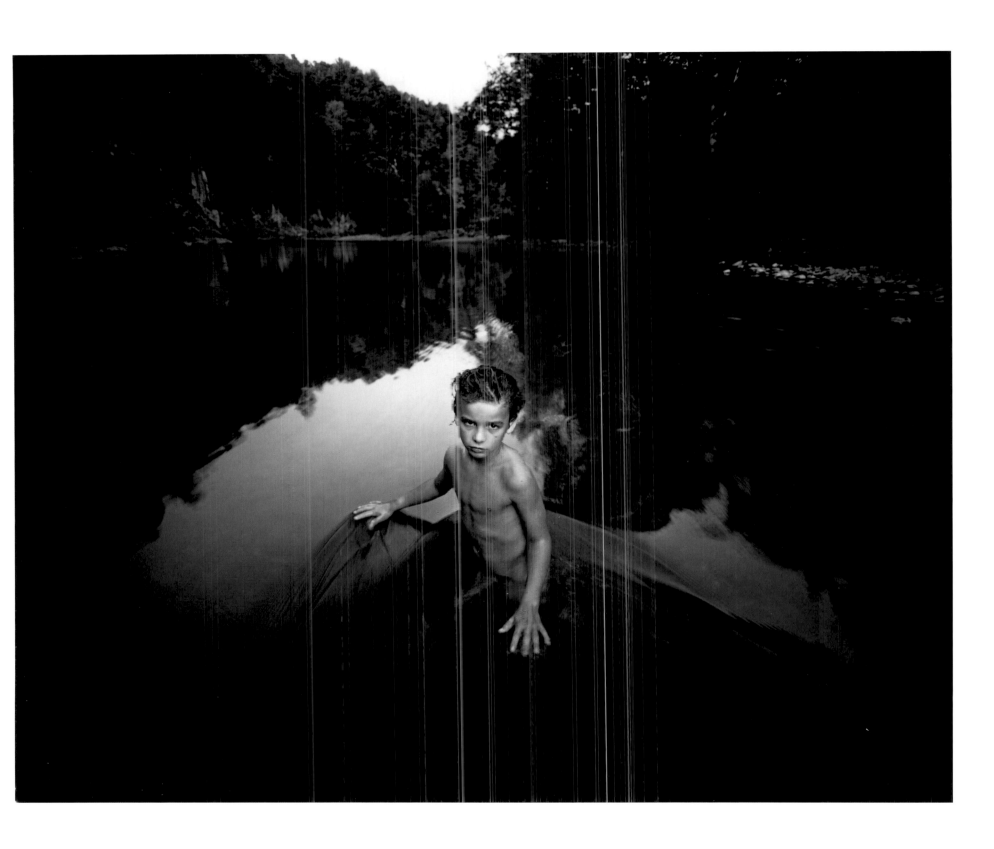

plate 20 / **The Last Time Emmett Modeled Nude** 1987

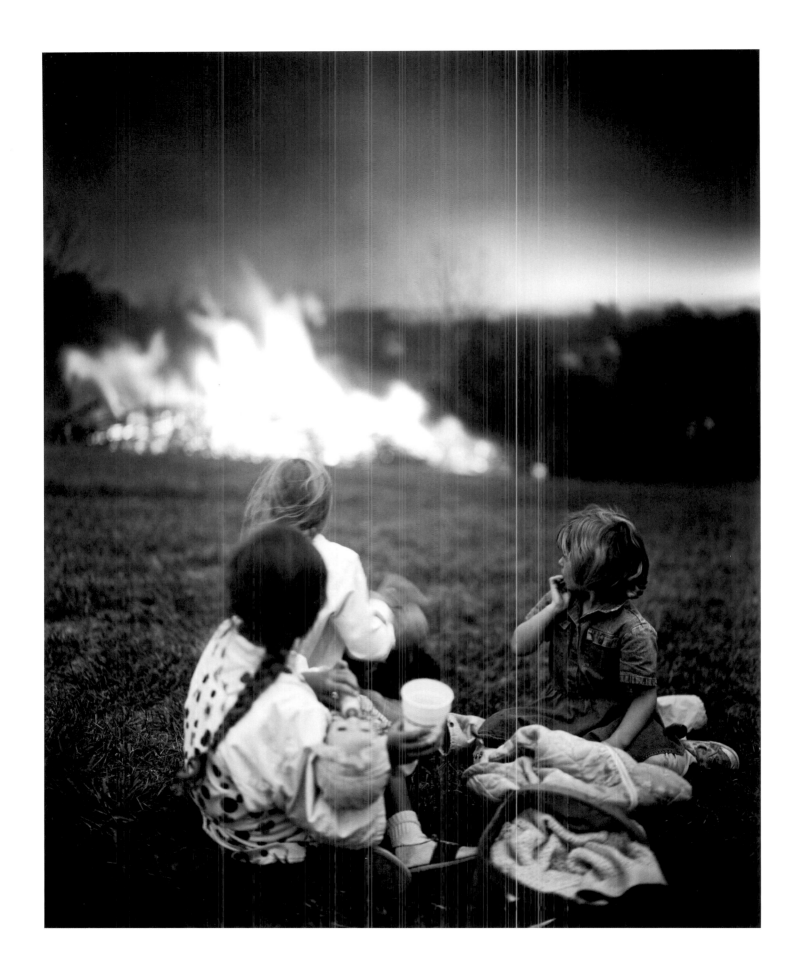

plate 21 / **Picnic** 1992

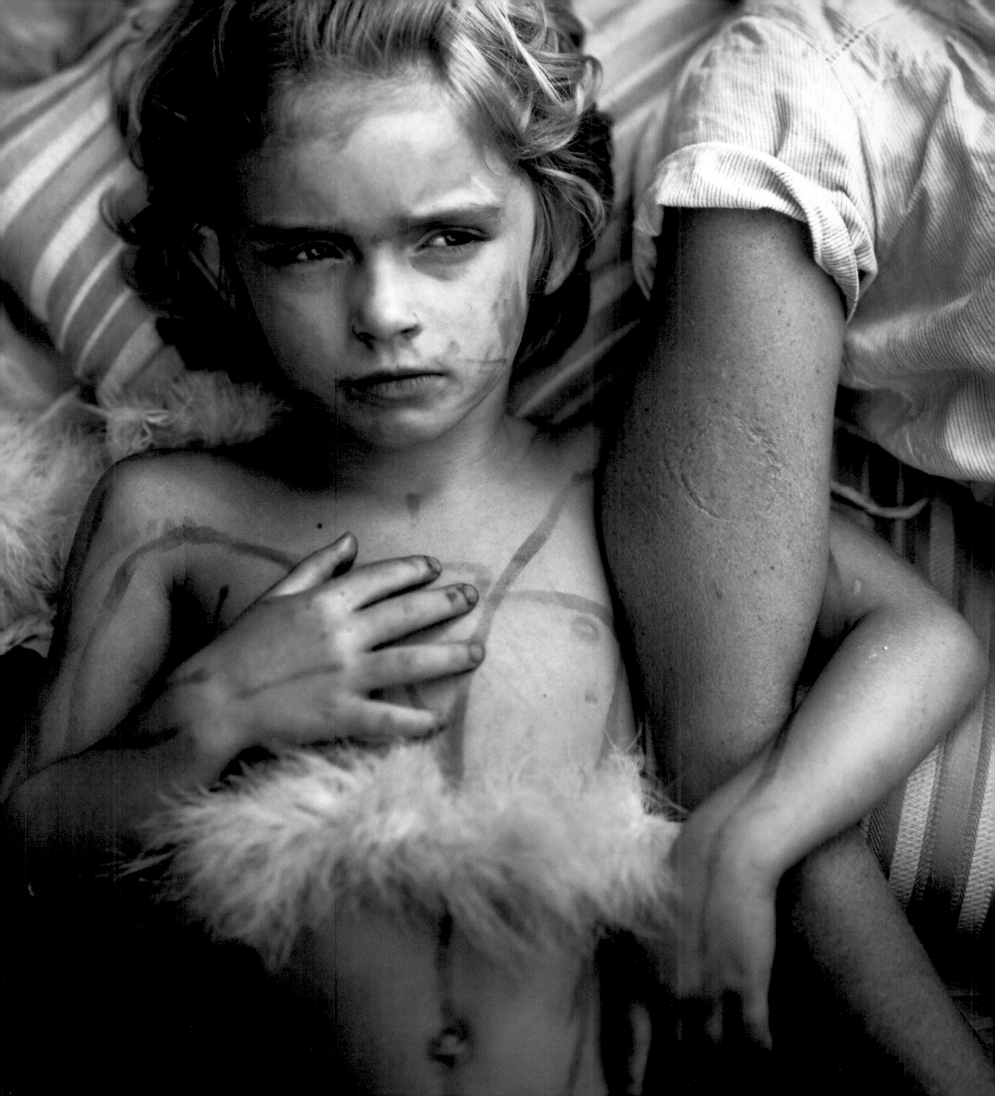

Flashes of the Finite: Sally Mann's Familiar Terrain SARAH KENNEL

I find the very nature of motherhood fraught with conflicts and fears, as well as with humor and tenderness.…Photographing my children in those quirky, often emotionally charged moments has helped me acknowledge and resolve some of the inherent contradictions between the idea or image of motherhood and its reality. And it has opened up to me a world of exquisite beauty in a form and place where I would have least expected it.

SALLY MANN, 1988

Like many parents who love their offspring but also long for ways to fill the often monotonous hours spent caring for them, Sally Mann photographed her three children—Emmett, Jessie, and Virginia—frequently. But for the first five or so years of raising her brood, Mann did not consider making serious art from the daily toils and pleasures of motherhood. Instead, from the births of Emmett in 1979 and Jessie in 1981 to the arrival of Virginia in 1985, she recorded "the under-appreciated and extra-ordinary domestic scenes of any mother's life" with a point-and-shoot camera, or sometimes a Polaroid SX-70.[1] In the few free hours not spent training an eye on curious toddlers and undertaking the seemingly endless repairs and extensions of the "spindly, hand-built, Rube Goldberg-like…house" she and husband Larry built by hand in Lexington, Mann devoted her artistic energies to making landscapes and still lifes, exploring different printing processes, and (starting in the early 1980s) photographing adolescent girls for the series *At Twelve*.[2] By 1985, however, Mann had realized that she need not leave home to

make art and that "good photographs could be made everywhere, even in the most seemingly commonplace or fraught moments."[3]

The body of works that followed from this realization—what Mann calls the family pictures—are anything but commonplace. Between 1985 and 1994, Mann transformed ordinary moments into extraordinary pictures by turning her lens onto her family, especially her children, and recording their interactions with one another, with friends, and with other family members as they cavorted and relaxed—sometimes unclothed—at the family's cabin on the banks of the Maury River in Rockbridge County, Virginia. Mann usually made the negatives during the summertime, reserving the labor-intensive work of editing and printing for cooler fall and winter months back in town, where Mann had access to her darkroom and precious uninterrupted hours while the children attended school.

Exquisitely composed and sumptuously printed, the approximately two hundred photographs that constitute the family pictures explore the pleasures and perils of the free-range childhood

afforded by the remote cabin and its arcadian setting: cool mornings canoeing along the tenebrous river; dog-day afternoons punctuated by naps, picnics, and popsicles; daredevil jumps off rocky cliffs; the usual assortment of scrapes, cuts, nosebleeds, and bug bites that accompanied these endeavors; and above all the strange games and hermetic rituals devised by children when they have free time and little adult supervision.[4] Although many of these photographs record intimate moments and quotidian events with a startling directness, Mann's pictures bear little resemblance to the typical snapshots that fill most family albums. For one thing, Mann's rigorous sensitivity to form and light, combined with her superlative handling of the gelatin silver process, endows her works with a symphonic complexity that yields far more visual pleasure and interest than the occasional random brilliance of some snapshots. The pictures also steer clear of the "deadly minefields of sentiment" that characterize the vast majority of commercial depictions of childhood.[5] Instead, they merge the documentary with the fantastic to transform glimpses of family life into something far richer, more provocative, and more universal. Ranging from tender to terrifying, her tableaus evoke the complexities of familial bonds and the psychic dramas of growing up with a searching and forthright intensity. A good many celebrate ludic pleasures, but others explore more ambiguous emotions and states of being, including sibling cruelty, incipient sexuality, and parental neglect. And several conjure the menacing specters of injury and death, intimating at the dangers that lurk even in paradise.

Starting in 1988 and through the early 1990s, Mann published and exhibited works from this series of family pictures, which were received with fervent acclaim as well as censure, primarily for depicting her children without clothing.[6] In a review of *Family Pictures: A Work in Progress*, Mann's 1989 exhibition at San Diego's Museum of Photographic Arts, one critic questioned Mann's fitness as a mother. "It may be art," the journalist sniffed, "but what about the kids?"[7] The public presentation of her work at this moment, as Mann later

recalled, was "cosmically bad timing."[8] In 1989, scandal erupted when the Corcoran Gallery of Art in Washington canceled a planned showing of *The Perfect Moment*, a retrospective exhibition of the photographs of Robert Mapplethorpe that had been organized by the Institute of Contemporary Art, Philadelphia. Anticipating a conservative and politically charged backlash against the explicit sexual content of some of Mapplethorpe's photographs, the Corcoran's leadership did not want to risk the ire of Congress or further endanger its funding from the National Endowment for the Arts. But the decision to cancel the show sparked an uproar and managed to simultaneously alienate supporters of artistic freedom and embolden political conservatives who attacked "tax-sponsored pornography."[9] When the exhibition opened in 1990 at the Contemporary Arts Center in Cincinnati, the museum and its director were charged by the State of Ohio with criminal obscenity but were ultimately acquitted on all counts at the trial.

Although never subject to legal challenges, Mann's work was not only drawn into these broader cultural discussions surrounding artistic freedom and censorship but also understood at some level to be an exemplar of the conflict itself. For example, Mann's photograph *Virginia at Four* was selected for the cover of *Aperture*'s 1990 issue, entitled "The Body in Question" and dedicated to artistic freedom and the culture wars.[10] Several months later, Raymond Sokolov published "Critique: Censoring Virginia," an op-ed in the *Wall Street Journal* arguing against government funding for the arts.[11] The article was accompanied by a heavily altered reproduction of *Virginia at Four* in which black bars were superimposed over Virginia's eyes, chest, and pubic area, a breathtaking and illegal act of editorial overreach that equated Mann's art with pornography.

Aside from the article in the *Wall Street Journal*, however, critical contemplation of Mann's photography remained more or less confined to the art world until 1992, when *Aperture* published a selection of sixty works from the series in the monograph titled *Immediate Family*. Widely acclaimed but also widely

debated, the book and the ensuing publicity catapulted Mann's work into an unexpected spotlight and exposed the artist and her family to intense scrutiny. While nearly all of her critics lauded the compelling beauty of Mann's work and many cheered her unalloyed refusal of the treacly stereotypes of childhood, others raised questions of both intent and consent.[12] A lengthy profile by Richard Woodward in the *New York Times Magazine* in 1992 argued that her photographs elicited "worrying personal concerns."[13] Woodward's article, which simultaneously acknowledged Mann's enormous achievement and interrogated the impetus behind it, crystallized some of the more subtle but harsh judgments Mann faced, chief among them that she was a bad mother who sacrificed her children's privacy, safety, and autonomy in order to satisfy her artistic ego.

The coverage in the magazine—which included not only Woodward's article but also letters written to the editor in response and published three weeks running—extended the reach of *Immediate Family* far beyond the usual parameters of the art world. Though very likely accounting for some of the book's robust commercial success, this exposure also subjected Mann's work to a public generally unfamiliar with contemporary photography and sensitized to representations of children's bodies thanks to a series of high-profile legal cases concerning child abuse and pornography.[14] The most sensational of these, the McMartin trial, ran from 1987 to 1990 and morphed from an investigation of sexual abuse allegations in a preschool to full-fledged nationwide hysteria over pedophilia and satanic rituals that victimized many innocent children and adults.[15]

Amidst this moral panic over obscenity, pornography, and the abuse of children, the family—as concept, representation, and demographic reality—became a focus of these societal struggles.[16] As both an artist portraying nude minors and a mother making provocative and unsettling images of her children, Mann was, to some, doubly complicit in the period's perceived challenge to traditional family values. Her photographs not only elicited fears about the vulnerability and exposure of children to unsanctioned and unregulated gazes but also seemed to threaten the stability of the nuclear family by staging its quotidian dramas in an overtly public manner.[17] And as an artist using her children to create photographs that seemed both "saturatingly maternal" and undeniably shot through with intimations of abuse, danger, and sex, she seemed to epitomize a conflict between emerging feminist art practices, which asserted subjectivity and challenged taboos, and an equally potent cult of motherhood, which declared that a mother's fundamental role was to shelter and protect her children at all costs.[18]

As the moral panic over the depiction of child nudity has receded in recent years, *Immediate Family* has been widely embraced as one of the most consistently affecting, revelatory, and transcendent photographic explorations of childhood ever produced. Yet the work has not completely shed the mantle of controversy, and the questions it raised in the 1990s about photographic agency, privacy, and exploitation have taken on new significance at a moment when the unregulated traffic in images is far more extensive than anyone could have imagined twenty-five years ago.[19] While the publication has achieved almost mythic status as both an artistic landmark and an emblem of controversy during the culture wars, far less attention has been devoted to the origins of the pictures themselves. Nor has a full accounting of the complexity of the visual and emotional rhetoric of the wider range of family pictures—many of which remain unpublished—been undertaken. To better understand the family pictures, one must return to their origins: to Mann's own family and the land that generated and sustained them, to the constellation of photographers who paved the way with their own lyrical and intimate studies of family, and to the culture that still struggles to reconcile tenacious myths of artistic creativity with equally tenacious myths of motherhood.

From its start, photography has been a powerful means of recording and exploring intimate bonds within family and community. Familial portraits and scenes of domesticity account for some of the most enduringly sensitive and beautiful

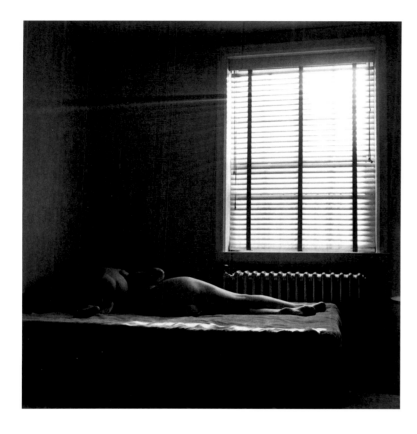

decades created a penetrating and sensitive record of their long and intimate partnership. Eleanor was Callahan's most consistent model and muse, but after the birth of their daughter Barbara in 1950, he often photographed both mother and child, exploring their gentle affections and physical tenderness in such pictures as *Eleanor and Barbara, Chicago* (fig. 1).

Callahan's exploration of his intimate surroundings charted a course that others soon followed. By the late 1960s, a handful of American photographers, including Lee Friedlander, Nicholas Nixon, and Emmet Gowin, began to turn their lenses inward, photographing their families and loved ones with a persistent and searching intensity that had previously been associated with documentary and street photography. Gowin was extremely important as both mentor and friend to Mann. A native of Danville, Virginia, a rural area about a hundred miles south of Lexington, Gowin studied with Callahan at the Rhode Island School of Design. Soon after his marriage to Edith Morris in 1964, Gowin embarked on what would become a two-decade project photographing his wife, her extended family, and their children going about their daily lives. Intimate and frank, Gowin's luminous photographs discover in the quotidian rhythms of family life the full range of emotional experience, putting, as he declared, "our unspeakable feelings into a discreet form."[20] The frankness of Gowin's regard—evident especially in the many photographs of Edith nude but also in his unvarnished views of her extended family—raised eyebrows, and he was asked on at least one occasion whether his photographs were "incestuous."[21] Photographs like *Edith, Danville*—a picture of Edith urinating in a barn, recently admired by one critic as bringing "love near enough that we can feel its hot breath"—shocked viewers more accustomed to the conventionalized rituals and emotions recorded in most family photography (fig. 2).[22]

Gowin was a crucial artistic and spiritual mentor for Mann in several ways. In collaborating so closely with his subjects, especially Edith, he demonstrated how deep trust between photographer and subject enabled each to take risks that yielded

photographic creations of the nineteenth century, including those by prominent women photographers of the time like Julia Margaret Cameron and Lady Clementina Hawarden. And with the introduction of the snapshot camera at that century's close, the camera entered millions of homes and ushered in a new era of self-authored family photography. Yet until the 1960s, few serious photographers achieved artistic renown by focusing their efforts on documenting the private sphere of their own families. One of the great exceptions was Alfred Stieglitz, who made more than three hundred powerful and intimate portraits of his wife, artist Georgia O'Keeffe, between 1917 and 1937. Stieglitz transformed their intense collaboration into an extended exploration of intimacy, subjectivity, and psychological complexity. Keenly aware of Stieglitz's achievement, Harry Callahan began to photograph his wife Eleanor in the 1940s and over the next five

1 / Harry Callahan **Eleanor and Barbara, Chicago** 1954, printed 1970s, The Metropolitan Museum of Art, New York, Gift of Joyce and Robert Menschel

startlingly intimate and emotionally rich images. And in using a large format camera to record the daily occurrences and intimate glimpses normally reserved for the snapshot, Gowin summoned the vocabulary of the family photograph only to expand and transform it, merging its candid spontaneity with a sense of time-lessness and grace. His use of a lens designed for a 4 × 5 inch camera on his 8 × 10 inch equipment to create darkly silhouetted, circular compositions would also intrigue Mann, who subtly reworked this effect in some of her photographs, including *The Alligator's Approach* and *The Ditch* (pls. 6, 8). Finally, as a southern artist successfully working outside a major metropolitan center, Gowin demonstrated that a powerful and distinctive photo-graphic voice could emerge from the passionate examination of one's home environment.

Although Gowin's commitment to photographing the rhythms and intimacies of his domestic life was met with surprise

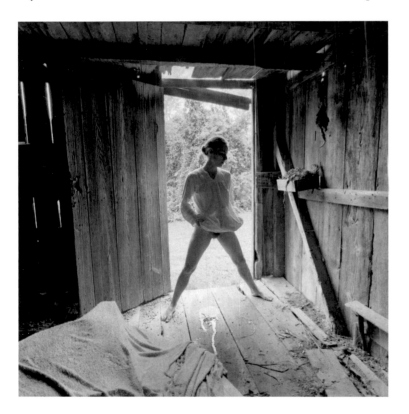

in the early 1970s, within a decade the subject of the family emerged as one of the most powerful and contested themes in American photography. The cultural upheavals of the 1960s, including the sexual revolution, feminism, gay rights, civil rights, legalized abortion, and divorce, had profoundly challenged the white, bourgeois, heteronormative fantasy of the American family. As more attention and anxiety focused on the changes in family life in the 1970s, the intimate sphere was increasingly recast as a political space — becoming more of a distorted and psychologi-cally intensified mirror of culture and politics than a refuge from those realms.[23] By the early 1980s American photographers of many different stripes had begun to investigate the home front. Some, like Nixon, documented families — their own and others' — with a searing candor and an eye for both beauty and pain, while others, including Carrie Mae Weems and Philip-Lorca diCorcia, created complex and staged pictures that address issues of alien-ation, sexuality, race, and class. These varied efforts were brought together in 1991 when the Museum of Modern Art mounted *The Pleasures and Terrors of Domestic Comfort*. Wide-ranging and powerful, the exhibition tracked this shift in photographic practice from the documentation of public life to the exploration of the private sphere as territory on which social and political battles were being fought.[24] Selecting more than 150 works by seventy-four photographers, the exhibition's curator Peter Galassi instituted a dialogue between those who remained in the tradition of modern-ist and documentary photography and those who deliberately constructed and manipulated their work. For Galassi, these diver-gent approaches — one deeply attached to the camera as witness to the world, the other questioning the medium's claims to truth — overcame their antipathies in their shared focus on family and home. "Thus it is," Galassi argued in the exhibition catalogue, "that the beleaguered modernist tradition, in its aim to clarify personal experience, and the post-modernist juggernaut, eager to unmask Big Brother, meet (of all places) in the kitchen."[25]

If the exhibition revealed a shared conviction that the American home was no longer a safe haven but rather, in the

2 / Emmet Gowin **Edith, Danville, Virginia** 1971, printed 1975, Princeton University Art Museum. Gift of Mrs. Saul Reinfeld

words of one critic, "a kind of psychological and sociological war zone, the battles being no less intense for being waged bloodlessly in the trenches of the bedroom," the distinctive way in which Mann photographed the domestic sphere during these years was primarily forged in the crucible of her personal experience, both as a mother of three and as a daughter of the South. As Reynolds Price trenchantly observed, the notion of family writ large — whether "blood and friends or familiar enemies" — had long been a peculiarly southern obsession across the arts, perhaps because the region was, he noted, "among the last forts of the powerful family."[26] Consequently, the southern artists who entered the national debate over the family did so from a distinctive vantage point, one that was wrought by an abiding attachment to the idea of kin, whether the "ancient nexus of blood or the inescapably close relations of a rural village world of families and neighbors."[27]

Although none of Mann's family pictures were included in the exhibition, two works from Mann's earlier series *At Twelve* were featured. In their regional specificity and their focus on the poignant contingency of adolescence, Mann's photographs sounded an original note.[28] In this project, Mann photographed twelve-year-old girls — mostly daughters of friends and neighbors — in the distinctly southern setting of Rockbridge County, Virginia. Probing the contours of adolescence, especially its wafer-thin line between innocence and knowledge, Mann observed her subjects patiently in order to gain their trust, attending to the nuances of their mobile, expressive faces and the self-conscious ways they inhabited their changing bodies, by turns awkward and graceful. The resulting photographs combine a piercing directness with a lyrical dreaminess, capturing the breath-bated suspension of both past and future in a single image.

While some of the portraits depict the girls alone, others tease out their tangled relationships to peers and parents, frequently with unsettling consequences. In one photograph, a girl leans against the doorway of a small home in a contrapposto pose (fig. 3). The porch is bedecked with pint-sized chairs and a table adorned with a cloth and tea set — all far too small and puerile

for the lanky adolescent. But the most startling aspect of the picture is the presence of a man in a black suit standing directly behind the girl, snaking his powerful arm across her chest and grasping her exposed underarm. Only his chest and neck are visible — his face, in the deep shadows under the roof, is not — so his age, expression, intent, or worryingly assertive intimacy cannot securely be assessed. Her gaze, at once defiant and cautious, reveals not just an awareness of her developing sexuality but also an understanding that its price will be scrutiny and possession by others. In the caption to this work, Mann noted that the picture "of the girl and her father proved disturbingly prophetic; her eyes sibylline, foreboding."[29]

The weight of incipient adulthood is carried differently in another picture showing a hot, tired, and heavily pregnant woman, Leslie, embraced by her daughter, who gazes pensively into the camera lens (see page 32, fig. 12). Their communion is bathed in a quiet sadness, as though they sense their tender intimacy will be short lived. Soon enough, the mother will be weighed down by the demands of a needy baby and the daughter, by the still-inchoate pressures of womanhood.

When Mann made this picture, she was also pregnant. As she awaited the arrival of her third child, Virginia, she detected in Leslie's "resignation, ambivalence and determination" a mirror of her own feelings about her expanding family and the struggle with what she called the "discrepancy between the reality of motherhood and the image of it."[30] This common yet rarely articulated experience of maternal ambivalence, along with the yearning to bridge the gap between the ideal and the actual experience of motherhood, sparked a deep transformation in Mann's photography, opening up what she described as "the tender as well as political (in its broadest sense) side."[31] Recognizing, for the first time, the immense potential that lay — sometimes literally — at her feet, she turned the camera onto her own family, particularly her children.[32] It was an act that would forever alter her career and her family, and leave an enduring mark on twentieth-century photography.

3 / Mann **Julie, John, and Doll House** 1983, The Art Institute of Chicago, Smart Family Foundation Fund

4 / Mann **Damaged Child** 1985, courtesy of the artist

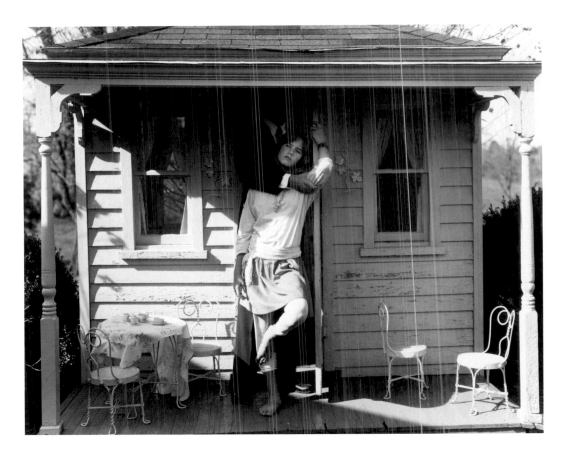

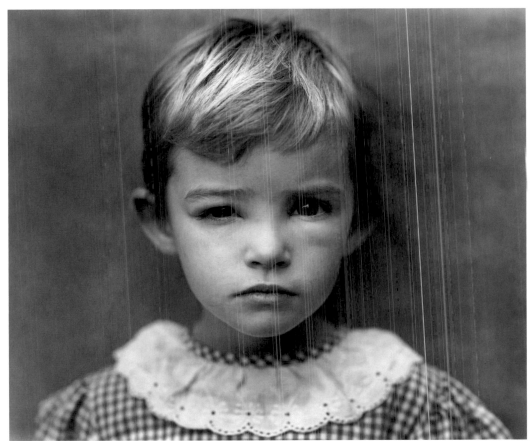

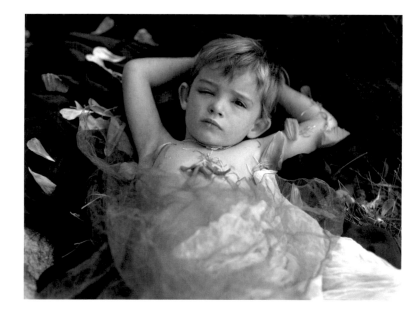

Like many of the works that would follow, the first photograph in the *Family* series, *Damaged Child*, was sparked by a real event but transformed by Mann's artistry into something powerful and provocative, as much metaphor as document (fig. 4). As Mann recounted, her daughter Jessie returned home from school one day with eyes swollen from bug bites, to which she was especially sensitive. Fascinated with the distortion that transformed Jessie's face, Mann first photographed her gazing back at the camera through half-slit eyes, recumbent in the leaf-strewn grass and wearing what appears to be a tutu (fig. 5). The photograph resembled, as Mann later noted, the gauzy, feminine still lifes she had been making since the late 1970s: delicate studies of translucency, texture, and light (fig. 6). But then Mann was inspired to try something different. Setting up her 8 × 10 inch view camera against a wall pasted with wrapping paper, she photographed Jessie—now wearing a checked dress with an eyelet lace collar—at close range. Steady and defiant, Jessie gazes directly at the viewer. The shallow depth of field, which sheds the picture of extraneous detail, focuses attention on the swells and dips of Jessie's face; the chapped, slightly pouty lips; the determined set of the jaw; and the startlingly mismatched eyes: one squinty and suspicious, the other wide and appraising.

As an origin point for the ensuing *Family* series, *Damaged Child* signaled Mann's willingness to take risks, to agitate her viewers, and to wade into dangerous territory by invoking the suggestion of child abuse just when awareness and anxiety over the maltreatment of children were at an all-time high.[33] Yet what lay behind this and other similarly disturbing photographs depicting her children injured or in threatening situations, including *Bloody Nose* (pl. 17) and *The Alligator's Approach*, was maternal anxiety over potential danger as well as a desire to provoke and unsettle. As Mann related, the experience of holding the "still-damp contact print" of Jessie's swollen face and witnessing her fully healed daughter twirling around the room offered her a strange sense of relief and comfort. The image, she later wrote, "inoculated me to a possible reality that I might not henceforth

5 / Mann **Pre–Damaged Child** 1985, courtesy of the artist

6 / Mann **Untitled** 1980, National Gallery of Art, Washington, Corcoran Collection (Gift of the artist)

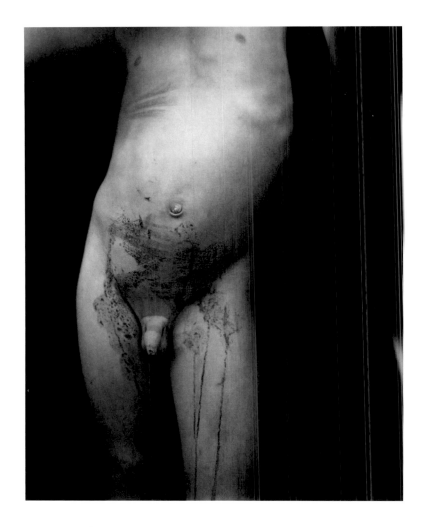

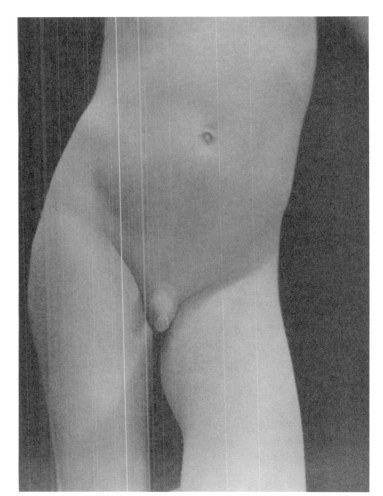

have to suffer. Maybe this could be an escape from the manifold terrors of child rearing, an apotropaic protection: stare them straight in the face, but at a remove—on paper, in a photograph."[34]

While *Damaged Child* functioned on one level as a photographic exorcism of maternal fears, it also drew inspiration from and cannily asserted its own place within the broader history of photography. Upon seeing the print, Mann noticed its resemblance to Dorothea Lange's Depression-era photograph *Damaged Child, Shacktown, Elm Grove, Oklahoma*, and titled it accordingly. And Jessie's change of clothing from frilly tutu to vintage-looking dress does suggest that Mann may have made

this connection even before making the exposure. In either case, *Damaged Child* demonstrated to Mann that she could make photographs that were immediate and truthful yet also consonant with a rich history of art making. From this beginning flowed other pictures that plucked inspiration from other artists— Mann herself admitted to being "a shameless borrower"—but reworked them in ways that assert the distinctiveness and authority of her vision.[35] A study of Emmett's nude torso smeared with dark and sticky popsicle residue, *Popsicle Drips* (fig. 7) looks back at Edward Weston's *Neil* (fig. 8), a photograph of his son's graceful torso, itself an evocation of classical sculpture.

7 / Mann **Popsicle Drips** 1985, The Art Institute of Chicago, Smart Family Foundation Fund

8 / Edward Weston **Neil** 1925, Center for Creative Photography, Tucson, Purchase

But the grubby drips sully the purity of Weston's ephebic nude and infuse Mann's photograph with a startlingly palpable, almost abject physicality. And even if Jean Siméon Chardin's eighteenth-century paintings of a boy blowing bubbles did not directly inspire Mann's ethereal *Blowing Bubbles* (pl. 4), the photograph declares its place in a long history of art that reflects on the transience of childhood through the theme of a fragile and glorious globe sure to pop at any moment. And yet the poignancy of Mann's *Blowing Bubbles* also derives from its specific invocation of time and place: everything from the plastic toy shopping cart and the discarded life preserver to the lambent light that imbues the scene with a magic, otherworldly serenity speaks to the centrality of place—*this* cabin, *this* river, *this* afternoon light—in the creation of the picture. Mann affirmed as much in the introduction to *Immediate Family* when she declared in her opening lines: "The place is important; the time is summer. It's any summer, but the place is home and the people here are my family."[36]

Just as important as the physical beauty and privacy afforded by the farm and especially the cabin—miles from town and lacking modern conveniences, including electricity and running water—was the distinct sense it offered of being a place unhindered by the clock, passing cars, television, nosy neighbors, and social conventions. Mann's own childhood had been defined by a similar experience of being an outlier, unbound by normative social values but anchored by the distinctive freedom she experienced as a child within the confines of her family's land. "Like my children today," Mann recounted in 1991, "I wore no clothes until kindergarten interfered with my feral life, a life of freedom not only from clothes but from constraints of any kind, limited only by the boundaries of our property and the pack of boxers (12 in all) that were my nursemaids."[37]

The farm—featuring a cabin built by Mann's father and brothers in the early 1960s—was more than just a rustic escape from town. With its flinty cliffs, glossy dark river, and gorgeous amber light filtering through dense brush, the Edenic landscape offered Mann, in photographing her own family, a perfect stage for the primal drama of childhood and its discontents. The lustrous Maury River, chatoyant in the summer light, played an especially important role in their lives and thus wends itself through many of the *Family* pictures. Frequently it is the site of exuberant play and physical daring, as in *Jessie at Nine*, *Bean's Bottom*, and the joyful *River Dance* (pls. 19, 15, 16). The river and the creatures that dwelled in it also set the stage for more ruthlessly clinical experiments, as in *Fish Heads* (pl. 14). In other pictures, however, the river is as much metaphor as setting and conjures themes of passage, time, and death. In the achingly lovely *On the Maury* (pl. 1) the family appear as explorers, their canoe drifting downstream, casting them forward into an unknown future, away from the camera and its operator's loving reach.

The river serves as a metaphor for another rite of passage in *The Ditch*, a strange and compelling work that depicts Emmett's lithe body wedged into a narrow channel running perpendicular to the river. As others have noted, the scummy water and the crumpled up boy pushing his way out through the narrow opening—away from the camera and toward the welcoming river, where a naked child awaits—evoke an image of birth and baptism.[38] Yet the group of solemn spectators attending this curious ritual also suggests something funereal, and the looming perspective and darkened periphery of the picture heighten this impression of claustrophobic anxiety.

At first glance, the scene, like many others in *Immediate Family*, appears to record a moment of spontaneous if somewhat enigmatic play at the river's edge. In particular, the blurred and truncated figures standing around Emmett invoke the arbitrary cropping typical of amateur photographers hastily attempting to capture a central subject, oblivious to the edges of the picture. But such devices in Mann's work are deliberate and belie the precision and control she—and her children—wielded in the creation of her works. Like any good director, Mann adroitly marshaled the instinctive talents and individual personalities of her children in the creation of the photographs. But they too

were critical participants in the conceptualization and execution of the pictures, not only accustomed to the camera but also attuned to the situations, poses, and expressions that might intrigue their mother or make for a good picture.[39] As Mann noted, "At times, it is difficult to say exactly who makes the picture. Some are gifts to me from my children: gifts that come in a moment as fleeting as the touch of an angel's wing."[40]

Each child, of course, gave this gift in distinctive ways. Whether twisting in *The Ditch*, gushing blood in *Bloody Nose*, or practically levitating in the baptismal *Emmett Floating at Camp* (pl. 11), Emmett expressed the tender and fierce energies of boyhood primarily through the actions of his lithe and athletic

body. A natural actress, Jessie cycled through poses and expressions with ease, from the charming curtsy of *Easter Dress* (pl. 2) and the defiant glare in *Jessie Bites* (pl. 13) to the preternatural cool of *Candy Cigarette* (fig. 9). In contrast, Virginia appears as the most vulnerable and guileless of the three. In *The Alligator's Approach*, for example, she is absorbed in a dreamlike state, unaware of the creeping danger of the (plastic) predator, while in *Gorjus* (pl. 3) she passively accepts the ministrations of her older sister. In other works, including *Last Light* and *The Two Virginias #4* (pls. 10, 85), a kind of inner ecstasy seems to have taken hold of her young body, and she spreads her arms as if anticipating a divine embrace.

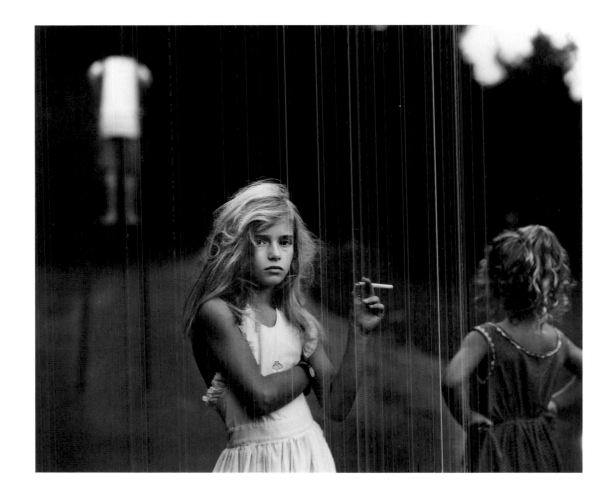

With the exception of the color works in the *Family* series, nearly all of the family photographs were made with a large format, 8 × 10 inch, camera set on a tripod. This setup required loading film into the camera one sheet at a time and assessing focus and composition by referring to the laterally reversed image that appeared upside down on the ground glass at the back of the apparatus. A photograph of postprandial relaxation on the cabin's spacious deck area attests to the presence of the unwieldy, old-fashioned camera on the sidelines, a constant witness to the family's daily activities (fig. 10).

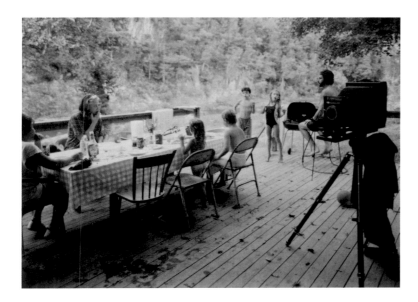

Given the limitations imposed by Mann's equipment, it is all the more impressive that some of the strongest photographs were the result of the artist's rapid and intuitive response to an observation or chance encounter. One such picture, the radiant and dreamlike *Perfect Tomato* (fig. 11), came about when an unclothed Jessie suddenly assumed a balletic pose at the edge of the picnic table. Bathed in celestial light, her arms fluttering behind her like the wings of a hummingbird, she resembles a heavenly apparition, emanating an otherworldly glow that dazzles the earthbound spectators who regard her with wonder

from their shadowed realm. In a letter to a friend, Mann described the process of making such pictures: "You wait for your eye to sort of 'turn on,' for the elements to fall into place and that ineffable rush to occur, a feeling of exultation when you look through that ground glass, counting ever so slowly, clenching teeth and whispering to Jessie to *holdstillholdstillholdstill* and just knowing that it will be good, that it is true."[41] The sense of urgency was compounded by the knowledge that she had only one chance—and one sheet of film—to get the picture right while the exultation was compounded by "fear that I'd screw it up in the developer, fear that the fraction of a second I saw was not the one on film."[42]

While certain photographs—it is not always clear which ones—represent the artist's quick and sure seizing of what novelist Don DeLillo once called the world "unrolling into moments," others were carefully wrought and hard won.[43] Mann, with her collaborators, sometimes conceptualized, staged, and restaged a composition multiple times before discovering the strongest combination of expression, pose, and light. Making the prints was equally challenging, requiring many hours in the darkroom—burning, dodging, spotting, discarding, and starting anew—until the prints achieved something close enough to perfection to pass muster. Frequently, the efforts that went into the creation of a photograph were masked by the guise of immediacy it assumed. *Easter Dress*, for example, appears as one of the more spontaneous and naïve of the family pictures—so much so that one reader who saw its reproduction in the *New York Times* likened it to a "single badly composed frame of an amateur home-movie."[44] Indeed, the blur, the scattered composition, and the enigmatic relations between figures summon the language of the snapshot, haphazard and obscure. Only the center holds, just barely, as Jessie regards the camera directly with an impish smile as she holds aloft the skirt of the crisp white dress that had been made by her grandmother and namesake. By contrast, the dingy and tattered housedress that hangs from the clothesline injects a jarring and forlorn note. None of this was entirely by accident,

10 / Mann **Camera at Cabin** late 1980s, courtesy of the artist

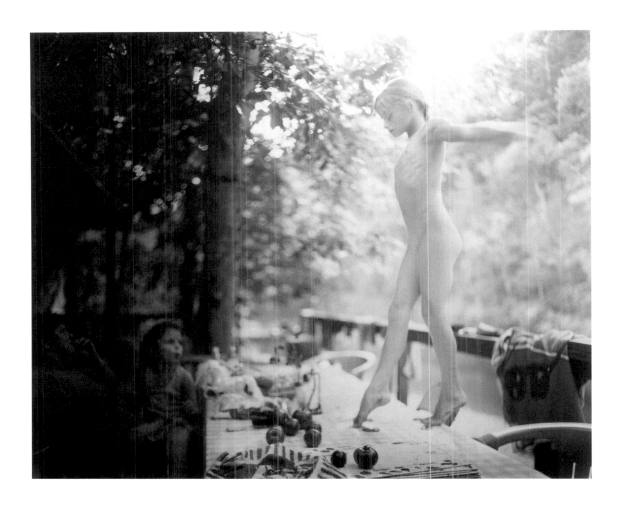

of course. The squirming dog was released and Jessie spread her grandmother's beloved dress in a welcoming gesture many times over until Mann got the exposure she wanted.[45]

Other photographs similarly restage incidents to create multilayered narratives. *Jessie Bites*, for example, seems to show the raw aftermath of a clash between an obstinate, disheveled Jessie and an adult whose arm, at once embracing and restraining Jessie, bears fresh teeth marks. But the teeth marks (made long after the original impression of Jessie's bite had faded) are Mann's own and Jessie's convincingly refractory expression was expertly produced for the camera. Despite this artifice, *Jessie Bites* offers an emotionally fraught tableau that conveys an

elemental experience of childhood: the fierce battle between independence and the gravitational pull of attachment.

The evocative force of *Jessie Bites* derives in no small part from the accumulation of textures — downy feathers, smeared dirt, wrinkled cotton, and primly striped silk cushions together suggest a war between decorum and disorder. Mann's mastery of the gelatin silver process enabled her to not only wrest such fine variations from her negatives but also impart a sense of timelessness to the family pictures as a whole, lending them a mythic and stilled quality. In late 1989 or 1990, she started making family pictures in color with a handheld Mamiya camera. Loading it with 6 × 6 centimeter color film, she experimented: using this

new equipment on its own or alongside her large format camera and exploring how color and format elicited different qualities in a composition.[46] Although Mann printed and exhibited only a few of the more than eighteen hundred color photographs she made between 1990 and 1994, and they were excluded from the publication of *Immediate Family*, this body of work not only adds a rich dimension to the family pictures but also offers a more nuanced and quotidian view of life at the cabin.

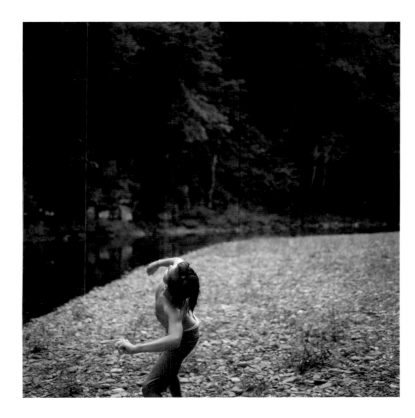

Mann was clearly drawn to the dramatic potential of color, especially as expressed in the vibrant, highly saturated tones characteristic of the silver dye bleach process. The shocking scarlet blood streaming down Emmett's face in *Bloody Nose* or the glorious harmony of green water and golden light in *River Dance* also offers a more particular and time-bound experience than the black-and-white works, in part because the use of color

photography itself is so closely associated with the late 1970s and onward. The portability of the handheld camera that enabled Mann to work quickly and intuitively also lends many of the color works a sense of spontaneity and freedom. Mann has noted that this "snapshotty" quality was partly inspired by two conditions: first, she was given the (relatively expensive) film for free; second, by this time she was already several years into the family pictures and had achieved a high level of confidence and ease that is reflected in photographs like *Skipping Stones* (fig. 12).[47] But in the strongest color works, including *Fish Heads*, *Bean's Bottom*, and *Bloody Nose*, immediacy and spontaneity are merged with powerfully condensed, dramatic compositions, suggesting that they were as much crafted as they were captured.

In the introduction to *Immediate Family*, Mann articulated the slippery relationship between the world limned in the photographs and the reality of her family's life at the cabin. "Many… are intimate, some are fictions and some are fantastic," she wrote, "but most are of ordinary things every mother has seen—a wet bed, a bloody nose, candy cigarettes." She elaborated further on their attenuated relationship to observed reality: "When the good pictures come, we hope they tell truths, but truths 'told slant,' just as Emily Dickinson commanded." For Mann, photography— much like poetry and literature—conveys truth precisely through the operation of its fictions.[48] Other photographers coming into prominence at this moment, including diCorcia, Tina Barney, and Larry Sultan, embraced photography's capacity to simultaneously dissimulate and speak truth.[49] In carefully staged, large-scale color photographs, they too explored the emotional dynamics within modern families. And yet, their work seemed worlds apart from Mann's sumptuously crafted prints that, as one critic aptly noted, possessed the "contradictory qualities of immediacy and elusiveness that characterize a dream."[50] From the twisting dance of hands and hair in *The Two Virginias #4* to the dreamy softness of *Cherry Tomatoes* (pl. 7) and the equation of sleep and death in *Last Light*, many of Mann's photographs reveal an unabashed romanticism, a fascination with sensuous

12 / Mann **Skipping Stones** 1991, courtesy of the artist

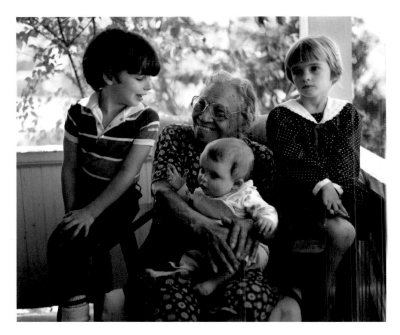

form, and a fierce attachment to narrative. In these ways, some of the family pictures have prompted comparisons with the swooning and theatrical domestic tableaus of Cameron, but where the latter's sweetness can verge on the mawkish, Mann's dreamy idylls frequently possess a darker edge.[51]

A kind of reverse-gendered pietà, *Last Light* possesses the most overtly Victorian sensibility of all the family pictures, largely through its invocation of nineteenth-century postmortem photography. Reclining between her father's knees, Virginia appears nearly unconscious, her heavy-lidded eyes open just enough to reflect a pinpoint of light. The searing intimacy of the image is made manifest in the multiple points of contact between father and daughter that weave in and out of the shallow plane of focus: his fingers at the pulse of her neck, her hair streaming over his arm, their linked pinky fingers. Virginia's pliancy and the title's ambiguity also mobilize the viewer's anxiety: is she only sleeping or is she a whisper away from death? The darkening shadows that herald the close of day keep their secrets.

Although he appears only a handful of times in *Immediate Family* and is rarely the main subject of the photographs, Larry Mann assumes a quietly supportive role throughout the family pictures: The tender embrace between Larry and Virginia in *Cherry Tomatoes* and the casual intimacy with Jessie in *Larry Shaving* (pl. 5) offer affecting counterpoints to the more provocative and emotionally charged works. In other photographs, Mann cast her husband in the role of protector and provider. Oar in hand, he navigates the family (plus a friend) downstream, providing both strength and steadiness in *On the Maury*. As Jessie later recalled, "Mom, Emmett, Virginia and I — we're all drama queens, actors on a stage, doing our thing and putting on a performance. But Dad *is* the stage....He's there to work between all these strong characters and keep everything together."[52] Aside from Larry, the only other adult who makes a repeat appearance in *Immediate Family* is Virginia "Gee-Gee" Carter, the indefatigable African American woman who served as the prevailing maternal figure in Mann's life (fig. 13).[53]

13 / Gee-Gee with the Munger kids on porch, c. 1951, courtesy of Sally Mann

14 / Gee-Gee with the Mann kids on porch, c. 1985, courtesy of Sally Mann

Hired by the Mungers (Mann's parents) in the early 1950s as a nanny and domestic employee, Gee-Gee was a young widow who also raised six children of her own, managing to send each to boarding school and college while working six days a week for the Munger family. She worked for the Mungers for nearly fifty years, visiting with Mann's three children often, before passing away in 1994 at the age of one hundred (fig. 14). Mann experienced the comfort of Gee-Gee's love and concern from her earliest days, and only later began to interrogate the social relations of race and class that shaped the contours of their intimacy and defined the hard edges of Gee-Gee's life, as they did for so many African Americans in the South (see the essay by Hilton Als in this volume).

In the four works that constitute *The Two Virginias* series, Mann focused on Gee-Gee's tender interactions with her young namesake. Each photograph explores likeness and difference: Gee-Gee's slack, wrinkled forearm against Virginia's smooth, doughy one (pl. 88), or Gee-Gee's aged, clawlike hand perched protectively on the head of a young Virginia (pl. 86). In *The Two Virginias #3*, Gee-Gee's misshapen toes, swollen feet, and scaly legs seem to sprout tiny feet, as if delicate new buds were erupting from a gnarly branch (pl. 87). Despite these poignant contrasts, the powerful bonds between the two Virginias are manifested through mirroring and touch. In *The Two Virginias #4* (pl. 85), for example, Gee-Gee's abundant hair, which she frequently pinned back for work, as neat and smooth as the white uniform she wore, here cascades freely down her back. Silvery white, the twisting tendrils echo Virginia's dark curls. The dance-like gestures of their hands, delicately suspended in the air, also mirror each other while their bodies seem to merge and dissolve under the ripples of clothing and blankets. It is as if Mann were willing into being a perfect union, one that transcended boundaries of time, age, and race.

Critics responded in conflicting ways to the interweaving of the casual and the staged that characterizes individual pictures and serves as an organizational principle of the family pictures as a whole. Reviewing Mann's 1992 exhibition at the Houk Friedman Gallery for the *New York Times*, Charles Hagen noted that on occasion the "melodramatic, lushly printed pictures seem so overblown, so blatantly symbolic, that they don't ring true." But, he continued, "a real strength of the photographs is that for the most part the actions they depict seem to have originated in the children themselves."[54] By contrast, Edward Sozanski complained in the *Philadelphia Inquirer* that the artist "dishes up mannered poses and artful dodging" in place of "real experience, genuine intimacy and soulful truth."[55] Challenging Mann's assertion that the works represented "photographs of my children living their lives," he claimed that the images "cannot be trusted."[56] The critic was careful, however, to pinpoint the source of Mann's transgressions: "What makes Mann's work provocative isn't the nudity, which for the most part is casual and innocent, but the demarcations between fact and fiction, which are usually suspect."

To those who understood their nudity as "casual and innocent," Mann's photographs offered an arresting vision of childhood as a prelapsarian state. In the blissful *Jessie at Nine*, the nude body, sanctified by sun and water, signifies the instinctive freedoms of childhood, not its loss or corruption. The wistful beauty that threads through these gleaming moments arises from the recognition that this state of grace is irretrievable, knowable only as an image or memory of what has already been lost. Other photographs are anything but Edenic: the bloody noses, broken legs, wet beds, and ruptured eardrums insist on the almost abject physicality of childhood, made all the more startling for the riveting beauty of the bodies upon which such traumas are visited. And in one of *Immediate Family*'s most unnerving photographs, *Hayhook* (fig. 15), these two visions of the body—sacred and profane—are joined. A girl—Jessie—is hanging naked from a metal hook in front of the cabin's door, her head thrown back, her hair cascading down to her waist. Her figure, a gleaming shaft of alabaster, leaps out from the shadows, while the rank afternoon heat has lulled the nearby adults into an indolent oblivion. At

once goddess and martyr, she hovers between sacrifice and warning, recalling all those twelve-year-old girls Mann photographed on the uncertain cusp of adulthood. It was reportedly the one photograph that even *Artforum* initially refused to publish.[57]

In the early 1990s, such editorial concerns were not unwarranted. Passed by Congress in 1977, the Protection of Children against Sexual Exploitation Act prohibited the production and commercial distribution of "obscene" depictions of children younger than sixteen (the age had been twelve under a previous incarnation of this law). In 1984, the law was revised to protect children up to age eighteen. In 1992, the court case *United States v. Knox* further redefined child pornography to include images in which a minor is depicted in such a way that *might* appeal to "lascivious interests," regardless of whether the child is even nude or is engaged in a sexually explicit act.[58] These shifting and vague definitions of child pornography soon meant that everything from mundane snaps of a toddler in the tub to artistic projects depicting children in states of partial or full undress could be considered child pornography, regardless of the intended circulation. Photography labs in some states were required to report nude photographs of children to law enforcement, in effect turning citizens into informants scrutinizing snapshots for dangerous content.

Legal scholar Amy Adler has argued that the tightening of child pornography laws in the 1980s and 1990s paradoxically changed the perception of children's bodies by associating them with an exploitable sexuality and by requiring adults to assume the gaze of a pedophile "in order to root out pictures of children that harbor secret pedophilic appeal."[59] Although they were designed to protect children from sexual abuse, the laws threaten "to enslave us all, by constructing a world in which we are enthralled—anguished, enticed, bombarded—by the spectacle of the sexual child."[60] More broadly, these legal developments coincided with and fueled the elision of categorical distinctions between childhood sexuality—a curiosity and awareness of the body's libidinal drives before sexual maturity—and adult

sexuality. The anxiety over the "disappearing child" was not just an effect of changing laws but also a much-debated aspect of media and culture. From the provocative Calvin Klein jeans advertisements featuring fifteen-year-old Brooke Shields to a burst of films exploring teenage sexuality, long-standing cultural notions of childhood innocence appeared to be under siege.[61]

Given the disquiet over representing or even simply looking at the child's body at this moment, it was inevitable that some of the family pictures would provoke controversy. Mann herself

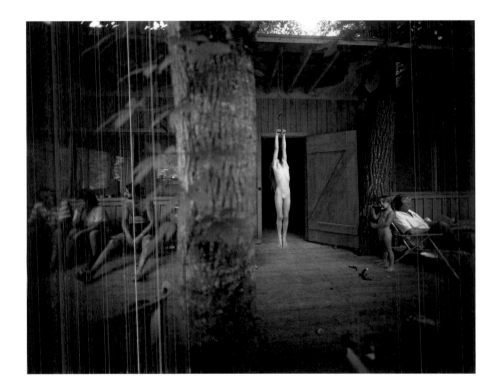

admitted that she had cut certain photographs from her initial layout, afraid of "what would happen to the children if it blew up into some kind of issue."[62] Anticipating the potential embarrassment that might befall her children, particularly in the conservative, small-town atmosphere of Lexington, Mann also contemplated delaying the publication of *Immediate Family* until they were older. Upon learning this, the children were angered that

they had not been consulted and asked her to reconsider. After conferring with a psychologist who assured Mann and Larry that Emmett and Jessie were well adjusted and fully cognizant of the implications of the publication (little Virginia was thought to be too young to benefit from the sessions), Mann moved forward with the publication. Nevertheless she and her family were unprepared for the fame and the infamy *Immediate Family*—and Woodward's profile in the *New York Times Magazine*—delivered.

On the whole, the critical establishment lauded the work as a signal achievement delving into childhood from within and without, as ambitious and sweeping as any great work of literature.[63] These same critics, however, almost universally acknowledged the unsettling or disturbing nature of the photographs and noted how they had embroiled Mann in controversy. For some, the unadulterated authenticity of Mann's vision of childhood was the root cause of provocation: "Gone is the contrived idyll of childhood, the lie that we create about our pasts because we all long for a counterpoint to the indecipherability of adult life," one critic averred. "With nostalgia, we bulldoze our fears of what childhood is really about. It's the way Mann disables our nostalgia with these pictures that makes them so unsettling (not to mention controversial)."[64] Others homed in on the ways in which Mann's pictures punctured the sentimental conventions of the family album (whose memory-keeping functions, it should be noted, were historically administered by mothers).[65] And there were certainly outraged viewers who considered any public display of naked children as pornographic—a sentiment that was heightened by the cultural politics of the moment—as well as a few people who took the pictures as proof positive that Mann herself had suffered sexual abuse as a child.[66]

Debate over the depiction of childhood sexuality followed a more or less predictable path. For every writer who accused Mann of foisting upon her children unnatural, "sexualized" poses, eminent critics like Janet Malcolm and Luc Sante passionately defended *Immediate Family* and its "great ring of disturbing truth."[67] The myth of childhood innocence that Mann's photo-

graphs pierced, these critics argued, reflected deep-seated cultural anxieties about the boundaries of adult sexuality. In this sense, Mann's crime was not so much the exposure of her children as the exposure of the chasm between the child's shame-free experience of the body and the adult's knowledge of how fleeting that state of grace is. As Sante put it, "the collision of the two perspectives may make us feel more helpless than the kids themselves: we see their frank physical enjoyment and at the same time the looming spectre of adult sexuality in the way we'd see a running figure and the hidden ravine in its path. Mann is not the one who will cry 'Stop!'"[68]

Mann's failure to "cry 'Stop!'"—her seeming refusal to shield her children from both the imagined dangers in her pictures and the real dangers posed by their circulation—raised the most vexing questions concerning the relation between parental authority and photographic agency.[69] Had Mann abused the maternal privilege that sanctioned the production of the photographs in the first place? Was she exploiting her children by making their innermost experiences—the anger, awkwardness, and shame that mark the process of growing up—the fodder for her art? And how would they bear the unavoidable scrutiny and the burden of representation placed on them by the photographs? Underlying all of these questions was a pervasive unease that Mann's extraordinarily creative vision derived its power from a form of maternal omnipotence, yet the pictures themselves transgressed deeply held convictions about motherhood, staging an irresolvable conflict between making art—what Oscar Wilde once called "the most intense mode of individualism the world has ever known"—and maternal duty, which assumes the sublimation of the mother to the child's needs. For Mann, making art from the crucible of motherhood required suturing two antagonistic value systems.[70]

As Mann has argued, many of the bad-mother criticisms of her work emerged from the fundamental misunderstanding that photography transparently recorded reality. Thus the image of childhood in Mann's pictures—riven with conflict, vulnerability,

sexual precocity, anger, resistance—seemed to imply a lack of nurturing and parental protection that left the children exposed and defenseless. As one writer noted in response to *The Alligator's Approach*, "our aesthetic experience is tied up with that question parents never really stop asking—are they safe?"[71] In response to these misapprehensions, Mann has explained that "taking those pictures was an act separate from mothering, and the kids knew the difference. When I stepped behind the camera, and they stepped in front of it, I was a photographer and they were actors and we were making a photograph together."[72] Savvy and self-confident, the children understood the crucial difference between their real lives and those moments "more or less illusorily abducted from time's continuum" that were, in many cases, staged for the camera. Moreover, their agency extended to selecting or vetoing works for publication.[73]

Yet even sophisticated consumers of photography sometimes failed to fully separate the truth from the fiction—or the mothering from the photography. For Sante, the frisson of *Picnic* a photograph depicting Jessie and two friends enjoying a picnic while a distressingly close bonfire rages, lies squarely in its staging of maternal risk (pl. 21). The image, he wrote, "crystallizes our idiot concern. Do we want Mann not to take the picture, but to swoop the girls up and away from the threat?"[74] The concern *is* idiotic, at some level, not only because the implied choice—take the picture or save the girls—is a false one but also because Sante (as he is likely aware) is responding to a photograph as if it were real. But photography is neither fully identical with the world nor wholly separate from it, but bound to reality through ongoing processes of creation and interpretation. In this way, the family pictures constitute their own world, a zone where the boundaries between truth and fiction, innocence and knowledge, motherhood and danger, dissolve. Their seduction lies in how convincingly they manifest the extraordinary intimacy and mutual trust that exist within the confines of immediate family, a trust that is breached in the very act of its disclosure. Mann's works not only probe childhood, but also hold the maternal bond

up for raw inspection. Startlingly dark and fraught with danger and desire, it is ever ballasted with love.

And how do the pressures of motherhood impact the artist-mother? Arriving at day care to pick up her children one day, the writer Jane Smiley witnessed all the preschoolers lined up and crossing the street. "My inner mom says, Oh my God, what if a car comes screaming down the street right over the kids? And my inner author says, Wow, that's an idea."[75] For Mann, too, alarming maternal anxieties fueled creativity, as photographs like *Bloody Nose*, *The Alligator's Approach*, or *Last Light* attest. But the magical thinking behind Mann's impulse to photograph danger and threat as a way to ward them off was challenged when real life proved more terrifying than her photographs. In September 1987 as seven-year-old Emmett ran across the street to greet his mother, he was hit by a car and thrown some forty feet, landing bleeding and unconscious in the middle of the road. Although he appeared to recover swiftly, the horrific experience shook Mann to the core.[76] Writing to a friend soon after, she described how

the real image of Emmett lying in a pool of blood has come to make the family pictures seem, ummm, trivial to me....I thought during that eleven-minute eternity that the world of motherhood is a far more complex thing than you and I ever imagined when we plunged so willingly into it, and that the fear and... joy I have encountered have staggered me.[77]

Unable to rid herself of the memory of the accident, Mann undertook a series of photographs of Emmett as a kind of exorcism, trying to escape the vise grip of that terrible memory. At first, Mann tried to re-create the way Emmett had looked to her after the accident, bloodied and injured (fig. 16). But whereas in other works Mann had restaged or transformed traumatic incidents for the camera as a way to psychically arm herself against such peril, Emmett's accident had so shocked her that the habitual cure did not take. She was, as she reported to her friend, "afraid that by photographing my fears I might be closer to actually seeing them, not the other way round."[78]

Eventually, Mann and her family returned to the cabin where "the honeyed September light and the lazy, limpid river offered, as always, the cure, the balm for my bunged-up soul."[79] Yet Emmett's accident continued to gnaw at her and so, for more than a week, Mann hauled her equipment to the lower rapids of the Maury, perched the heavy camera and tripod precariously on rocks, and photographed her son in the river. Many attempts failed for usual and not so usual reasons: awkward compositions, wet negatives, a flotilla of interrupting canoes. Compounding these difficulties was the river itself: Mann could make only two exposures at a time before having to swim (with film holder over her head) to the banks to retrieve more

film. The tenacity of both artist and model finally paid off, in the form of the heart-stoppingly beautiful photograph that closes the central section of *Immediate Family*, *The Last Time Emmett Modeled Nude* (pl. 20).

Braced by fear and love, this photograph is at once a bulwark against time and a sorrowful acknowledgment of impermanence. Although the title, Mann recounted, was prompted by Emmett's announcement that it was "the last damn time he would model in the freezing river," it also alludes to the inescapable and poignant transitions of childhood, the moment when fusion gives way to independence.[80] The inevitability of this transition permeates the photograph. The day's end is near as dark shadows grow long on the glimmering surface of the river. Standing at the apex of a triangle of light, Emmett looks upward at the camera with a mixture of trust and reproach. He spreads his palms flat, caressing the water and creating gentle eddies that barely break its satin surface. But just as he cannot staunch the implacable current, the photograph, like all photographs, cannot still time or vanquish death. It can only preserve the feeling of that moment, perfect and true, and raise a darkly gleaming mirror to the desire, aching and eternal, to hold on to what is loved most.

In 1994, Mann wrote to a friend

there's something strange happening in the family pictures. The kids seem to be disappearing from the image, receding into the landscape.... Judging by the scrutiny we were subjected to over the last few years, I expect much will be made of the distance springing up in the pictures between the children and me. But, in fact, what has happened is that I have been ambushed by my backgrounds.[81]

Soon after writing this letter, Mann ceased making new family pictures, turning instead to an intense and purposeful exploration of the landscape and region that had so powerfully shaped her upbringing and identity. The shift away from the family pictures was in part a retreat from the unexpected controversy and fame surrounding *Immediate Family*. Writing to another friend soon after the publication, Mann revealed

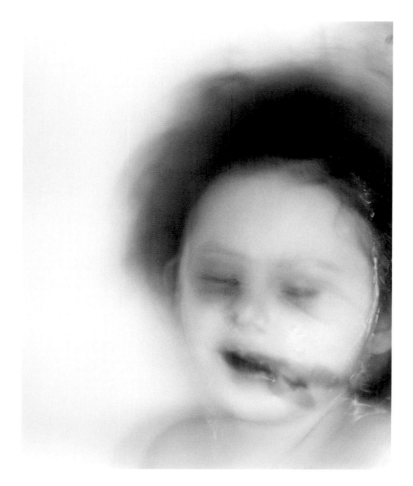

16 / Mann **The Way It Looked** 1987, National Gallery of Art, Washington, Corcoran Collection (Museum Purchase)

"the phenomenon of the last year spun me around and now leaves me wobbling, like a spent top, towards stasis."[82] But in many ways this end point was also natural, for as the children approached adolescence they asserted greater control over their time and privacy. "I felt that it was a time when I should pull away," Mann noted in 1997. "When we're working together, it's such an inelastic type of bond. So moving on to other things now is a way of releasing them to be by themselves."[83]

The transition from photographing the family pictures to the landscape of her native region offered novel challenges and required different approaches, for the new subject was "teasingly slow to give up its secrets." It would ultimately lead Mann to a thoroughly transformed pictorial vocabulary and an expanded sense of photography's potential to probe universal experiences, among them time, memory, history, loss, and death (for a discussion of these developments, see the essays by Sarah Greenough and Malcolm Daniel in this volume). "If the family pictures are flashes of the finite," she wrote in 1994, "these landscapes offer them residence in the languid tableaux of the durable."[84]

The drive to visualize the "durable"—that which remains after all else fades away—was the bedrock underlying several series of photographs that Mann made between 2000 and 2004. Collectively, they formed the basis for the magisterial 2004 exhibition What Remains. As part of this project Mann recalled her children to her studio in 2004, where she executed a series of haunting close-up studies of their faces (pls. 100–103). Emmett, Jessie, and Virginia, who were by then young adults, reclined on a bench as Mann positioned her camera directly over them at close range and exposed the collodion-coated glass plates (see page 292, fig. 12).

Translating the negatives into larger-than-life 50 × 40 inch prints, Mann created startling and enigmatic portraits—at once vivid and fugitive, profoundly affecting and (dreamlike) dissipating upon awakening. This contradictory quality derives in part from Mann's exploitations of her materials. Because the nineteenth-century photographic chemistry Mann employed

exaggerated red or brown pigmentation in skin, in such works as Triptych the children's freckles acquire a material density, like a lunar landscape (pl. 103). In other photographs, Mann evoked qualities of fragility and evanescence by overexposing the plates and allowing the artifacts of the collodion process, including drips, streaks, and blurs, to function as metaphors for change and transformation. During the long exposures (upward of three minutes) the negatives registered the slight movements and shifts of the children's faces, further underscoring this sense of mutability.

The deliberate references to nineteenth-century postmortem photography also contribute to this quality of temporal displacement. While the serene Jessie #25 conjures the eternal calm of a death mask, the ghostly Emmett #15 seems to dematerialize, as a visual metaphor for not only the effects of time on matter but also photography's fraught relationship to memory. Though it is charged with preserving a moment in time, the "twilight art" of photography inevitably transforms the flux of experience into a fixed image, always already past.[85] Mann, of course, has long been fascinated with the instability of memory. For the preface to the 1994 edition of Still Time, she selected an excerpt from Eric Ormsby's poem "Childhood House," a lament of not just the passage of time but also the treachery of memory that "decays like the rest, is unstable in its essence, flits, occludes, is variable, sidesteps, bleeds away, eludes all recovery."[85]

Seeking the answer to the question that framed the series—what remains after death?—Mann returned to the subjects she knew so intimately, her children. This time, however, the photographs are marked by a keen awareness of time's forward march. Trading the particular for the general, Mann emphasized the children's shared features—full lips, sharp nose, and downy lashes—in order to erase differences. Affirmations of common origin that seem to float between past and future, they are also testaments to the ferocity of maternal love, bone-deep and unyielding, even in the face of death.

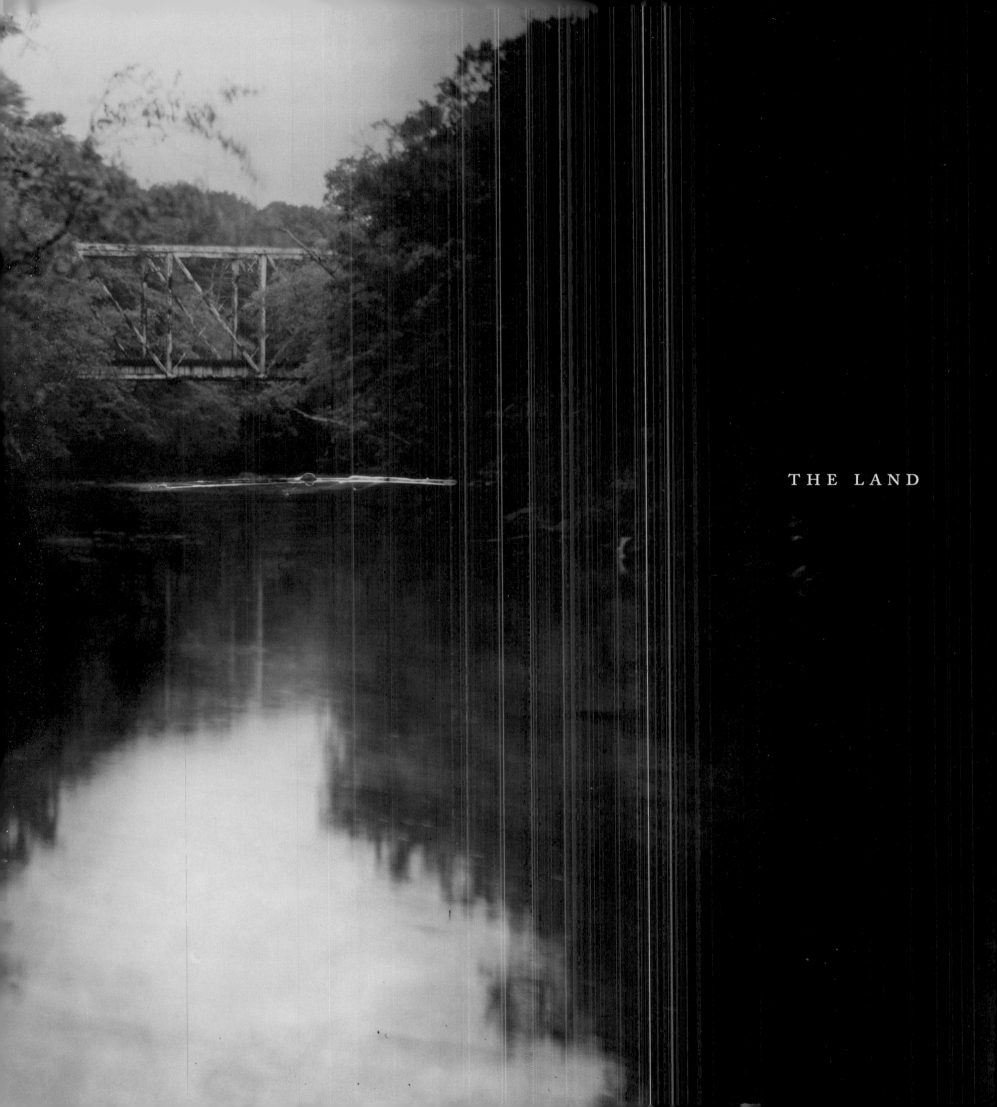

THE LAND

Living in the South means being both nourished and wounded by the experience. To identify
a person as a Southerner is always to suggest not only that her history is inescapable and profoundly
formative, but that it is also imperishably present. Southerners live at the nexus between myth
and reality where that peculiar amalgam of sorrow, humility, honor, loyalty, graciousness and renegade
defiance plays out against a backdrop of profligate physical beauty.

SALLY MANN, 2007

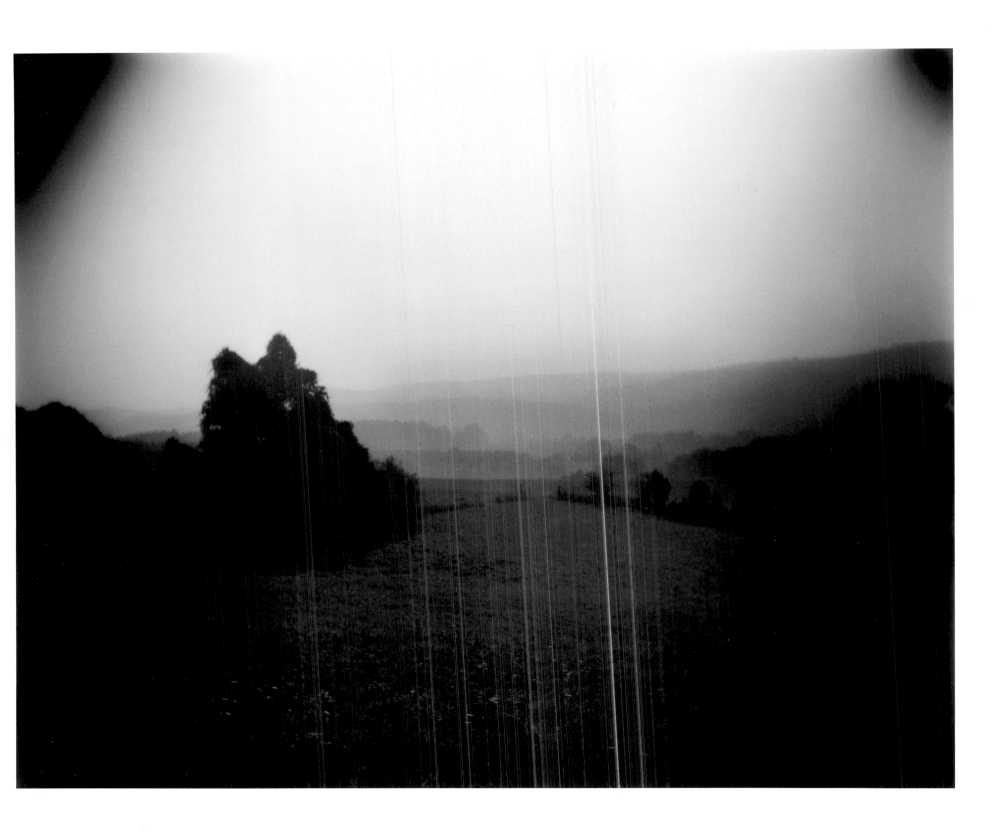

plate 22 / **Virginia, Untitled (Blue Hills)** 1993

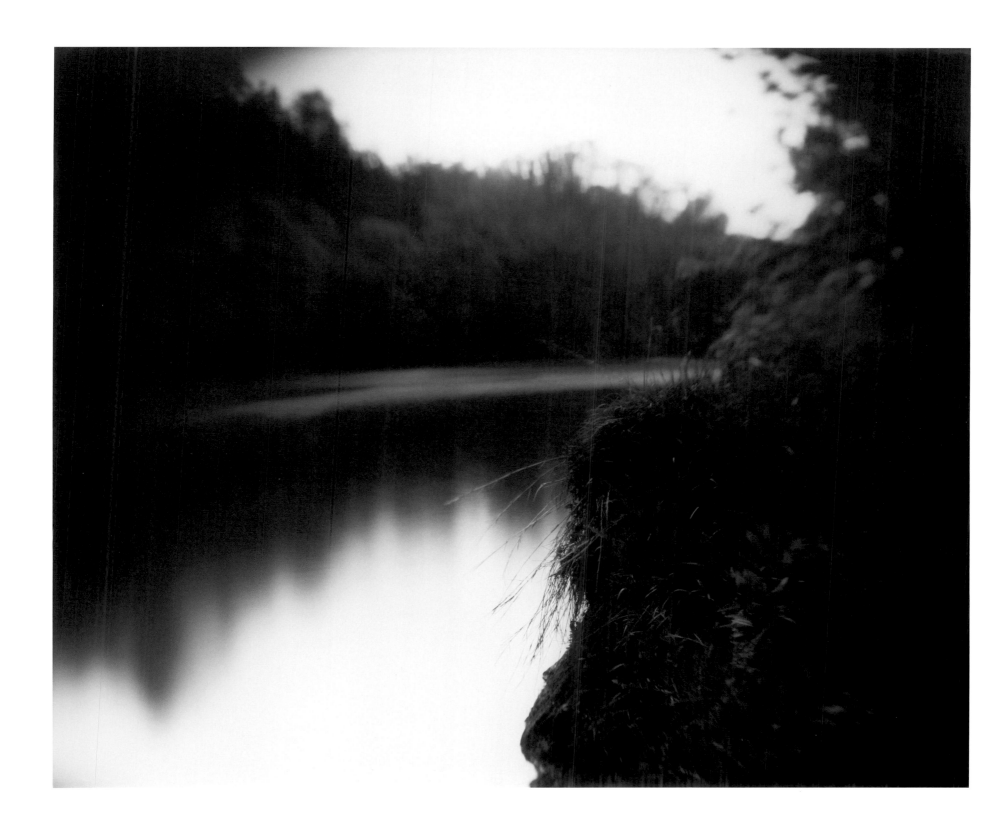

plate 23 / **Virginia, Untitled (Niall's River)** 1994

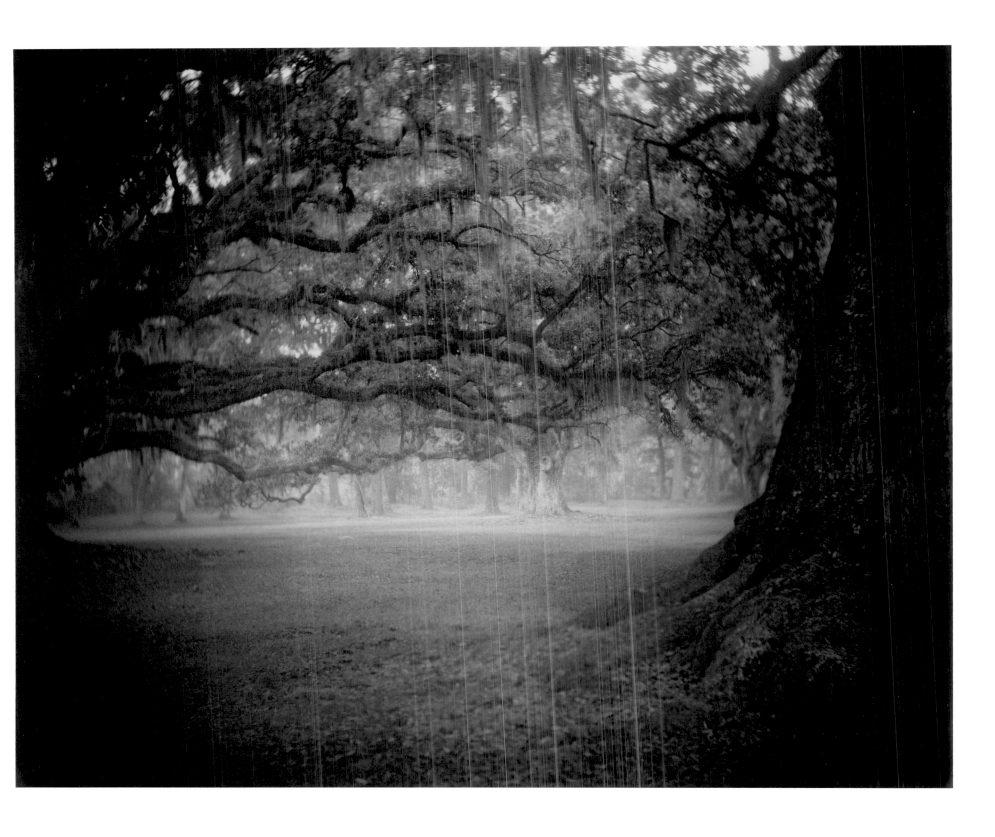

plate 24 / **Deep South, Untitled (Fontainebleau)** 1998

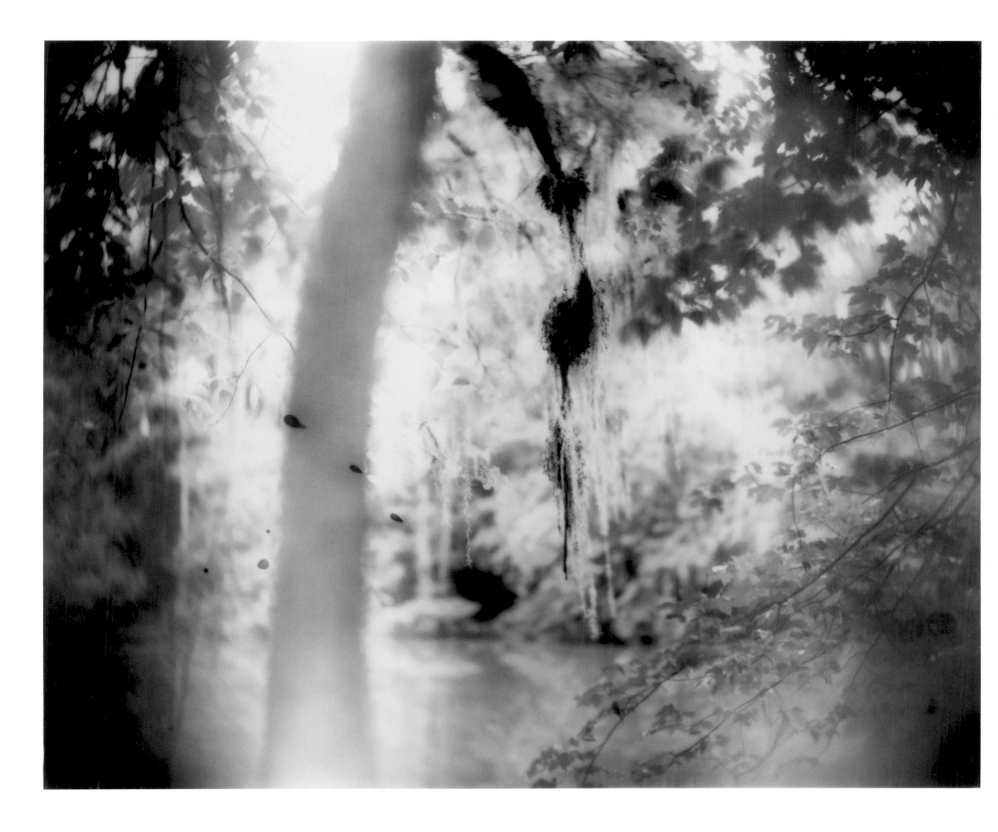

plate 25 / **Deep South, Untitled (Three Drips)** 1998

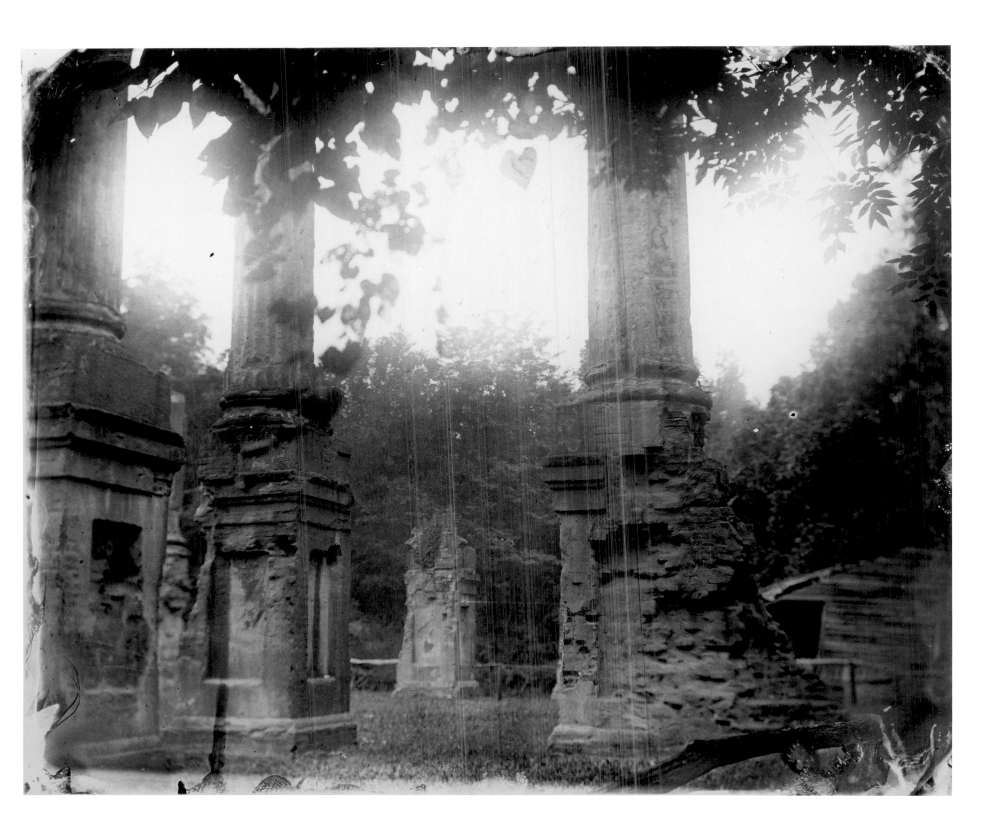

plate 26 / **Deep South, Untitled (Valentine Windsor)** 1998

Flannery O'Connor said the South is Christ-haunted, but I say it's death-haunted. The pictures I took on those awestruck, heartbreaking trips down south were pegged to the familiar corner posts of my conscious being: memory, loss, time, and love. The repertoire of the Southern artist has long included place, the past, family, death, and dosages of romance that would be fatal to most contemporary artists. But the stage on which these are played out is always the Southern landscape, terrible in its beauty, in its indifference.

SALLY MANN, 2005

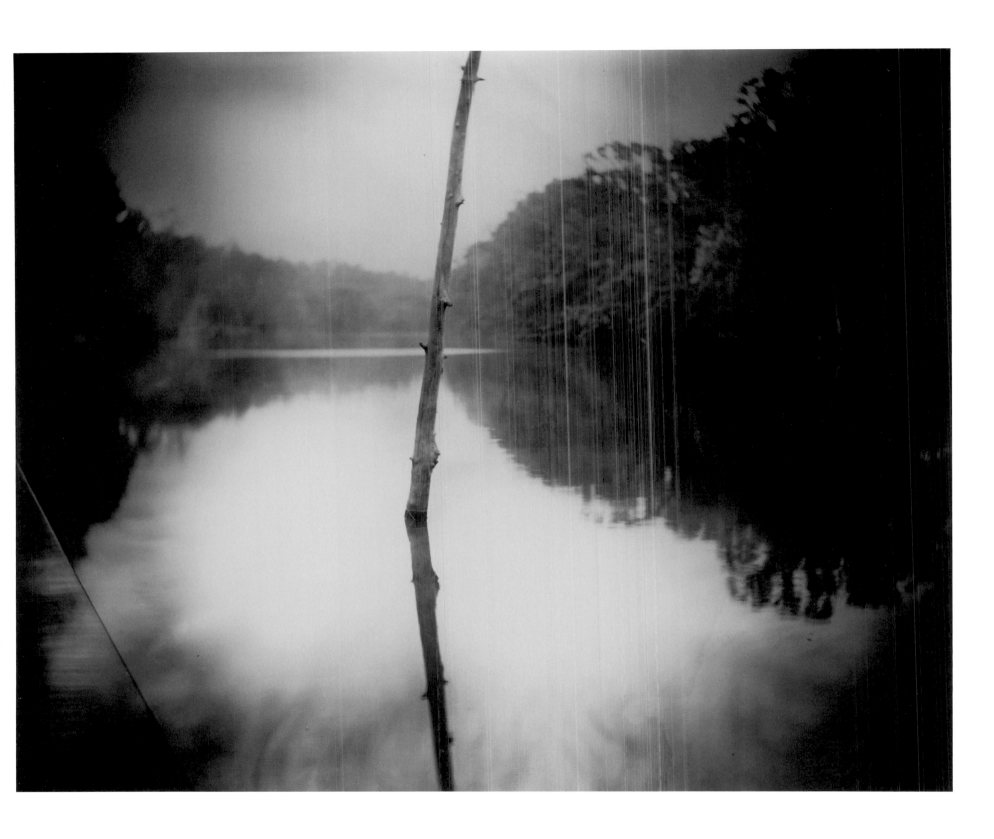

plate 27 / **Deep South, Untitled (Stick)** 1998

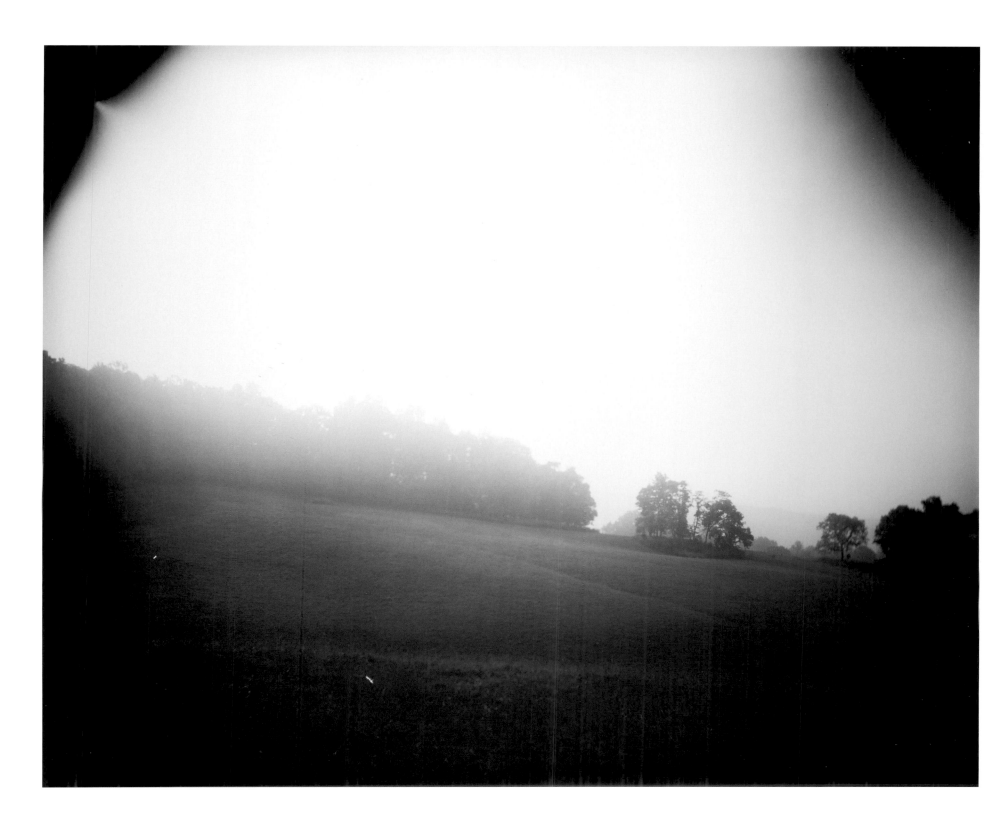

plate 28 / **Virginia, Untitled (Upper Field)** 1993

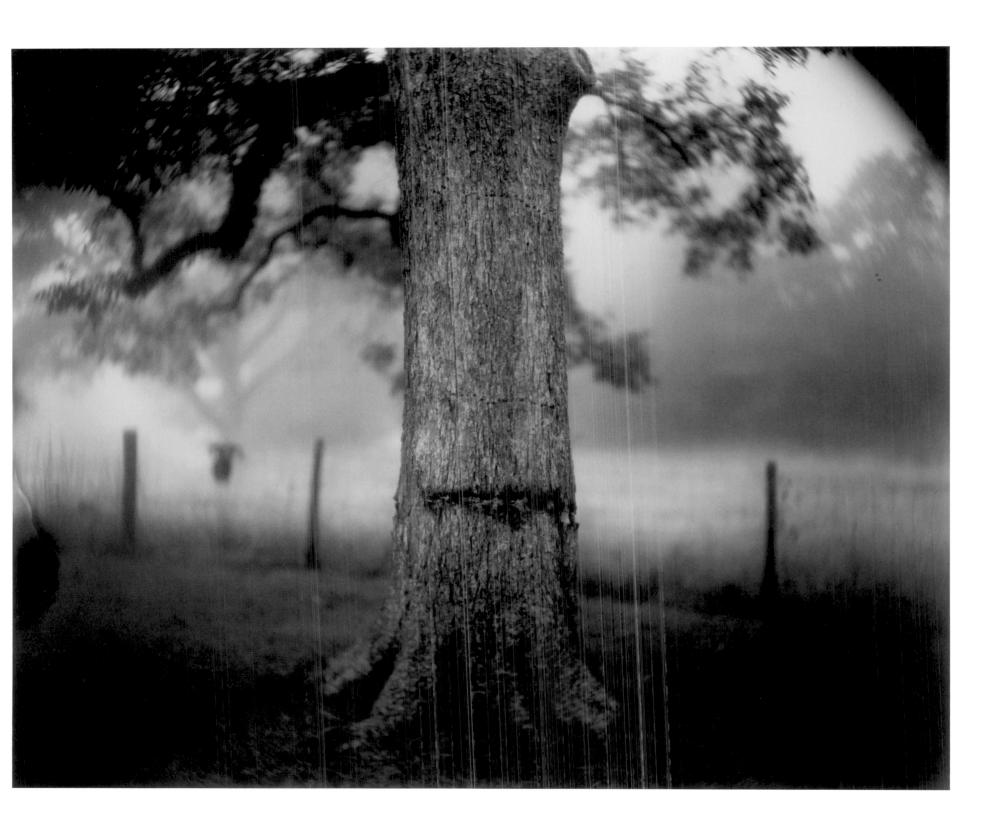

plate 29 / **Deep South, Untitled (Scarred Tree)** 1998

The pictures I wanted to take were about the rivers of blood, of tears, and of sweat that Africans poured into the dark soil of their thankless new home. I was looking for images of the dead as they are revealed in the land and in its adamant, essential renewal. One death in particular had haunted me since childhood, that of Emmett Till, which took place in Maude Clay's home territory. On my way there, I traced the route his murderers had taken in his last hours, beginning with the fateful (and possibly apocryphal) wolf whistle in Money, Mississippi, passing along the Tallahatchie River, and winding up on a balmy, serenely yellowish afternoon at the very boat lock from which fourteen-year-old Emmett was heaved into the river, naked, blinded, beaten, a cotton gin fan lashed with barbed wire to his neck.

SALLY MANN, 2015

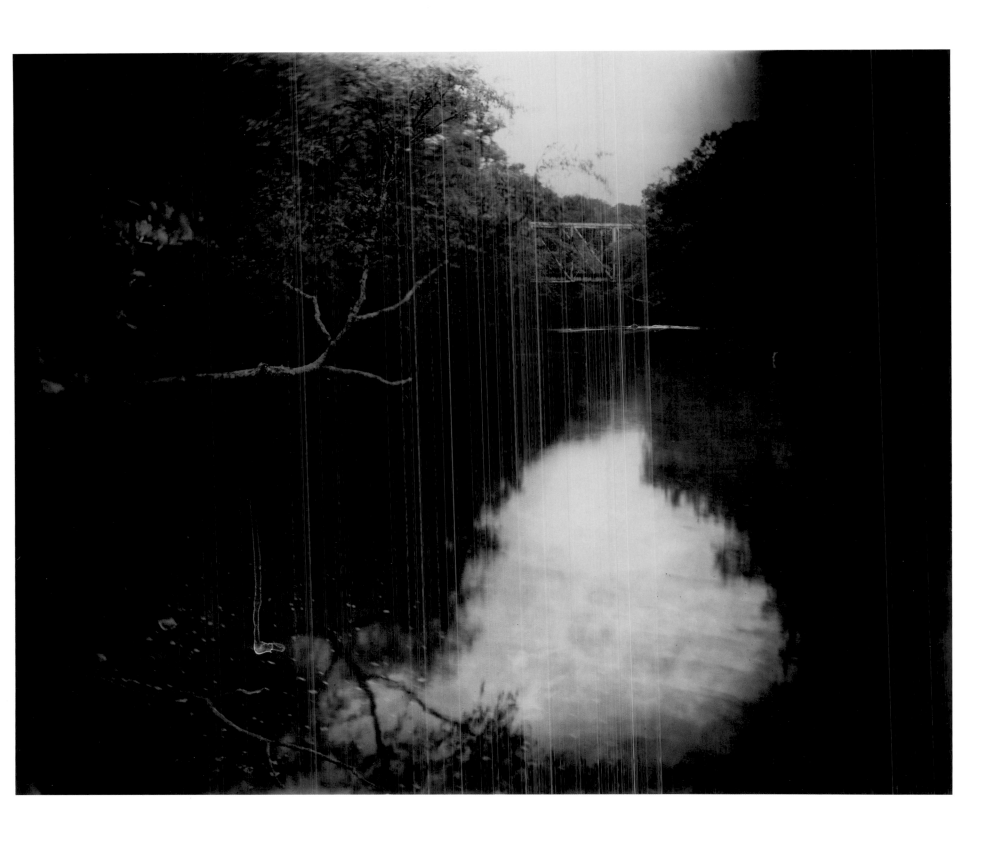

plate 30 / **Deep South, Untitled (Bridge on Tallahatchie)** 1998

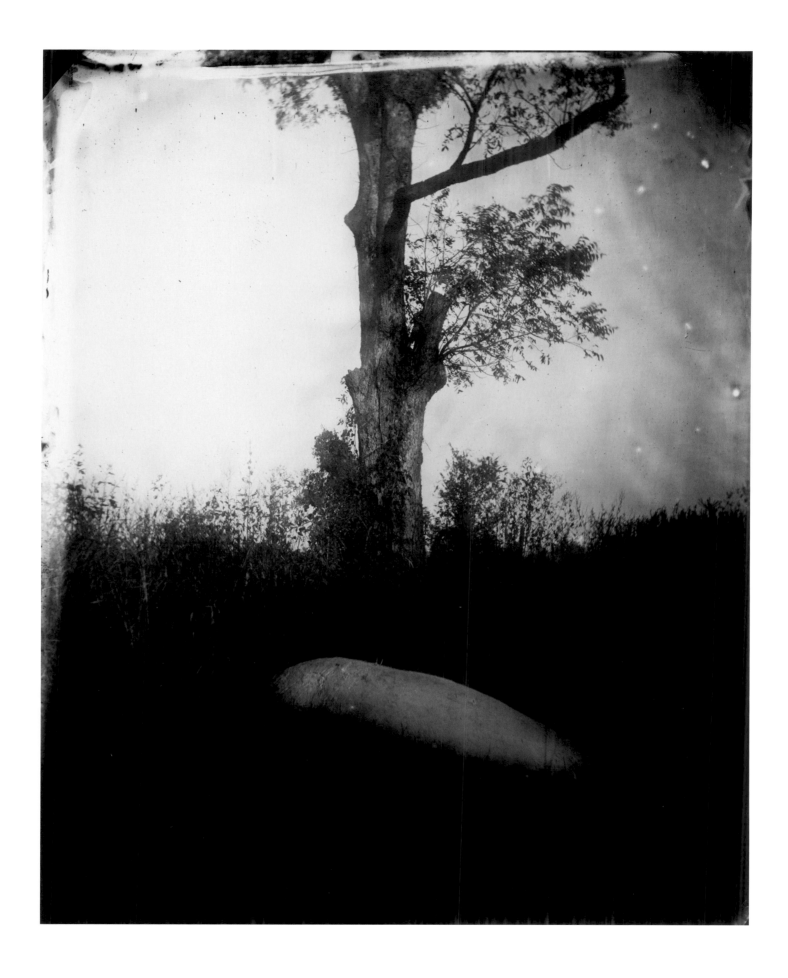

plate 31 / **Deep South, Untitled (Concrete Grave)** 1998

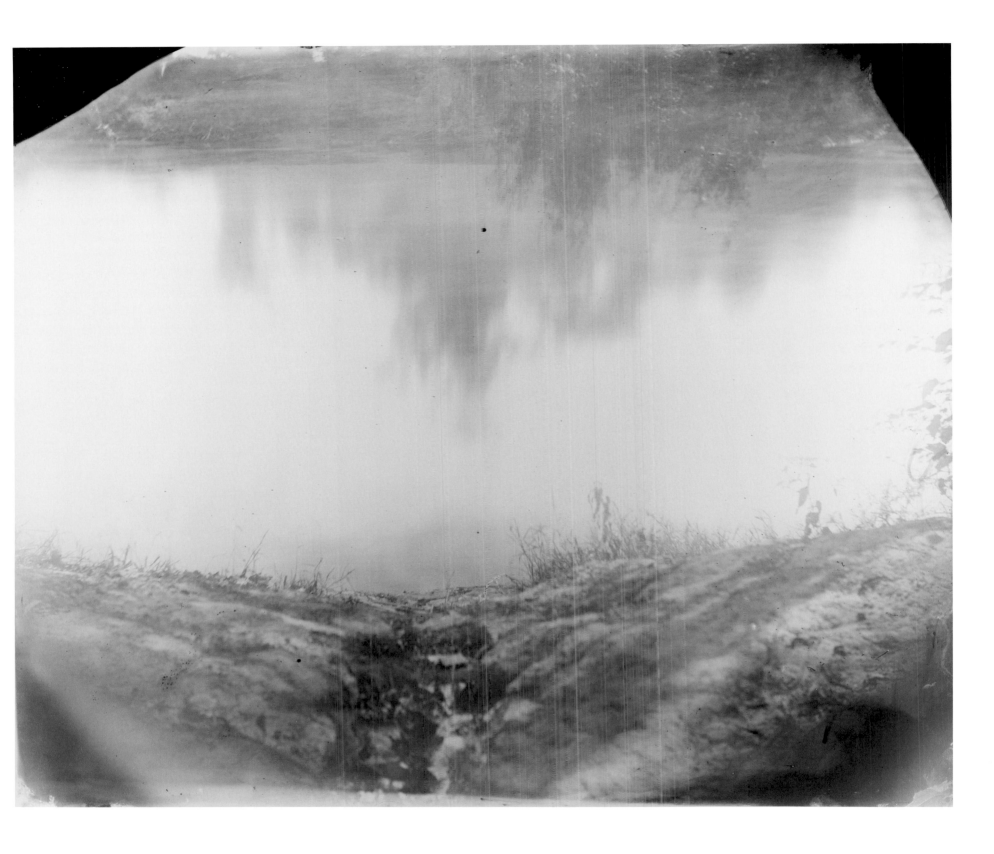

plate 32 / **Deep South, Untitled (Emmett Till River Bank)** 1998

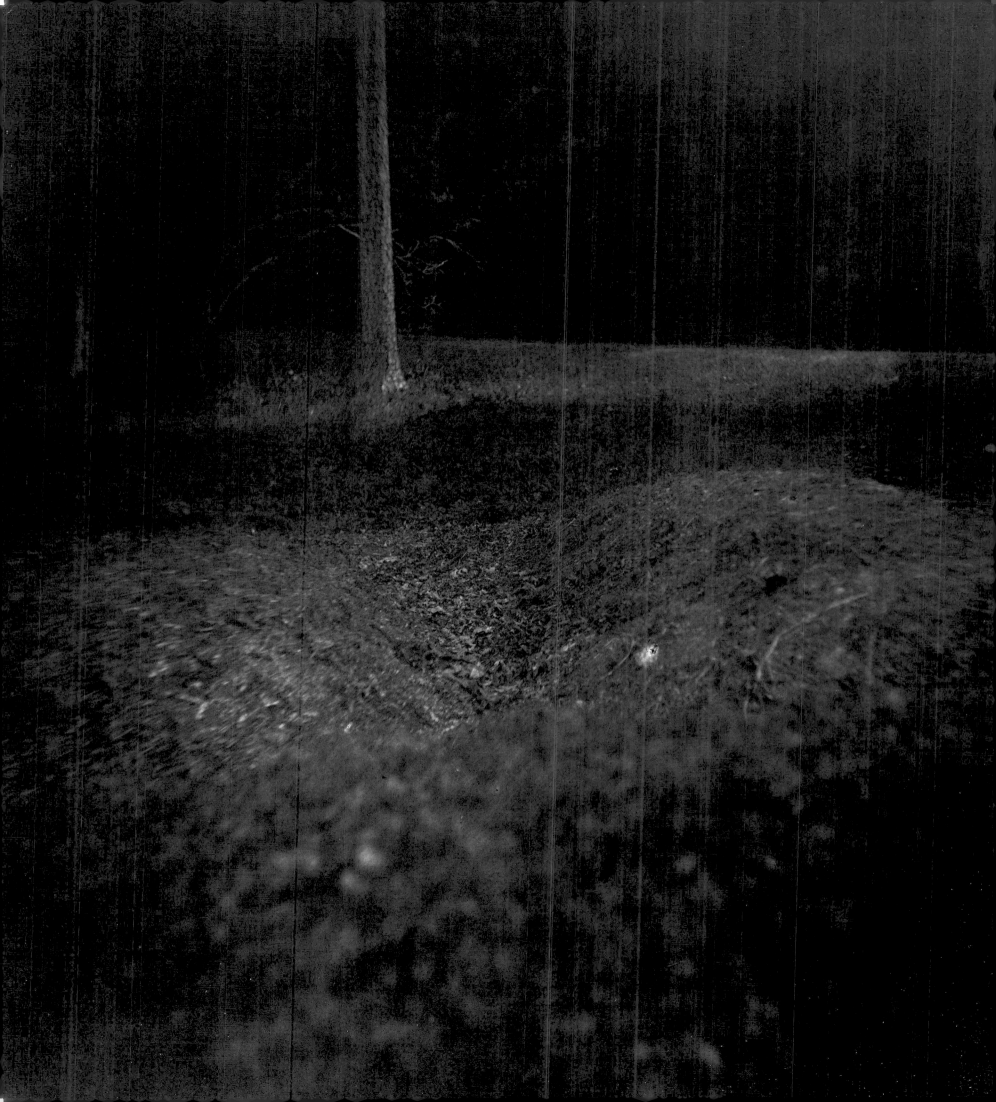

The Earth Remembers: Landscape and History in the Work of Sally Mann DREW GILPIN FAUST

I have been through the whole Valley campaign with the Great Stonewall Jackson…

and learned what the horrors of war are by being an eye witness to the most inhuman heart sickening

and brutal slaying of men. I walked over the field early on the morning after the dreadful battle

of Coal Harbor and the dead lay thick enough in some places to have walked on.

The scene was one never to be forgotten. Where the battle raged the fiercest every twig was riddled

and many trees not more than a foot in diameter had as many as forty balls in its trunk.…

Language would in no way express the true picture as it really was.

REUBEN ALLEN PIERSON, 1862

Cold Harbor. June 3, 1864. "It was not war," Confederate general Evander Law observed, "it was murder." The slaughter was so terrible, the Union losses so great, Abraham Lincoln thought it could "almost be said that the 'heavens are hung in black.'" Anticipating an assault at dawn, Union soldiers had pinned their names to their uniforms in hopes their dead bodies would be identified and relatives informed. Within little more than an hour, the sun scarcely up, the futility of the Union assault was clear; the Army of the Potomac had lost some seven thousand men to wounds and death. An unfamiliar species of buzzard lured from the deeper South by the slaughter joined the native Virginia turkey vultures circling and descending upon fallen men their comrades could not reach. More than four days elapsed before Yankees and Confederates could agree on a flag of truce and permit access to the wounded and slain. By that time, General Ulysses S. Grant reported, only two of the wounded still remained alive. The suffering was unspeakable (fig. 1).[1]

Nearly a year later, seven weeks after the Confederate surrender at Appomattox, Union troops returned to Cold Harbor to inter the still-unburied dead. And five years after the battle, a visitor found "in all parts of the field…skulls, ribs, legs, and arm bones…scattered about in fearful array" (fig. 2).[2]

Cold Harbor. 2003. Sally Mann's photograph asks us to remember this history, this nineteenth-century body farm created by the cruelties and exigencies of war, asks us to acknowledge the way even now we walk "among the accretion of millions of remains," among "the bones, lives, souls, hopes, joys and fears that devolve into the earth." The skulls found months and even years after the battle in a spiritual and metaphorical sense persist still. Death, as Mann has explained, "sculpted this ravishing landscape and will hold title to it for all time."[3]

Our existence as a nation and a people derives from this loss. These dead, as Lincoln explained so powerfully at Gettysburg, gave their lives, the "last full measure of devotion" so the "nation might live." But we are also created, sculpted, by these deaths in a

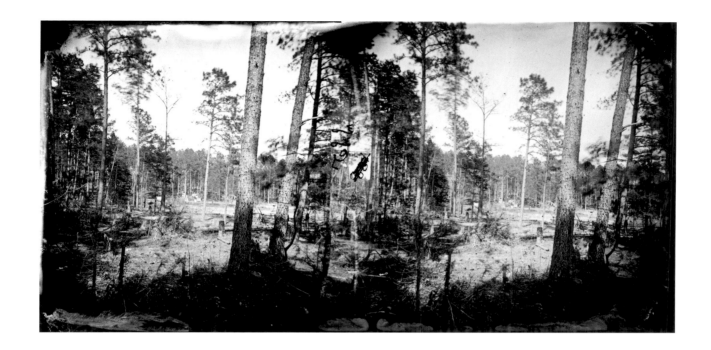

1 / Timothy H. O'Sullivan **Cold Harbor, Camp in the Woods** 1864, Library of Congress, Washington, Prints and Photographs Division

2 / Attributed to John Reekie **Unburied Dead on Battlefield** 1862, Library of Congress,

Washington, Prints and Photographs Division

more individual manner: as the products and occupants of this soil, this place—Virginia, the South, America.

Mann's *Cold Harbor* (pl. 40) seems eerily to reflect the very perceptions of those who came nearly a century and a half before. Part of a series of battlefield scenes she entitled *Last Measure*, the photograph itself is "hung in black," to borrow Lincoln's words, with dark edges, like curtains or mourning crepe, bordering each side of the frame. When the Union charge began about 4:30, it was, one Union soldier observed, just "beyond gray in the morning, but not quite sun-up." There is a similar hue just beyond gray here, with brighter light barely touching the tree in the center of the frame. Participants in the battle noted that the bugled sound ordering the Union assault could almost not be heard because it was muffled in the heavy, humid air. Mann has often written of the joy and challenge of capturing the ineffable southern air—air that, as she put it, is itself ghostlike and almost breathes an image onto the negative to "reveal the dark mysteries of a haunted landscape." A landscape haunted by the memory of the men who died there, haunted by the way war and death have permanently scarred it, often in a literal as well as a figurative sense. The air, like death itself, possesses its own substance. Mann found the trees before her spindly, their needles thin—stunted, she imagined, from the poisoning lead of spent minié balls. More durable than flesh or bones, these relics still infest the ground—"the spoor, the spoils of war still surfacing, unbidden and irrepressible."[4]

History has not just sculpted the southern landscape. It has indelibly shaped Sally Mann. For her, the past is "impossibly present." It is this consciousness that defines her most distinctively as a southern artist. The burden of the southern past—the "historical burden I carry"—is inescapable for her. Yet this burden is at the same time the wellspring of her creativity, as it has been for the pantheon of visual and literary artists who emerged in the twentieth-century South—from her friend and neighbor Cy Twombly, to his friend Jasper Johns, to William Faulkner, Robert Penn Warren, Allen Tate, Katherine Anne Porter, Eudora Welty, Tennessee Williams, Flannery O'Connor, and the myriad founders and heirs of the Southern Renaissance.[5]

As early as the 1920s and 1930s, writers began to confront the heritage of the white South with a newly critical air, with a clear-eyed gaze that at once embraced southern identity and rejected its romanticization of the past. They possessed no patience with myths of moonlight and magnolias or the Lost Cause. For the Southern Literary Renaissance, the past was far darker, deformed by the moral obloquy of slavery and by the violence and tragedy of war. But these complexities made history and the search for understanding both unavoidable and compelling for artists who confronted it out of urgency and necessity. Their work and indeed the work of many of their fictional characters became the excavation of history—from Jack Burden, who as a PhD student in Warren's *All the King's Men* (1946) began the exploration of the dark and tragic past of his relative Cass Mastern, to Eugene Gant in Thomas Wolfe's *Look Homeward, Angel* (1929), "trying... to recover what he had been a part of," to Quentin Compson in Faulkner's *Absalom, Absalom!* (1936), struggling to explain the South both to himself and his Canadian roommate, Shreve. Shaking with cold in his Harvard dormitory, Quentin endeavors to recount his tortured investigation of a shocking and disturbing past of slavery, war, incest, violence, and human cruelty that seems almost unimaginable in the cold, sterile, uncorrupted northern air. "Wait. Listen," Shreve insists.

"I just want to understand it.... Because it is something my people haven't got.... We don't live among defeated grandfathers and freed slaves... and bullets in the dining room table and such, to be always reminding us to never forget. What is it? Something you live and breathe in like air? A kind of vacuum filled with wraithlike and indomitable anger and pride and glory at and in happenings that occurred and ceased fifty years ago.... The South," Shreve said. "The South. Jesus. No wonder you folks all outlive yourselves by years and years and years."

Shreve, the Canadian, cannot comprehend it; Quentin, the Mississippian, cannot escape it. "You cant understand it," Quentin says, "You would have to be born there." Mann was born there, and she bears the burden and consciousness of the past that compel her toward history and place her firmly within the tradition of southern art.[6]

Mann grew up not just in the South, but in a town redolent of the past, of slavery and Civil War. Much of Lexington, Virginia, she has noted, "dozed off in 1865 and it hasn't quite awakened." The hospital in which Mann was born was once Stonewall Jackson's house. Lexington is home to both the Virginia Military Institute (VMI), where Jackson served on the faculty, and Washington and Lee University, where Robert E. Lee assumed the presidency after the Civil War. Both Jackson and Lee are buried—enshrined—in the town (fig. 3). It has been said that if Richmond, 110 miles to the east, was the cradle of the Confederacy, Lexington is its grave. Even their horses, Little Sorrel and Traveller, were preserved as tangible relics, in a manner not available for the war's human heroes. Jackson's mount—or at least the remnants of his hide, which was in 1886 stretched over a plaster of Paris model that had been made to size in anticipation of his death—has long received admirers in the VMI Museum. Traveller's articulated skeleton was displayed for years at Washington and Lee, but was in the 1960s at last consigned to an honored grave where he receives regular tributes of apples and carrots. On the grounds at VMI, a statue entitled *Virginia Mourning Her Dead* memorializes ten young cadets killed after being pressed into service at the Battle of New Market in 1864, one of fourteen occasions when students were called to fight in the course of the war. Before it even began, VMI cadets had occasion to display their sectionalist sentiments, marching up the Shenandoah Valley in 1859 to Charles Town under the command of their professor Thomas J. Jackson to bear witness at the hanging of John Brown, who was executed for endeavoring to foment an uprising of slaves.[7]

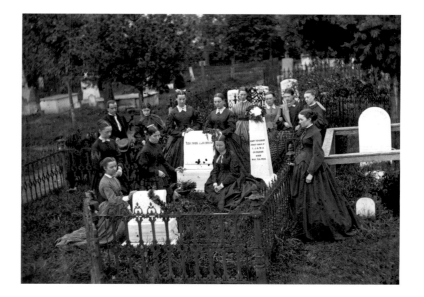

Born in 1951, Sally Mann could not have escaped the intensifying interest in the Civil War generated by the approach of its centennial in 1961. Growing up not quite four years older than Mann, on a farm on the Shenandoah River a little more than a hundred miles up the Valley from Lexington, I recall how friends and neighbors mobilized to join or attend a series of reenactments—of Brown's raid, of Antietam, of repeated battles over Winchester, of Cedar Creek. What must have seemed to Virginians of the 1860s an unrelenting progression of encounters in a seemingly endless war repeated itself in shadowed form and in real time as I passed into adolescence. The past truly became the present as Virginia refought the Civil War. I cannot help but think that for Mann, at the opposite end of the Valley, it must have been in essential ways the same.

Mann has made frequent reference to another aspect of our common Virginia girlhood that stood in ironic juxtaposition with the celebratory, neo-Confederate tone of most centennial observances. She was raised, Mann has written, "in the South of massive resistance." She was only three years old when the United States Supreme Court handed down its decision in *Brown v. Board of Education* mandating that school segregation

3 / Women Mourning at Stonewall Jackson's Grave c. 1866, Virginia Historical Society, Richmond

be ended "with all deliberate speed." The response from Virginia's Senator Harry F. Byrd, Sr., was to call for "massive resistance" to what he viewed as an unwarranted and unconstitutional encroachment on states' rights and racial custom. Virginia would close its schools, he warned, before it would integrate them. In Prince Edward County, it did just that, eliminating all public schooling for five years. In other parts of the state, school boards delayed and stalled, encouraged by their senator's determination.[8]

Byrd's signature appeal for "massive resistance" became a clarion call for southern opposition to integration and the nation's emerging civil rights agenda. Byrd was himself also a resident of the Valley—from my home county, Clarke. His defiance brought what had for white Virginians been a somewhat hushed discourse of race into open view. Segregation shifted from practices of oppression embedded in accepted and unquestioned folkways into overt confrontation and delineation of hierarchy and racial division. Until I overheard adults for the first time openly expressing racial anxieties and prejudices in the aftermath of *Brown*, it had not occurred to me that my elementary school was all white by design and not by happenstance. Segregation was stripped of its posture of deferential courtesies and exposed as the cruelty it always had been. To grow up in the white South of the 1950s and 1960s amidst the Civil War Centennial and the Civil Rights Revolution was to know with certainty that the past was far from dead. History, with its legacies of violence and injustice, was confronting young southerners with choices that would determine the future of their society and the course of their own lives.[9]

Mann has written with anguish about the taken-for-grantedness of the practices of race and oppression that were woven into her childhood. In particular, she has recounted the complexities of her relationship with the African American woman Virginia Carter, known as Gee-Gee, who was her beloved caretaker. Gee-Gee was simply part of the family, Mann and her parents assumed and reassured each other. Yet in hindsight, Mann has realized, Gee-Gee was a person they never truly saw.

"What were any of us thinking?" she asked. "That's the mystery of it—our blindness and our silence....It's that obliviousness, the unexamined assumption, that so pains me now: nothing about it seemed strange, nothing seemed wrong." This failure of feeling was in a fundamental way for Mann a failure of *sight*, a blindness that became a part of the burden Mann carried, a burden not just of a historic southern past of slavery, war, and segregation, but of her entanglement with the tentacles that history had extended into her own time.[10]

It was the same cold northern light that encouraged Quentin's illumination that led Mann to what she has called her "Awakening." Sent by her parents to the Putney School in Vermont, Mann found herself challenged to look critically at her origins and her region; she confronted "the truth of all that I had not seen, had not known, and had not asked." Perhaps the teacher who assigned Faulkner played Shreve's role as interrogator for Mann. Clearly, the writer played a powerful part in her transforming consciousness. Senior year at Putney School, she has written, was "the year of Faulkner." He "threw wide the door of my ignorant childhood" and introduced a "heartbroken future." Like Quentin, Mann came to feel compelled to understand, to explain, to awake and open her eyes, to see beyond her initial blindness about her region, about the curse of slavery and the tragedies of war that had shaped it. The camera and the art of photography that she seriously embraced for the first time at Putney would become her instruments of sight and insight as she strode through the door Faulkner had thrown wide.[11]

In the course of her career, Mann has sought to see the South through a variety of lenses, exploring a range of its characteristic attributes and defining preoccupations—family, race, death, memory, and landscape. The enduring sense of place that has been an essential component of southern consciousness has infused her life and her work. Places and landscapes have served as the vehicles for representing the humans past and present who have been indelibly shaped by their interactions with and impact upon the land. Humans must be actively remembered,

but place persists as both living history and memento mori, a visual emblem of things absent and unseen.

A Thousand Crossings divides Mann's landscape photographs into two sections: "The Land" and "Last Measure." For the most part, they are chronologically distinct, the former taken in the 1990s, the latter from 2000 on. A trip in the late nineties to the Deep South brought her to the heart of slavery's past, to Mississippi, where she sought a way to capture "the rivers of blood, of tears, and of sweat that Africans poured into the dark soil of their thankless new home." This was the land of Faulkner, and her photographs resonate with fetid air, with mists and moss and shadows and decay, containing her rendering of what Faulkner called, "all the suspiration of slow heat-laden time." As she passed into Mississippi, Mann found herself somehow transported out of the present, breaking through into "that dimension of revelation and ecstasy that eludes historical time."[12]

But this was not just the South of Faulkner's narratives or slavery's tragedies. It was the South of slavery's more recent legacies as well. This was the South that murdered Emmett Till. A fourteen-year-old African American from Chicago, Till was visiting relatives in the Delta in the summer of 1955 when he was abducted by two white men, beaten, shot, tied to a cotton-gin fan, and thrown in the Tallahatchie River. His mutilated body, defiantly displayed in an open casket by his grieving mother, became a catalyst and a symbol for the civil rights movement. Mann has described being haunted by Till's death from an early age. To photograph the place where he had been pulled from the Tallahatchie represented a kind of visual pilgrimage.[13]

This photograph (pl. 32) is not, like so many others of her *Deep South* series, an evocation of the rotting structures and "moldering decadence" of a society whose claims of grandeur were erected on oppression and cruelty. This photograph is a site of actual, identifiable death, of active evil that occurred during Mann's own lifetime. There are no Old South myths of moonlight, magnolias, and crumbling pillars or suggestions of fading gentility. The river is not wide, but narrow and muddy, nearly stagnant, little more than a creek. Its rutted bank is almost bare of any growth, much less the lush vegetation of so many of Mann's depictions of the Deep South. Only the shadow of a copse of trees reflected in the water from the opposite bank suggests the season and the possibility of a broader landscape. There is a fitting sense of entrapment in this view. The momentousness of what happened here contrasts sharply with the smallness and meanness of the place. But of course this is a place momentous for its very meanness — the pointless, virulent, and violent hatred that did not just kill, but tortured a child. There is no hint of the beautiful or the pastoral or the uplifting, nor of the intoxicating decay of some of Mann's other Deep South views. The meaning of this place comes not from its inherent nature, but from actions of two murderous white southern men. Their heinous crime in August 1955 seized the place out of time and out of its insignificance and anonymity. More than four decades later, Mann captured the place once again in an act of photographic redemption that sought to give it a different meaning, to challenge what she has sometimes referred to as the "indifference" of the southern landscape. The camera sees Emmett Till even in his absence; it notices and notes his death in an act of simultaneous memory and moral judgment. Like Till's mother, who insisted on an open coffin, Mann has required us to see. This is the death-haunted, pain-haunted South that had left the awakening Mann heartbroken.[14]

The South's history, Mann has noted, placed it on a "firstname basis" with death. Mann's father manifested a lifelong death obsession, focused chiefly on the exploration of the iconography of death in art, and Mann herself possesses what her children have called "her death thing." Her decision, just at the beginning of the new century, to turn her photographic eye on Civil War battlefields seems almost inevitable. But it was prompted by an incident that brought sudden and violent death into the bucolic atmosphere of her Lexington farm, vividly underscoring the intimate connection between the beauty and the danger of the southern landscape. An escaped and armed prisoner was

surrounded by law enforcement officers as he approached her house, and he decided to shoot himself rather than be apprehended. Home alone, Mann witnessed the drama unfold. Later, watching his blood seep into the soil, she found herself fascinated by her sense that the familiar ground of her own home had been transformed. A new set of questions arose in her mind and thus in her art. "What does death do to the landscape? What does death do to the earth?" Mann knew well that mass death had happened in her corner of the world less than a century and a half before. "Does the earth remember? Do these fields upon which unspeakable carnage occurred, where unknowable bodies are buried, bear witness in some way?"[15]

Unknowable and unspeakable. Both capture essential elements of Civil War death. We can only estimate the number of lives lost in the war. The most recent conjecture, employing sophisticated contemporary techniques of demographic analysis, posits that the total may be as high as 750,000. A similar rate of death in the United States today would yield nearly 7 million fatalities. Outnumbered Confederates died in disproportionate numbers—at a rate three times that of their Yankee counterparts. One in five white southern men of military age did not survive the war. "Death reigned with universal sway," one Confederate soldier observed. And in no theater of the war was its reign more pronounced than in Mann's Virginia. She has herself done the calculation: of the 384 battles of the war, 123 were fought in Virginia. "This is more than three times as many," she noted, "as the next most blood-soaked state, Tennessee." Long before the dead prisoner's blood sank into her soil, the Virginia land she knows so well had absorbed its measure of violent death.[16]

Mass armies—approximately 2.1 million northerners and 880,000 Confederates took up arms between 1861 and 1865—and dramatically enhanced firepower created war on a scale neither side had anticipated. Both sides were entirely unprepared to confront or manage the harvest of death they reaped. At the end of battles, soldiers were often stunned by the "ghastly picture" of carnage and devastation before them. In an oft-repeated image

of war's horror, men spoke of bodies massed so closely together, it was as if "they paved the earth." After Fredericksburg in 1862, one soldier described with grim precision a two-acre area in which he counted 1,350 dead Yankees. After Shiloh, Grant reported a field "so covered with dead that it would have been possible to walk across the clearing, in any direction, stepping only on dead bodies without a foot touching the ground." At Antietam it was not just possible but necessary: men estimated stretches of "a mile or more where every step had to be planted on a dead body."

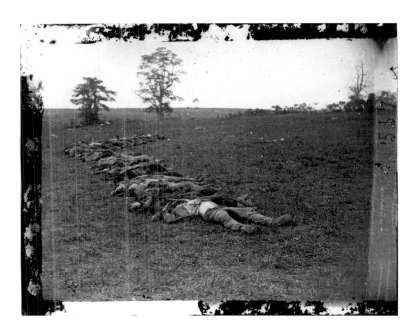

The image of corpses so numerous as to become a kind of carpet and the expression of awe and revulsion at the notion of trampling dead bodies recur repeatedly in soldiers' diaries and letters. They served as means of visually capturing a horror for which men struggled and failed to find words. As Confederate Reuben Allen Pierson wrote his father after a Virginia battle in 1862, "Language would in no way express the true picture as it really was." War was unspeakable (fig. 4).[17]

Mann is haunted by an image very like the one so often repeated by soldiers who traversed Virginia more than a century

4 / Alexander Gardner **Antietam, Bodies of Confederate Dead Gathered for Burial** 1862. Library of Congress, Washington, Prints and Photographs Division

ago: "As I walk the fields of this farm, beneath my feet shift the bones of incalculable bodies." But to walk on a Civil War battle-field is for Mann about more than physical remains that have scattered and disintegrated over more than a hundred years. It is about the lives and loves and hopes and surviving spirits of the men who died there. Mann is not content with leaving these truths and legacies "unspeakable." What words cannot convey, she endeavors to find through the lens of a camera, going beyond language to impart Pierson's "true picture" of what "really was" and is. Hers is a visual articulation of the otherwise lost and incommunicable.[18]

And the unknowable. The anonymous and now invisible dead. Civil War armies had no formal procedures for burying the dead or reporting losses to families, no designated burial units, and no standard identification badges or other equivalent to today's dog tags. Burying the dead in the chaotic aftermath of the Civil War's epic battles was essentially an act of improvisation. In such circumstances, many of the slain were never identified, but thrown with dozens of other bodies into mass burial pits by enemy forces holding the field, or interred in unmarked and unrecorded graves. Americans North and South regarded these practices with intensifying dismay. By the end of the war, public sentiment had come to demand that soldiers—in the Civil War overwhelmingly volunteers—be treated with the respect their sacrifices had earned.

In the North, the recognition that the war had been fought for principles of human equality and national citizenship made the obligations of the nation to its dead all the more compel-ling. The dead as well as the living had claims upon a government understood to be of, by, and for the people. In 1866, the federal government undertook a massive reburial program, reinterring more than 300,000 Union soldiers whose bodies had been scattered across the South in seventy-four new national cemeter-ies. Meticulous attention and effort—including public circulars and newspaper advertisements seeking information, research in military hospital records, muster rolls, casualty reports, records

of voluntary association—were dedicated to identifying as many of these bodies as possible, but 46 percent nevertheless remained unknown (fig. 5).

Notably, this official government effort included only Union soldiers. In the South, volunteer organizations of white women succeeded in relocating tens of thousands of slain Con-federates into cemeteries like Hollywood in Richmond and Magnolia in Charleston. But nationwide, nearly half the war's dead remained unidentified, leaving hundreds of thousands of families without certain knowledge of their loved ones' fate and the nation with a burden of unresolved grief. Americans of the late decades of the nineteenth century were individually and collectively in mourning. Their dead and their losses were unknown and unknowable. But Sally Mann shares a determina-tion with Walt Whitman, whose war-born poetry she invokes, to "lose not my sons, lose not an atom."[19]

Although Mann has photographed a number of sites critical to the Virginia theater of the war—Manassas, Fredericksburg, the Wilderness, Appomattox, and, of course, Cold Harbor—it is Antietam that has captured her most intense attention. For a number of reasons, it is appropriately her place. The Antietam battlefield sits at the very top of the Shenandoah Valley, just above the confluence of the Potomac and Shenandoah Rivers in Harpers Ferry. The rolling hills of the countryside, the bluish haze emanating from the gentle mountains on the horizon are not unlike Lexington, 165 miles down the Valley to the south. But this seemingly quiet and peaceful place hosted what was perhaps the most significant battle of the Civil War. It is what we might call the irony of the southern landscape. Antietam was critical to the war's outcome, blunting Lee's determination in 1862 to bring the war onto northern soil and force the Union to concede. The battle was critical to the fate of slavery, for it pro-vided Lincoln with the long-sought victory that enabled him to issue the preliminary Emancipation Proclamation in its imme-diate aftermath. And it was critical to the American experience of death, for September 17, 1862, was and remains the bloodiest

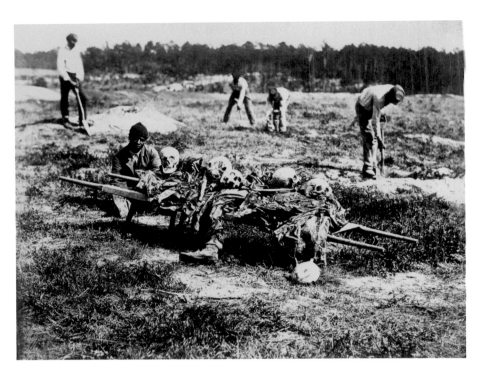

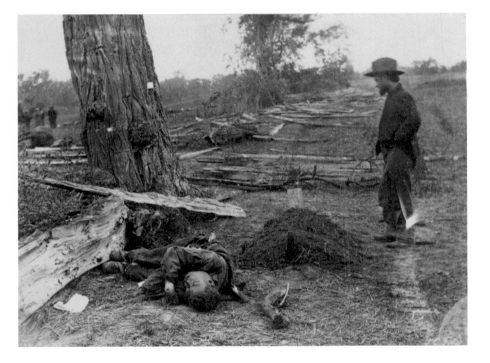

single day in our national history. Antietam yielded more than twice the number of deaths as 9/11, and four times as many casualties as the landings in Normandy. The distinguished Civil War historian James McPherson has estimated that as many as 6,500 soldiers were killed or mortally wounded on that single day.[20]

The effort by Mathew Brady and Alexander Gardner, the photographer in charge of his office in Washington, DC, to record the dimensions and meaning of the slaughter made Antietam a critical moment in the history of photography as well. Mann approached Antietam in the footsteps of her photographic predecessors, situating her work in not just the traditions, but the actual technologies of their undertaking. She employed an 8 × 10 inch view camera with bellows and hood and the same wet-plate collodion process that was used by Civil War–era photographers. She shot her twenty-first-century scenes using her collection of antique uncoated lenses, which together with emulsions that must necessarily be prepared in the field, produce the soft focus, light leaks, scars, fogging, and flares that characterize her work. Mann welcomes the accidents the antique process can yield, rather than seeking, as her predecessors had, to minimize them. She sees her subject through a nineteenth-century lens, the closest she can get to nineteenth-century eyes. Mann has described the elaborate process surrounding such photography as "ceremonial"—an act of ritual homage to the past she seeks to capture. And perhaps it also represents for Mann a belated ritual of respect for the thousands of men who were honored with no ceremony at the time of their deaths a century and a half ago. Here photographic technique literally embodies and enacts the notion of the past in the present that rests at the heart of her consciousness.[21]

Although they used a similar technique, her nineteenth-century forbears sought a very different photographic outcome. Brady and his colleagues employed the new medium of photography in an effort to offer an unprecedented and previously unimaginable glimpse into the realities of war. They would use the camera to document war in a manner that had never before been possible. Live-action battle scenes were still well beyond the

technical capacity of mid-nineteenth-century photography, and Gardner did not in any case arrive on the field until the day after the battle took place. As a result, the realism he captured—in part through the artifice of rearranging bodies—was not that of battle, but of death. A significant proportion of the seventy exposures Gardner made within five days of the battle depict the remains of the slaughter and the efforts to dispose of the dead. In October of 1862, Brady presented an exhibition at his studio in Manhattan that confronted New Yorkers with a shocking rendition of war. These photographs offered a "terrible distinctness," wrote the *New York Times*. If Brady "has not brought bodies and laid them in our dooryards and along the streets, he has done something very like it."[22]

Mann's Antietam photographs picture no bodies. They are indistinct, scarred, cloudy. They are intended as works of art, not documentation. As one review of her 2004 show *What Remains*, where the Antietam work was exhibited, explained, Mann "reports on nothing, she creates everything." These photographs are reminders of what we cannot see. A shadowed stand of corn-stalks at the left-hand side of one photograph (pl. 36) invokes the savage, now legendary, fighting that took place early on the day of battle in what has come to be known as The Cornfield. But the center of the frame is a shimmering cloud—of heat, of conflagration. In another photograph (pl. 39) a dark line of trees seems studded with fairy lights—actually small imperfections in the emulsion that suggest a multitude of individual explosions

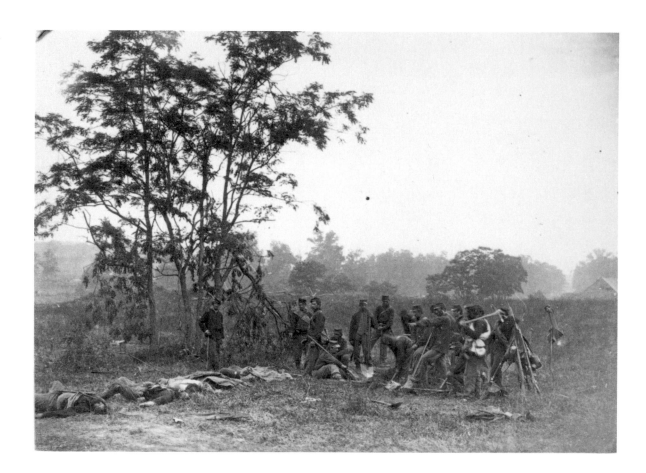

7 / Alexander Gardner **Burying the Dead on the Battle-Field of Antietam** 1862, Library of Congress, Washington, Prints and Photographs Division

erupting across the scene. In another (pl. 43), brightened hillocks of earth emerge as bulges out of the background gloom — likely the remains of defense works or burial mounds, but clearly a lingering claim the war has imposed on the land. Antietam is, in Mann's words, "exulted by — sculpted by death."[23]

There can be few places more death-haunted than Antietam. At the end of the day on September 17, one observer described "hundreds of dead bodies lying in rows and piles," but many others present simply found "words are inadequate to portray the scene." The ferocity of battle had left Yankee and Confederate armies staggering. Lee limped south, leaving the field — and the dead of both sides — to the Union army (fig. 6). Its general, George McClellan, seemed paralyzed and failed to pursue Lee to take advantage of the victory, and this paralysis extended throughout the army as commanders and soldiers struggled to come to terms with the need to attend to the dead and wounded. In many cases, days went by before officers established burial details to dispose of the dead. A Union surgeon reported with dismay that a full week after the battle, "the dead were almost wholly unburied, and the stench arising from it was such as to breed a pestilence."[24]

A New Yorker, Ephraim Brown, who had fought in the battle found himself ordered two days later to begin to bury Confederates right along the line where he had struggled so fiercely. He counted 264 bodies along a stretch of about fifty-five yards — each destined for a trench he was now required to dig. Origen Bingham of the 137th Pennsylvania did not take part in the fight, and when he arrived on the field four days after the battle, he discovered that most Union soldiers had been interred by their comrades. But he and his men were detailed to bury the hundreds of Confederates who still remained. Bingham secured permission from the provost marshal to purchase liquor for his men because he believed they would be able to carry out such orders only if they were drunk. Another Union burial party sought to make their task manageable by throwing 58 Confederates down the well of a farmer who had fled before the arriving armies (fig. 7).[25]

Desperate families traveled by the hundreds to battlefields to search in person for kin. Frantic relatives crowded railroad stations in pursuit of information about husbands, brothers, fathers, and sons. Fearing his son dead after learning he had been wounded at Antietam — "shot through the neck thought not mortal" — Oliver Wendell Holmes, Sr., rushed from Boston to Maryland filled with both terror and hope (fig. 8). When after days of searching he at last located his son, it was as if the young captain had been raised from the dead: "our son and brother was dead and is alive again, and was lost and is found." But in the

8 / **Note by Oliver Wendell Holmes, Jr.** 1862, Harvard Law School Library, Collection of Oliver Wendell Holmes, Jr., Papers 1715–1933, Historical & Special Collections

meantime, Holmes had encountered parents far less fortunate than he, and had been horrified by his view of battle's "carnival of death." The maimed and wounded made "a pitiable sight," he wrote, "truly pitiable, yet so vast, so far beyond the possibility of relief" (fig. 9).[26]

The makeshift nature of arrangements for dealing with the dead and wounded, the exhaustion of men called on for burial duty in the immediate aftermath of battle, the frequent lack of adequate tools—even such basics as shovels or picks— often meant that graves were shallow and bodies were overlooked. When Lee marched north again in the summer of 1863, his soldiers were horrified to find hundreds of corpses still lying on top of the ground, prey for buzzards and rooting hogs. Death remained visible on Civil War battlefields long after the silencing of the guns. Sally Mann sees it still.

As they undertook the terrible work of burying both their comrades and enemies, soldiers found it deeply disturbing to be compelled to treat humans like themselves with such disrespect. To throw men into the ground like animals—with no coffin, likely not even a blanket to cover them; with no funeral rites; and

more often than not, without even a name—dehumanized the living as well as the dead. The horror of the slaughter at Antietam and the toll it imposed on survivors as well as the slain significantly contributed to changing national attitudes and policies about governmental responsibility toward the dead. By 1864, a group of eighteen northern states whose citizens had died at Antietam had joined together to purchase land for an official cemetery. In the years just following the war, 4,776 soldiers from the battle and surrounding skirmishes were interred in what became the Antietam National Cemetery, where only 38 percent of the bodies were identified. The bodies of some 2,800 Confederates were gathered in three nearby burial grounds (fig. 10).

The Civil War changed many aspects of American life— eliminating slavery, establishing a powerful new nation state, creating hundreds of thousands of grieving widows and orphans. But at the heart of its transformations were new understandings of death and dramatically altered assumptions about the obligations of the nation to citizens who had died in its defense. The attitudes of the Civil War era seem today unimaginable. The United States is now committed to identifying every soldier lost in battle, returning them to their families, and honoring their sacrifice. The Department of Defense spends more than $100 million every year in the continuing effort to locate and identify approximately 88,000 individuals still missing from World War II, Korea, and Vietnam. These commitments and policies grew out of the mass casualties of the Civil War. Those deaths have exerted their powerful impact on the present, just as the bodies of the slain have made a lasting imprint on the soil where they fell, infusing those fields with the spirits and sacred meaning Mann's photographs seek to capture.[27]

The cruelties of Civil War death assaulted fundamental assumptions about what it means to be human as well as essential beliefs about how to die. Americans of the mid-nineteenth century had a clear understanding of what constituted a Good Death, and these expectations were directly challenged by the circumstances of war. Perhaps most distressing was that thousands

9 / After F. H. Schell **Civilians Visiting the Battlefield of Antietam** 1862, *Frank Leslie's Illustrated Newspaper*, October 18, 1862, courtesy of the Library of Congress, Washington, Prints and Photographs Division

of young men were dying away from home, distant from family and friends who could record their last words and scrutinize their last moments for evidence of their eternal destiny—of whether they were prepared to die, were at peace with their fate, confident in their faith, and prepared for the world beyond. Such a departure from life could reassure family that they could anticipate being reunited with their lost loved one in eternity. Readiness for death was critical both to the moment of passing and to life everlasting. All should keep death ever in their consciousness and be prepared for its appearance.

Much has been written about the very different posture toward death of today's Americans. Rather than living with an acute awareness of death's proximity, American society has repressed and denied it, in personal and family life, in religion, and in funereal and medical practices. But Mann has a decidedly different sensibility—one more like her forbears in the nineteenth century than inhabitants of her own time. Like Americans a century or more ago, Mann believes that only by looking death in the face can we fully comprehend and relish its opposite. A good life is one undertaken in full view of its end. Loss, she has said "is designed to be the catalyst for more intense appreciation of the here and now."[28]

Photography is a remarkable instrument for such appreciation. It has a special relationship with death. It captures, steals, stills time; it renders the impermanent permanent; it transforms a moment into meaning. It has the capacity to exert a kind of control by defining and framing what is otherwise incoherent and formless. It compels us to look, to see both absence and presence, and to strive to understand how each constitutes the other. Yet in appreciating the here and now, Mann also requires us to acknowledge its inseparability from what has come before and what will persist after us, its inseparability from history and from the inevitability of our own deaths.

These themes are in one sense abstract, universal, almost philosophical, but Mann situates them within the context of a particular place and a particular moral narrative—that of the South of slavery and war and their revelation of the capacity for cruelty and inhumanity, the "sediment of misery" this history has imposed on the land. Mann's is a South that must remember its past clearly in order to struggle beyond it. She knows that work is not complete. As I write, in August 2017, Charlottesville, just seventy miles east of Lexington, has erupted in devastating racial violence sparked by white supremacists protesting the planned removal of a statue of Robert E. Lee. "The past is never dead. It's not even past," Faulkner wrote in a line quoted so often because we see again and again that it is so very true. We as a people and a nation, as southerners, as Virginians, are still struggling with the meaning of the Civil War's legacy, still striving to realize that "new birth of freedom" Lincoln insisted must be the justification for the war's slaughter, still seeking to overcome the legacies of racial injustice that have so deeply defined us. Sally Mann's photographs are a part of that struggle, exhorting us not to look away but to confront that past, to embrace our mortality, and to live deliberately and humanely in the face of the truths we have tried so long to deny.[29]

10 / After D. Bachrach **The Dedication of Antietam National Cemetery** 1867, from *Frank Leslie's Illustrated Famous Leaders and Battle Scenes of the Civil War* (New York, 1896), National Gallery of Art Library, Washington, David K. E. Bruce Fund

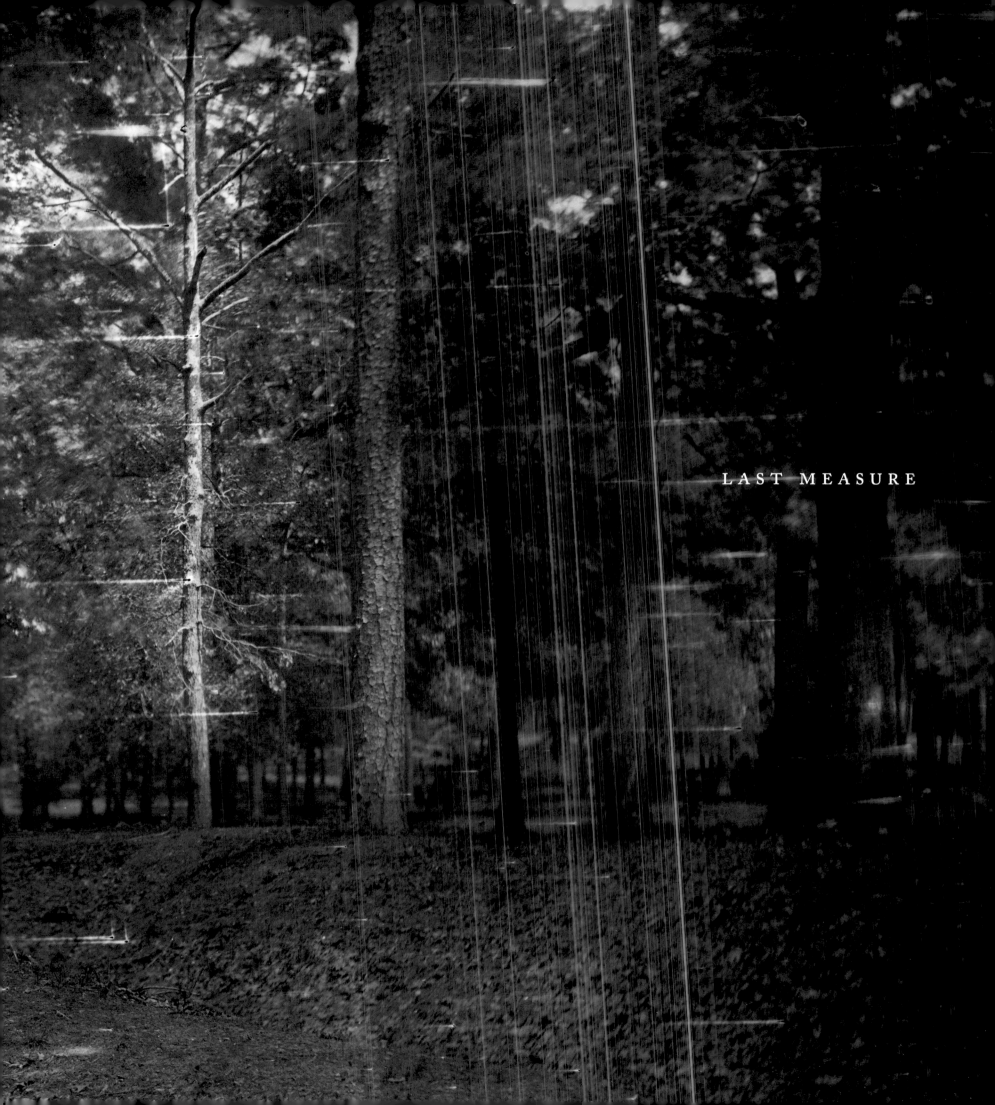

It is rather for us to be here dedicated to the great task remaining before us—that from these honored dead we take increased devotion to that cause for which they gave the last full measure of devotion—that we here highly resolve that these dead shall not have died in vain.

ABRAHAM LINCOLN, 1863

Surely the people is grass.

ISAIAH 40:7

plate 33 / **Battlefields, Manassas (Veins)** 2000

plate 34 / **Battlefields, Manassas (Airplane)** 2000

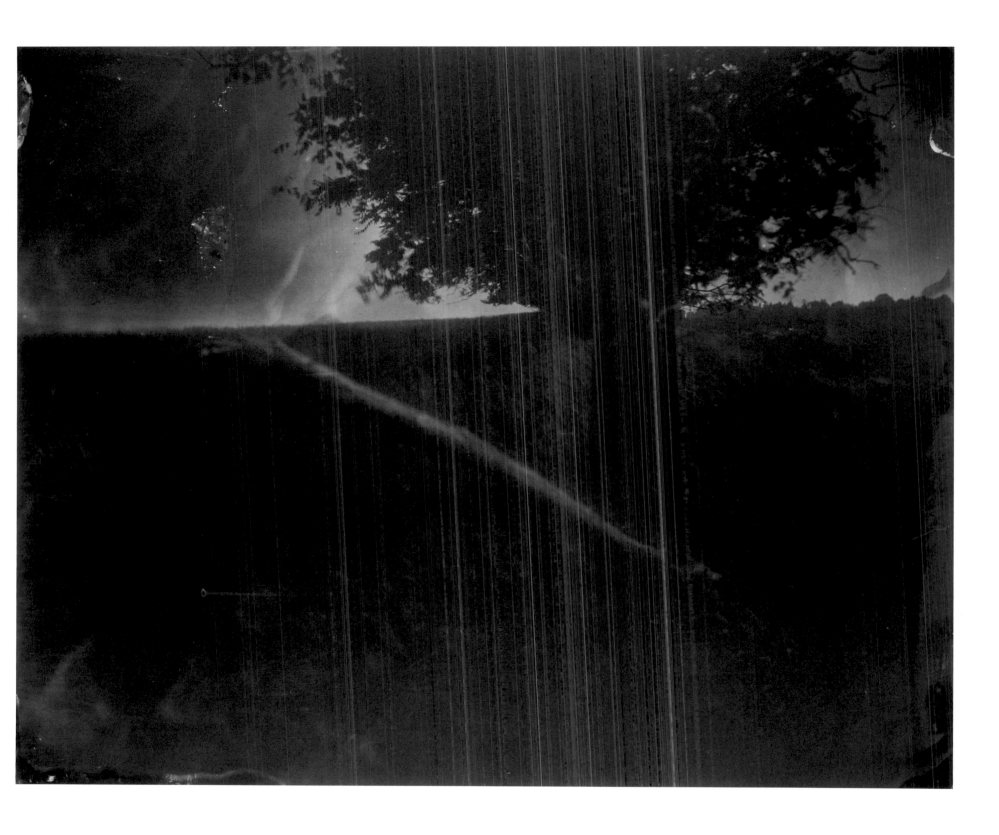

plate 35 / **Battlefields, Antietam (Smoke)** 2000

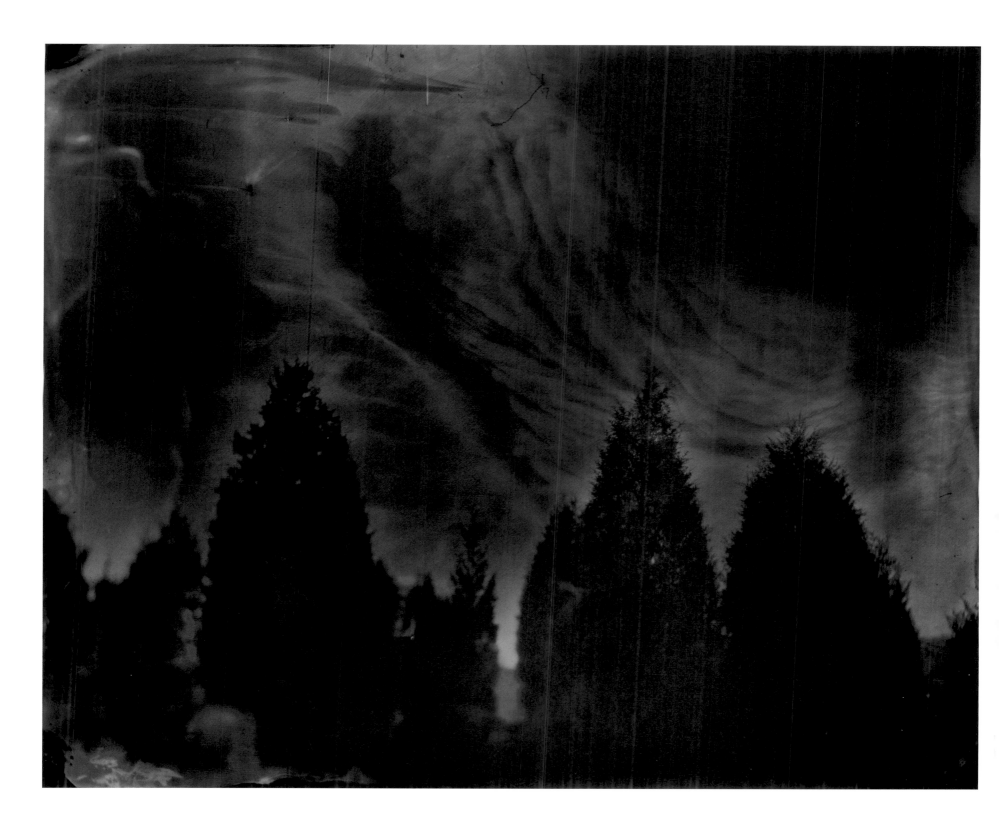

plate 37 / **Battlefields, Fredericksburg (Cedar Trees)** 2001

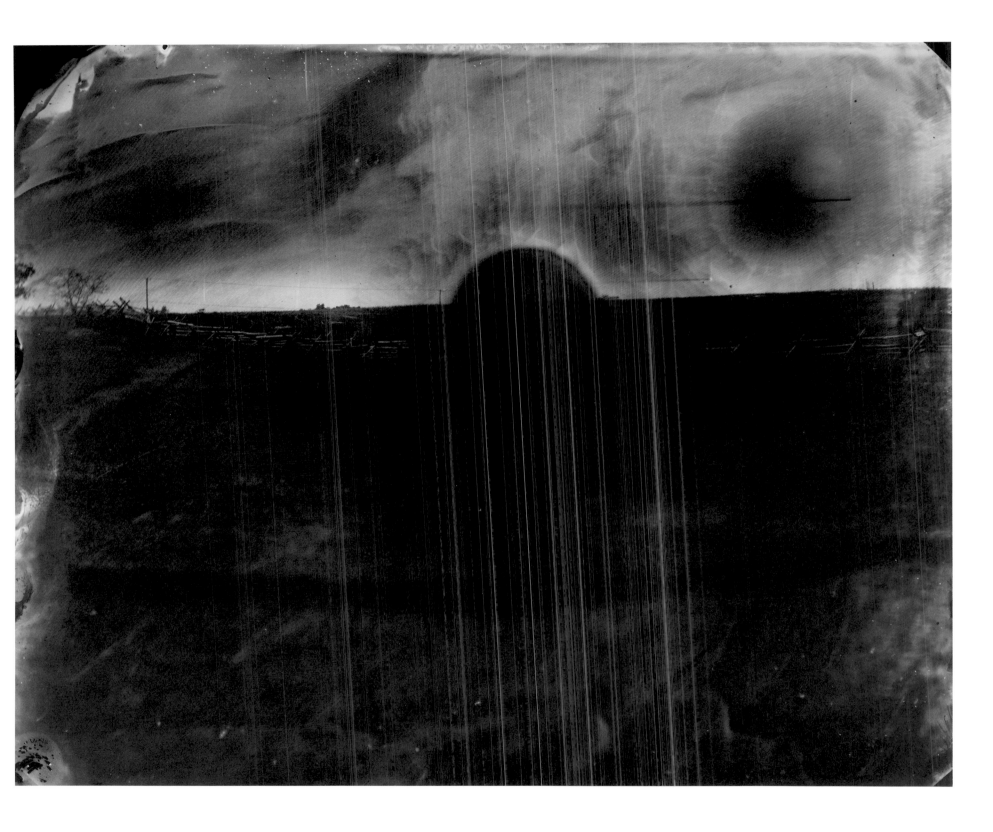

plate 38 / **Battlefields, Antietam (Black Sun)** 2001

After darkness has put an end to the struggle, a hush settles over the field. Such a contrast to the roar of the fight. Never is silence more oppressive, more eloquent. You hear the cries of the wounded, which is never distinguished in the roar of battle....You see the outlines of forms gliding through the gloom carrying on litters, pale, bloody men. Or perhaps your friend with his hair matted with blood over his white face and his dead eyes staring blindly up to the sky.

C.H., 1863

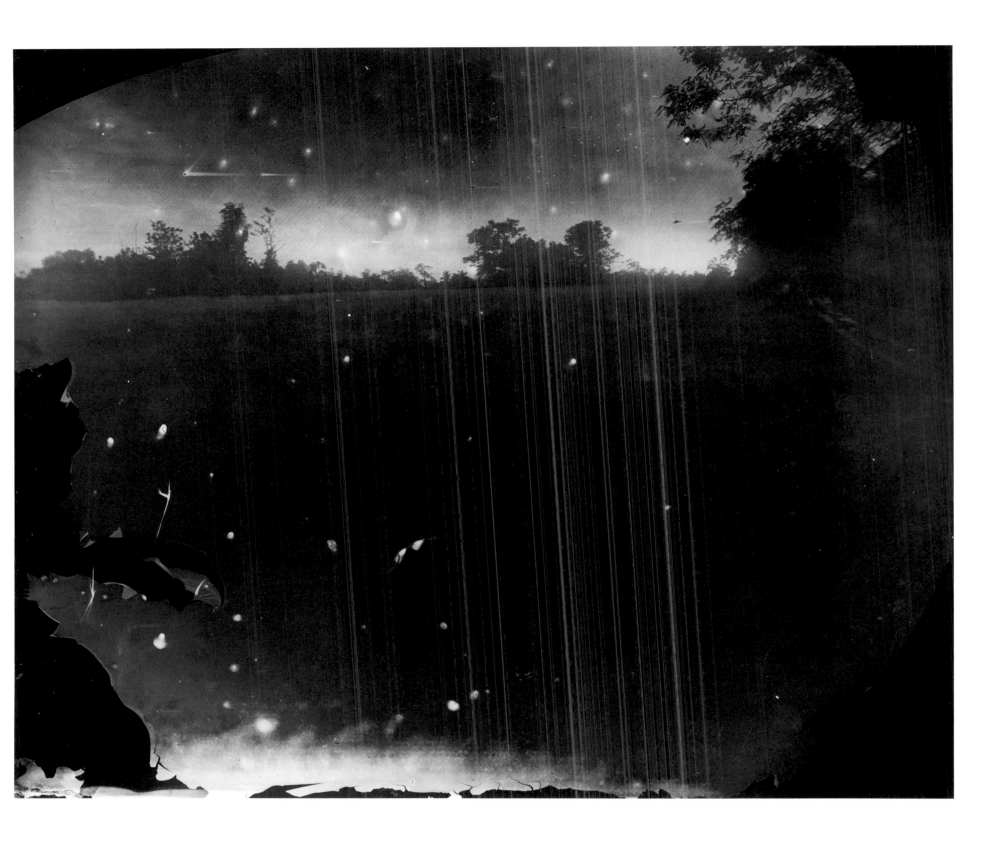

plate 39 / **Battlefields, Antietam (Starry Night)** 2001

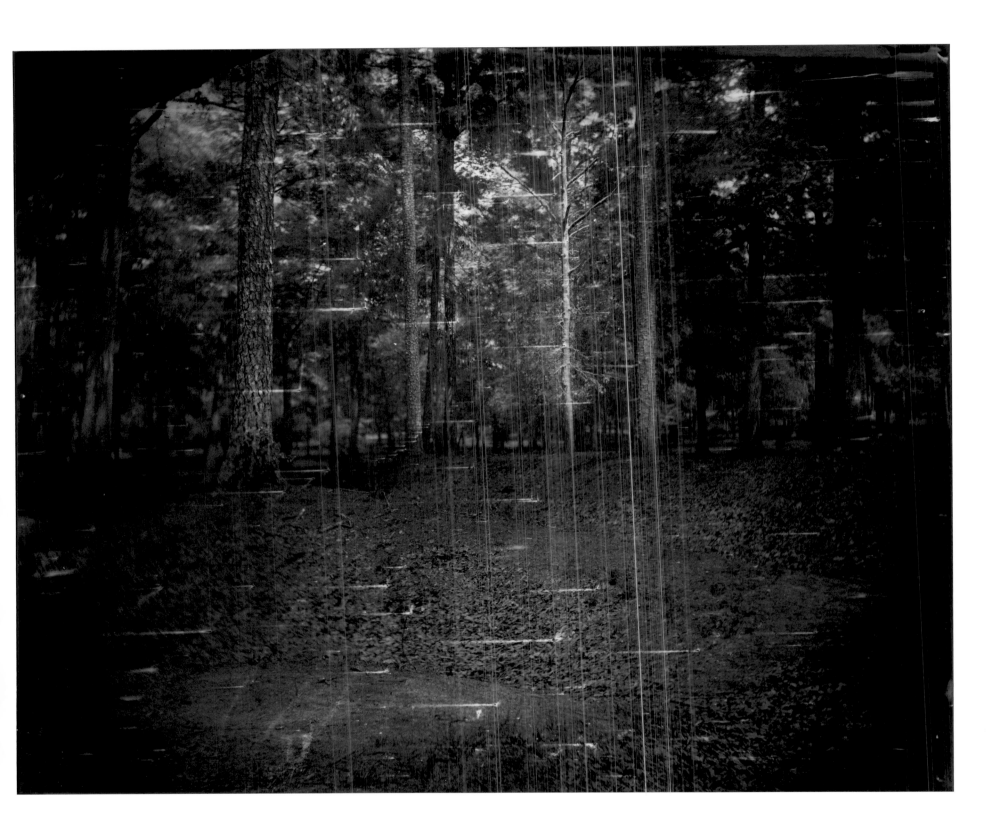

plate 40 / **Battlefields, Cold Harbor (Battle)** 2C03

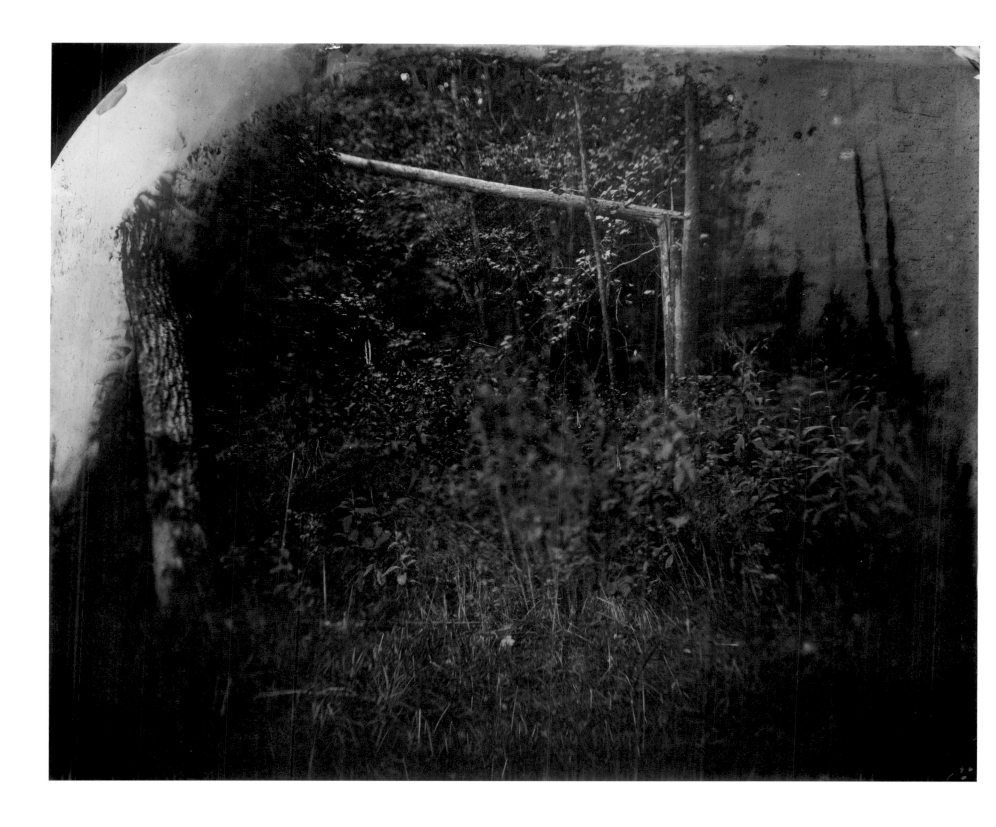

plate 41 / **Battlefields, Wilderness (Solarized Trees)** 2002

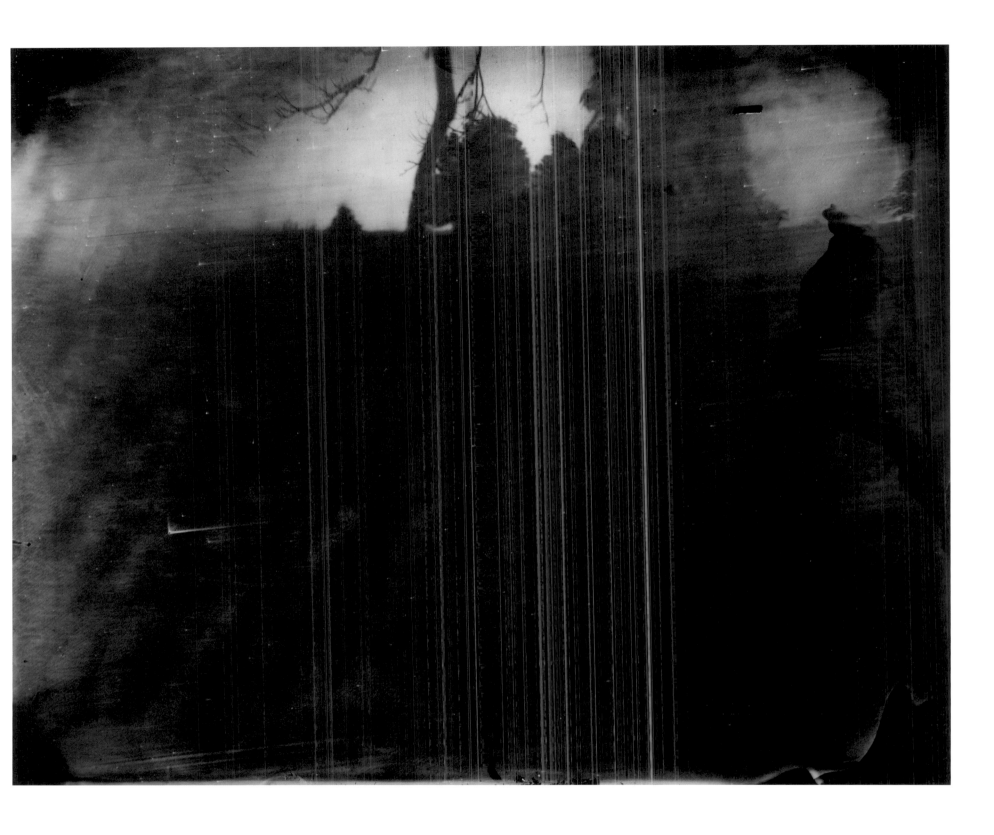

plate 42 / **Battlefields, An-ietam (Last _ight)** 2001

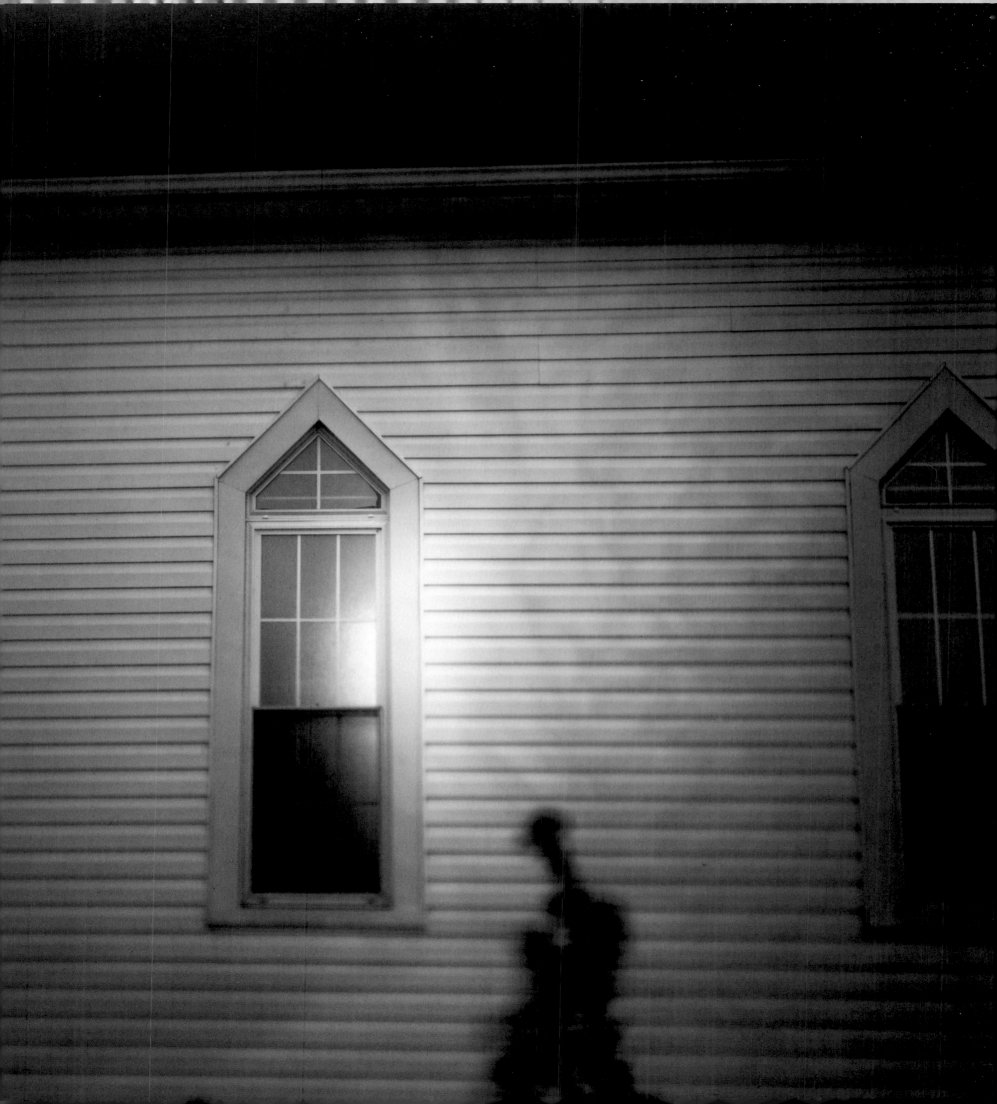

Abide with Me: The Color of Humanity in Sally Mann's World **HILTON ALS**

The place is physically dark, dark like the negative of a photograph,
dark like an X-ray: the atmosphere absorbs its own light, never reflects light but sucks it in
until random objects glow with a morbid luminescence.

JOAN DIDION, 2017

Our voices rise and subside as the organ wheezes, goes. We're standing in a church filled with white light, dust motes, and sin. Salvation sits in a corner by itself, an unattainable dream that both haunts men and makes men. The church is in Virginia or Alabama or some other place. Inside, the vertical saints, as James Baldwin referred to the Harlem-based congregation of his youth, stand or sit, directed by words.

We're in Virginia, where the photographer Sally Mann was born in 1951, and where she still lives, making work so rooted in place that it is inseparable from history, from lore, and from the effects of slavery. Like Janus, she looks forward as she looks back at all those bodies that made her and her place in Virginia, and into the landscape, filled with rutted earth, big or low clouds, storybook fantastic vegetation, and the southern light that reminds so many of photography itself. Dark, as Joan Didion wrote, and glowing "with a morbid luminescence." That entire vision is a part of Mann's photographs, as she asks in these images of family members, roads, rivers, churches, and the effects of

blackness on whiteness and whiteness on itself: *Abide with me.* And it all does—it does, including the voices we cannot hear in that church where the phantom organ goes—voices, sounds, the invisible things that Mann's haunted and haunting photographs allow us to see.[1]

Mann has written: "No doubt about it, history is a big deal down here; but, still, even among the competitive crowd of southern states, Virginia stands out in its obsession with the past....Physically, the reminders are everywhere." Including the children of the slaves that built Jefferson's rotunda at University of Virginia, not to mention the colonnade of Washington and Lee University. Bones in the stones. Virginia, where the first black bodies—*20-odd Negroes*—to arrive on these shores from Africa landed at Point Comfort on the James River, after dying and shitting and losing their respective minds on an English ship named the *White Lion*—a bitter irony. This was in 1619. At Point Comfort some of the Negroes' bodies were sold in exchange for food and some were transplanted to Jamestown, Virginia's

former capital. It didn't take long for that blood to trickle into the blood of the lamb. In 1639 English settlers established the Jamestown church, one of the oldest houses of worship in America, and in that church they read the Book of Common Prayer and gave voice to their sins during morning prayers and evening prayers—confessing what? The agony of looking at black bodies harvesting tobacco in mineral-rich Virginia soil for profit, and then building churches and families based on all that profit and the dream of more?[2]

When the organ plays and the hymnals are opened up, the congregation stands, sometimes singing:

> *Abide with me! Fast falls the eventide;*
> *The darkness deepens: Lord, with me abide!*
> *When other helpers fail, and comforts flee,*
> *Help of the helpless, O abide with me!*

Written by the Scottish Anglican poet Henry Francis Lyte in 1847 while he lay dying of tuberculosis, the lyrics of "Abide with Me" are most often sung to English composer William Henry Monk's "Eventide." The pairing was a favorite of both England's George V and Mahatma Gandhi, and is often sung at funerals. The yellow, brown, and black faces singing it now may not know the song's history, but they do know about death, and how death can open up a world of beginnings.[3]

Other words: from James Cone's seminal 1975 book *God of the Oppressed*, "There are many ordinary blacks who point to Jesus' suffering as a source of empowerment in their struggle to survive with dignity in a world they did not create." Growing up in the segregated Arkansas of the 1940s, Cone saw that theology of liberation at work:

> *For them, salvation meant that they were not defined by what whites said about them or did to them, but rather by what Jesus said about the poor in his teachings and did for them on the cross. They really believed that Jesus' death expressed God's solidarity with the little ones—making them human in every sense of the word.*

This faith not only gave blacks an identity that whites could not take away, it also empowered them to resist.

And from Baldwin, describing his early life as a poor boy preacher, and his eventual disillusionment with the Baptist church, in his classic 1963 piece "Down at the Cross: Letter from a Region of My Mind":

> *In spite of everything, there was in the life I fled a zest and a joy and a capacity for facing and surviving disaster that are very moving and very rare. Perhaps we were, all of us…bound together by the nature of our oppression, the specific and peculiar complex of risks we had to run: if so, within these limits we sometimes achieved with each other a freedom that was close to love. I remember, anyway, church suppers and outings, and, later, after I left the church, rent and waistline parties where rage and sorrow sat in the darkness and did not stir, and we ate and drank and talked and laughed and danced and forgot all about "the man." We had the liquor, the chicken, the music, and each other, and had no need to pretend to be what we were not.*[4]

No need to pretend what we were not. In 1998, Mann started to travel deeper into the South—to Louisiana, Mississippi, and so on, making a collective portrait of the troubling and troubled landscape (fig. 1). The gothic scene would have been powerful in its own right—*Abide with me*—but Mann's fascinating clinical distance adds another eerie layer to the pictures; she sees the world as it is and wonders, through the camera, how it became what it is. Mann does not rearrange the fact of the earth in her work, but she doesn't turn away from the death that lies in it, either.

The people in Baldwin's church, the southern churches that Mann photographed over a decade or so later, churches surrounded by outrageous nature, roots coming out of the earth in Virginia and Georgia and Louisiana while the earth sweats, tree limbs so big and wide they look like an overgrown monster, and the memory of those black bodies hanging from those fat limbs—Mann's churches have no need to pretend they are other

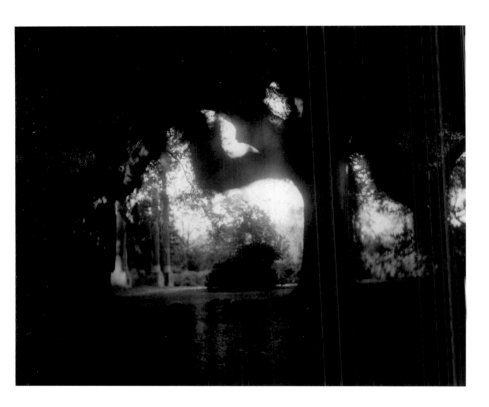

Now those men are standing with their wives and children, singing, asking Him to abide with me and you and our neighbor over there, too:

I need Thy presence every passing hour.
What but Thy grace can foil the Tempter's power?
Who like Thyself my guide and stay can be?
Through cloud and sunshine, O abide with me!

And He does. His light and those voices, both unseen from the distance of time and history, fill the churches.

As Mann journeyed into the "deep South," she was guided in part by the southerner's interest in lore, place, and the ties that bind and abide, along with her willingness to revisit or discover where she had not gone before, to see those places and faces and territories her eyes saw growing up but maybe hadn't sufficiently registered from the distance of her class and race. It was the world in which her whiteness flourished:

I had always seen, but not seen, black men on the fringes of white life, mowing, tending bar, or waiting for work in the shade of the big trees at the courthouse....Knowing black people only by their first names or nicknames back then was unremarkable. And conversely, the title "Miss" was always affixed to my first name when it crossed black lips, and, worse, "Master" often proceeded my brothers' names, irrespective of their ages.

Who were these men on the margins? Who were the black people who called her "Miss" and her brothers "Master"? To hear these words — the language of subservience, of the supplicant — is to be in an old familiar southern movie, a black strip of film illuminated by scenes of violence and subjugation: there can only be a master if there is a "nigger."[6]

Indeed, "nigger" hangs in the air of the Virginia Mann was born into; John Rolfe, slave trader, referred to the first Africans dumped in Virginia as "negers." No one knows precisely when and how the Latin term "niger" turned derisively into "nigger" and attained a pejorative meaning. But by the end of the

than what they are: images of shelter built on complicated ground. And while there are no figures in those churches, they are filled with ghosts. (Flannery O'Connor: "Ghosts can be very fierce and instructive.") Most of the colored people lining the pews didn't aspire to be white, which is the color of power; they aspired to *survive*, which is the color of humanity. Faith was the shield, was the way, and the church was the meeting place where working-class black men, among others, didn't have to live up to the degradation the white man thought should be their portion, all the better to emphasize his power. But O'Connor, the brilliant Georgia-born writer, wasn't foolish or self-deluded enough to believe that saying a black man was a buffoon made him one. In a 1963 interview, she said: "The uneducated southern Negro is not the clown he's made out to be. He's a man of very elaborate manners and great formality which he uses superbly for his own protection and to insure his own privacy."[5]

1 / Mann **Deep South, Untitled (Scrim)** 1998, courtesy of the artist

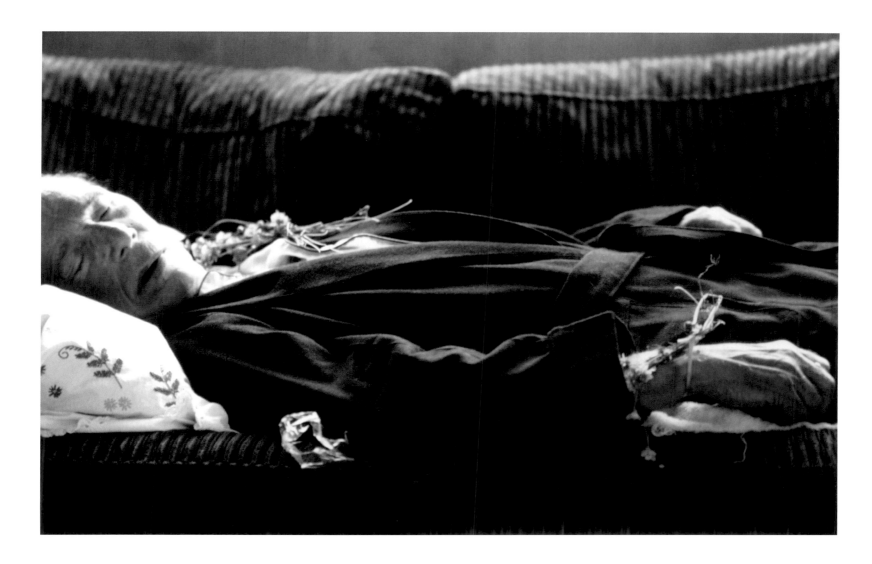

League of Women Voters chapter. But, best of all…she took on the infamous Virginia poll tax."[12]

The tax was imposed in 1865, after the Civil War ended. During Reconstruction many southern states charged for the privilege of voting; poor blacks could not afford their right. Nor could you vote if you could not write your name, and since most slaves were denied that basic skill, they had no say. Despite the establishment of the Fifteenth Amendment in the United States Constitution in 1870—that no individual can be denied the

right to vote based on race or color—southern state legislators found new ways to maintain political control over blacks. The poll tax stayed in effect into the civil rights era, and the Supreme Court did not declare the tax unequivocally unconstitutional until 1966.[13]

In addition to her politics, Elizabeth had a love of writers and writing. She not only worked hard to establish a local library, but also ran the university bookstore at Washington and Lee. Elizabeth and Robert were liberal in spirit and mind; they raised

3 / Mann **Daddy Dead on the Couch** 1988, courtesy of the artist

a family in a region that was not. Reared by a mother who cared deeply about appearances, Robert was an atheist in what O'Connor, a Catholic novelist, called the "Christ-haunted" South. For O'Connor, this outsider status did not alienate her from her home, but made her a wittier and more observant participant; in her 1954 story "A Temple of the Holy Ghost," one character scoffs at two Catholic girls singing psalms: "must be Jew singing." In a similar way, Mann was twice blessed by estrangement: by having "different" parents who loved art and words, and by not being stigmatized by that family for being a woman and an artist. Had they been "real" southerners, one wonders if Sally Mann would have become Sally Mann at all. Mann, a writer turned photographer who sees words in pictures and pictures in words, lives inside her inherited outsiderness, in part because of the questions it provokes in her: Who made this world? What does it look like? What life have I inherited here, and what is it in my bones that is in the bones of the landscape? She has written:

I have loved Rockbridge County, Virginia, surely since the moment my birth-bleary eyes caught sight of it. Not only is it abundant with the kind of obvious, everyday beauty that even a mewling babe can appreciate, but it also boasts the world-class drama of the Natural Bridge of Virginia, surveyed by George Washington....Like any true native, I didn't bother to investigate our local tourist draw until well into my thirties, and when I did I was chagrined, blown away by its airy audacity.[14]

As a young person, Mann was fascinated by a story that was endemic to Virginia and Virginia ways: minister Nat Turner, his revolt, capture, and death. As an adult, Mann photographed in and around the Blackwater and Nottoway Rivers, which served as one line on the Underground Railroad. This path to freedom, let alone a white woman recording it, brings to mind the controversy that surrounded William Styron's powerful novel *The Confessions of Nat Turner*.

Published in 1967 at the height of the civil rights era, the book was first praised, then condemned because Styron, a white Virginian, presumed to speak in Nat's voice. In addition, there was the matter of Styron's Nat lusting after a white woman. The controversy was so great that in 1968, the Beacon Press published *William Styron's Nat Turner: Ten Black Writers Respond*. From black novelist John O. Killens' essay:

After faithfully plodding through the Number One Best Seller The Confessions of Nat Turner, *after reading all the ballyhoo and pretentious interviews...I too have a confession to make. I had this uncomfortable feeling, even worse, that the reading public dearly loved it. Like a whore being brutally ravished and loving every masochistic minute of it Americans loved this fake illusion of reality because it legitimized all of their myths and prejudices about the American black man.*[15]

While black writers like John A. Williams offered more considered essays—and Baldwin supported the book publicly when it came out—Killens' point of view was the overwhelming one, and in his screed there is this question: Who gets to speak for blackness? I think the question should be both more pointed and more general: Who gets to speak for Americanness? To ask who gets to speak for blackness feels segregationist, as if black people, events, history, lore, voices, are somewhere "over there," separate from the larger issue of America as a whole. How can this be when blacks—like Native Americans, Latinos, women, Jews—are endemic to a country that has long tried to shut them out?

I think the artists who "get to" speak are those who do justice to the country's complexity, in work that is as complex, dense, strange, and incomprehensible as the country that made them—and made Emmett Till and, before him, Nat Turner. Contemporary white artists post-Faulkner, post-O'Connor, who want to go to the heart of it are not "imperialist" for the most part, but rather just as perplexed as the land that made them. In her work, Mann doesn't assume that she is speaking about

the black experience, but *a* black experience — one that is linked to the Virginia that made her, and made her family housekeeper Virginia "Gee-Gee" Carter, and made the black men she did not know (fig. 4).

The landscape as story, the story as landscape, and the drama of race. When Mann was fifteen, on holiday from school in Vermont, she took a drive from her family's home into Lexington. On the way, she picked up a hitchhiker, a young crippled black man known to her and Gee-Gee. When Mann returned home, Gee-Gee, who raised her, was preparing the family dinner. Mann told this woman who was her heart — Elizabeth Munger had conceded to Mann and Gee-Gee's strong connection years before — what had happened in the afternoon:

I went on, and Gee-Gee was listening, but then she was turning her body toward me with an ominous heaviness, as if a Henry Moore sculpture were being rotated 180 degrees. She had biscuit dough stuck to her hands, but above those hands was that wide face, shiny with sweat and…was it anger? Anger at me?

No, perhaps it was fear but there was also anger, and it was taking over her features in a way I had never seen before.…

She pressed me back against the wall with her floury forearms, and said in a voice I'd never heard, low and afraid, "Don't you ever pick up a colored boy again, no matter what, no matter who. You hear me?"

Despite having been so affected as a child by stories of Emmett Till's murder, it was many years before I realized that it was unclear just which of us Gee-Gee was most worried about.[16]

How did one's blackness survive in the South back then, and even now? One's femaleness? Boundaries. Not crossing a line into white maleness. By picking that colored boy up, Mann was doing what any "guy" would, including her father: helping someone out. Unfettered by southern hierarchy, she did not know how to behave in order to save her life — or another black person's. Gee-Gee's love, along with her father and mother's politics and humanitarianism, had made her free, but by pinning her against that wall Gee-Gee was telling her that there were limits. This was Virginia, a world defined by race. What if she ended up like the murdered figure in that Welty story? What if some white men, like the white men in William Faulkner's 1931 short story "Dry September," saw Mann with that black man and having nothing better to do but hate, decided to string them up?

Southern fiction — the best of it — has always been true to southern life. Reading Faulkner's "The Bear" by flashlight as a teenager, Mann was taken aback by one character crying, "Don't you see? Don't you see? This whole land, the whole South, is cursed, and all of us who derive from it, whom it ever suckled, white and black both, lie under the curse?" But what about the curse of being female? Gee-Gee knew something about that, just as she knew something about blackness, and couldn't Mann see how much she had invested in her, so that her femaleness would go unharmed in a world with a history that was thick with death? Couldn't Mann see that by being loved and taken in

4 / *Christmas, 1962, courtesy of Sally Mann*

by her housekeeper, Mann was, along with her own children, one of the best parts of Gee-Gee? And Gee-Gee knew what it was like to have the best part of anything killed: she was black and female and poor in Virginia.[17]

Still, there was faith. *Abide with me, child*. Don't let white maleness kill you or that black boy because of your unthinking kindness. Kindness must be thought about as much as the evil ones think about doing evil—certainly in this world.

Gee-Gee, a widow, the mother of six, all of whom she put through college working six days a week for the Mungers: her children, including the Mungers, were her faith (fig. 5).

On Sundays, Gee-Gee had the day off. Maybe on Sundays she let her body, thick and attentive, sing from her chair in the second pew in the church of history: *Abide with me*.

There she is in Mann's photographs, one woman looking at another, both of them mothers by then, and the pictures are important for a number of reasons, chief among them being Gee-Gee's willingness to be seen as herself, to inhabit what Baldwin said about his "vertical saints" within that church (fig. 6). There was no need for Gee-Gee to be *what she was not*. Sitting squarely in the frame of her life, Gee-Gee is what Toni Morrison might call the Africanist presence, the black female figure whose

5 / Wesley and Gee-Gee Carter, Hampton Institute, c. 1949, courtesy of Sally Mann

6 / Mann **Gee-Gee** c. 1979, courtesy of the artist

marginal status defines the privilege of others. But Mann's pictures say otherwise: She is central to the frame and not marginalized by the camera (figs. 6–8; pls. 85–87). What strikes one in Mann's pictures and any family photographs of Gee-Gee is the artistry of her care and her desire to communicate through the means available to her, including the language of anger— the better to save a life (figs. 7, 8).[18]

And what means are available to the artist? From O'Connor's 1963 essay "The Regional Writer":

Unless the novelist has gone utterly out of his mind, his aim is still communication and communication suggests talking inside a community…our best writers are able to do this. They are not alienated, they are not lonely suffering artists gasping for purer

air.…The isolated imagination is easily corrupted by theory, but the writer inside his community seldom has such a problem.

The community members Mann speaks of and with in her memoir and in these photographs are most alive and intimate when she describes Gee-Gee and her father in their place— the places behind the faces. But I think loneliness is the shadow photographer in these pictures. Loneliness asks Mann to abide with her, too. It's not just the loneliness we feel when we see the inevitable gulf between the thing being observed and the observer, but the great loneliness found in the South meeting the loneliness of the southerner. In a 1946 essay about his native New Orleans, Truman Capote said that, to him, the city's streets had long, lonesome perspectives. Mann's view—her understanding

7 / Mann **Gee-Gee's Hand** c. 1980, courtesy of the artist

of loneliness even within community — is that the South has a long lonely perspective, one that can be unbearable to look at. And yet she makes it bearable enough to make a photograph from it.[19]

Looking at pictures of nature and what man looks like in nature makes me feel lost, the way great writers about the natural world — Ralph Waldo Emerson, Henry David Thoreau, Clarence King, John McPhee — can make us feel on the page: a vastness of mind meeting vastness of place. It's madness to claim one's own significance in relation to that, but we can learn. A question I discovered early on, looking at Mann's landscapes, and then later at her pictures of Gee-Gee and her father: When will the South stop being the South? Stop being a place of blood ties,

spilled blood, black and white blood, blood money, bloody earth? I have been waiting for history to be so different "down there" — to not be a place that asks us to abide with its terrible history and epic natural beauty, and the decimation of all those black bodies and their articles of faith, their "Abide with me."

Photographers are ruthless editors or should be when it comes to showing us what they mean in what they see: why this rock instead of that, why this model instead of that one. Mann's disinterested eye and her sense of life and nature being essentially lonely — like failure, or a mystery life does not help us unravel — all are in these southern landscapes: the once visible — bodies, voices — disintegrate in the southern earth with the inevitability of shadows, family, distant organ music, and ever present life.

8 / Mann **On the Porch** 1990, courtesy of the artist

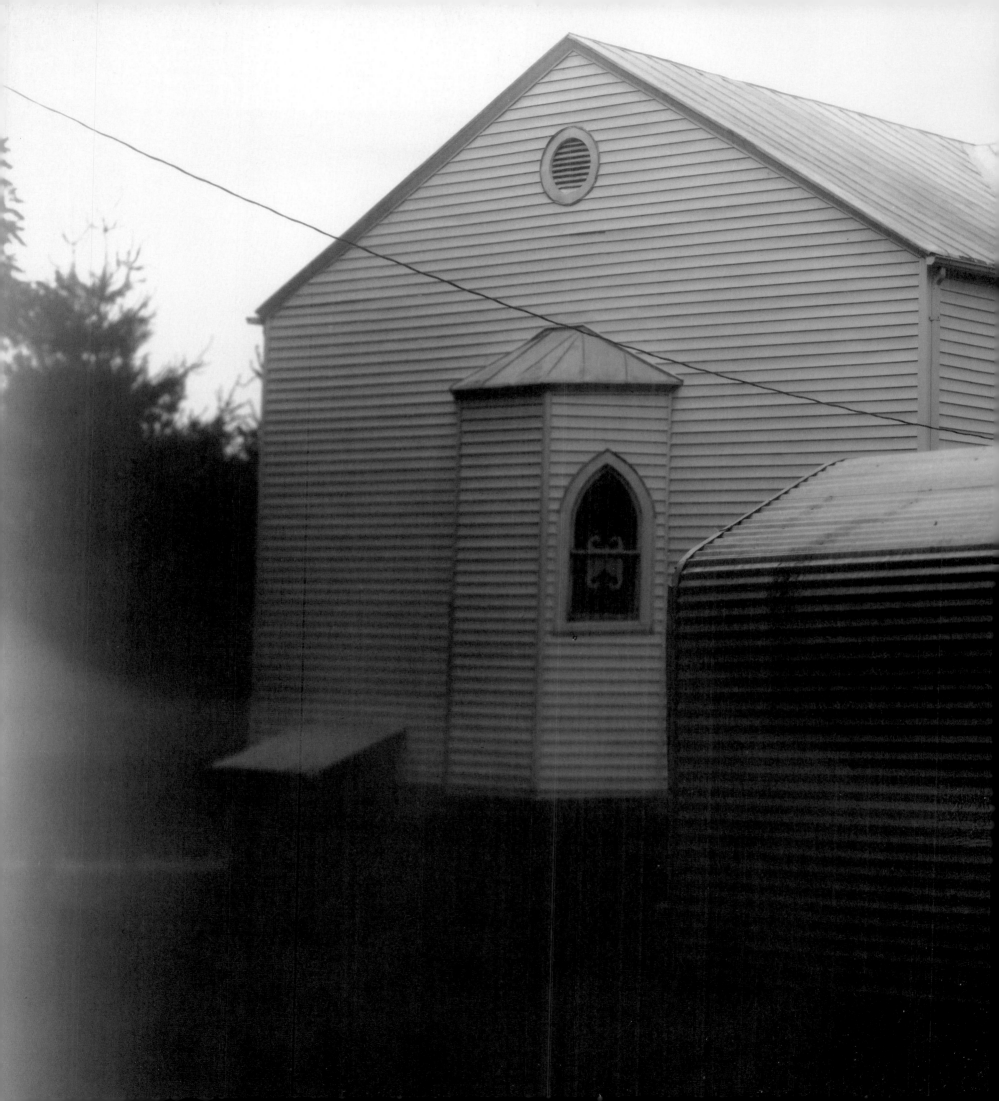

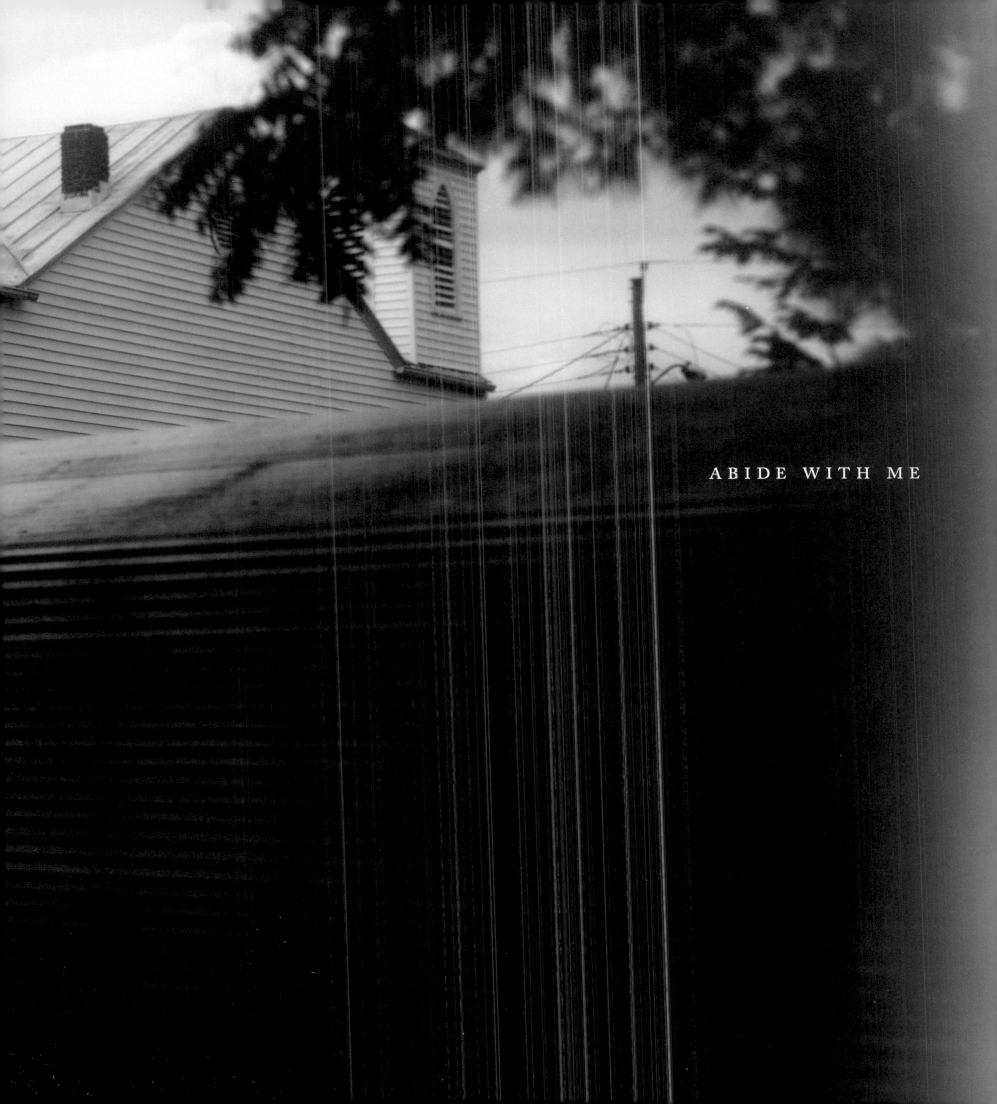

ABIDE WITH ME

I've been coming to terms with the history into which I was born, the people within that history, and the land on which I live, since before I could tie my shoes. Even then, I felt shame and some inchoate sense of accountability; the past haunted me from what seemed like the far side of time.

Now, in this present, there is an urgent cry rising, one that compels me again and again to try to reconcile my love for this place with its brutal history.

SALLY MANN, 2017

plate 44 / **Blackwater 9** 2008–2012

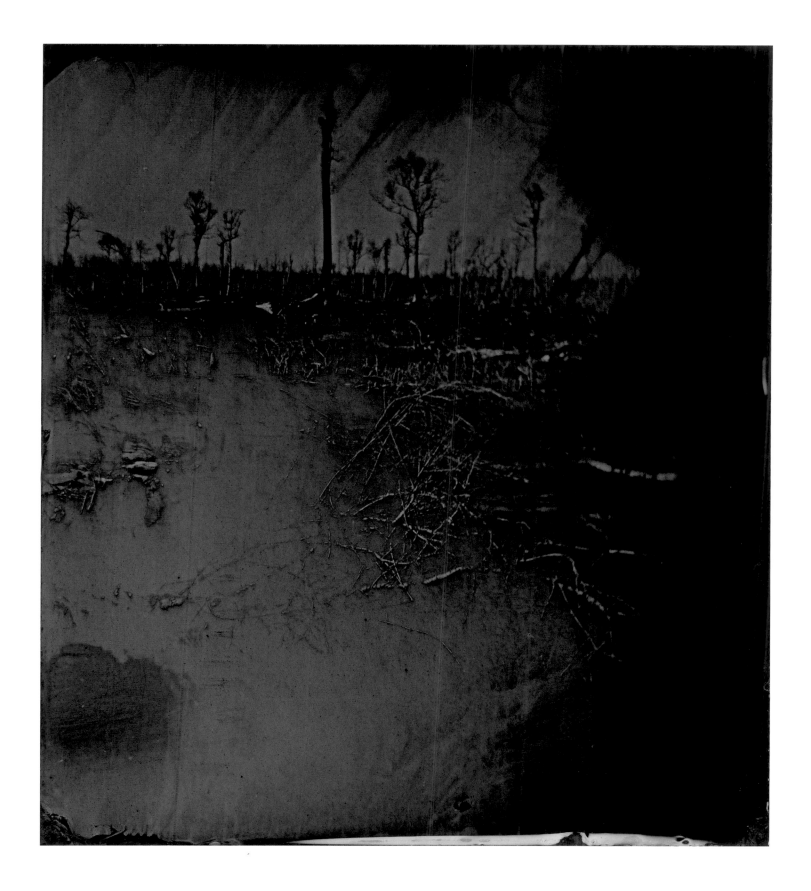

plate 45 / **Blackwater 7** 2008–2012

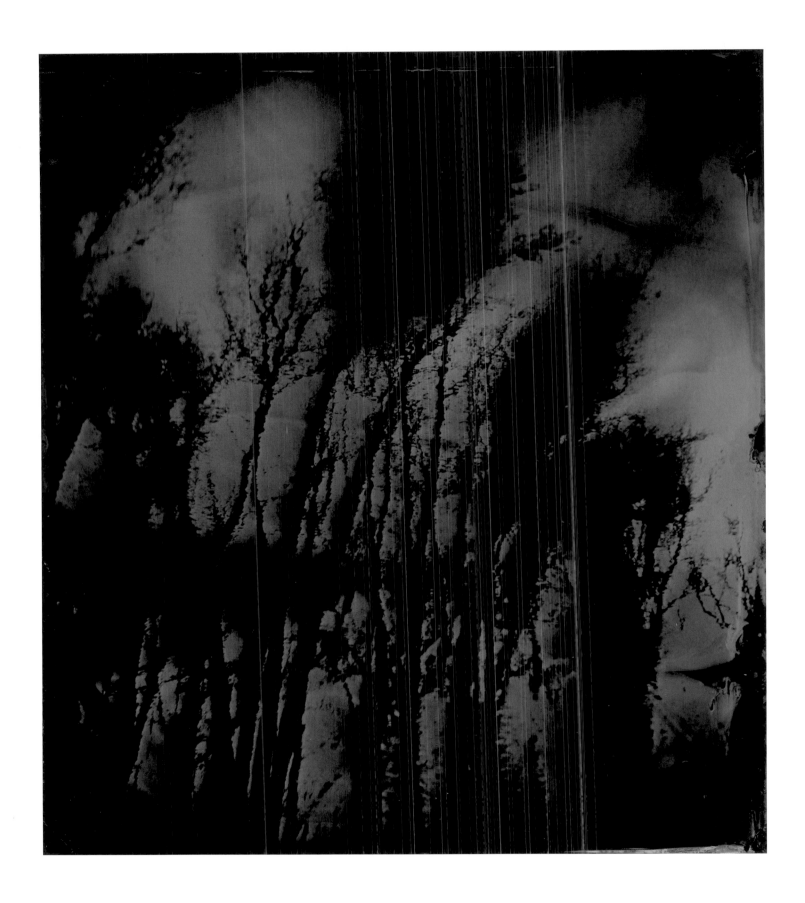

plate 46 / **Blackwater 20** 2008-2012

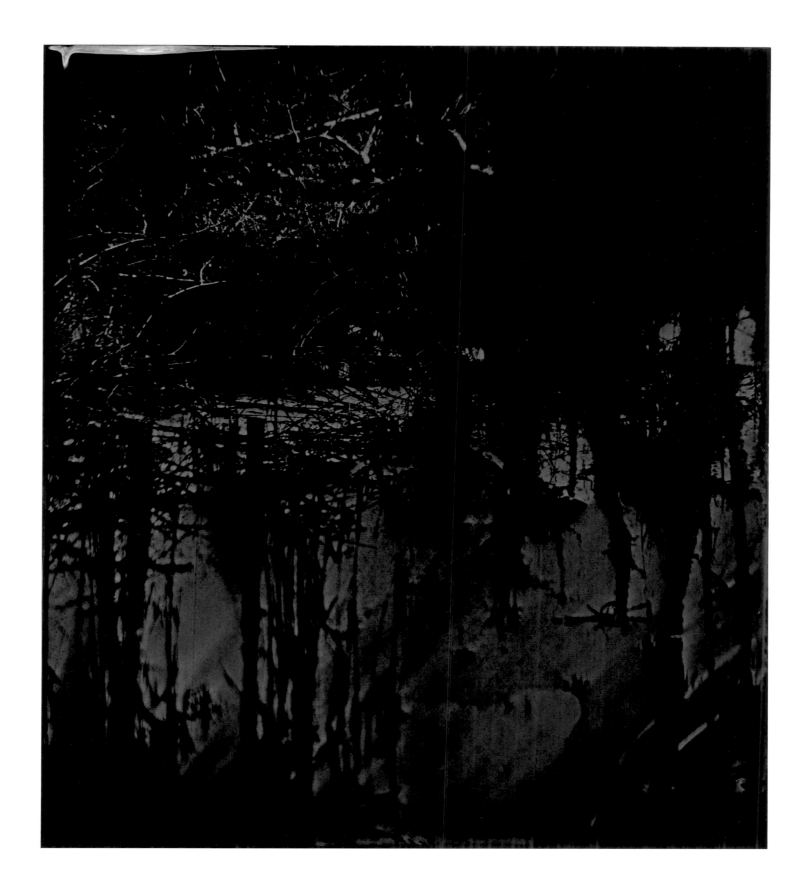

plate 47 / **Blackwater 24** 2008–2012

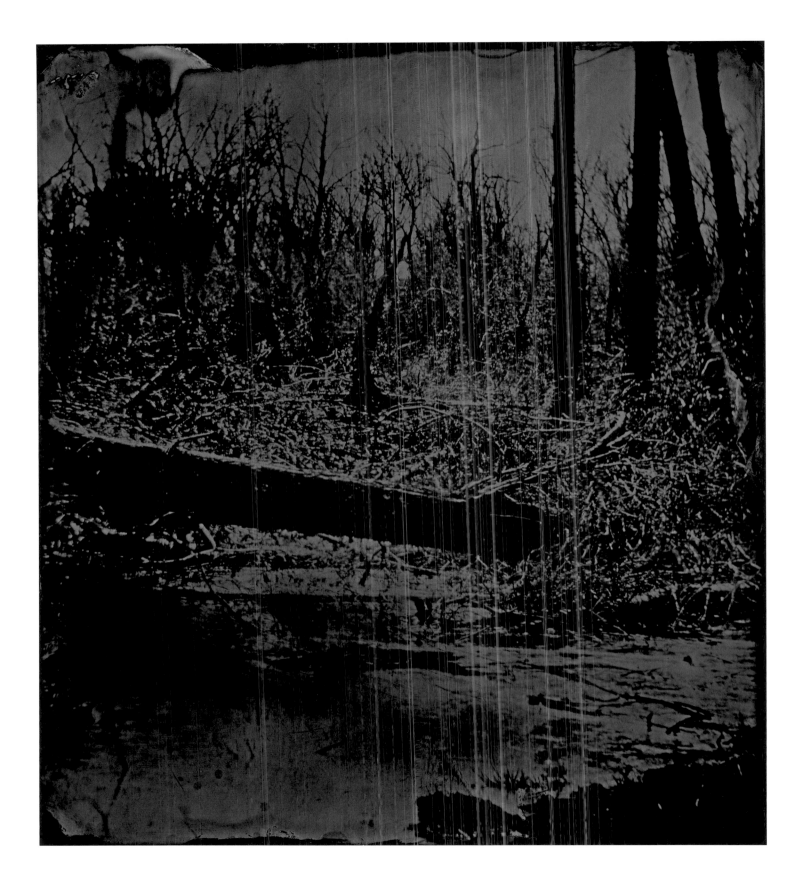

plate 48 / **Blackwater 5** 2008–2012

And about this time I had a vision—and I saw white spirits and black spirits engaged in battle, and the sun was darkened — the thunder rolled in the Heavens, and blood flowed in streams.

NAT TURNER, 1828

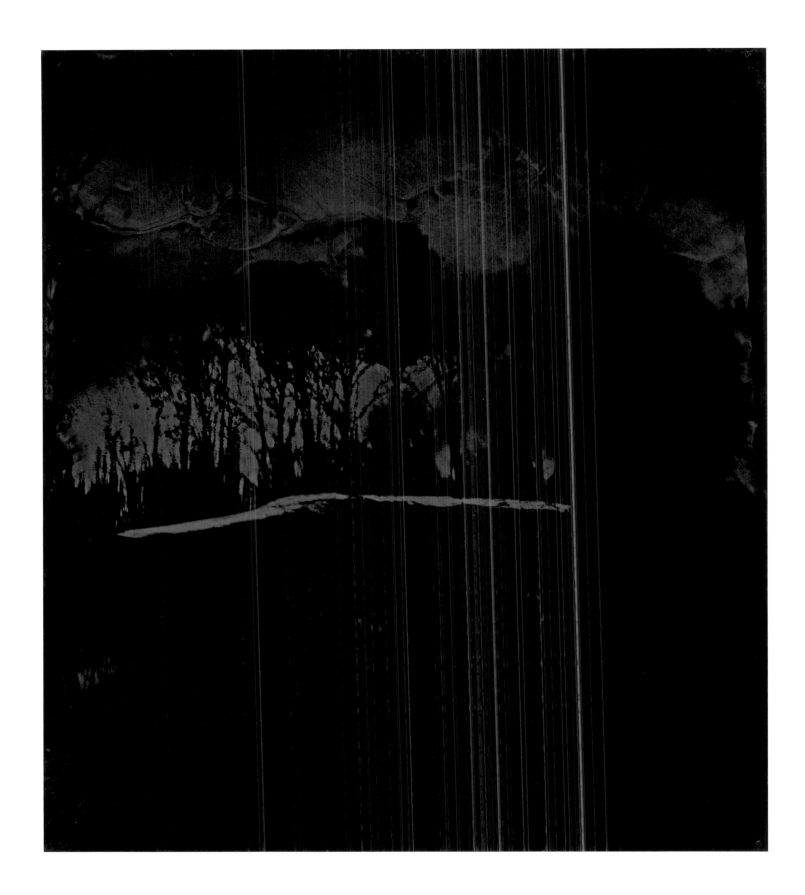

plate 49 / **Blackwater 30** 2008–2012

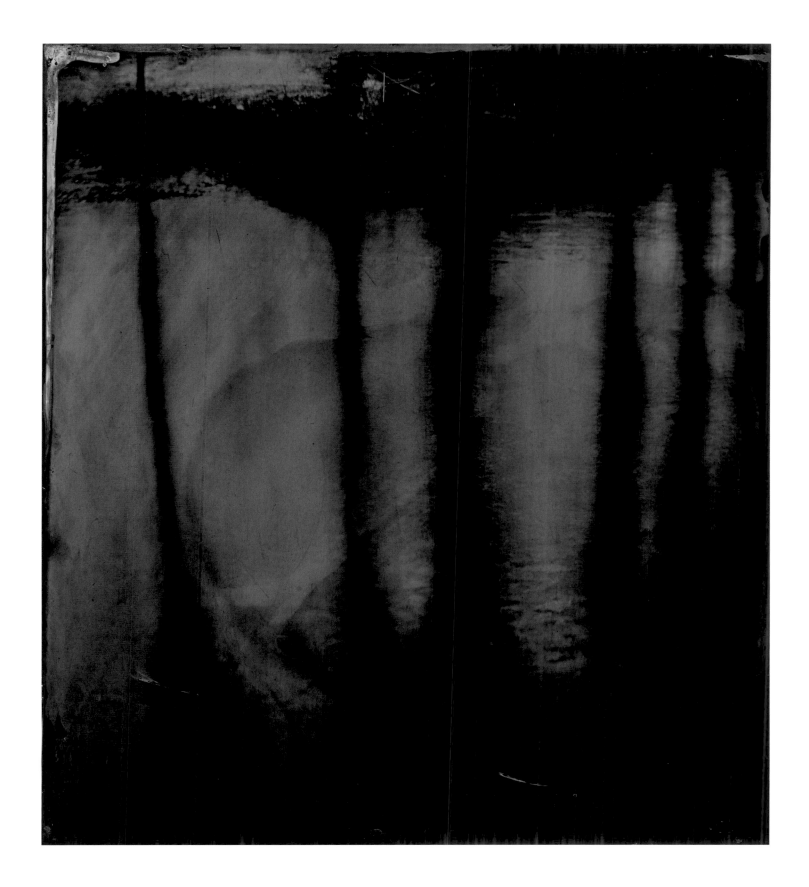

plate 50 / **Blackwater 18** 2008–2012

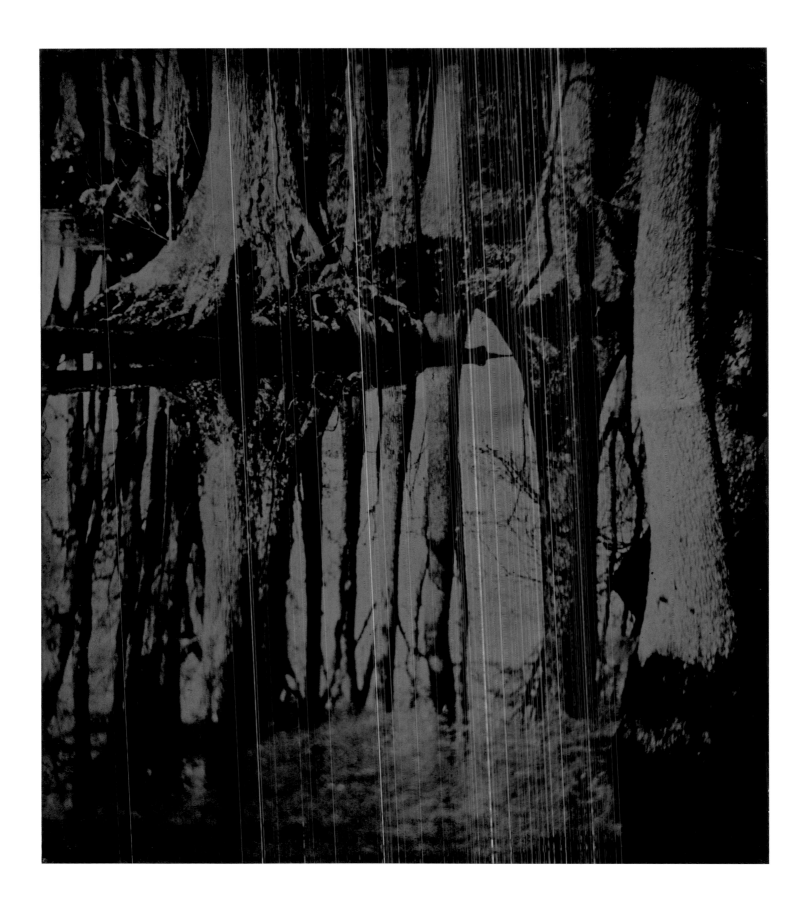

plate 51 / **Blackwater 25** 2008–2012

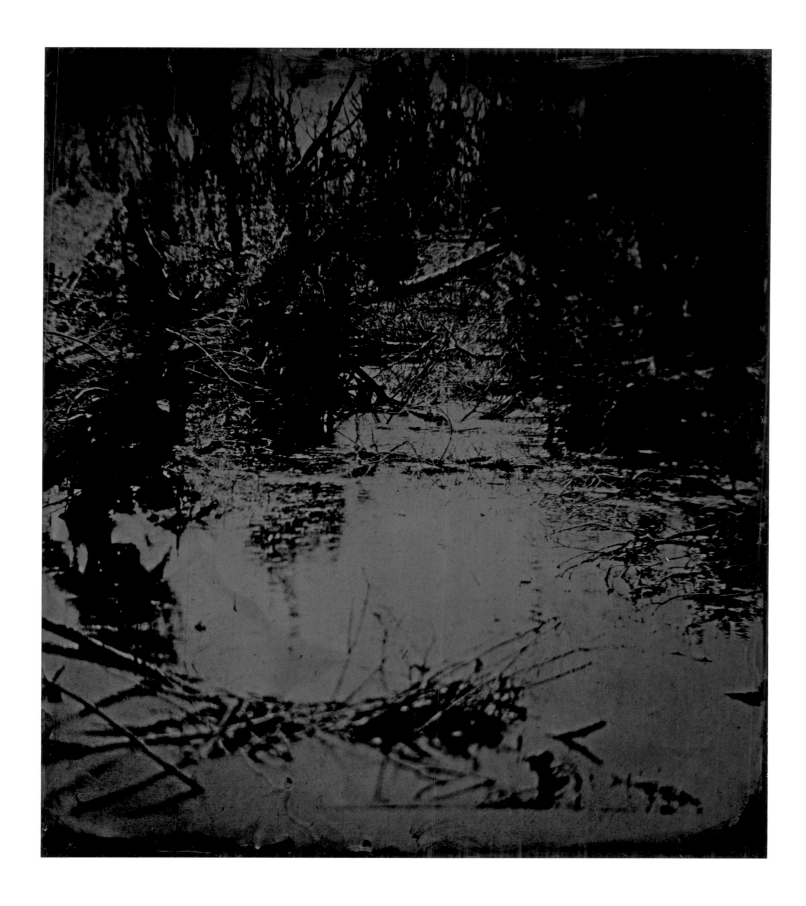

plate 55 / **Blackwater 28** 2008–2012

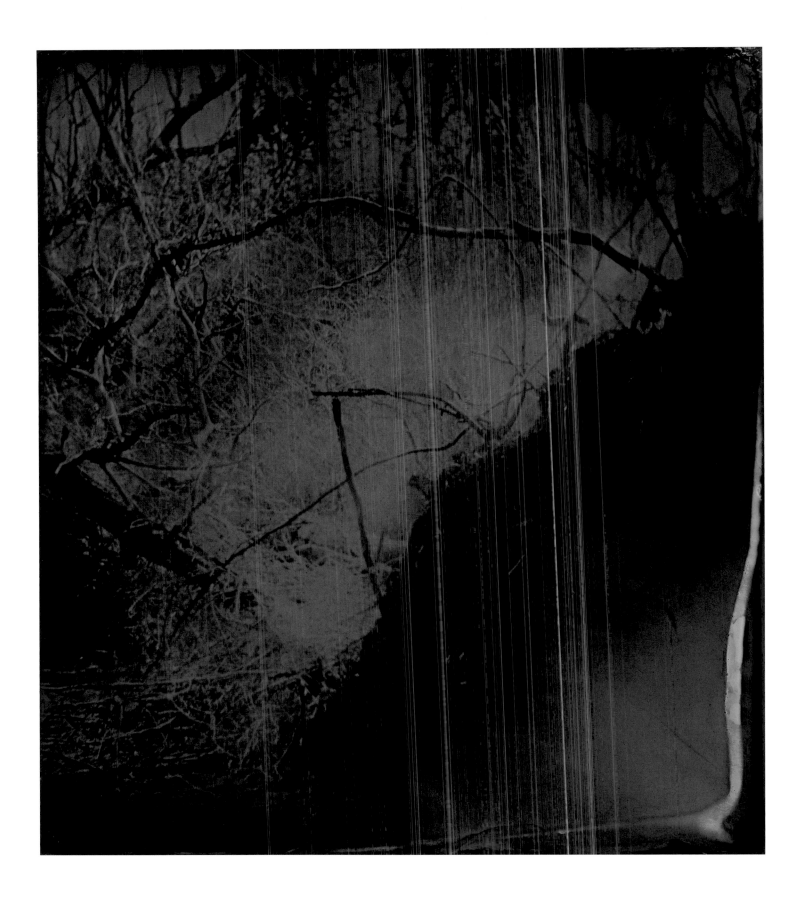

plate 56 / **Blackwater 1** 2003–2012

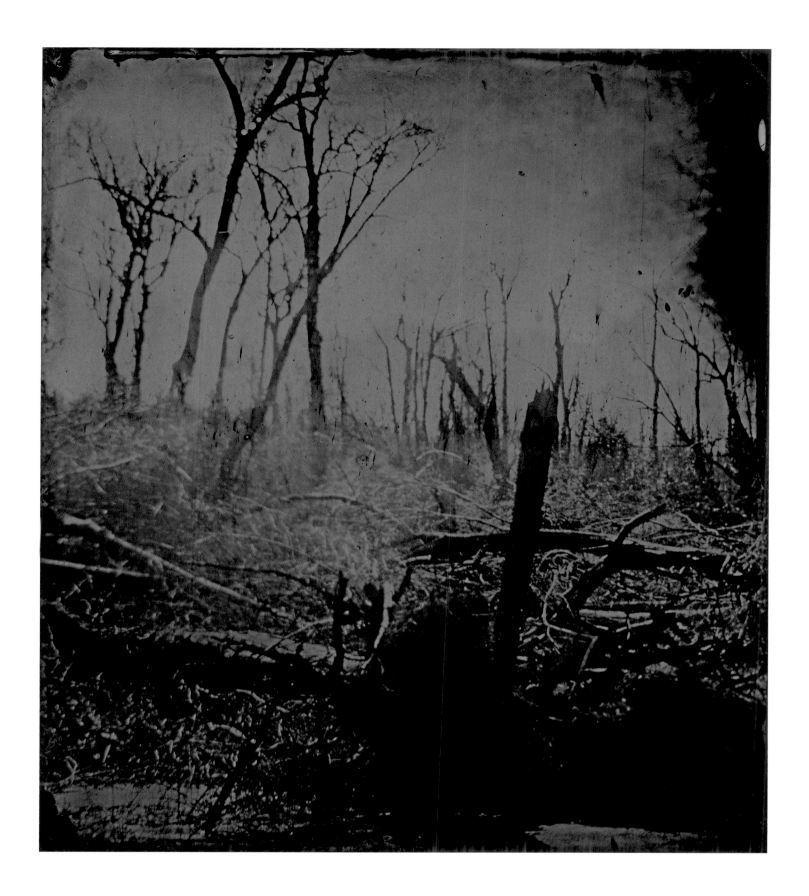

plate 58 / **Blackwater 13** 2008–2012

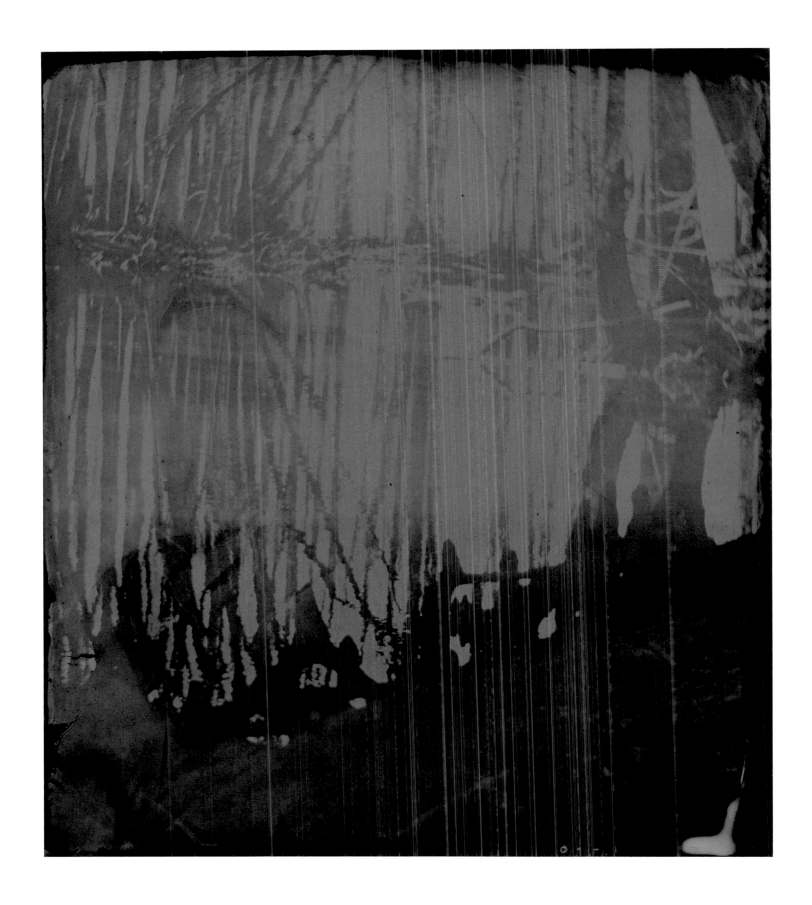

plate 59 / **Blackwater 4** 2008–2012

plate 60 / **Blackwater 3** 2008–2012

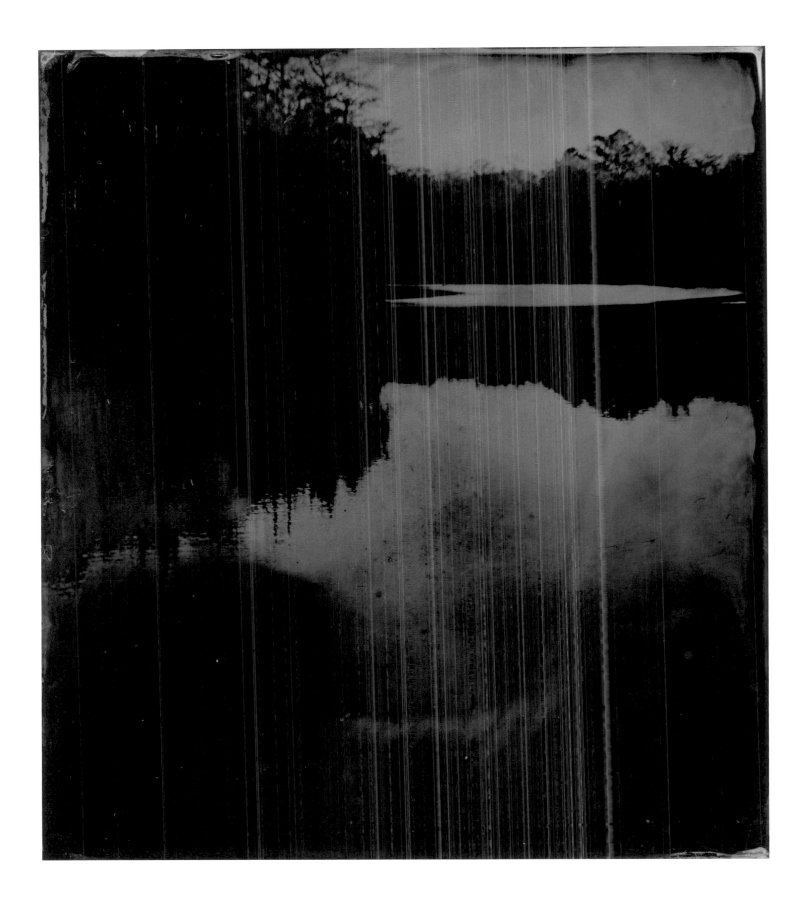

plate 63 / **Blackwate 17** 2008–2012

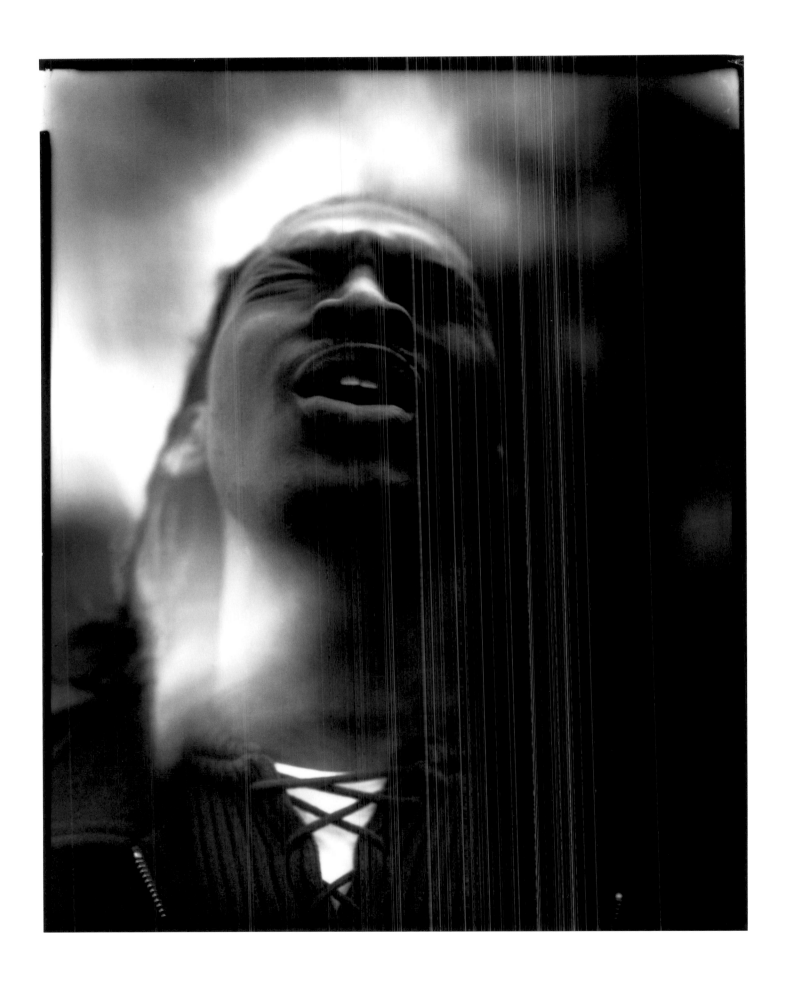

plate 66 / **Singer, DJ** 2C06–20_5

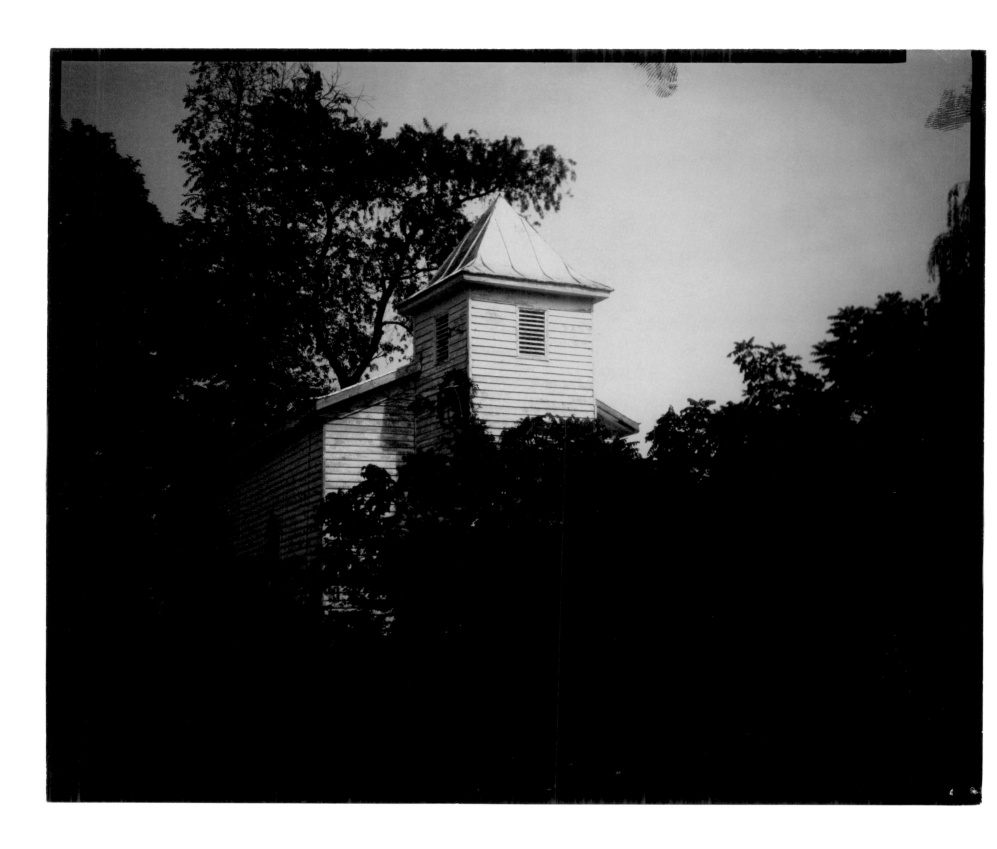

plate 67 / **Mt. Airy Baptist** 2008–2016

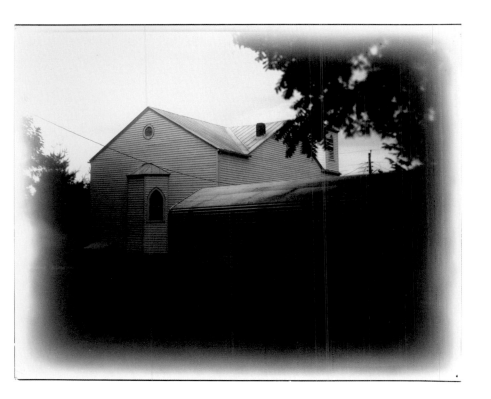

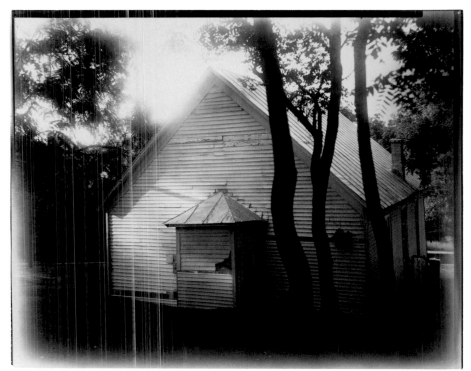

plate 68 / **Asbury United Methodist** 2008–2016

plate 69 / **St. Paul African Methodist Episcopal** 2008–2016

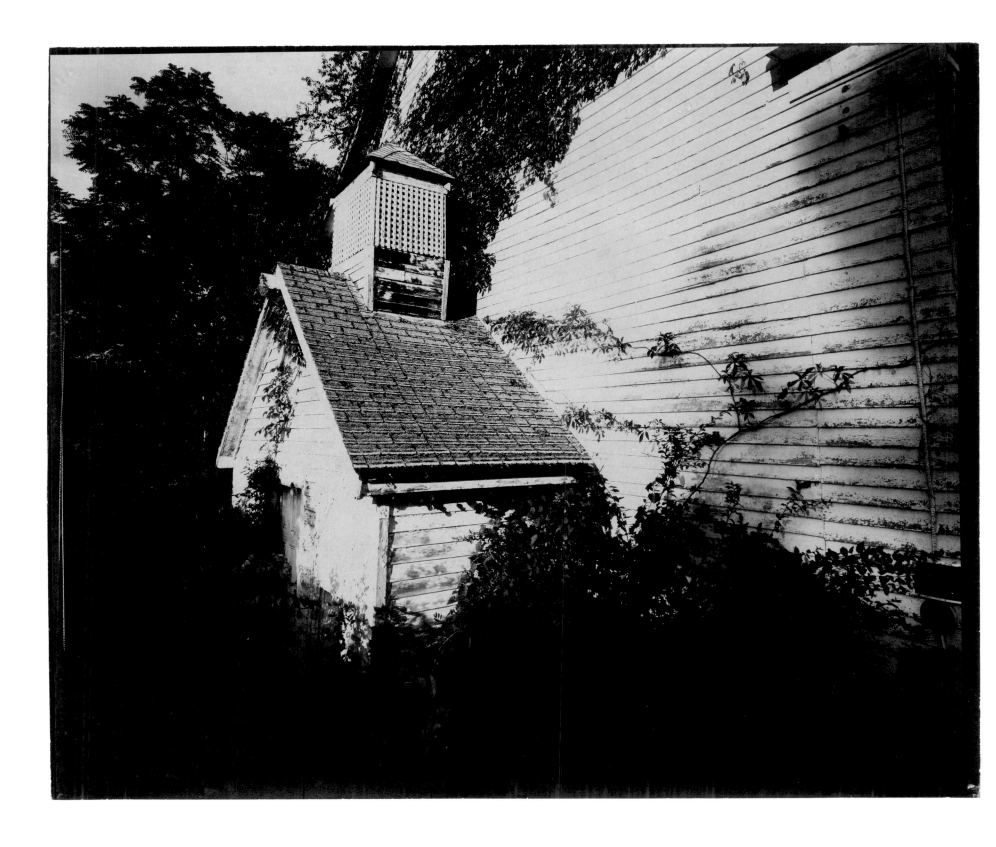

plate 70 / **First Baptist Church of Goshen** 2008–2016

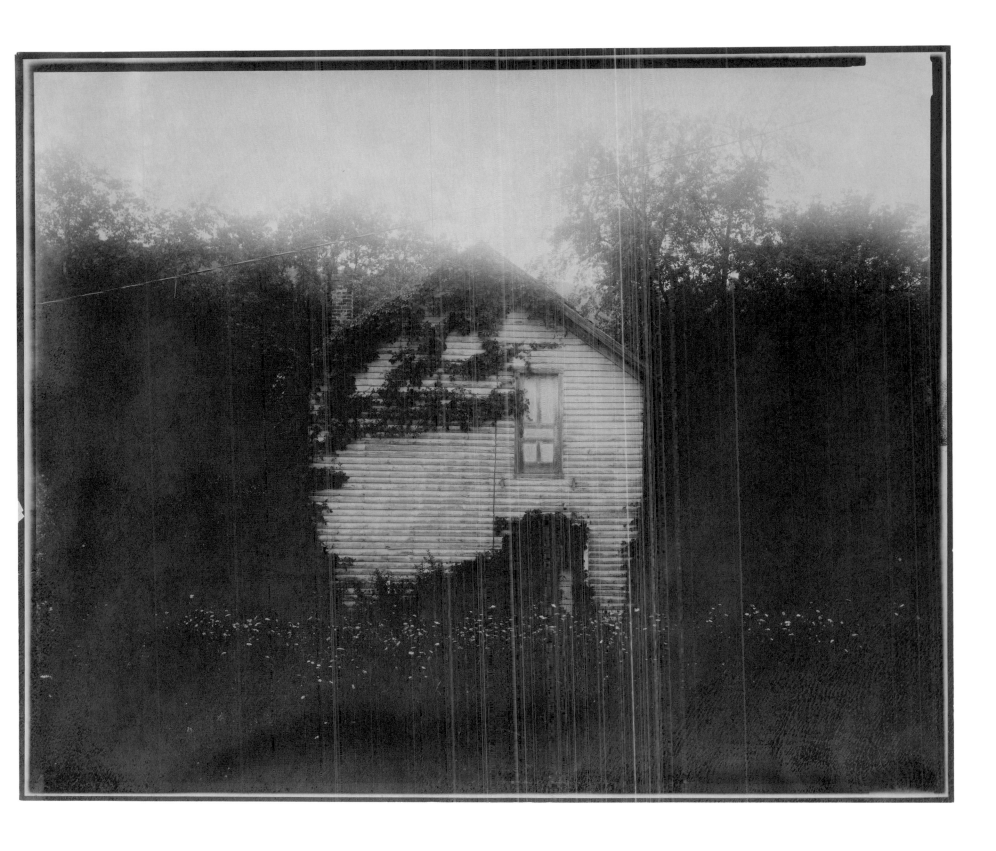

plate 71 / **First Baptist Church of Goshen, Rectory** 2008–2016

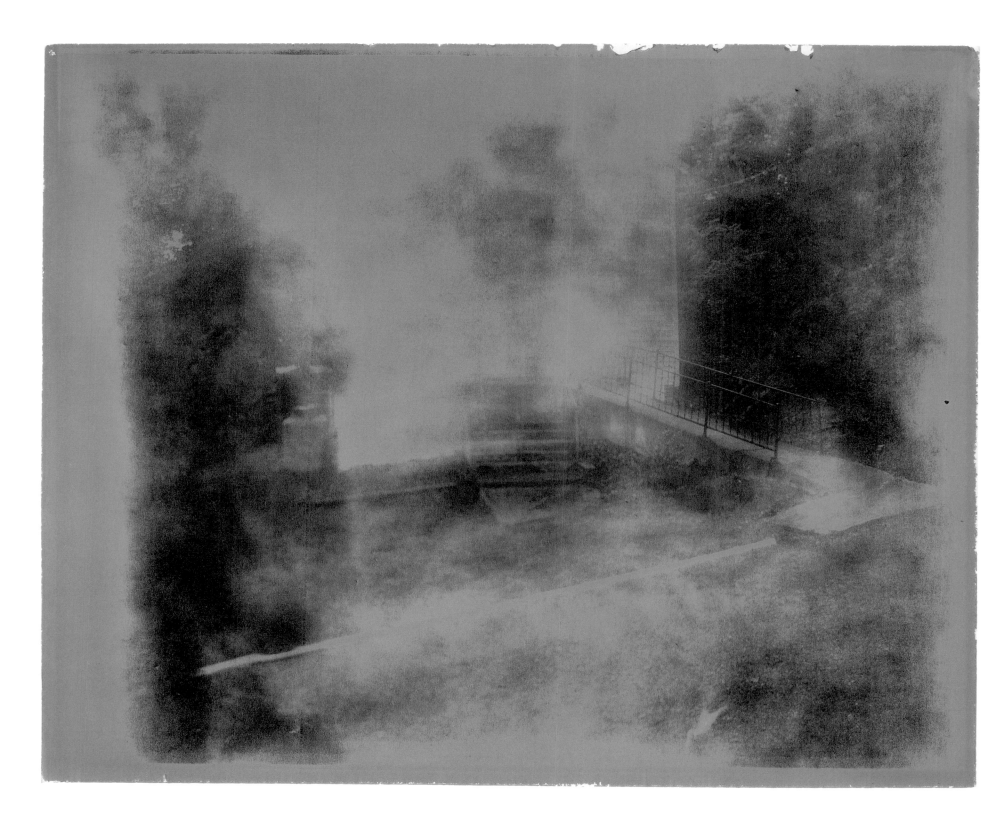

plate 72 / **Oak Hill Baptist** 2008–2016

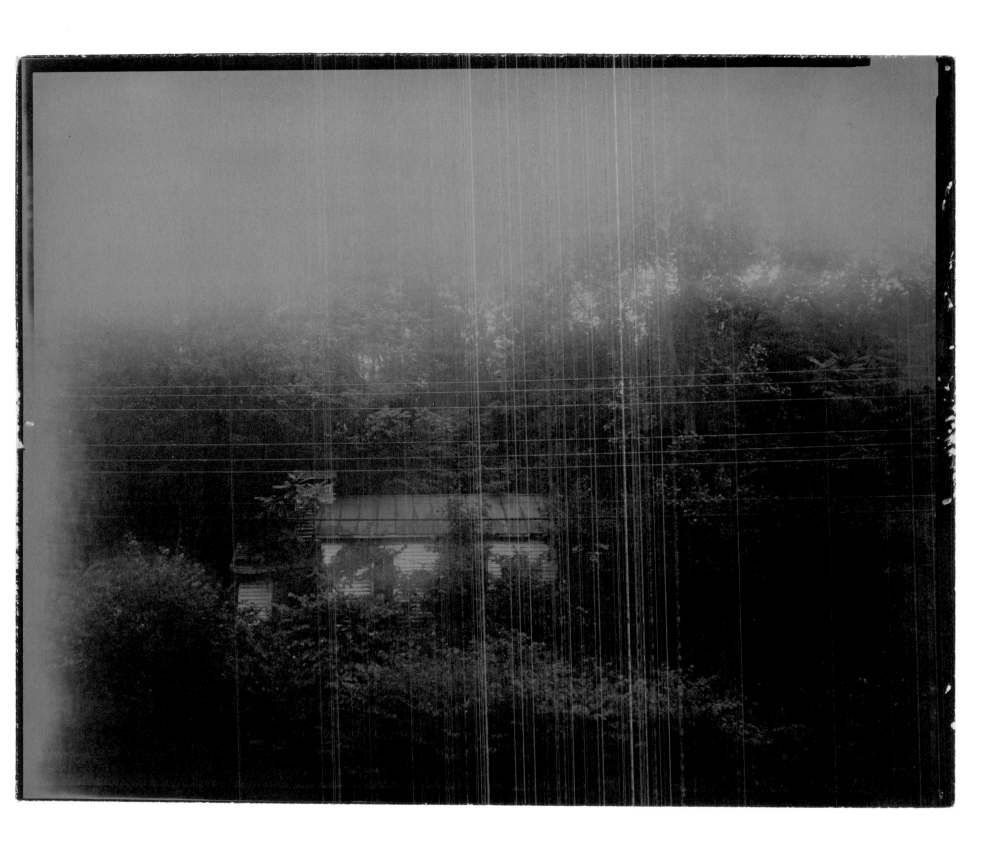

plate 73 / **Marl Hill Baptist** 2008–2016

plate 78 / **Morning Star Baptist** 2008–2016

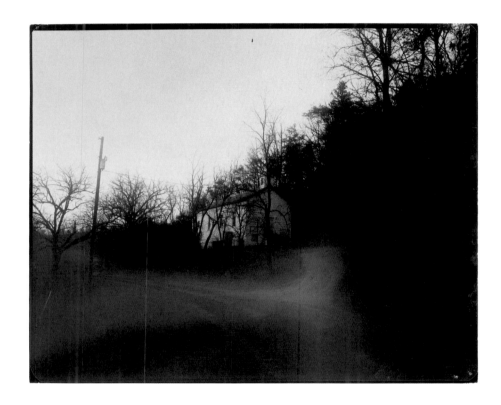

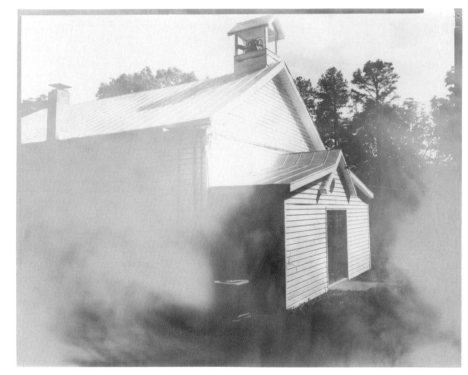

plate 82 / **Oak Hill Baptist** 2008–2016 plate 83 / **Mt. Tabor United Methodist** 2008–2016

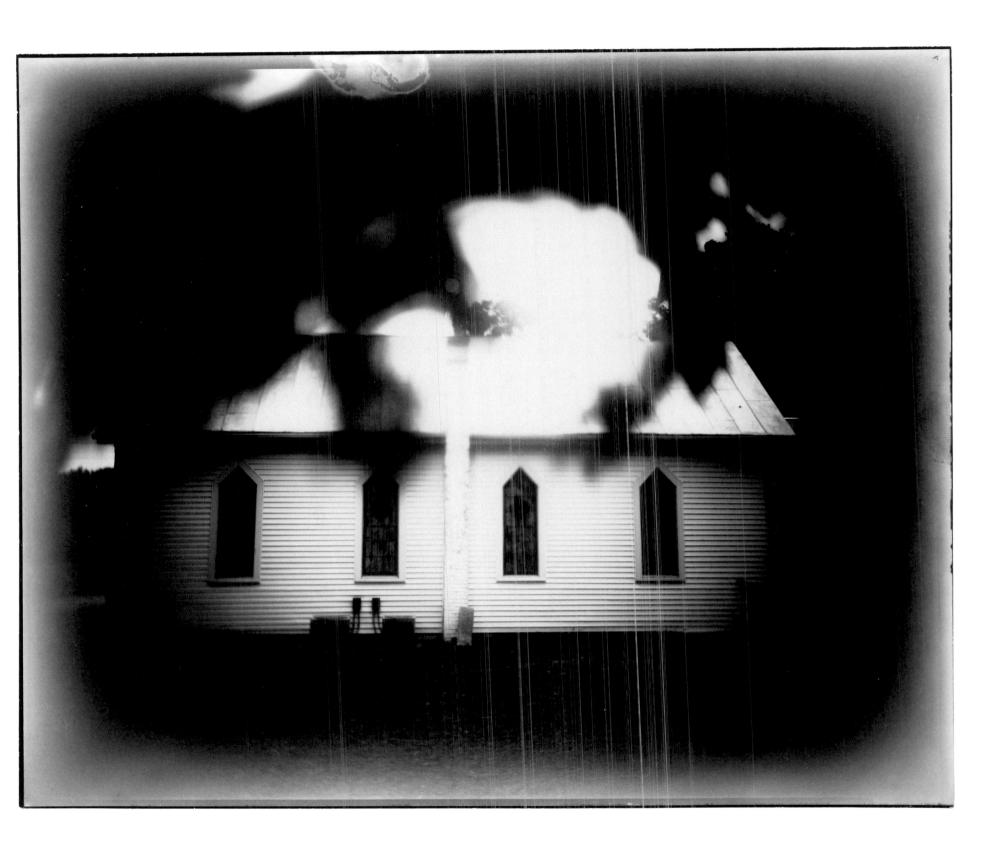

plate 84 / **Beulah Baptist** 2008–2013

Down here, you can't throw a dead cat without hitting an older, well-off white person raised by a black woman, and every damn one of them will earnestly insist that a reciprocal and equal form of love was exchanged between them.

This reflects one side of the fundamental paradox of the South: that a white elite, determined to segregate the two races in public, based their stunningly intimate domestic arrangements on an erasure of that segregation in private.

Could the feelings exchanged between two individuals so hypocritically divided ever have been honest, untainted by guilt or resentment?

SALLY MANN, 2015

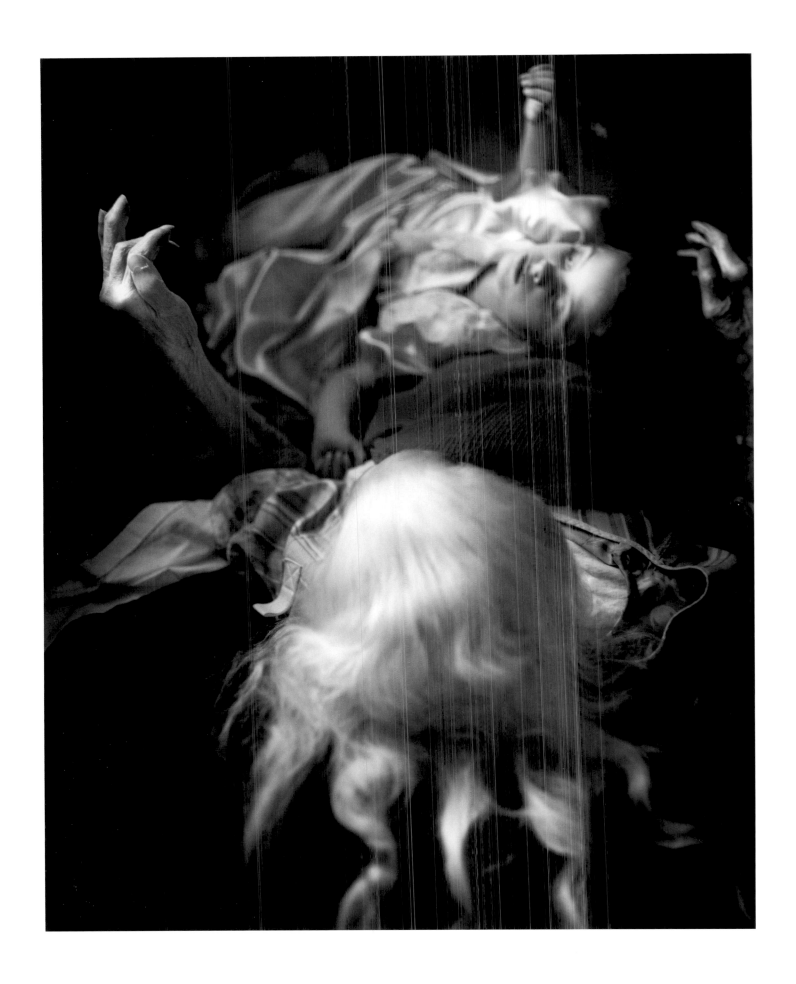

plate 85 / **The Two Virginias # 4** 1991

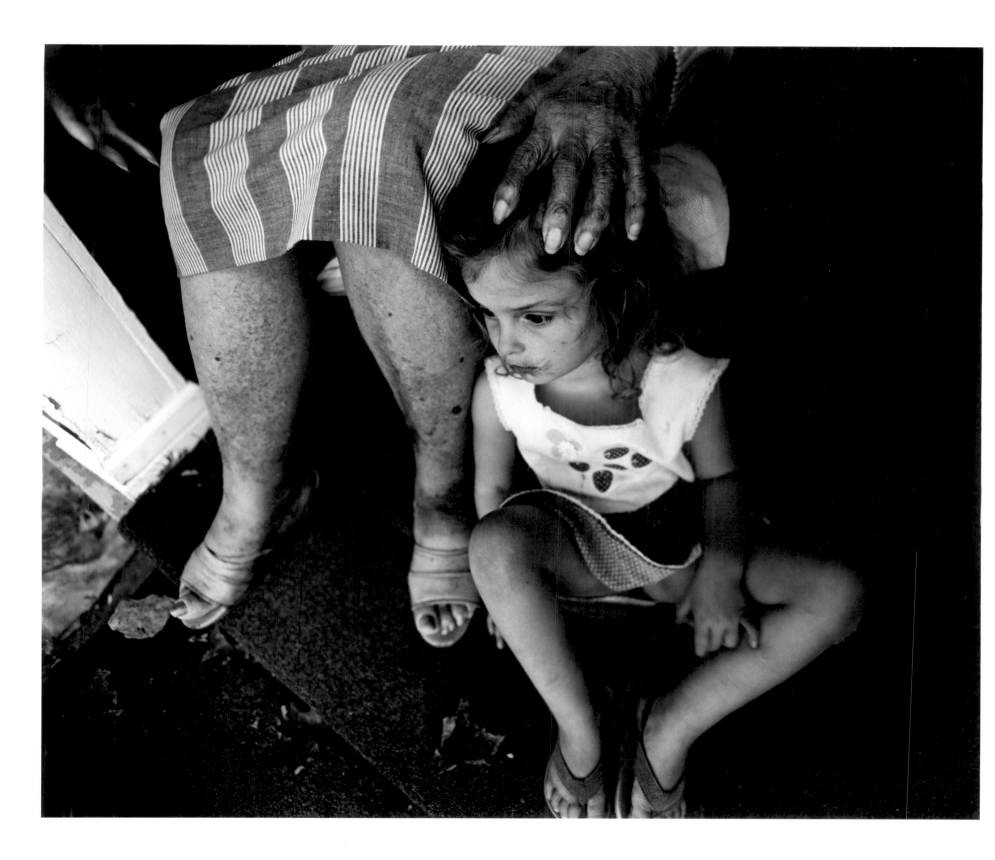

plate 86 / **The Two Virginias #1** 1988

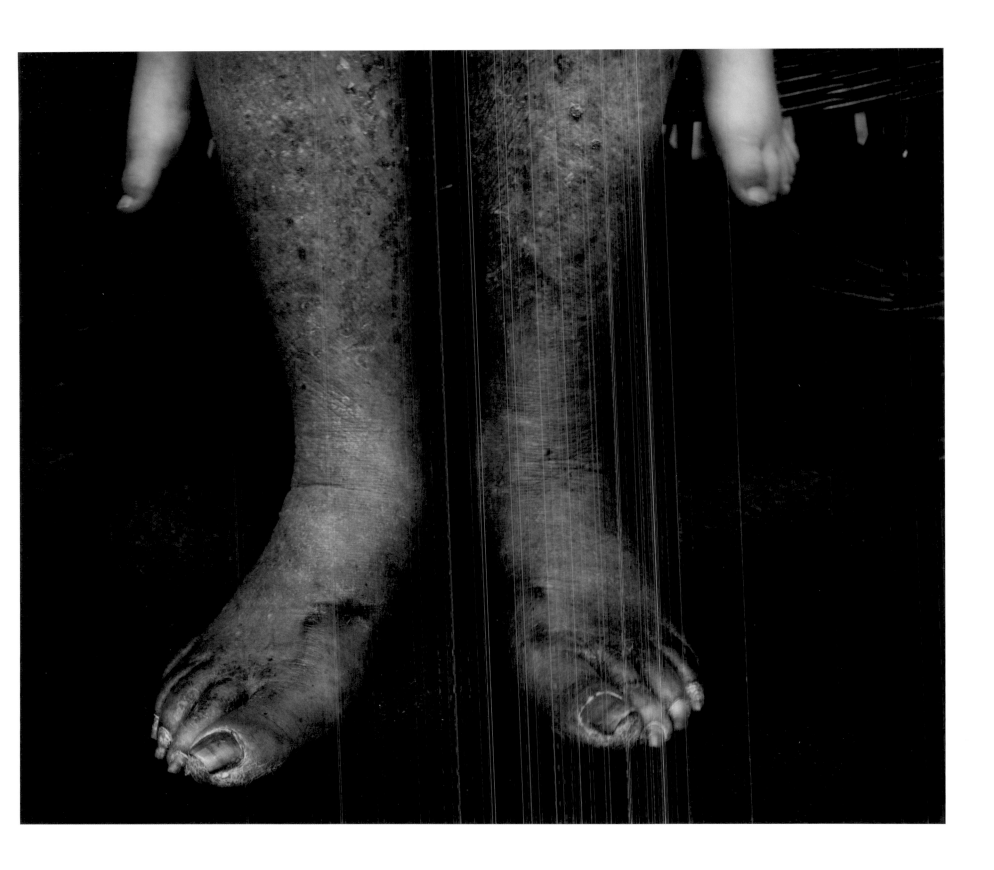

plate 87 / **The Two Virginias # 3** 1991

How did a widowed black woman pay for the housing, the food, the travel, and the tuition to educate six children?

By working twelve hours a day and by taking in linens to iron at night, linens stuffed into white sacks crowding her front door when my father took her home after all day on her feet at our house. What did he think when he saw those bags?

What were any of us thinking? Why did we never ask the questions?

That's the mystery of it — our blindness and our silence.

SALLY MANN, 2015

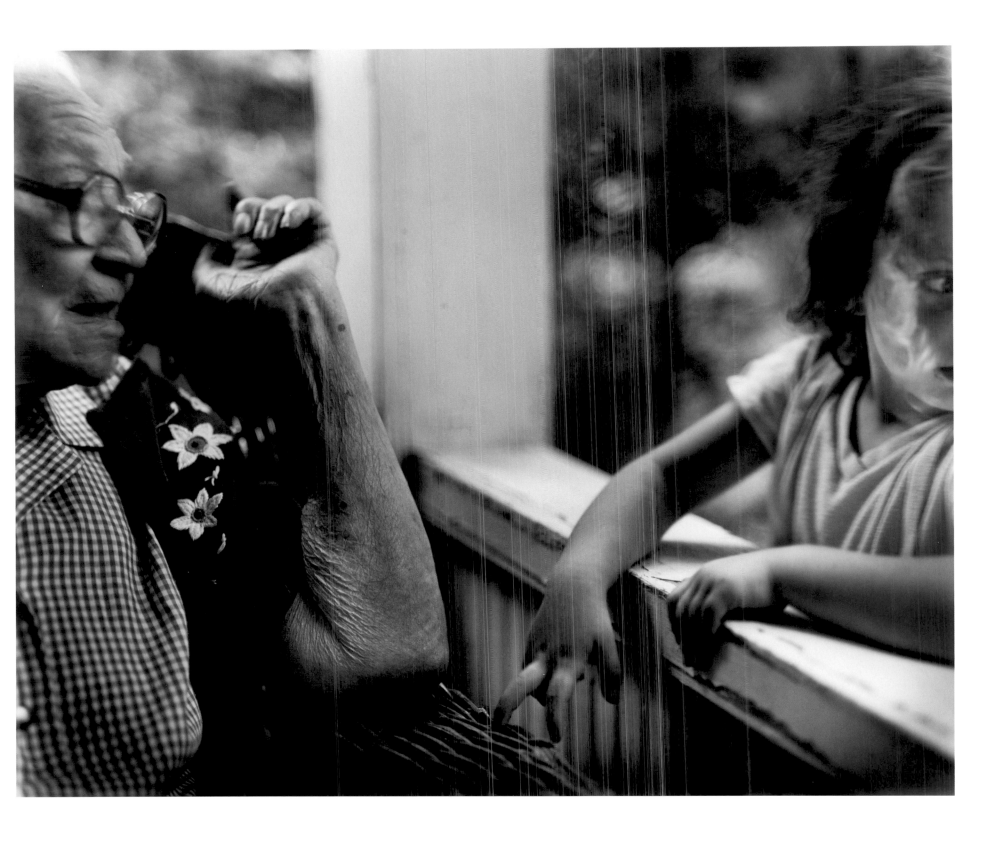

plate 88 / **The Two Virginias # 2** 1989

plate 89 / **Lawson Chapel United Methodist** 2008–2016

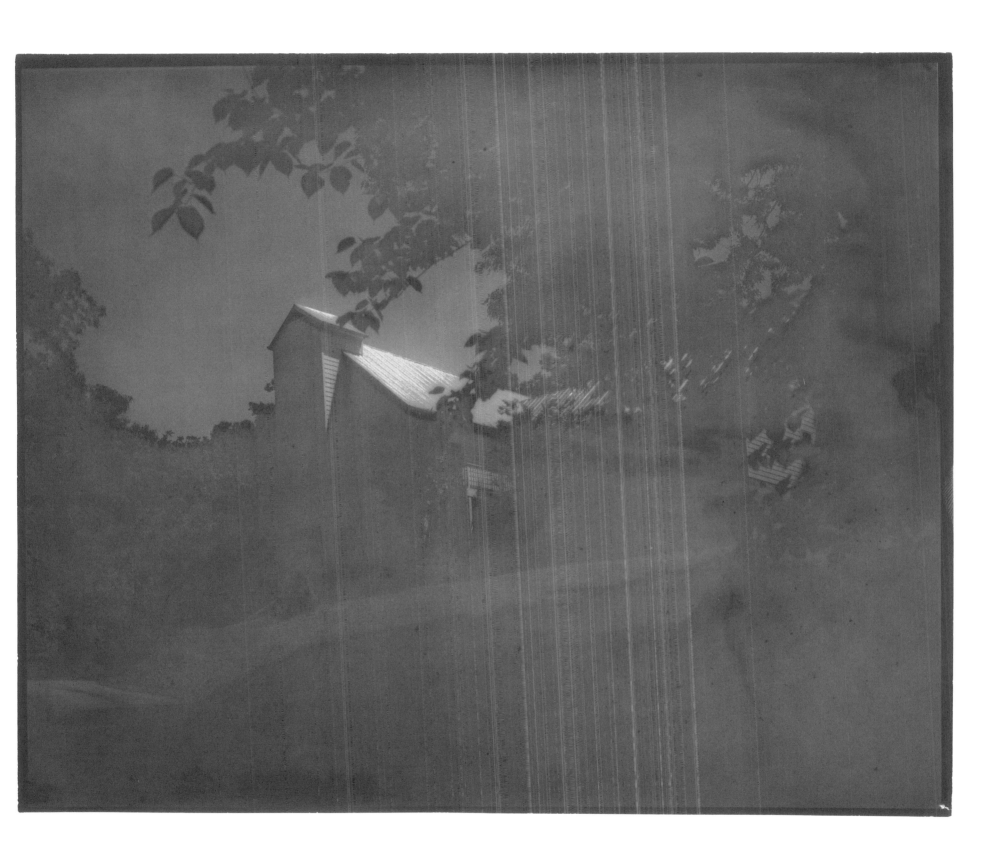

plate 90 / **First Baptist Church of Natural Bridge** 2008–2016

It is clean here, and empty. But no one would come who did not believe.
There is an intensity of gentleness beyond any description, and in silence a sense of congregation
like layers of souls, close to each other, caring. We have come. We should have.

JAMES DICKEY, 1974

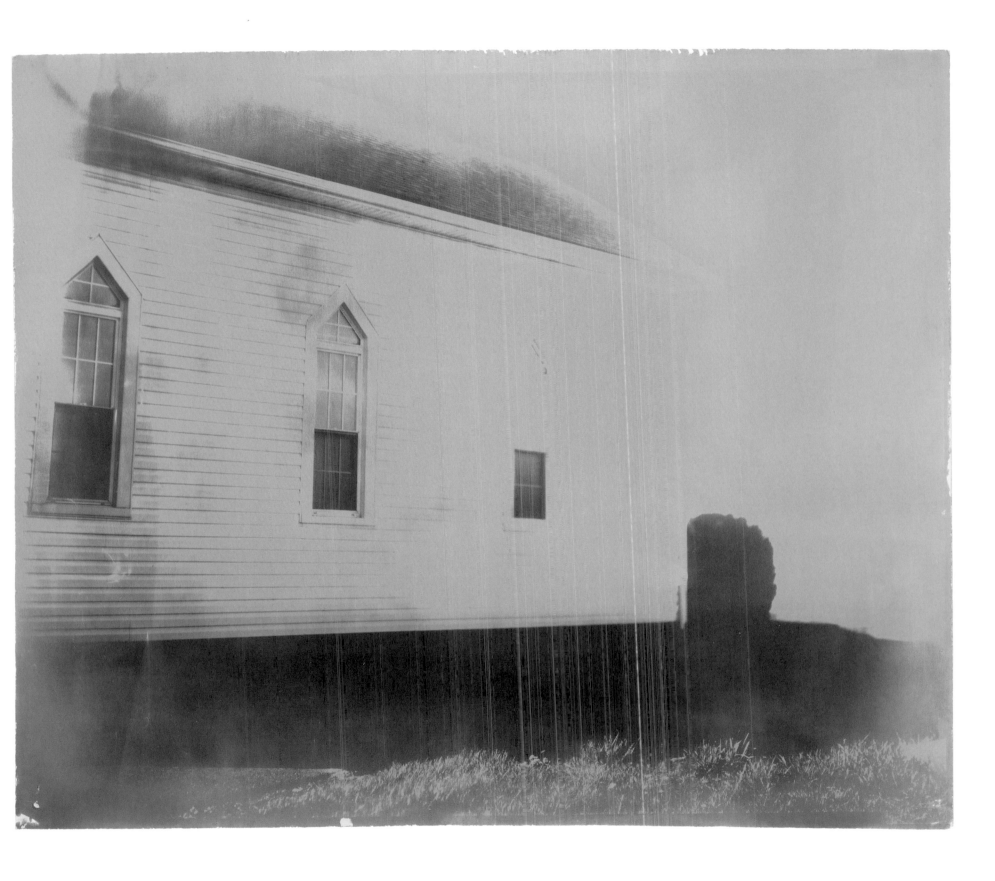

plate 94 / **St. Paul United Method st** 2003–2016

238

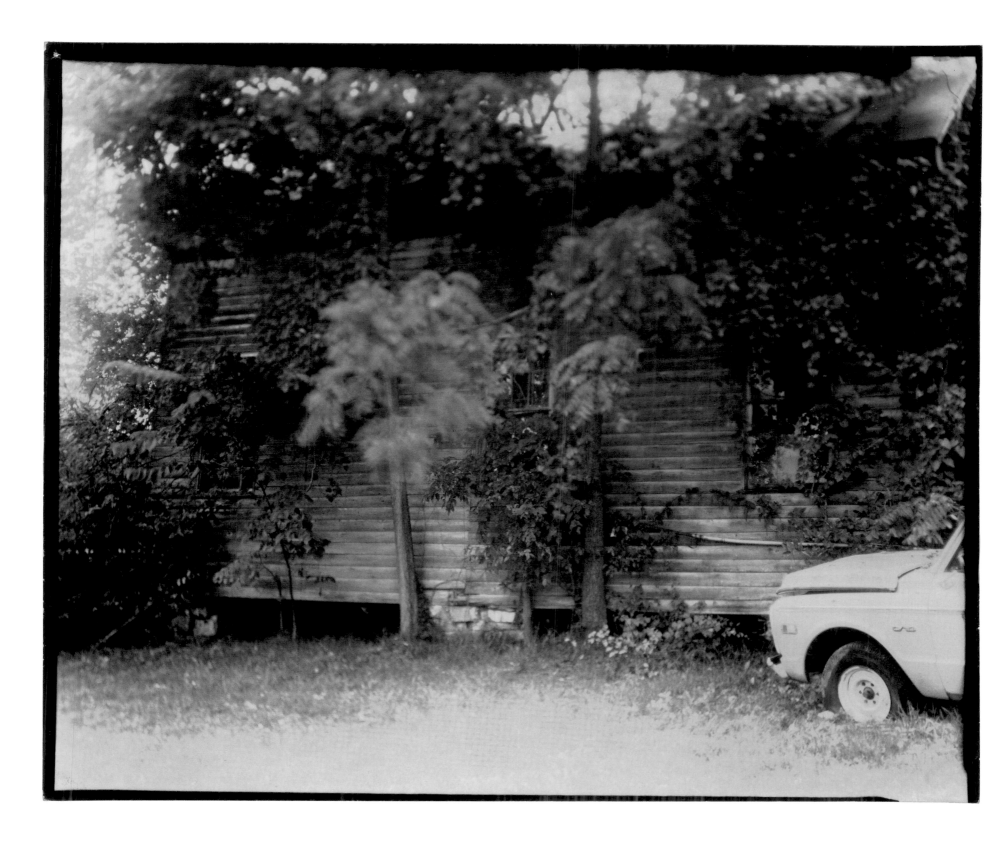

plate 95 / **Bright Hope Baptist** 2008–2016

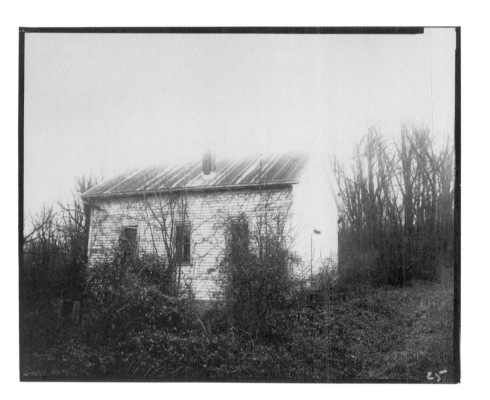

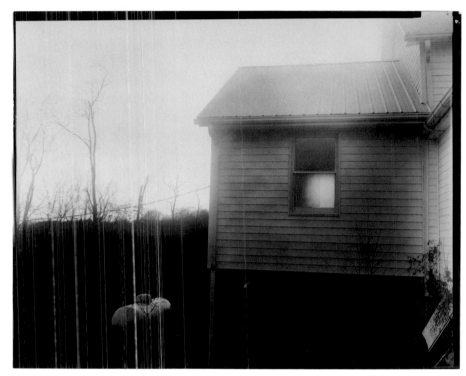

plate 96 / **Payne's Chapel United Methodist** 2008–2016 plate 97 / **Lawson Chapel United Methodist** 2008–2016

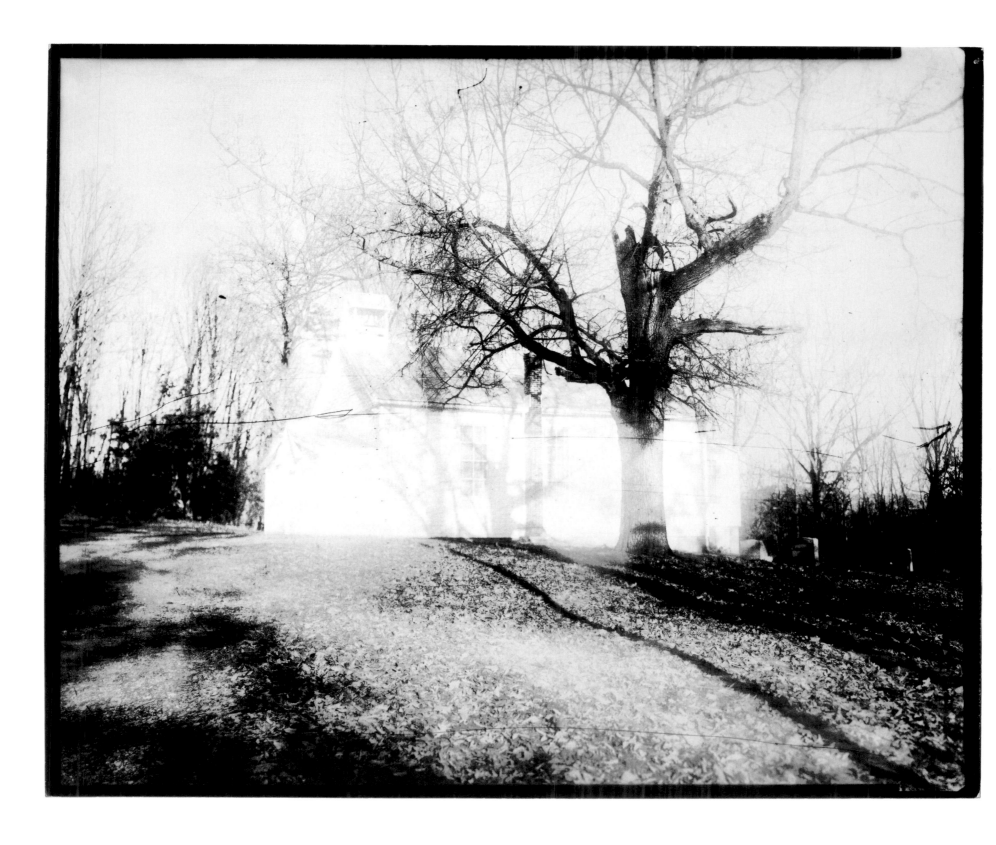

plate 98 / **Mt. Tabor United Methodist** 2008–2016

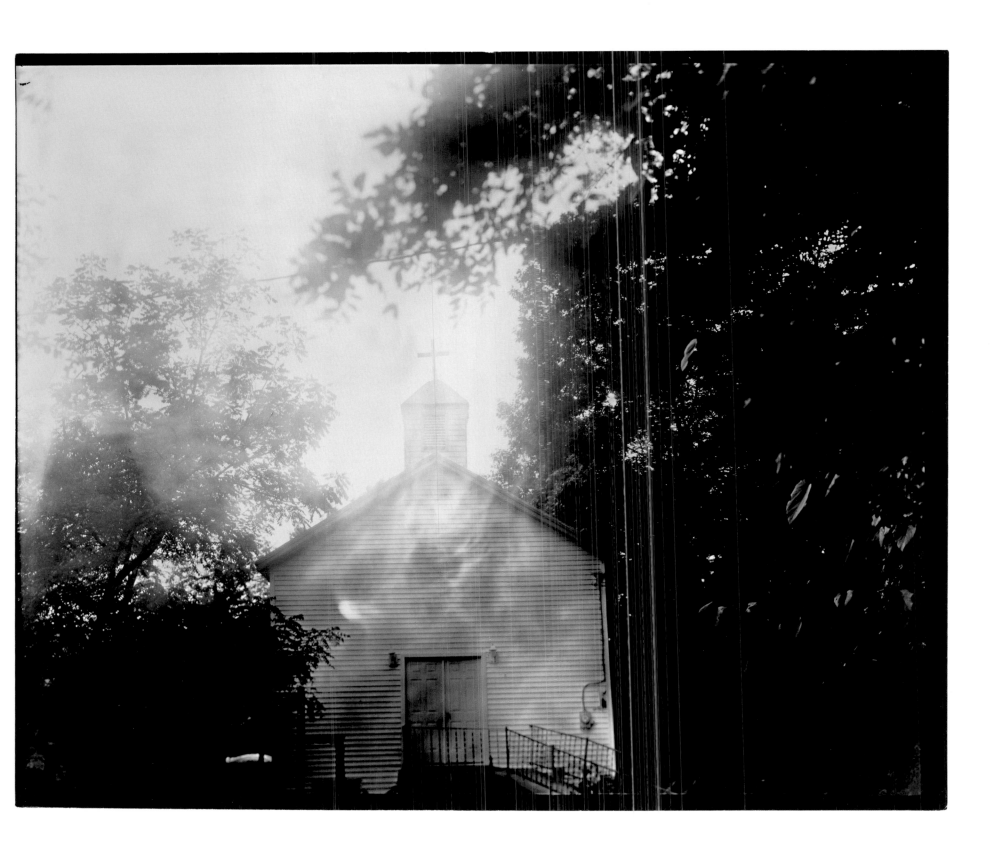

plate 99 / **Oak Hill Baptist** 2008–2016

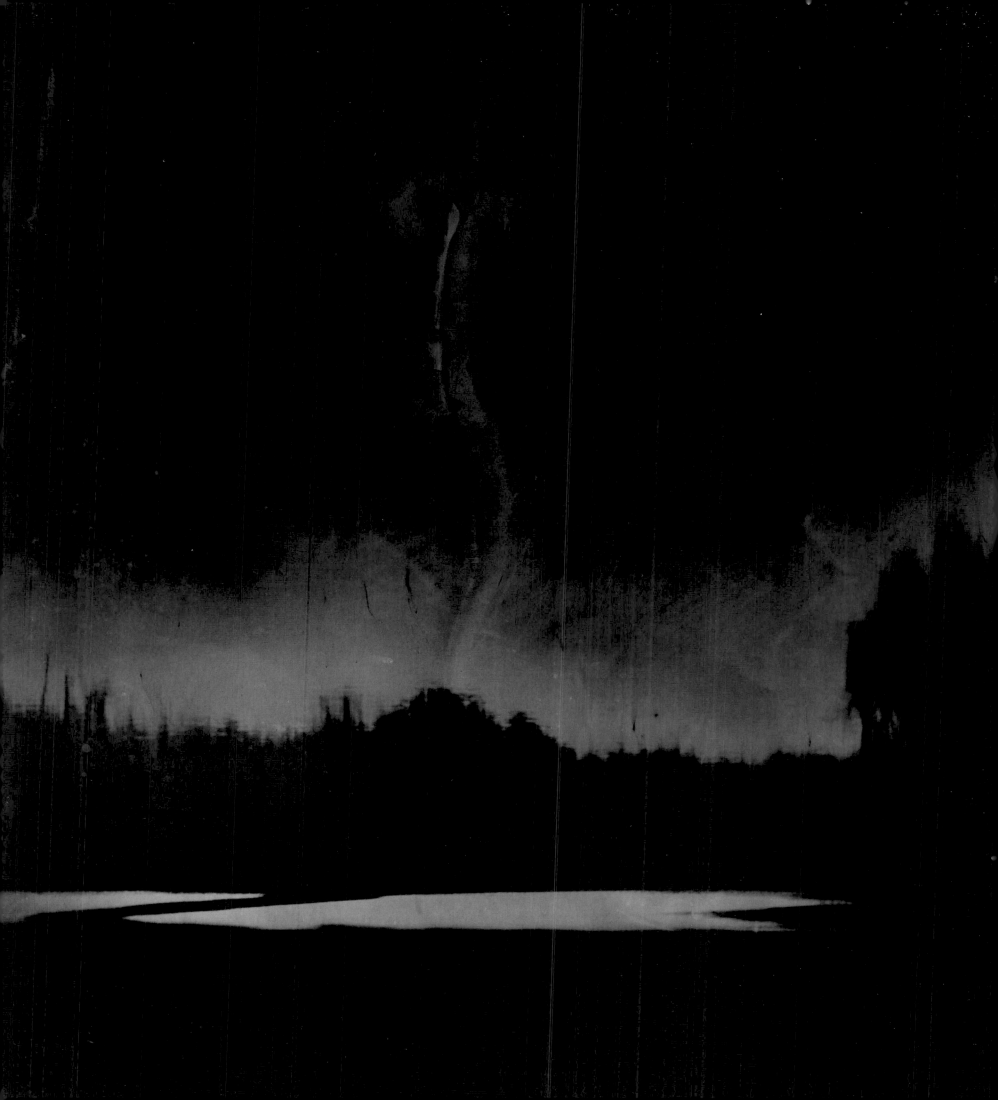

Torn from Time Itself: Sally Mann's New Avenues from Old Processes **MALCOLM DANIEL**

You pray "please don't let me totally screw it up,
but still…screw it up enough to make it interesting."

Just off the living area of the home that Sally and Larry Mann built in the Shenandoah Valley near Lexington, Virginia, is a spacious darkroom equipped with an enlarger big enough to hold 8 × 10 inch negatives and all the tools, chemicals, and developing trays necessary for Mann's large gelatin silver prints—just the type of darkroom that so many other photographers have now replaced with a big inkjet printer. Adjacent to the darkroom is a sunlit space with broad countertops, ranges of flat files, and a wall on which to view freshly printed photographs (fig. 1). The studio is as dust-free as country life and a passel of curious mutts allow. One morning, as part of Mann's preparations for this exhibition, an assistant laid out five large prints, each 50 × 40 inches, of an image from the artist's *Men* series (pl. 54). Mann studies them carefully. To an outsider, it recalls a game that tests one's powers of observation—find the image that is unlike the others, or find ten things that differ within five seemingly identical prints. Even Mann has difficulty at first: "Which is the darker one?" she asks.[1] And then the differences begin to emerge—

the bottom right corner a bit lighter in one, a flaw in the negative masked or heightened in another. Mann is a meticulous printer, a perfectionist, a true master of the good old-fashioned black-and-white gelatin silver print. Over the years far more sheets of Agfa Portriga Rapid (the no-longer-manufactured paper beloved by so many photographers) and the Ilford Multigrade she now uses have ended up on the burn pile than have earned her signature. All that attention to the most minute details of printing may seem odd at first, for the wet collodion glass negative she is printing from is, by most standards, a disaster—emulsion peeling from the edges, the image interrupted by chemical tide lines, "comets," and scratches here and there throughout.

Out the back door and fifty yards away lie a second studio and darkroom, on the upper level of the property's implement shed where Larry stores his tractors and tools. Here Mann made that negative, the one so flawed that any self-respecting nineteenth-century photographer would have wiped the glass clean and started over. The studio is a capharnaum of chemical bottles,

measuring cups, scales, plastic jugs, books, papers, clippings, dead flies, and, it appears, every speck of dust that has been banished from her other studio (fig. 2). A hundred-year-old behemoth of a camera, capable of holding 15 × 13 ½ inch negatives, towers over it all. On a worktable, Mark Osterman's "The Wet-Plate Process: A Working Guide" is open to the section "Silver Nitrate Solution (also called 'the silver bath')." Spattered and blotted with chemicals and various notations, the well-worn page attests to its frequent consultation (fig. 3). (Indeed, so obscured with stains had this copy become that a second copy was purchased; lying open to "A Basic Positive Collodion for Ambrotypes and Ferrotypes," it too is attracting a colorful patina.)

To learn the ins and outs of making a wet collodion negative, the somewhat cumbersome process that dominated photographic practice from the mid-1850s into the 1880s, Mann could not have found better instructors than Osterman, photographic process historian at George Eastman Museum, and his wife, photographer France Scully Osterman.[2] Mann met "the Ostermen" (as she affectionately jokes) in early 1997 while visiting her daughter Jessie at the George School in Newtown, Pennsylvania. Mark was then teaching photography at the school and France was a photojournalist and editor at the local newspaper. Sally came by their apartment to introduce herself just as the Ostermans' home was filled with framed prints for an exhibition of landscapes—gelatin silver prints from collodion negatives shot the previous summer in Ireland.[3] Mark had just hung France's *Altar Stone* when Mann arrived and, as he recalls, dropped her bag and exclaimed, "Oh fuck! That's what I want to do!"[4] Mann later bought the print from the Ostermans' exhibition, and to this day it sits on the countertop in her work area. It was, she felt at the time, more exciting than anything she had just seen in New York.

It was not the first time that Mann found herself enthralled by collodion. In 1973, when she was barely in her twenties and serving as the school photographer for nearby Washington and Lee University, she stumbled upon some seventy-five hundred

terrain, including her family's swimming hole on the Maury River.[7] As fascinating as the time travel through Miley's negatives was, what stuck in Mann's mind more than two decades later were those pictures where the photographer had accepted unforeseen accidents—uneven coating, imperfect processing, unexpected solarization—or where the ensuing years had left negatives with peeling emulsion or broken glass that bore witness to their forgotten status (fig. 4).

Mann's meeting with the Ostermans came at an auspicious time. She had been photographing the Virginia landscape close at hand since 1992 in a series she eventually titled *Mother Land.* The pictures she made of the hills, pastures, and river closest at hand and most intimately known were imbued with a nearly romantic quality of light, a pictorialist softness, and a falling off of lens coverage that made them appear as if seen through a spy-glass (pls. 22, 23, 27, 28). As she mulled over how to infuse the pictures with the deep sense of history, loss, and death she saw as essential to those fields, woods, creeks, and mountains as well as how to render the refulgent light she saw as characteristic of the Deep South, Miley's negatives—with all of their imperfections—returned vividly to her mind. During 1996 while photographing *Picturing the South* in Georgia in fulfillment of a commission from the High Museum in Atlanta, Mann experimented with Ortho film. She discovered that this high-contrast graphic-arts film could simulate some of the accidental flaws she found so intriguing on nineteenth-century plates if she photographed using old, uncoated lenses and processed her film without the meticulous care she had lavished on the *Family* pictures. "When the time came to develop the negatives, if there was a tray of used-up print developer headed for the drain I'd just slop the ortho in it; no pre-soak, no painstaking temperature control, no replenishment, and, best of all, no darkness. Ortho could be processed under the safelight."[8] The results were just the sort of expressive technical failures she had hoped for—"almost pure vapor: the whiff of dark loss and neglect"[9] (fig. 5).

glass negatives stacked against the walls and in piles and boxes on the floor—"unsheathed, coated with dust, scratched, and sometimes broken, glass shards scattered about the rough-hewn flooring"—in the attic of the journalism building on campus.[5] The glass plates, ranging in sizes up to 16 × 20 inches, were the work of Michael Miley, a returning Civil War soldier from Rockbridge County who photographed Lexington, Washington College and Virginia Military Institute students, and, most famously, Robert E. Lee and his family.[6] Over the next two years, as Mann cleaned and catalogued Miley's negatives and printed more than one thousand of them, she recognized bits of the local

3 / Mann's copy of Mark Osterman's *The Wet-Plate Process: A Working Guide,* courtesy of the author

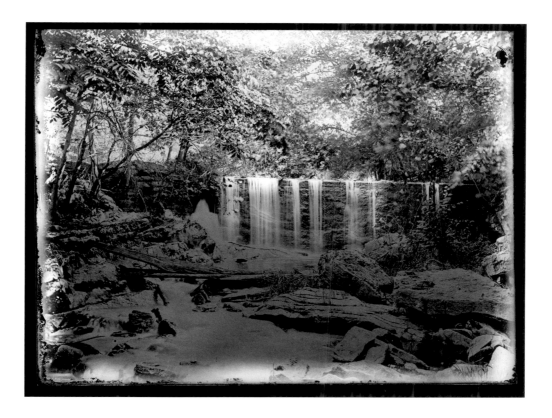

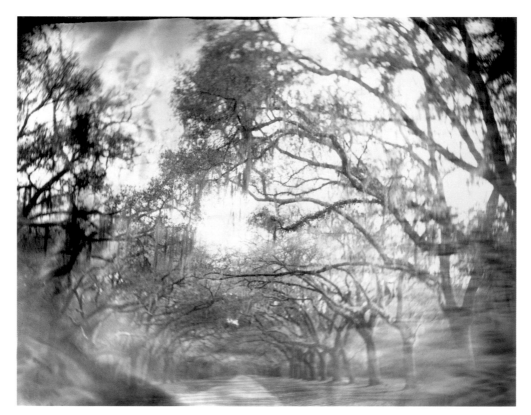

4 / Michael Miley **Untitled** c. 1890s, courtesy of Sally Mann

5 / Mann **Georgia, Untitled (Allée)** 1996, courtesy of the artist

As liberating as the work with Ortho had been, France's *Altar Stone* opened a door of possibility. Mann had now found guides to help her make the "technical and aesthetic leap" to wet-plate collodion. She invited the Ostermans to Lexington the following summer to teach her the basics of wet collodion and to help set up a darkroom appropriate for the process. "This required a complete retooling: an 8 × 10 inch camera set up especially for wet plate with custom-made film holders sized for glass…and a collection of esoteric and explosive chemicals," wrote Mann.[10]

"Naturally Sally wanted to start with 8 × 10 inch plates, while shooting the most difficult thing possible," recalls France. "She aimed our camera downward over the swimming pool—which was alarming, as our portrait lens is quite heavy. She had her husband take off his clothes and jump in, and photographed him floating underwater. This would be a difficult shot under any circumstances, and of course practically impossible with collodion not only because of color insensitivity [blue registers more quickly than other colors on collodion] but also because of movement."[11] Nevertheless, she persisted (fig. 6).

Although the wet-plate process had never completely died out, few artists were adept at it (or even cared to be) by the later 1990s aside from those who had attended the Ostermans' workshops at Eastman House, which had begun in 1995. The process dated to the early years of the medium, introduced by the British photographer Frederick Scott Archer in 1851.[12] Within a few years it had almost entirely replaced the two initial photographic processes announced to the public in 1839: daguerreotypes, one-of-a-kind photographic images made directly in the camera on highly polished, silver-plated sheets of copper, sensitized in iodine and developed in mercury fumes; and talbotypes, negative images on photosensitized sheets of fine writing paper, from which numerous positive images could be printed. Daguerreotypes were magically precise, but the images could be hard to see, the materials were expensive, and the surface of the finished plates was fragile if not bound behind glass. Talbotypes had the

distinct advantage of yielding numerous prints on paper from a single negative, but they lacked the daguerreotype's dazzling detail since the paper of the negative often imparted a fibrous texture to the finished image. Wet collodion negatives seemed to offer the best of both worlds—a degree of clarity close to that of the daguerreotype combined with the economy and reproducibility of the talbotype.

The wet-plate process is an involved one, requiring practice and mastery of a series of manipulations, which become exponentially more difficult as the size of the negative increases, as well as an on-site darkroom. The process is hard enough for studio portraits, but harder still when working in the field in a dark-tent or mobile facility (the retrofitted back end of a Suburban, in Mann's case). Manuals from the wet collodion era present myriad recipes for the various chemical solutions—the collodion itself, sensitizing agents, developer, and fixer—each of which an experienced photographer may tweak according to the temperature and humidity, subject, working conditions, and of course aesthetic preferences.

6 / Mann **Larry in Pool** 1997, courtesy of the artist

The instructions in Mann's well-worn copy of the Osterman guide were gleaned from many nineteenth-century sources and updated for the present day. (It is now common, for instance, to purchase plain collodion and to dilute and salt it, rather than to make one's own collodion by soaking cotton wool in sulfuric and nitric acids, washing and drying it to produce highly flammable guncotton, and dissolving it in ether and alcohol.)[13] In brief, after having prepared the various solutions, there are ten basic steps in the process:

1. Clean a sheet of glass.

2. Pour collodion containing potassium iodide and cadmium bromide onto the glass plate. Allow the collodion to flow to all corners and drain the excess (fig. 7).

3. When the film sets, place the coated plate in a solution of silver nitrate in the darkroom.

4. Remove the sensitized plate, drain it, place it in a negative carrier, and place the carrier in the camera.

5. Make the exposure.

6. Back in the darkroom, develop the plate by pouring a solution of iron-based developer (ferrous sulfate) onto the surface. ("Flowing the developer across the plate is the most capricious and sometimes frustrating step, affected by the temperature, the speed of the flow, and other factors," laments Mann.)

7. Stop the development by pouring water onto the plate.

8. Fix the plate in sodium thiosulfate (popularly called "hypo").

9. Wash the plate to remove the hypo.

10. Dry and varnish the plate. (Mann uses a nineteenth-century type of varnish, sandarac, but suspects that a modern varnish would work just as well. Although the varnish can change the image, this step is necessary to protect the delicate surface of the photographic image.)[14]

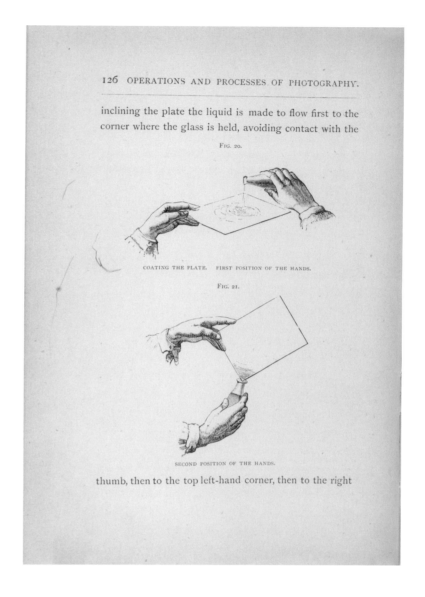

126 OPERATIONS AND PROCESSES OF PHOTOGRAPHY.

inclining the plate the liquid is made to flow first to the corner where the glass is held, avoiding contact with the

FIG. 20.

COATING THE PLATE. FIRST POSITION OF THE HANDS.

FIG. 21.

SECOND POSITION OF THE HANDS.

thumb, then to the top left-hand corner, then to the right

Each of those steps is, as the reader may guess, more complicated than it sounds. Manuals from the period contain hundreds of pages of detailed instructions, all meant to be followed to the letter. Without meticulous cleaning of the glass plate, without the smoothest of motions in coating the plate or pouring the developer, without guarding against the slightest impurities in the mixing of chemicals, and without rigorous

7 / Coating the plate, illustrations from Gaston Tissandier, *A History and Handbook of Photography* (London, 1876), courtesy of the Library of Congress, Washington

attention and discipline in every step, the negative might be ruined. And even for those exercising the greatest care, success was not guaranteed: "It often happens," declared one treatise, "that the operator searches in vain for the cause of imperfections on a negative which he has executed with the utmost care; it is impossible to lay down fixed rules in this regard. The photographer, like the chemist, must be patient, persevere, and resort always to that great teacher we call experience."[15]

Taking to heart these instructions, Mann practiced the steps with a nearly religious adherence: "Polishing the glass with a compound so ancient that the tin had a thirty-nine-cent price tag on it from a long-extinct hardware store, I welcomed the stupefaction produced by the humble buffing motions," wrote Mann. "Preparing to 'flow the plate,' I would reverently unscrew the collodion bottle and when it emitted its fragrant hiss of heavy ether take a lungful. Then with the splay fingered grace of a French waiter carrying a tray, I balanced the glass plate and poured the thick amber collodion onto it, watching for the chilly frisson as the ether evaporated."[16]

Surely, with modern supplies and equipment, time-tested formulas, and experts in the technique to guide her, a photographer as experienced as Mann would master the process. How is it, then, that after two decades of working with collodion, Mann's negatives are such a mess? "I'm no Carleton Watkins," she confesses happily, referring to the great nineteenth-century photographer of the American West whose mammoth wet collodion negatives represent the pinnacle of technique. Lining up her bodies of work in chronological order, one might imagine that it was exactly backward, for the technical accomplishment seems to move from mastery to messiness over the course of time. This, of course, is no accident, for what had attracted Mann to the process in the first place was not clarity of rendition — which was so key for photographers in the 1850s and can now be achieved far more easily on film — but rather the very flaws that she saw on the edges of Miley's negatives and Osterman's *Altar Stone* and that inevitably appear on the glass plates of a

novice. Another question is more appropriate: How — and more importantly *why* — has Mann found a way *not* to perfect her technique after two decades, but rather to allow chance and accidents to continue playing a role?

The *how* is relatively simple: "I encouraged accidents any number of ways. I read *The Silver Sunbeam*[17] and did whatever it said not to do," recalls Mann, referring to a popular treatise of the 1860s. "A big deal was made of the plate being absolutely clean, for instance, so I stopped cleaning the glass. 'Don't let a drop of fixer get in the collodion,' it said, so I would." That may sound like the rebellious teen that Mann once was, but now there was real purpose behind her violation of the rules.

First, it opened new avenues in the creative process. "It was so freeing not to care," says Mann. "It brought the fun back.... It may be antithetical to what Mark and France believe, but it's transporting, doing it by touch — by emotional, aesthetic feel. You have to readjust because you want it to work, and some steps are important to not fuck up, but usually, letting it flow, working in this transcendent way, allowing the picture to happen the way it wants to, that's when collodion is really almost a religious experience, it transcends technique, becomes pure expression, liquid expression."[18]

Second, Mann has found that when photographing people — especially for the recent *Men* series, where she and her subjects barely knew one another — it puts them at ease, breaks down barriers. Compared with using sheet film (not to mention digital!), collodion makes the whole process "slower and so much more primitive and basic," she says. "I'm so much of a goof when I do it, it must be comical to watch me. It helps humanize what otherwise can be an awkward conversation." In other words, Mann's choice of collodion in this case was about not only the final result but also the process, transforming an experience that could be intimidating (posing for a stranger before a mammoth view camera) and a relationship that might be adversarial into one of ease and collaboration. She likens it to the stories she has heard of Diane Arbus, who purposely appeared

clumsy on occasion in order to make her subjects feel comfortable or even superior.

And third, Mann's use of collodion has an inevitable association with the past, particularly that part of history that haunts so much of her own work—the Civil War. American landscapes of the 1860s, documentation of the war and its aftermath, even the period's portraiture, all were either printed from collodion negatives or produced as collodion positives. "When I was shooting with collodion, I wasn't just snapping a picture," Mann has asserted. "I was fashioning, with fetishistic ceremony, an object whose ragged black edges gave it the appearance of having been torn from time itself."[19] This sense of history being embedded in the imperfections of the process had been brewing in Mann's mind since first seeing Miley's negatives. "I'm sure he'd be appalled by the shoddy technique of my pictures and the way I am inspired by what, for him, were probably his most embarrassing failures, the overexposed, weirdly stained, solarized, and fogged images that he, for whatever reason, didn't scrape from the glass," Mann now muses.[20]

Outfitted with a supply of explosive chemicals and a makeshift darkroom in her SUV (fig. 8), Mann set out for Alabama, Louisiana, and Mississippi in 1998. *Deep South*, a natural follow-up to the pictures she had shot on Ortho in Georgia, was her first body of work using collodion. In some pictures (pls. 26, 31) the pooled silver at the edges, the tide lines and ripples of chemistry, the "comets" where dust interrupted the smooth flow of the collodion, and the peeling emulsion give the impression that Mann's negatives have suffered the same history as the subjects they portray—precisely the sense of time she hoped they would embody.[21]

In *Last Measure*, the 2000–2003 series that followed *Deep South*, Mann exploited the vagaries of collodion to the extreme, submerging the dark, blood-soaked landscapes of Antietam, Manassas, Fredericksburg, and Wilderness in scratches and swirls of chemistry (see, for instance, pls. 33, 34, 36, 37, 40, 42). The barely penetrable darkness of these pictures not only approximates the look of a negative buried for a century and a half but equally

suggests the fading vision of those for whom the battlefields literally became a burial place.

Despite the visual, tactile, and historical appeal of working with collodion, Mann was not tempted by the print processes that, in the nineteenth century, would have been paired with glass negatives—salted paper prints or albumen silver prints, both of which were warm toned and contact printed. While welcoming the historic associations conjured by her purposely imperfect collodion negatives, she was not searching for a way to make "ye olde" photographs, remarking that to do so would have been "too old-fashioned, too affected, and not necessarily the best thing for the image." A modern artist, not a Civil War reenactor, Mann wanted her art to reference the past, not imitate it, so scale and print medium, allied to vision, were a means of remaining planted in the modern world while evoking the past. The enveloping scale of Mann's *Deep South* landscapes, like *Mother Land* before and *Last Measure* after, is wholly contemporary in feel,[22] and despite having been dipped in tea to soften the highlights and suggest a certain patina of age—"carefully treading the line between the old-fashioned sepia look, which I abhor, and the necessary egg-shell warmth,"[23] as Mann wrote at the time—their palette remains unmistakably present day. "I just love gelatin silver paper," she says. "I think everything looks better on black-and-white paper."

In 2006, following a horseback riding accident that left her barely able to move for months, Mann turned to the subject closest at hand—herself—and used her now-familiar collodion in a new way—to make direct positive images. Years earlier, when sorting through the Miley negatives, she had observed the way some of the underexposed or fogged negatives could be read as positive images when placed against a black background[24]—a phenomenon observed and exploited in the nineteenth century as well. Such collodion positives were called ambrotypes when the glass plate was encased with a dark backing, most commonly velvet, or its back painted with a black varnish; ruby ambrotypes when the collodion image was made directly on

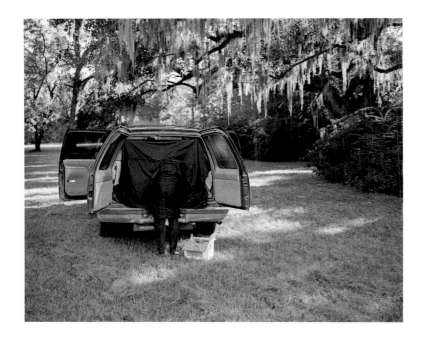

dark, rather than clear, glass; and tintypes or ferrotypes when the collodion image was made directly on a thin black-lacquered sheet of iron. In each case, the resulting photograph was unique, made in the camera directly on its support of glass or metal, and rendered in milky tones of varying opacity. In the nineteenth century, these poor cousins of the daguerreotype were most often presented in the same manner as their more dazzling predecessor—in a small leather case, bound behind glass with an elaborately decorated brass mat (fig. 9). If they lacked some of the magic of the daguerreotype, they were nonetheless easier to read and more simply and economically produced, making them accessible to a wider audience.

For Mann, collodion positives had a particular appeal: they were "primary sources," singular objects. Each ambrotype or tintype[25] was a direct imprint, rather than a matrix from which to print positives on paper that would be a further step removed from their real-world subjects.[26] Even more than in her prints from collodion negatives, the hand of the artist and the trace of the chemistry were visible; the photograph was not a clear window through which to view the world, but a palpable material on which the features imprinted themselves like the face of Christ on Veronica's veil. Mann liked, too, that each of the many ambrotype self-portraits she made beginning in 2006, for example, was by definition unique; ganged in grids, as she has often presented them, they form a crowd of identical but individual faces (pl. 102).

There is a skin-like quality to the collodion emulsion sitting on the smooth black surface of her ambrotype or tintype self-portraits, a visual and tactile equivalent of the human surface they depict.[27] Mann seems to have acknowledged that parallel in her nearly abstract series of neck-and-torso self-portraits, where the flaws in the collodion surface vie forcibly with the photographic image (fig. 10). She titled the 2006–2009 series *Thin Skin*. If Mann's use of wet-plate negatives for her southern landscapes inevitably evoked a sense of history and loss, the passage of time was every bit as present in her portrait and figure work, as though

8 / R. Kim Rushing, Mann's field darkroom in the back of an SUV, c. 1998, courtesy of the artist

9 / American 19th Century **George E. Lane, Jr.** c. 1855, National Gallery of Art, Washington, Gift of Kathleen, Melissa and Pamela Stegeman

the word *mortality* were mixed into the very solution of gun-cotton and ether. In both collodion positives and prints from collodion negatives, one senses the fragility of flesh and reads the flaws of the emulsion as metaphors for the wounded body (pls. 112, 113). Mann knew, of course, that collodion was used beginning in the mid-nineteenth century to dress wounds, covering fresh sutures with a layer of artificial skin.[28]

Having discovered the immediacy and tactility of ambro-types and tintypes, Mann naturally wanted to delve into the

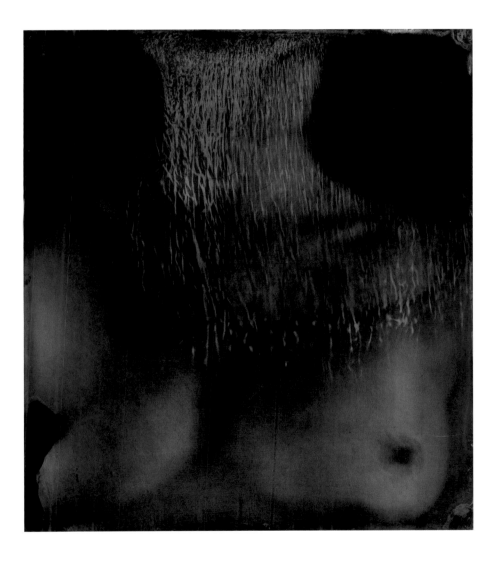

way they render the landscape. In 2008 she began to record the Blackwater and Nottoway Rivers and the Great Dismal Swamp, the inhospitable area in southeastern Virginia where freed and escaped slaves sought refuge in the antebellum era. The lugu-brious landscapes she made as part of her continuing exploration of the legacy of slavery show a visually confusing world of reality and reflection, strong contrasts, and heavy atmosphere, all interwoven with the artifacts of the tintype process. The standard challenges of working in the field are daunting enough, though some photographers in the nineteenth century had managed— with enormous difficulty—to work with very large wet-plate negatives in conditions as extreme as the Egyptian desert and the summit of Mont Blanc: the larger one's plates and the more divergent the climate from one's accustomed conditions, the more formidable the task. Mann had journeyed through the South with her traveling darkroom in the late 1990s and early 2000s, but had never attempted collodion plates larger than 8 × 10 inches, though in the studio, she had been making 15 × 13 ½ inch self-portraits.

Examining Mann's large *Blackwater* tintypes, one may easily envision the heroic effort that would be entailed in transporting and manipulating the mammoth camera and carrying out the various tintype operations in the Dismal Swamp. "Can't we just let people imagine me in waders, shooting with the big camera?"[29] Mann asks half plaintively, half tongue in cheek, before confess-ing: Heroism was not the point—picture making was; and she had options her heroic predecessors did not. The *Blackwater* pictures were shot digitally in color, tweaked on the computer, printed, and then rephotographed in the studio as tintypes with that hundred-year-old behemoth of a camera (fig. 11).[30]

That Mann shot in color was important because part of what she liked about collodion, part of what made her prints from wet-plate negatives and her ambrotypes and tintypes look different from pictures shot on film, was the way it renders color. Collodion is not panchromatic, not equally sensitive to all colors of the spectrum: blue, violet, and ultraviolet register

10 / Mann **Untitled (Thin Skin)** 2007–2008, courtesy of the artist

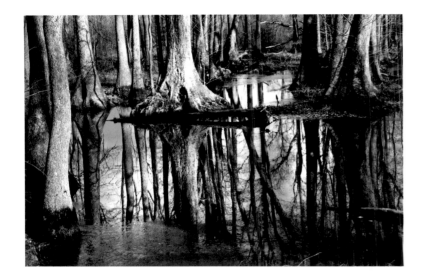

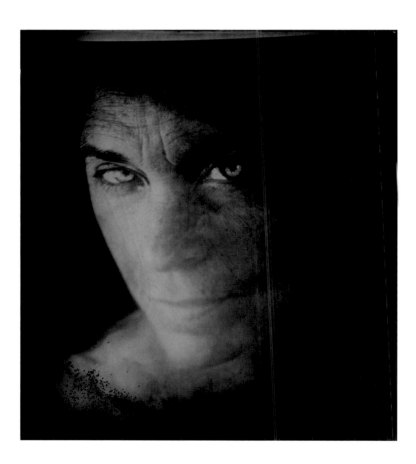

most strongly (hence the blank sky in most nineteenth-century landscapes), while green, yellow, orange, and red barely register at all and consequently end up reading as black.[31] Knowing how her collodion would translate a color image into its own rendition of black and white, Mann could adjust the color balance of her digital print for the desired effect. Beginning in about 2011, she followed the same strategy to extend the expressive potential of her tintype self-portraits—shooting in digital, manipulating the color on the computer, printing, and rephotographing on collodion—sometimes wildly changing the image colors to yield unsettling and seemingly inexplicable results on the finished tintype (fig. 12).[32]

Mann has thus been working in opposite directions simultaneously. One day the creative process may start with a wet-plate negative, made with a carefree acceptance of accidental processing artifacts but intended to be printed with meticulous care in her lab-like darkroom. Another day, the process may work in reverse, as she massages her source imagery in the dust-free realm of Photoshop to create an image that then serves as the matrix for a collodion positive, with all those welcome elements of chance coming at the conclusion rather than at the outset.

For some artists, bringing together the most modern photographic technology and one of the medium's oldest processes would be enough and would be proudly touted as a deep reflection on the changing nature of photography itself. But Mann kept that fact to herself—not because it was cheating in any way, but because it was irrelevant to the actual meaning of those landscapes and self-portraits. The process, moving from digital to collodion, was never the idea itself; it was always in the service of larger ideas about history, conflict, the land, memory, identity, mortality—the profound forces that shape life and culture.

11 / Mann **Digital Blackwater, 25** 2009 courtesy of the artist

12 / Mann **Untitled (Self-Portrait)** 2006–2012, courtesy of the artist

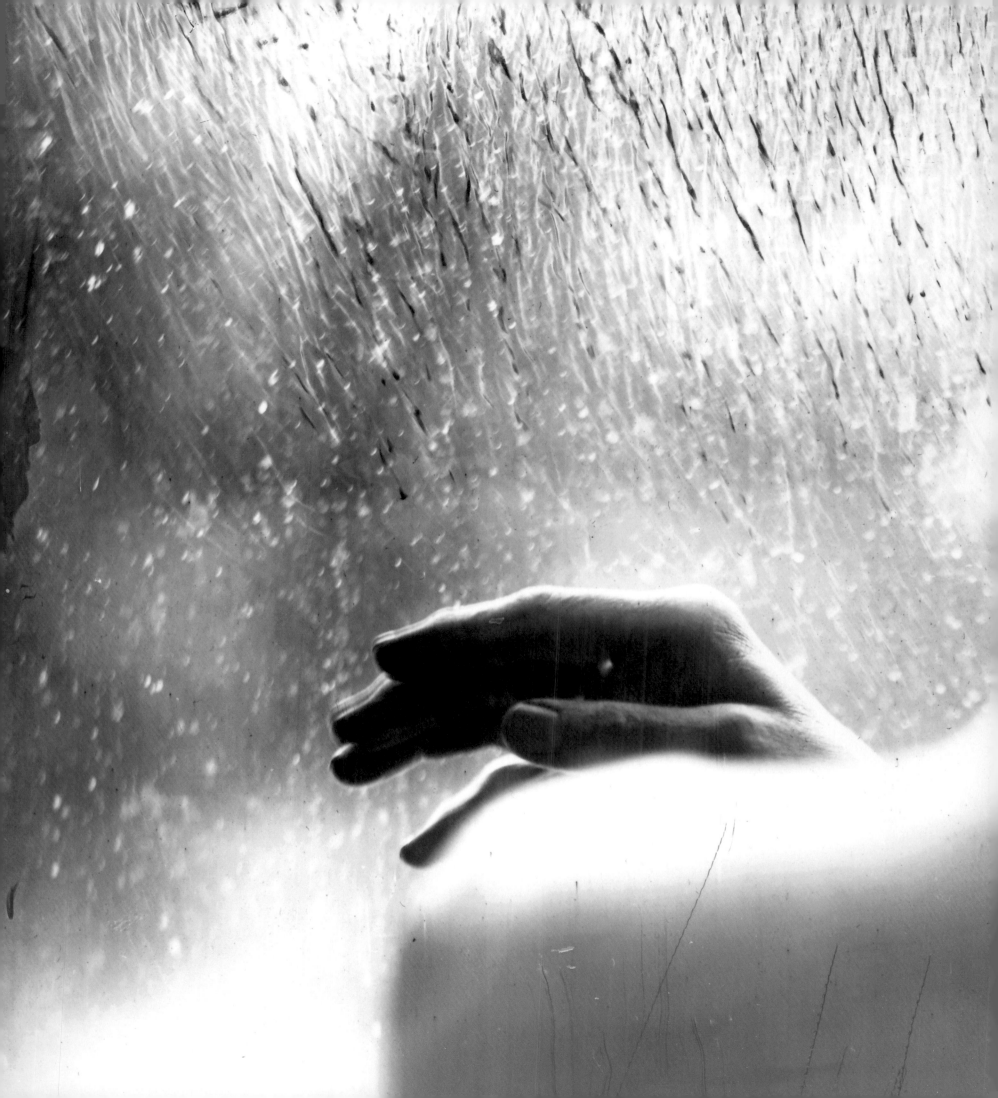

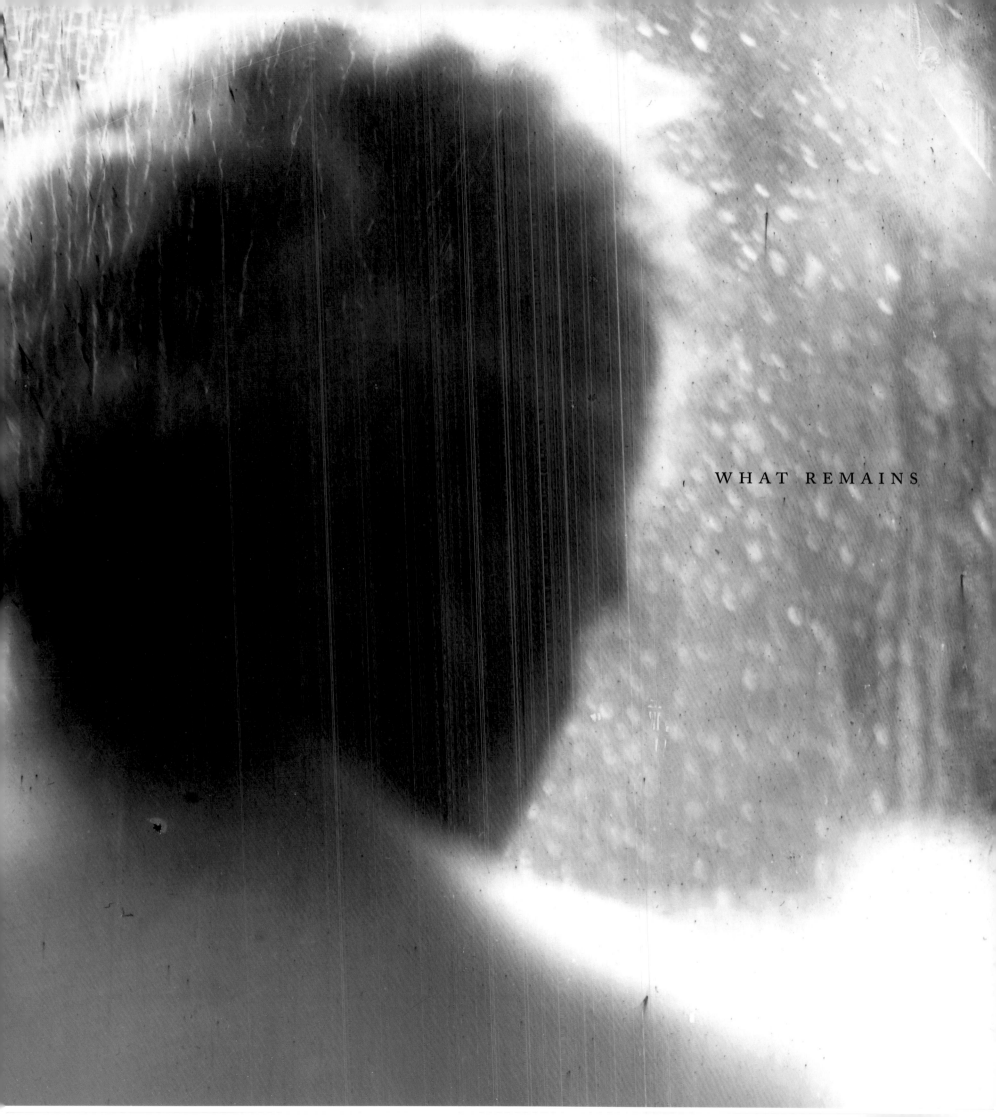

WHAT REMAINS

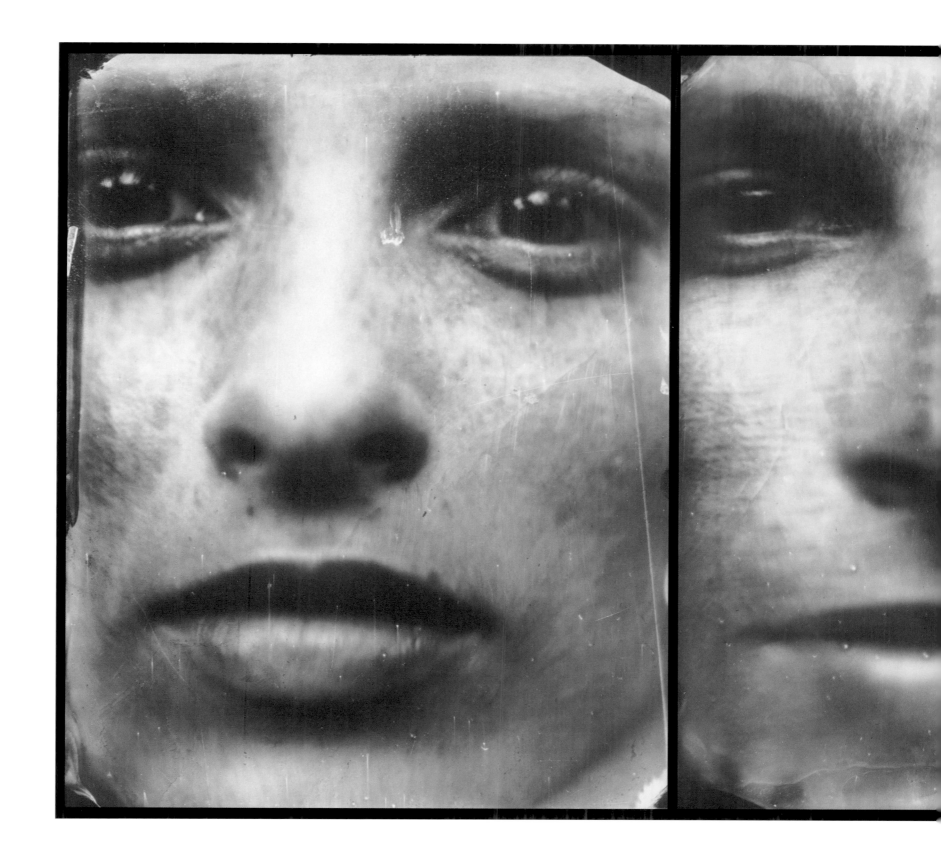

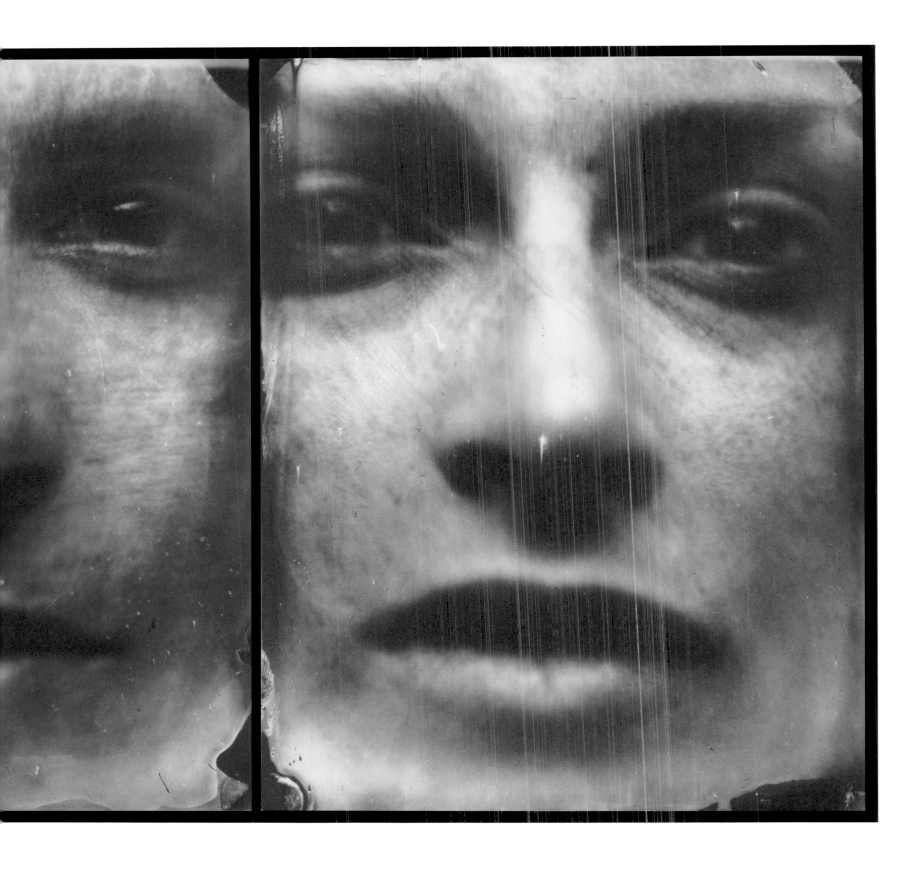

plate 103 / **Triptych** 2004

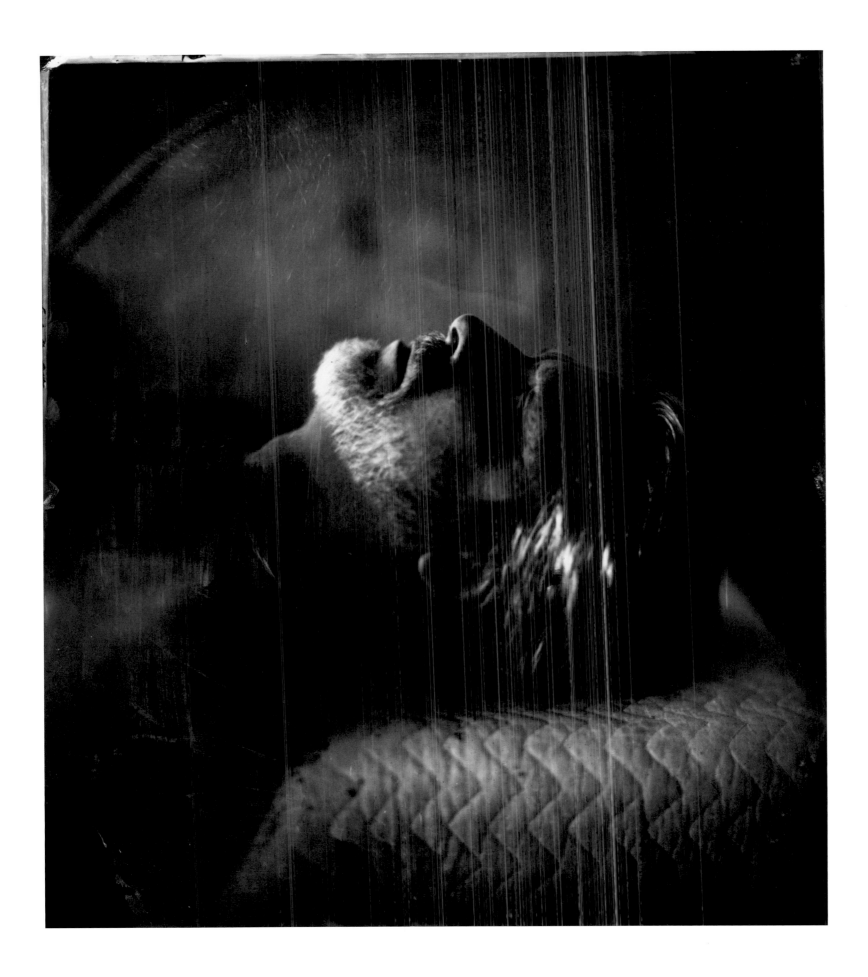

plate 105 / **Was Ever Love** 2009

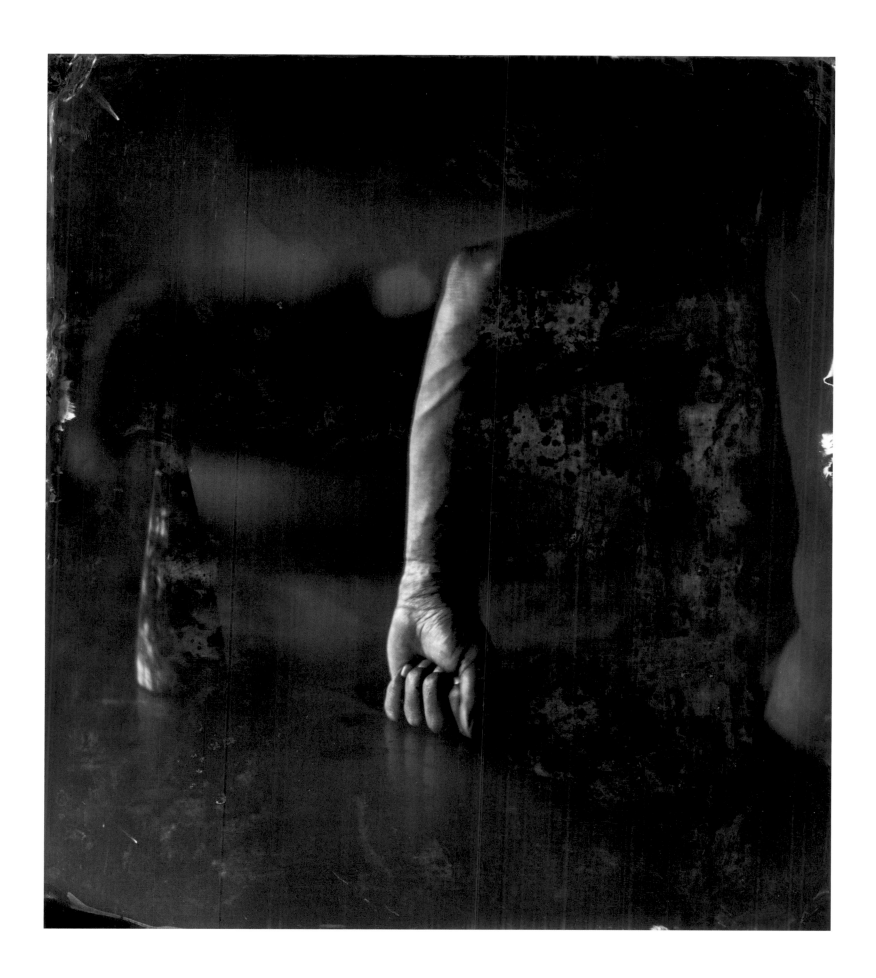

plate 106 / **Memory's Truth** 2008

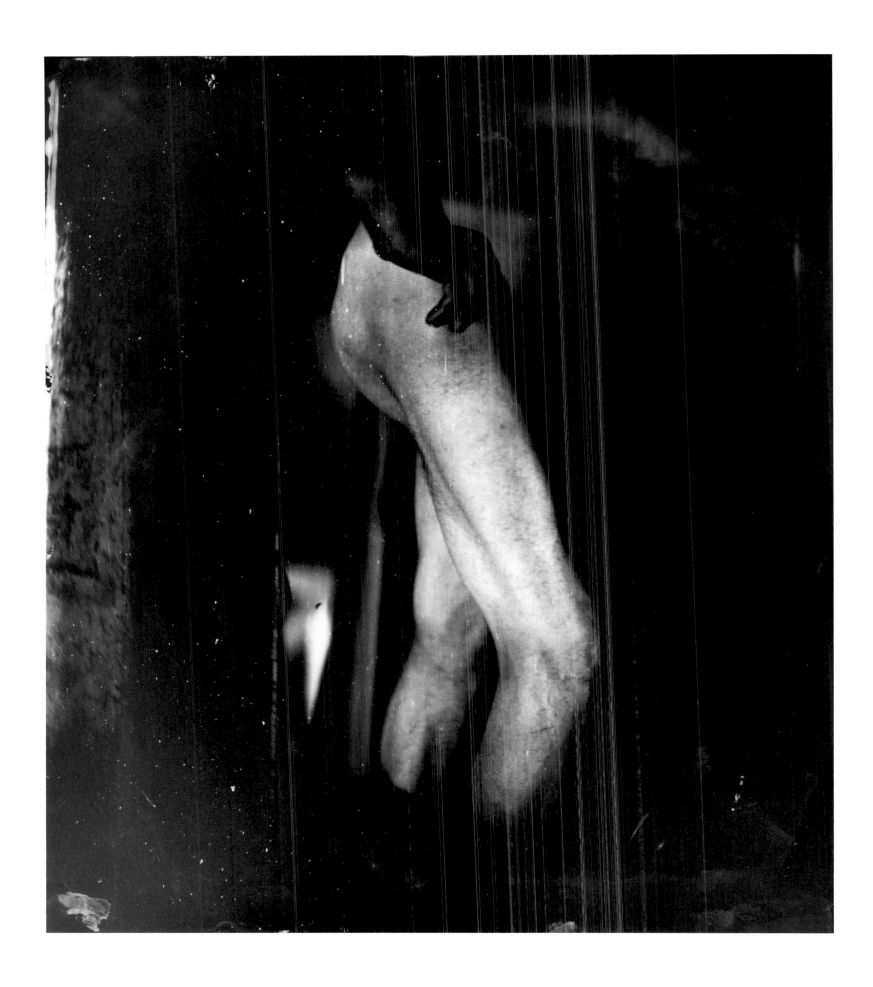

plate 107 / **David** 2005

plate 108 / **Time and the Bell** 2008

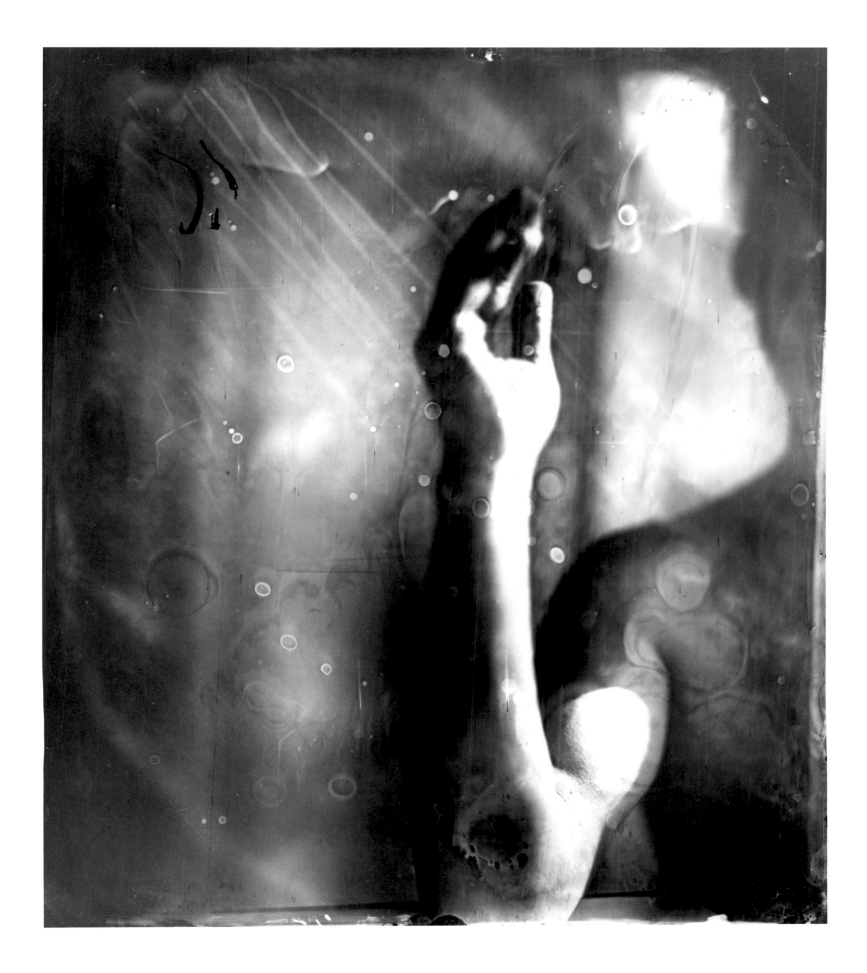

plate 109 / **Semaphore** 2003

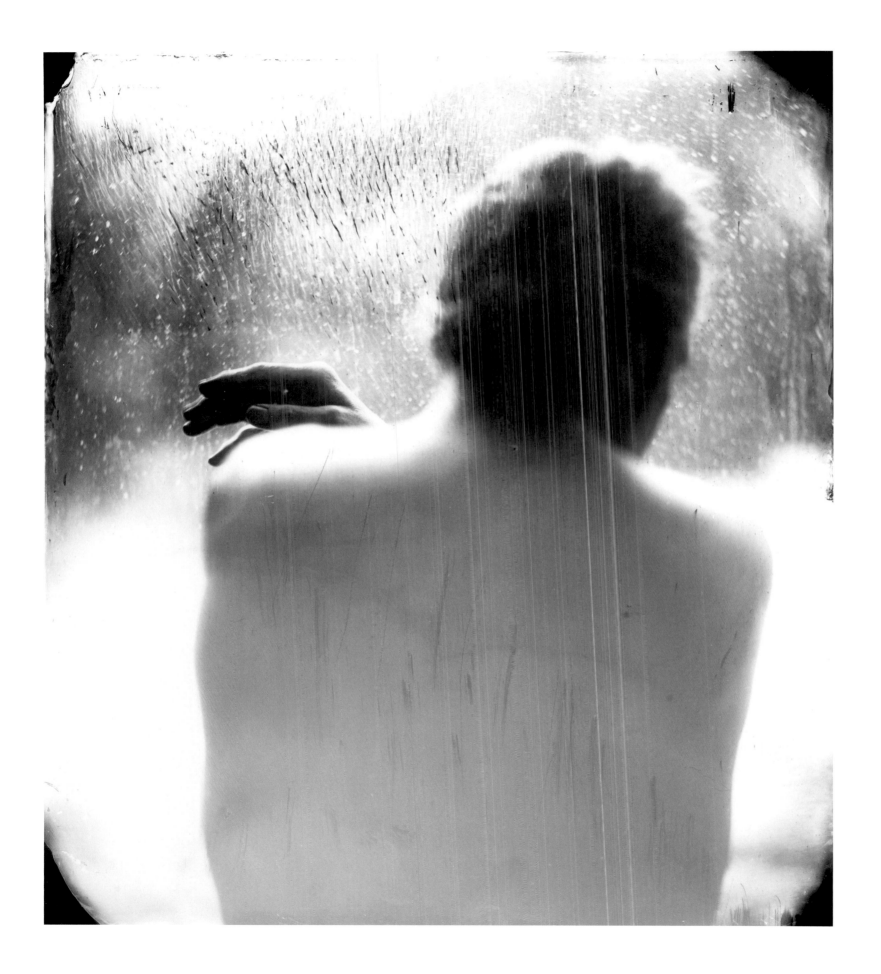

plate 110 / **Ponder Heart** 2009

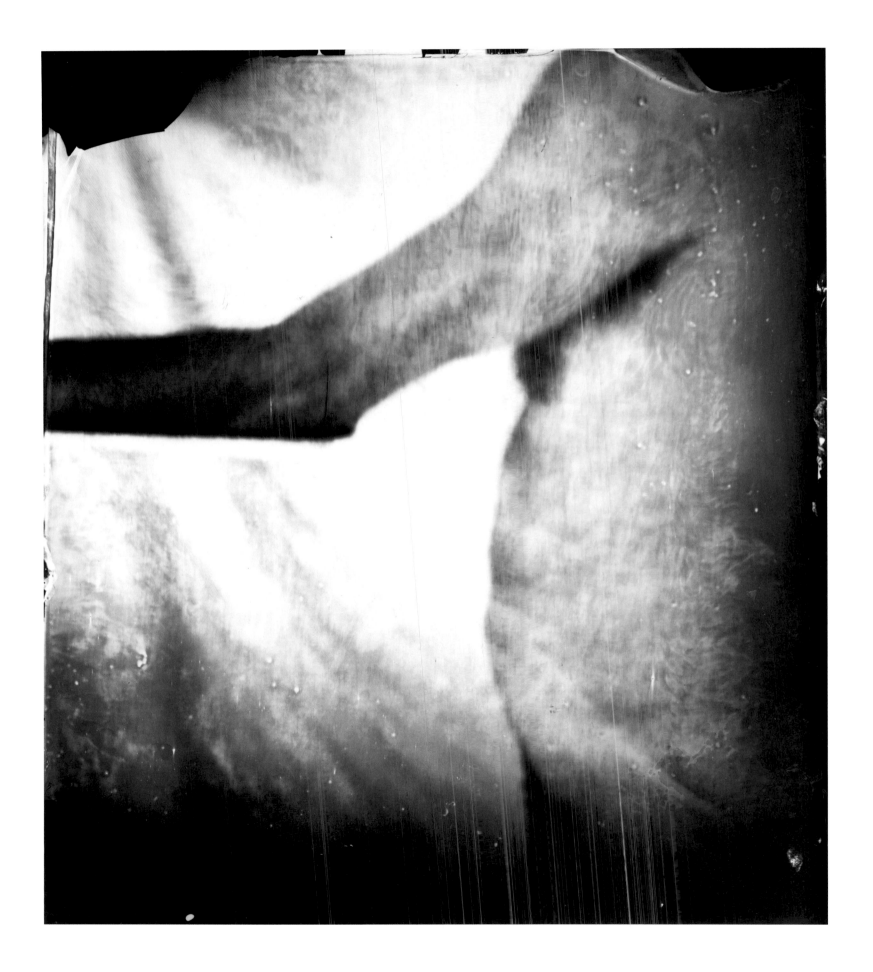

plate 111 / **Thinner** 2005

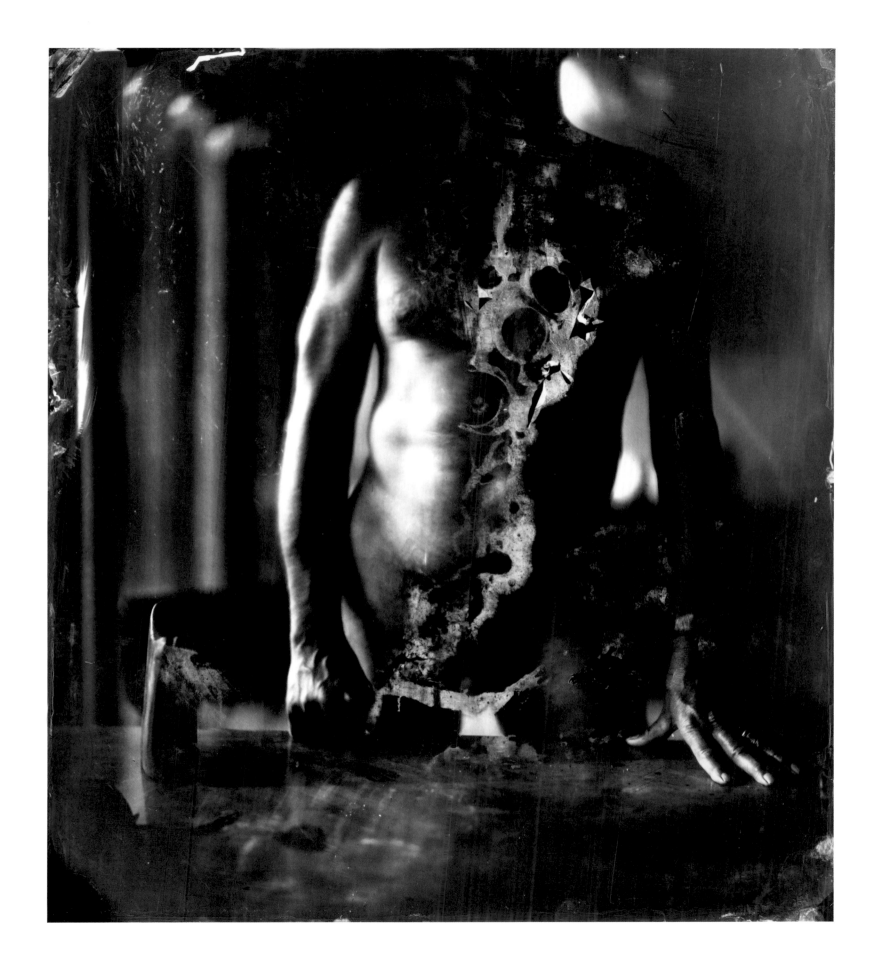

plate 112 / **Hephaestus** 2008

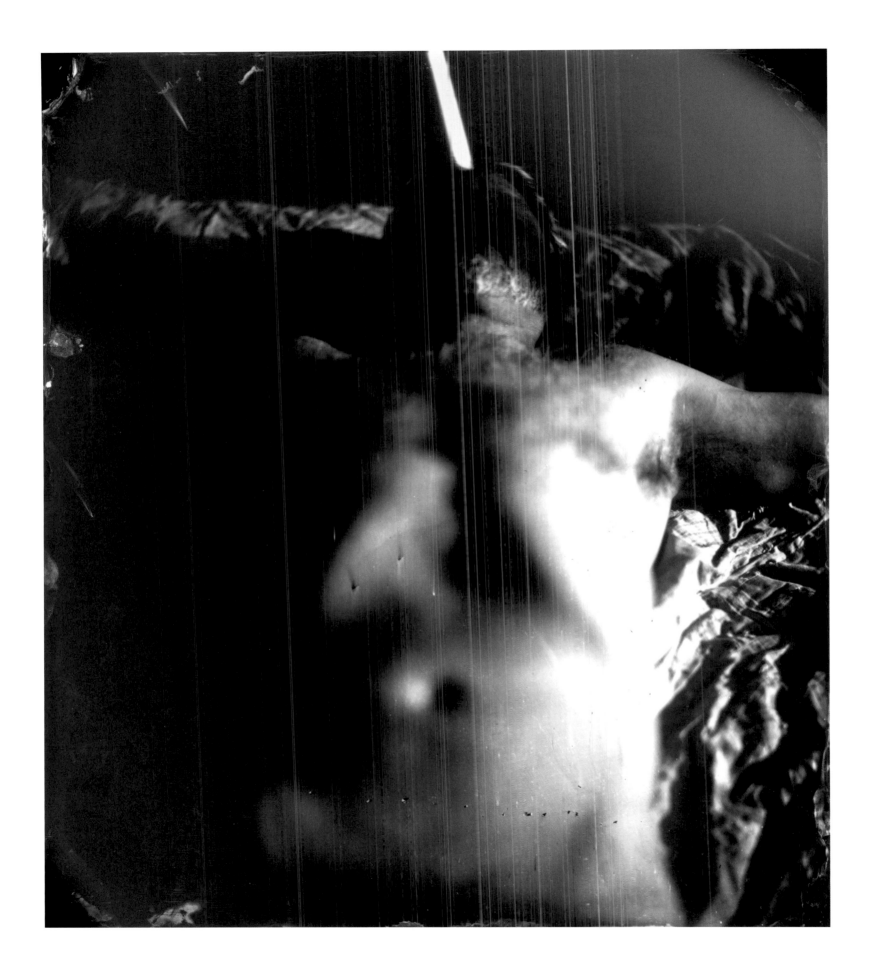

plate 113 / **Speak, Memory** 2008

 nothing matters but the quality
of the affection —
in the end — that has carved the trace in the mind
dove sta memoria

EZRA POUND, 1947

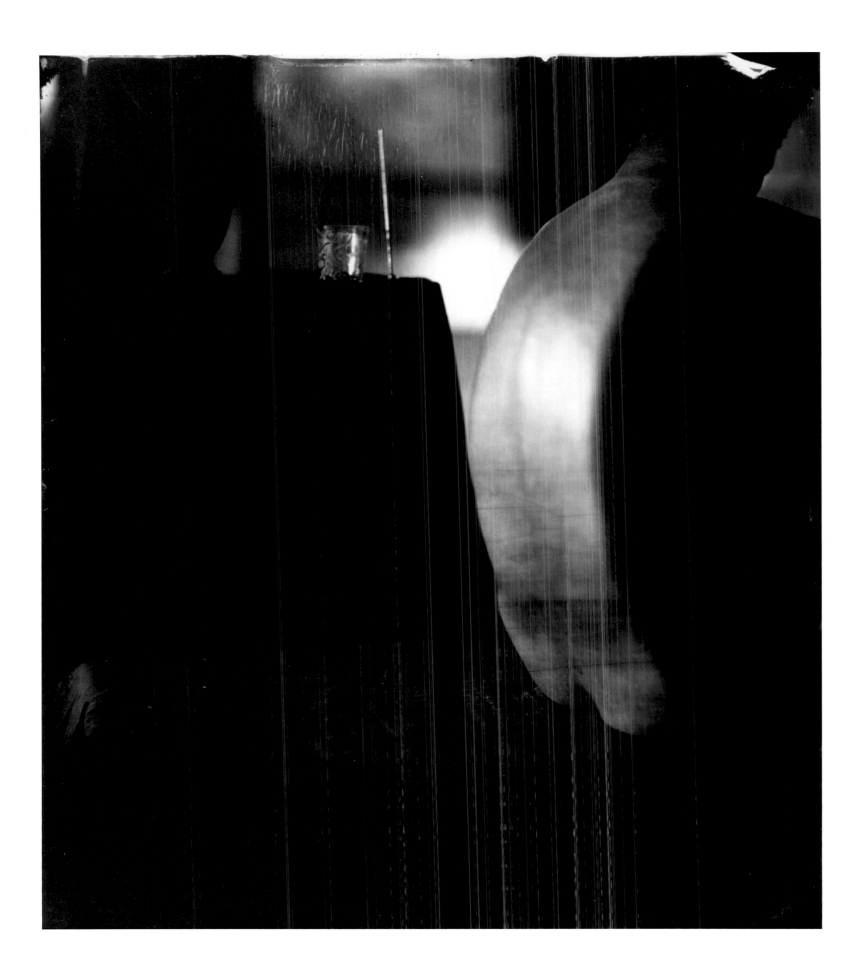

plate 114 / **The Quality of the Affection** 2006

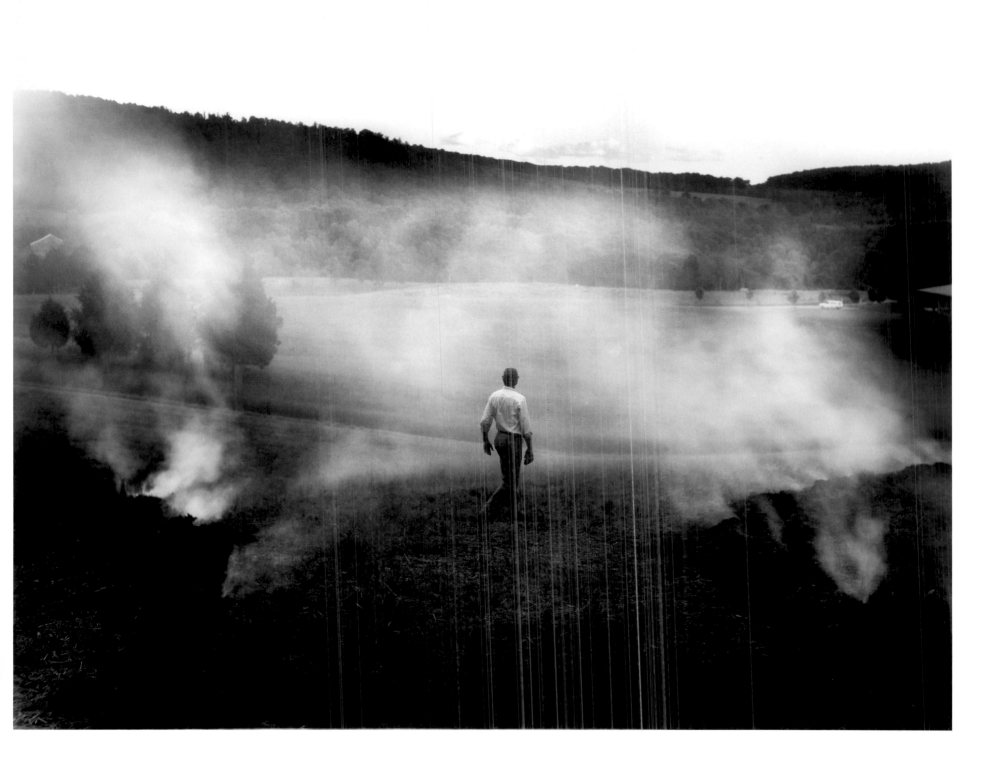

plate 115 / **The Turn** 2005

Chronology **ANNA WIECK**

1951 May 1 / Sally Munger (Mann) is born in Lexington, Rockbridge County, Virginia, to Dr. Robert S. Munger (born 1911), a general practitioner in Rockbridge County, and Elizabeth Evans "Betty" Munger (born 1916). Two brothers, Robert S. Munger, Jr., and Christopher E Munger, are nine and seven years older, respectively.

The Mungers purchase twenty-one acres of land on Ross Road in Lexington.

1952 The Munger family moves into a new house, designed by a Roanoke architectural firm, on the Ross Road land. Throughout the following decades Robert, Sr., undertakes a major planting program, growing both indigenous and exotic species. The property is eventually dubbed Boxerwood in honor of his beloved trees and boxers. In 1997 it opens to the public as Boxerwood Nature Center & Woodland Garden.

1960 Robert, Sr., purchases 364 acres of farmland just outside Lexington. Allowing the original owners to continue farming, the family builds a cabin on the banks of the Maury River where they, and later the Manns, spend their summers. Robert, Sr., deeds the land to Sally and her brothers in the 1980s.

1966 September / Sally attends the Putney School in Vermont.

1967 Elizabeth becomes a manager at the Washington and Lee University (W&L) bookstore, in Lexington, remaining until 1983.

1969 Sally visits the subsistence farm of Helen and Scott Nearing in Harborside, Maine, with her parents.

January / Robert, Sr., gives her the Leica III camera that he had used on his 1938–1939 travels throughout Europe and Asia.

April / Develops first roll of film. The majority of the photographs are of the Rockbridge County landscape.

May / Develops second roll of film, featuring nude studies of two classmates, one week before graduating from Putney. Narrowly avoids expulsion.

Summer / Studies Spanish in San Miguel de Allende, Mexico, and travels throughout the country.

September / Enrolls at Bennington College, Vermont.

December / Meets Larry Mann, a philosophy student at W&L.

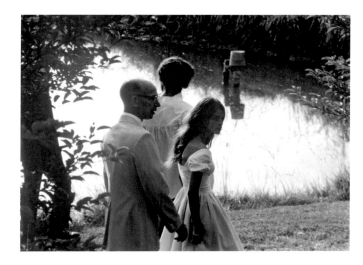

1970 January / Participates in Bennington's nonresident term in Harlan County, Kentucky, with Frontier Nursing Service. On horseback, accompanies nurses on their mountain medical visits, caring for the horses and photographing surroundings.

June 20 / Marries Larry Mann.

Group Exhibitions / Bennington College, Vermont / Middlebury College, Vermont.

1971 Studies with photographer Norman Seeff at Bennington College.

Receives first commission: a photograph-portrait of her classmate the princess Yasmin Khan, daughter of Ali Shah Khan and Rita Hayworth.

Begins *Landscapes* series (completes 1975).

Completes first photographic series *Dream Sequence*.

Studies abroad for her junior year through Friends World College. Travels with Larry from Denmark to Greece, bringing along a 5 × 7 inch view camera and studying photography at the Praestegaard Film School in Fjerritslev and poetry at the Aegean School of Fine Arts in Páros.

1972 Manns return to Virginia.

Summer / Begins working part-time as photographer at W&L.

Fall / Enrolls at Hollins College, Roanoke, Virginia.

1973 Continues to work part-time at W&L, where she discovers an archive of glass negatives dating from 1865 to 1910 by the photographer Michael Miley. Works to restore, print, and file the work, supported by a Robert E. Lee Research Grant.

June / Poem "Eliza (b. 1827)" is published in the *Hollins Critic*.

Summer / Attends Ansel Adams Yosemite Workshop, California; attends weekend Apeiron Workshop in Photography, Millerton, New York, and studies with George Tice.

Forms with five Adams workshop colleagues (David Bayles, Chris Johnson, Boone Morrison, Ted Orland, and Robert Langham) the Image Continuum, a loose collective of photographers who live across the United States and share work via a limited-edition journal distributed gratis among them.

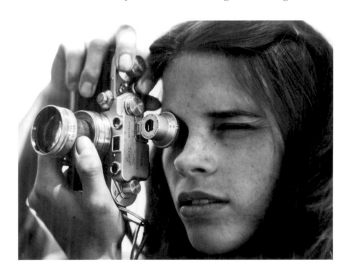

Manns provide overnight accommodations to a stranger stranded at the local Greyhound bus station. As they put him on the bus the next morning, he promises to repay their kindness by sending his grandfather's 8 × 10 inch view camera. Thinking the offer a fandangle, Mann is astonished when it arrives three weeks later. She continues to use the camera to this day.

Solo Exhibitions / Hollins College Art Gallery, Roanoke, Virginia / W&L Gallery, Lexington, Virginia.

1 / Coleman Blake, Wedding walk, 1970, courtesy of the artist

2 / Ted Orland **Mann with Leica** 1973, courtesy of the artist

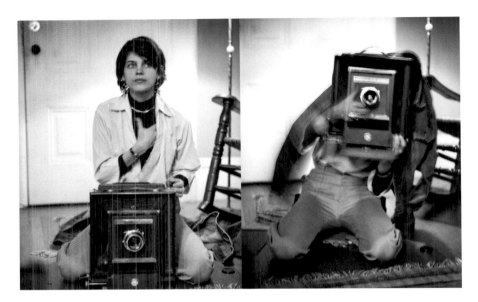

1974 Awarded a Ferguson Grant by the Friends of Photography, to support the work of an emerging photographer.

Teaches at Adams workshop in California.

Becomes full-time photographer at W&L.

Begins *Lewis Law Portfolio* series (completes 1976).

March / Publication of the journal *Image Continuum* 1.

Spring / Earns BA in literature, graduating summa cum laude, from Hollins College.

Solo Exhibition / *Platinum Prints*, Shenandoah Galleries, Lexington, Virginia.

Group Exhibition / *The Image Continuum*, New Roses Gallery, Palo Alto, California, September–October / Sam Houston State University Gallery of Art, Huntsville, Texas.

1975 Manns purchase small tract of land in Lexington, gradually building a home there and making additions throughout the following two and a half decades.

Spring / Earns MA in creative writing from Hollins College. Her thesis, "Early Pictures (Part I), Rebirth at Pisa (Part II)," includes original poetry and an analysis of Ezra Pound's cantos.

June / Publication of the journal *Image Continuum* 2.

Solo Exhibition / *Sally Mann: Prints in Platinum and Silver*, Enjay Gallery, Boston, October 20–November 15.

Group Exhibitions / *2nd Biennial, Exhibition 280: Photography and Cinematography*, Huntington Museum of Art, West Virginia, October 19–November 30 / *1st Lynchburg Juried Photography Show*, Lynchburg Fine Arts Center, Virginia / Roanoke Fine Arts Center, Virginia.

1976 To publish *The Architecture of Historic Lexington* (1977), featuring Mann's photographs, the Historic Lexington Foundation receives a National Endowment for the Humanities Grant.

May / Publication of the journal *Image Continuum* 3, edited by Mann.

Solo Exhibition / The Darkroom Gallery, Denver.

Group Exhibitions / *Image Continuum*, After-Image Gallery, Dallas, March 30–May 1 / *10 Women Artists/Women in Art*, Southeastern Center for Contemporary Art, Winston-Salem, North Carolina, June 4–28.

1977 Begins *Portraits of Women* series (completes 1978).

Mann's 1974 self-portrait (see page 54, fig. 28) is acquired by Olga Hirshhorn, one of her earliest patrons. She, as Mann recalls, saw it in a small exhibition of prints push-pinned to a wall in a university cafeteria in North Carolina and bought it.

3 / **Members of the Original Image Continuum Group (Chris Johnson, Ted Orland, Robert Langham, Sally Mann, David Bayles)** 1974, photograph courtesy of Ted Orland

4 / Ted Orland **Mann with Her 8 × 10 View Camera** 1975, courtesy of the artist

Solo Exhibition / *The Lewis Law Portfolio*, Corcoran Gallery of Art, Washington, September 24–November 13; associated publication.

Group Exhibitions / *Invitational Inaugural Exhibition*, Southeastern Center for Contemporary Art, Winston-Salem, North Carolina / *New Talent Plus*, Marcuse Pfeifer Gallery, New York / *Three Photographers*, Wynn Bullock Gallery, Friends of Photography, Sunset Cultural Center, Carmel, California, November 4–December 11.

1978 Begins series of abstract and nude photographs, which are later printed in platinum.

Solo Exhibition / *Sally Mann*, DuPont Gallery, W&L, Lexington, Virginia, February–March.

Group Exhibitions / *I Shall Save One Land Unvisited: Eleven Southern Photographers*, Virginia Tech, Blacksburg, Virginia; travels through 1981 / *The Male Nude in Photography*, Marcuse Pfeifer Gallery, New York.

1979 Birth of son Emmett.

September / Publication of the journal *Image Continuum* 4, edited by Mann and Orland.

1980 Solo Exhibitions / *Sally Mann / Photography*, Greenville County Museum of Art, South Carolina, December 20, 1980–February 1, 1981 / Northlight Gallery, Herberger Institute for Design and the Arts, Arizona State University, Tempe.

Group Exhibition / *Not Fade Away: An Exhibition of Contemporary Virginia Photographers*, Chrysler Museum of Art, Norfolk, Virginia, March 14–May 18.

1981 Birth of daughter Jessie.

Begins series of abstract photographs in color, later printed on Cibachrome paper.

Solo Exhibition / *Sally Mann*, Benedict Art Gallery, Sweet Briar College, Amherst, Virginia, October 20–November 12.

Group Exhibitions / *The Ferguson Grant Recipients, 1972–1981*, Ansel Adams Center, Carmel, California, July 24–August 23 / *New Color*, Southeastern Center for Contemporary Art, Winston-Salem, North Carolina.

1982 Awarded a National Endowment for the Arts (NEA) Individual Artist Fellowship.

Awarded a Virginia Museum of Fine Arts Professional Fellowship, cosponsored by the Virginia Commission for the Arts.

Included in the "Discoveries" section of *Photography Year 1982* by Time Life Books.

Solo Exhibition / *Sally Mann: Platinums*, Museum of Art, University of Oregon, Eugene, October 4–November 12.

Group Exhibition / *Six Contemporary Virginia Photographers*, DuPont Gallery, W&L, Lexington, Virginia, November 29–December 17.

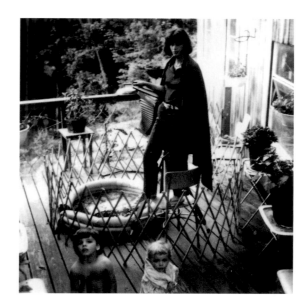

1983 Receives an 8 × 10 inch back, film, and processor from Polaroid. Makes a series of abstract color photographs picturing fabrics and plant matter submerged in water.

Publication of *Second Sight: The Photographs of Sally Mann*.

1984 Summer / Participates in the Visiting Artist Program at the University of Alabama, Birmingham, where she makes series of abstract, color, 20 × 24 inch Polaroid photographs.

Solo Exhibition / *Sweet Silent Thought: Platinum Portraits of 12-Year-Old Girls*, Martin Gallery, Washington, October 6–November 3.

5 / Mann with kiddie pool, c. 1983, courtesy of Sally Mann

Group Exhibition / *Alternative Printing Processes: Three Contemporary Photographers*, Chrysler Museum of Art, Norfolk, Virginia, November 30, 1984–January 13, 1985.

1985 Birth of daughter Virginia, named for Virginia "Gee-Gee" Carter, who had cared for Mann as a child. Mann photographs the birth with an 8 × 10 inch view camera she had set in place and focused before going into labor.

Begins to photograph her young children, a nine-year-long project (completes 1994) that appears under the titles *Family Pictures* and *Immediate Family*.

Teaches at Adams workshop in California.

Teaches at the Maine Photography Workshops, Rockland.

Solo Exhibitions / *Sweet Silent Thought: Portraits of 12-Year-Old Girls*, 1708 Gallery, Richmond, February 1–23 / *Portraits of 12-Year-Old Girls*, Marcuse Pfeifer Gallery, New York, November 23–December 21.

Group Exhibition / *Big Shots: An Exhibition of the 20 × 24 Polaroid Photographs Made at the University of Alabama at Birmingham in Summer, 1984*, Visual Arts Gallery, University of Alabama, Birmingham, June 23–July 19.

1986 Larry Mann diagnosed with late-onset muscular dystrophy.

Group Exhibition / *Commitment to Vision*, Museum of Art, University of Oregon, Eugene, November 9–December 22.

1987 Awarded a John Simon Guggenheim Memorial Foundation Fellowship.

Publication of *Sweet Silent Thought*.

Solo Exhibitions / *Still Time*, Marcuse Pfeifer Gallery, New York, September 12–October 15 / *At 12: Portraits of Young Women*, Second Street Gallery, Charlottesville, Virginia, October 12–25 / *Photographs by Sally Mann*, Port Washington Public Library, New York, December 9, 1987–January 7, 1988.

Group Exhibitions / *Mothers and Daughters*, Aperture Foundation, New York, May 7–May 30 / *Portrait: Faces of the 1980s*, Virginia Museum of Fine Arts, Richmond, July 20–September 13 / *Legacy of Light, Polaroid Photographs by 58 Photographers*, International Center for Photography, New York, November 20, 1987–January 3, 1988.

1988 Death of Robert Munger, Sr.

Awarded an NEA Individual Artist Fellowship.

Publication of *At Twelve: Portraits of Young Women*.

Solo Exhibitions / *Sally Mann: Still Time*, Alleghany Highlands Arts and Crafts Center, Clifton Forge, Virginia, August 6–October 8; travels to ten additional venues throughout Virginia through 1991; exhibition catalogue / *Family Pictures: A Work in Progress*, Southeastern Center for Contemporary Art, Winston-Salem, North Carolina, September 9–November 6; Museum of Photographic Arts, San Diego, March 7–April 30, 1989 / *More Family Pictures*, Marcuse Pfeifer Gallery, New York, September 10–October 13.

Group Exhibitions / *Un/Common Ground: Virginia Artists 1988*, Virginia Museum of Fine Arts, Richmond, January 13–March 6 / *Swimmers*, Aperture Foundation, New York, June 21–July 30 / *Visions: 28 × 5*, Virginia Museum of Fine Arts Traveling Exhibitions and Media Services, Richmond; travels through 1990.

1989 Awarded an NEA Individual Artist Fellowship.

Summer / Furor erupts over NEA-funded exhibitions featuring works by Andres Serrano and Robert Mapplethorpe. Within the context of the culture wars, the photographs from the *Immediate Family* series face criticism.

Recording of documentary *Sally Mann, Captured Images*.

Solo Exhibition / *At Twelve*, Kennedy Union Art Gallery, University of Dayton, Ohio, April 6–30.

Group Exhibitions / *Taken: Photography and Death*, Tartt Gallery, Washington, March 9–April 15 / *The Hand That Rocks the Cradle*, San Francisco Cameraworks / *Prospect Photographie*, Frankfurter Kunstverein.

1990 The photograph *Virginia at Four* (1989) is featured on the cover of *Aperture*'s fall issue, entitled "The Body in Question" and dedicated to the culture wars.

Regularly photographs Lexington-area births.

Begins shooting her family with color slide film in a 6 × 6 inch camera.

Solo Exhibitions / *At Twelve*, Cleveland Center for Contemporary Art, February 1–April 21 / *Family Photos*, La Grande Halle, La Villette, Paris, November 11, 1990–February 17, 1991 / *Immediate Family*, Tartt Gallery, Washington.

Group Exhibitions / *Indomitable Spirit: Photographers and Friends United against AIDS*, International Center for Photography, New York, February 9–April 7 / *AVA 9: Awards in the Visual Arts 9*, New Orleans Museum of Art, May 5–July 1; Southeastern Center for Contemporary Art, Winston-Salem, North Carolina, August 4–October 7; Arthur M. Sackler Museum, Harvard University, Cambridge, November 24–January 13, 1991; The BMW Gallery, New York, spring 1991.

1991 February 6 / *Wall Street Journal* publishes Raymond Sokolov's editorial "Critique: Censoring Virginia," illustrated with a cropped version of *Virginia at Four* in which black bars cover Virginia's eyes, chest, and pubic area.

Spring / Selected for the Whitney Biennial Exhibition.

Solo Exhibition / *The Photographs of Sally Mann*, Maryland Art Place, Baltimore, June 1–July 13.

Group Exhibitions / *The Body in Question*, Aperture Foundation, New York, January 17–March 2 / *Blood Relatives: The Family in Contemporary Photography*, Milwaukee Museum of Art, March 22–May 26 / *Biennial Exhibition*, Whitney Museum of American Art, New York, April 16–June 23 / *A Summer

Selection: Contemporary Color Photography, The Metropolitan Museum of Art, June 25–September 8 / *Pleasures and Terrors of Domestic Comfort*, The Museum of Modern Art, New York, September 26–December 31.

1992 Awarded an NEA Individual Artist Fellowship.

July / Takes what she later considers to be the first photographs in her *Mother Land* series (completes 1996) picturing Virginia and Georgia landscapes.

Publication of *Immediate Family*.

Solo Exhibitions / *Still Time*, Southeast Museum of Photography, Daytona Beach, Florida, April 11–February 15 / *Immediate Family*, Houk Friedman Gallery, New York, May 5–June 27 / *At Twelve*, Houk Gallery, Chicago, May 15–June 17 / *Immediate Family*, Institute of Contemporary Art, Philadelphia, October 29–December 31.

Group Exhibitions / *Family Album: Changing Perspective of the Family Portrait*, Tokyo Metropolitan Museum of Photography, July 3–August 18 / *The Invention of Childhood*, John Michael Kohler Arts Center, Sheboygan, Wisconsin, August 30–November 15 / *Flesh & Blood: Photographer's Images of Their Own Families*, Ansel Adams Center, San Francisco.

1993 Cy Twombly, who grew up in Lexington and knew Mann's parents, returns to his hometown where he and Mann renew their friendship. He splits his residence between Italy and Lexington, spending six months in each place until his death in 2011.

Completion of documentary *Blood Ties: The Life and Work of Sally Mann*. The following year it is nominated for an Academy Award for Best Documentary: Short Subject.

Solo Exhibition / *Selections from Immediate Family*, Center for Creative Photography, Carmel, California; Photo Gallery International, Tokyo, November 12–December 17.

Group Exhibitions / *Prospect 93*, Frankfurter Kunstverein and the Schirn Kunsthalle, Frankfurt, March 20–May 23 / *Elegant Intimacy*, Retretti Museum, Punkaharju, May 25–August 29 / *Family Matters*, Northlight Gallery, Herberger Institute for Design and the Arts, Arizona State University, Tempe / *Flora Photographica: The Flower in Photography from 1835 to the Present*, Musée des Beaux-arts de Montréal.

1994 December 25 / Death of Virginia Carter.

Publication of *Sally Mann: Still Time*, an expanded edition of the 1988 catalogue.

Solo Exhibitions / *Immediate Family*, Contemporary Museum, Honolulu, February 23–April 17 / *Photographs by Sally Mann*, Hollins College Art Gallery, Roanoke, Virginia, April 12–May 1.

Group Exhibitions / *Pro Femina*, Southeast Museum of Photography, Daytona Beach, Florida, April 12–May 13 / *Who's Looking at the Family?* Barbican Art Gallery, London, May 26–September 4 / *An American Century of Photography, from Dry-Plate to Digital, the Hallmark Collection*, Nelson-Atkins Museum of Art, Kansas City, Missouri, December 18, 1994–February 19, 1995 / *Embody—The Photograph and The Figure*, Proctor Arts Center, Bard College, Annandale-on-Hudson, New York.

1995 Selected as Photographer of the Year by the Friends of Photography.

Solo Exhibitions / *Recent Work*, Houk Friedman Gallery, New York, September 14–November 4 / *Sally Mann: At Twelve and Color Work*, Picture Photo Space, Osaka.

Group Exhibitions / *Imagined Children, Desired Images*, Davis Art Museum, Wellesley College, Massachusetts, April 21–June 4 / *Body of Evidence: The Figure in Contemporary Photography*, Cleveland State University Art Gallery, September 22–October 20 / *100 Years/100 Images*, Frankfurter Kunstverein / *Vision of Childhood: Four Photographers*, Center for Curatorial Studies, Bard College, Annandale-on-Hudson, New York.

1996 Spring / Receives inaugural *Picturing the South* commission from the High Museum of Art to photograph Georgia landscapes. Completes four large-scale landscape photographs, which are shown at the High that summer.

Solo Exhibitions / *Sally Mann: Recent Work*, Jackson Fine Art, Atlanta, January 19–March 2 / *Sally Mann: Immediate Family*, Christian Larsen Gallery, Stockholm, August 24–September 28; Galerie Bodo Nieman, Berlin, 1997 / *Sally Mann: Photographs*, Robert Koch Gallery, San Francisco, September 12–November 2.

Group Exhibitions / *Women in the Visual Arts*, Hollins College Art Gallery, Roanoke, Virginia, February 15–March 17 / *Picturing the South, 1860 to the Present*, High Museum of Art, Atlanta, June 15–September 14 / *Hospice: A Photographic Inquiry*, Corcoran Gallery of Art, Washington, in collaboration with the National Hospice Foundation, November 15, 1996–January 11, 1997; travels through 2000 / *Legacy of Light, Master Photographs from the Cleveland Museum of Art*, Cleveland Museum of Art, November 24, 1996–February 2, 1997 / *Collection in Context: Selected Contemporary Photographs of Hands from the Collection of Henry M. Buhl*, Thread Waxing Space, New York.

1997 Summer / Mark Osterman and France Scully Osterman visit Mann at her studio in Lexington and provide instruction for the wet-plate collodion process.

Solo Exhibitions / *Mother Land: Recent Landscapes of Georgia and Virginia*, Edwynn Houk Gallery, New York, September 25–November 8; exhibition catalogue / *Sally Mann: Mother Land*, Gagosian Gallery, Los Angeles, September 27–October 25 / *Sally Mann: Photographs*, Photo Gallery International, Tokyo, November 19, 1997–January 30, 1998.

Group Exhibitions / *From the Heart: The Power of Photography, Selections from the Sondra Gilman Collection*, Art Museum of South Texas, Corpus Christi, March 6–June 7 / *Under the Dark Cloth*, Museum of Photographic Arts, San Diego, September 23–December 7.

1998 Sally and Larry Mann purchase her brothers' shares of the Munger family farm.

Travels to Alabama, Louisiana, and Mississippi taking photographs that later form part of the *Deep South* series.

Group Exhibitions / *Presumed Innocence*, Anderson Gallery, Virginia Commonwealth University, Richmond, January 17–March 1; Contemporary Arts Center, Cincinnati, April 4–June 14 / *Shattering the Southern Stereotype: Cy Twombly, Sally Mann, Dorothy Gillespie, Nell Blaine, Jack Beal*, Longwood Center for the Visual Arts, Farmville, Virginia, March 21–May 9 / *Sacred Sites, Then and Now: The American Civil War*, Chrysler Museum of Art, Norfolk, Virginia, May 1–August 30 / *Degrees of Stillness: Photographs from the Manfred Heiting Collection*, Die Photographische Sammlung / SK Stiftung Kultur, Cologne, October 30–December 30 / *The Body and the Lens: Photography 1839 to the Present*, Newcomb Art Gallery, New Orleans, December 1998–February 1999 / *Secret Victorians: Contemporary Artists and a 19th-Century Vision*, The Minorities Art Gallery, Colchester, October 17–December 5; Arnolfini, Bristol, December 12, 1998–January 31, 1999; Ikon Gallery, Birmingham, February 10–April 4, 1999; Middlesbrough Art Gallery, May 1–June 26, 1999; Hammer Museum of Art at UCLA, September 20, 1999–January 2, 2000.

1999 Begins photographing Twombly's Lexington studio (completes 2012).

Begins presenting images from *Marital Trust* series in lectures. These photographs remain unpublished.

February 14 / Sudden death of Mann's greyhound Eva prompts a new photographic project. Mann has dog skinned, buries her body on the farm. Later she photographs both Eva's hide and dug-up remains. These photographs form part of the *Matter Lent* (2000–2001) section of the larger *What Remains* (2000–2004) project.

March / Travels to Calakmul Biosphere Reserve in Mexico, fulfilling a commission from the Nature Conservancy.

Solo Exhibition / *Deep South: Landscapes of Louisiana and Mississippi*, Edwynn Houk Gallery, New York, September 23–November 6.

9 / Jeremy Leadbetter, The family (from left to right): Virginia, Jessie, Emmett, Sally, and Larry, from "Nature of Mann," *Vogue*, 1999, courtesy of the artist

Group Exhibitions / *Some Southern Stories*, Museum of Contemporary Photography, Chicago, January 23–March 20 / *Assumed Identity*, Charlotte and Philip Hanes Art Gallery, Wake Forest University, Winston-Salem, North Carolina, February 12–March 28 / *Dreamworks: Artistic and Psychological Perspectives*, Equitable Gallery, New York, November 4, 1999–February 20, 2000, organized by Binghampton University Art Museum, New York / *Pink for Boys: Blue for Girls*, Neue Gesellschaft für Bildene Kunst, Berlin / *Through the Looking Glass: Visions of Childhood*, Snug Harbor Cultural Center, New York.

2000 Begins to photograph Civil War battlefields, which eventually form part of the *Last Measure* series.

May / Virginia's governor, without having seen Mann's work, criticizes the Virginia Museum of Fine Arts after he receives an "anonymous" complaint (later disclosed as coming from a staffer in his office) about a recent lecture delivered there by Mann and including images from the *Marital Trust* series.

Fall / Receives commission from *New York Times Magazine* to photograph the University of Tennessee Forensic Anthropology Center, colloquially known as the Body Farm.

December 8 / Police pursue a convicted sex offender onto Mann's farm. Facing imminent capture, he shoots himself near

the family's home. Mann later photographs the ground where he fell, which she includes in the series *What Remains*.

Solo Exhibitions / *Sally Mann: The Family and the Land*, Reynolds Gallery, Richmond, April 7–May 20 / *Deep South and Mother Land*, Cheekwood Museum, Nashville, June 2–July 31.

Group Exhibitions / *Children of the Twentieth Century*, Von der Heydt Museum, Wuppertal, January 9–March 26 / *Southern Exposure*, Contemporary Art Center of Virginia, Virginia Beach, April 14–May 28, organized by the Virginia Museum of Fine Arts, Richmond; travels in Virginia through 2003 / *The Swamp: On the Edge of Eden*, Samuel P. Harn Museum, University of Florida, Gainesville, September 29–January 7, 2001 / *Surface and Depth: Trends in Contemporary Portrait Photography*, Hood Museum of Art, Dartmouth College, Hanover, New Hampshire, October 7–December 13 / *Chorus of Light: Photographs from the Sir Elton John Collection*, High Museum of Art, Atlanta, November 4, 2000–January 28, 2001 / *Photography Now: An International Survey of Contemporary Photography*, Contemporary Arts Center, New Orleans.

2001 Continues to photograph the Body Farm. These pictures form part of the *Matter Lent* series within the larger *What Remains* project.

Named America's Best Photographer by *Time* magazine.

Featured in "Place," season 1, episode 1, of *Art21 — Art in the Twenty-First Century*.

Solo Exhibitions / *Deep South*, Galerie Karsten Greve, Paris, April 7–July 25; Milan, September 20–October 20; Cologne, March 8–April 23, 2002 / *Immediate Family*, André Simoens Gallery, Brussels, December 10, 2001–January 8, 2002.

Group Exhibitions / *The Crafted Image: 19th-Century Techniques in Contemporary Photography*, Boston University Art Gallery, January 19–February 26 / *In Response to Place: The Nature Conservancy's Last Great Places*, Corcoran Gallery of Art, Washington, September 15–December 31; travels through 2007.

2002 Begins to make collodion portraits of Emmett, Jessie, and Virginia, which form final section of *What Remains* and are also known as *Faces* (completes 2004).

10 / Jon Humburg, Sally and Larry Mann on their thirtieth wedding anniversary, 2000, courtesy of the artist

Featured in "Giving up the Ghost," episode 301 of *Egg: The Arts Show*.

Solo Exhibition / *Sally Mann: Yucatan*, Catherine Edelman Gallery, Chicago, October 11–November 9.

Group Exhibitions / *Aquaria: The Fascinating World of Man and Water*, Landesgalerie am Oberösterreichischen Landes-museum, Linz, February 7–April 7; Kunstsammlungen Chemnitz, May 5–June 30 / *Contemporary Photography in Virginia*, Art Museum of Western Virginia, Roanoke, February 8–June 16 / *The Antiquarian Avant-Garde*, Sarah Morth-land Gallery, New York, June 13–August 9 / *Visions from America: Photographs from the Whitney Museum of American Art, 1940–2011*, Whitney Museum of American Art, New York, June 27–September 22 / *Fictions in Wonderland*, Reynolds Gallery, Richmond, October 18–December 14.

2003 November 12 / Discusses *What Remains* project on *The Charlie Rose Show*.

Begins photographing the effects of muscular dystrophy on Larry's body for the *Proud Flesh* series.

Publication of *What Remains*.

Solo Exhibition / *Last Measure*, Edwynn Houk Gallery, New York, September 18–November 15; Reynolds Gallery, Richmond, May 7–June 5, 2004; Hemphill Fine Arts, Washington, June 10–July 31, 2004.

Group Exhibitions / *Flesh Tones*, Robert Mann Gallery, New York, March 7–April 19 / *The Disembodied Spirit*, Bowdoin College Museum of Art, Brunswick, Maine, September 25–December 7 / *The New Sublime*, Northlight Gallery, Herberger Institute for Design and the Arts, Arizona State University, Tempe, October 13–November 9.

2004 Solo Exhibitions / *What Remains*, Corcoran Gallery of Art, Washington, June 9–September 7; Ogden Museum of Southern Art, New Orleans, October 4, 2008–January 4, 2009 / *Sally Mann: Battlefields*, Galerie Karsten Greve, Paris, September 11–November 27; Cologne, January 21–April 23, 2005.

11 / Emmett Mann, Mann and William Eggleston at the Sundance Film Festival, 2006, courtesy of Sally Mann

12 / Len Prince **Sally and Jessie Mann, Plate #10** 2004, courtesy of the artist

Group Exhibitions / *Images of Time and Place: Contemporary Views of Landscape*, Lehman College Art Gallery, Bronx, New York, February 3–May 15 / *About Face: Photography and the Death of the Portrait*, Hayward Gallery, London, June 4–September 5 / *Two Visions: Photographs by Sally Mann, Paintings by Janet Fish*, Eleanor D. Wilson Museum at Hollins University, Roanoke, Virginia, August 26–December 10 / *Common Ground: Discovering Community in 150 Years of Art, Selections from the Collection of Julia J. Norrell*, Corcoran Gallery of Art, Washington, October 23, 2004–January 31, 2005.

2005 Publication of *Deep South* and *Sally Mann: Photographs and Poetry*, a limited-edition book featuring eleven hand-coated platinum prints.

Completion of documentary *What Remains: The Life and Work of Sally Mann*. Premiers at the Sundance Film Festival in 2006 and is nominated in 2008 for an Emmy Award for Best Documentary.

Group Exhibition / *Contemporary Photography in the Garden: Deceits and Fantasies*, organized by the American Federation for the Arts, Middlebury College Museum of Art, Vermont, January 20–April 17; travels through 2007.

2006 Receives the Century Award for Lifetime Achievement by the Museum of Photographic Arts, San Diego.

Awarded an honorary doctorate from the Corcoran School of Art, Washington.

Begins to work on a large-scale project exploring the legacy of racism in the South.

August 5 / Suffers a riding accident, a result of her horse's ruptured aneurysm. Badly injured and with limited mobility, Mann embarks upon a multiyear self-portraiture project (completes 2012) focusing on close-ups of her face. In a parallel series, *Thin Skin* (completes 2009), Mann photographs her nude torso.

Solo Exhibition / *Sally Mann*, Gagosian Gallery, New York, March 16–April 22; Reynolds Gallery, Richmond, November 3–December 23; exhibition catalogue.

Group Exhibitions / *Picturing Eden*, George Eastman House, Rochester, New York, January 28–September 4 / *Shifting Terrain: Contemporary Landscape Photography*, Wadsworth Athenaeum, Hartford, Connecticut, July 15–November 5 / *So the Story Goes: Photographs by Tina Barney, Philip-Lorca diCorcia, Nan Goldin, Sally Mann, and Larry Sultan*, The Art Institute of Chicago, September 16–May 27.

2007 Receives annual Aperture Award from the Aperture Foundation, New York, for outstanding contribution to advancing the photographic arts.

Twombly photographs Mann's studio.

Solo Exhibitions / *Sally Mann: The Family and the Land*, Kulturhuset, Stockholm, February 3–May 7; Stenersenmuseet, Oslo, June 21–September 30; Tennis Palace Museum, Helsinki, October 17, 2007–January 6, 2008; Dunker Kulturhus, Helsingborg, February 16–April 6, 2008; The Royal Library, Copenhagen, May 9–September 20, 2008; Fotomuseum Den Haag, September 24, 2009–January 10, 2010; Musée de l'Elysée, Lausanne, March 6–June 6, 2010; The Photographer's Gallery, London, June 18–September 19, 2010 / *Sally Mann: Deep South/ Battlefields*, Kunstsammlung im Stadtmuseum Jena, March 17–April 21; exhibition catalogue / *Sally Mann: Photographs*, Texas Art Gallery, Houston, March 24–April 21 / *The Given: Studio Work by Sally Mann*, Second Street Gallery, Charlottesville, Virginia, June 1–August 18 / *Sally Mann: Faces*, Galerie Karsten Greve, Paris, November 15, 2007–January 12, 2008; Cologne, January 18–April 5, 2008.

Group Exhibitions / *Family Pictures*, Solomon R. Guggenheim Museum, New York, February 9–April 16 / *Pretty Baby*, Modern Art Museum of Fort Worth, Texas, February 25–May 27 / *Relative Closeness: Photographs of Family and Friends*, Museum of Contemporary Photography, Chicago, June 11–August 18 / *Stripped Bare: The Exposed Body — Photographs from the Collection of Thomas Koerfer*, C/O, Berlin, September 28–December 9.

2008 Death of Elizabeth Munger.

Solo Exhibitions / *Sally Mann*, Gagosian Gallery, Los Angeles, January 8–February 9 / *Sally Mann: Untitled*, Jackson Fine Art, Atlanta, March 7–April 26.

Group Exhibitions / *Presumed Innocence, Photographic Perspectives of Children: From the Collection of Anthony and Beth Terrana*, DeCordova Museum and Sculpture Park, Lincoln, Massachusetts, February 2–April 27 / *Role Models: Feminine Identity in Contemporary American Photography*, National Museum of Women in the Arts, Washington, October 17, 2008–January 25, 2009 / *Rethinking Landscape: Photography from the Collection of Allen G. Thomas, Jr.*, Taubman Museum of Art, Roanoke, Virginia, November 8, 2008–March 1, 2009 / *Oh l'amour: Contemporary Photography from the Stéphane Janssen Collection*, Center for Creative Photography, University of Arizona, Tucson, November 22, 2008–March 1, 2009.

2009 Solo Exhibition / *Proud Flesh*, Gagosian Gallery, New York, September 15–October 31; Jackson Fine Art, Atlanta, September 9–October 29, 2011; exhibition catalogue.

Group Exhibition / *The Art of Caring: A Look at Life through Photographs*, New Orleans Museum of Art, May 16–August 2.

2010 Solo Exhibition / *Sally Mann: The Flesh and The Spirit*, Virginia Museum of Fine Arts, Richmond, November 13, 2010–January 23, 2011; exhibition catalogue.

Group Exhibitions / *Haunted: Contemporary Photography/Video/Performance*, Solomon R. Guggenheim Museum, New York, March 26–September 1 / *Pictures by Women: A History of Modern Photography*, The Museum of Modern Art, New York, May 7, 2010–April 18, 2011 / *Memento Mori: The Birth & Resurrection of Post-Mortem Photography*, Merchant's House Museum, New York, September 9–November 29 / *Disquieting Images*, La Triennale de Milano, October 19, 2010–January 19, 2011.

2011 May 2–4 / Delivers the William E. Massey, Sr., Lectures in the History of American Civilization at Harvard University; the series is titled "If Memory Serves."

September / Speaks at the Museum of Modern Art's Cy Twombly memorial service.

Group Exhibitions / *Time Regained, Cy Twombly Photographer and Invited Artists*, Collection Lambert en Avignon, Musée d'Art Contemporain, June 12–October 20, 2011 / *High Speed Insanity*, Blomqvist Gallery, Oslo, June 14–August 14 / *Dawn till Dusk*, Jen Bekman Gallery, New York, June 17–July 30.

2012 Awarded an Honorary Fellowship by the Royal Photographic Society of Great Britain.

Solo Exhibitions / *A Matter of Time*, Fotografiska Museet, Stockholm, June 1–September 30 / *At Twelve*, La Fabrica, Madrid, September 13–November 17 / *Upon Reflection*, Edwynn Houk Gallery, New York, September 13–November 3.

Group Exhibition / *By Way of These Eyes*, The American Museum in Britain, Bath, July 14–October 28.

2013 Publication of *Southern Landscapes*, a limited-edition book including three platinum prints.

Group Exhibition / *Everyday Epiphanies: Photography and Daily Life since 1969*, The Metropolitan Museum of Art, New York, June 25, 2013–January 26, 2014.

2014 Group Exhibitions / *Gorgeous*, Asian Art Museum, San Francisco, June 20–September 14 / *Self-Processing—Instant Photography*, Ogden Museum of Southern Art, New Orleans, October 4, 2014–January 4, 2015 / *Dialogues: Recent Acquisitions of the Sheldon Museum of Art*, Sheldon Museum of Art, Lincoln, Nebraska, October 28, 2014–February 1, 2015 / *Fusion: Art of the 21st-Century*, Virginia Museum of Fine Arts, Richmond, December 19, 2014–July 26, 2015.

13 / Mann, Collodion studio, 2012, courtesy of the artist

2015 May / Publication of *Hold Still: A Memoir with Photographs*. It is a National Book Award finalist and receives the Andrew Carnegie Medal for Excellence in Nonfiction (2016).

June 1 / Discusses *Hold Still* on *The Charlie Rose Show*.

Solo Exhibition / *Sally Mann*, Reynolds Gallery, Richmond, September 18–October 30.

Group Exhibitions / *Rooted in Soil*, DePaul Art Museum, DePaul University, Chicago, January 29–April 26 / *A History of Photography: Series and Sequences*, Victoria and Albert Museum, London, February 6–November 1 / *Forensics: The Anatomy of Crime*, Wellcome Collection, London, February 26–June 1 / *Fatal Attraction: Piotr Uklanski Selects from the Met Collection*, The Metropolitan Museum of Art, New York, March 17–June 14 / *The Memory of Time: Contemporary Photographs at the National Gallery of Art, Acquired with the Alfred H. Moses and Fern M. Schad Fund*, National Gallery of Art, Washington

May 3–September 13 / *Southern Exposure*, Museum of Contemporary Art Jacksonville, Florida, May 16–August 30 / *The Energy of Youth: Depicting Childhood in the NCMA's Photography Collection*, North Carolina Museum of Art, Raleigh, September 26, 2015–April 3, 2016 / *Phantom Bodies: The Human Aura in Art*, The Frist Center for the Visual Arts, Nashville, October 30, 2015–February 14, 2016.

2016 *Aperture*'s summer issue, dedicated to the theme of vision and justice, includes seven photographs from the *Men* series (2006–2015) in print for the first time.

June 5 / Death of Emmett Mann.

Solo Exhibition / *Remembered Light: Cy Twombly in Lexington*, Gagosian Gallery, New York, September 22–October 29; Paris, January 25–April 29, 2017; exhibition catalogue.

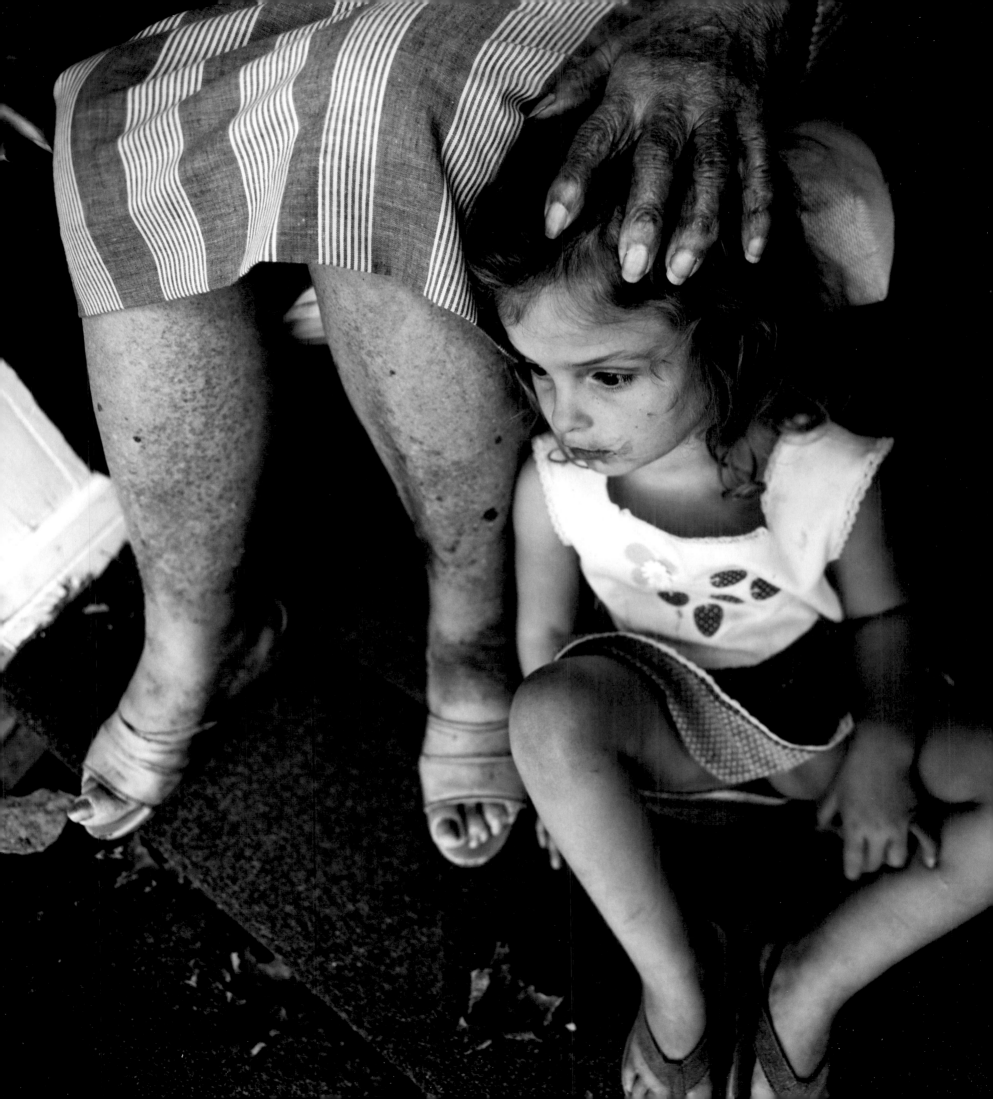

NOTES

Preface

1 Sally Mann, *Mother Land: Recent Landscapes of Georgia and Virginia* (exh. cat., Edwynn Houk Gallery, New York, 1997), 6.

2 Sally Mann, *Hold Still: A Memoir with Photographs* (New York, 2015), 263.

3 Mann 2015, 293–294.

Writing with Photographs: Sally Mann's Ode to the South, 1969–2017

1 Mann herself recognized the Ad Reinhardt–like qualities of several of these photographs; see Sally Mann, fax to Ellen Dugan [Fleurov] and Ned Rifken, February 22, 1996, High Museum of Art, Atlanta.

2 Charles Hagen, "Review/Art: Childhood without Sweetness," *New York Times*, June 5, 1992, C 30, and Luc Sante, "Luc Sante on Photography: The Nude and the Naked," *New Republic*, May 1, 1995, 30.

3 Pat Robertson, as quoted in Steven Cantor, *Blood Ties: The Life and Work of Sally Mann* (New York, 1993); Raymond Sokolov, "Critique: Censoring Virginia," *Wall Street Journal*, February 6, 1991, A 10.

4 Sally Mann, *Hold Still: A Memoir with Photographs* (New York, 2015), 134.

5 Sally Mann to Melissa Harris, July 1, 1994, as quoted in "Sally Mann: Correspondence with Melissa Harris," *Aperture* 138 (Winter 1995): 24; and "'I Photograph What I Love but Not Necessarily What I Understand,'" interview with Sally Mann by Erik Stephan, in *Sally Mann: Deep South/Battlefields* (exh. cat., Kunstsammlung im Stadtmuseum Jena, 2007), 40. In 1996 Mann said that she began to make these pictures after a visit from the California photographer Richard Misrach, who told her that he would return to photograph the landscape near her. She said she responded: " No, you're not. This is my territory. I'm not going to have some California interloper take these pictures." As quoted in Abigail Foerstner, "Sally Mann's New Work Poses New Risks," *Chicago Tribune*, October 20, 1996.

6 Vicki Goldberg, "Photography Review: Landscapes That Are Steeped in Time," *New York Times*, October 17, 1997, E 35.

7 A.D. Coleman, "Sally Mann Heads South to Explore New Landscapes," *New York Observer*, October 20, 1997, 35.

8 Coleman 1997, 35; Mann admitted to self-censorship when she was selecting the photographs for *Immediate Family*, telling Vince Aletti, "Child World," *Village Voice*, May 26, 1992, 37: "What I'm afraid of is what's happened in my own mind. When I first laid out the book, I was far more courageous than in the final selection. I actually took pictures out of the book 'cause I was afraid. And not so much afraid of what could happen to me but really afraid of what would happen to the children if it blew up into some kind of issue. That no matter how resolute they are, and how defiant, and how proud, they're still *children* and it's still going to be hard for them."

9 Goldberg 1997. See also Susan Freudenheim, "It May Be Art, but What about the Kids?" *San Diego Tribune*, March 29, 1989, C 1.4; Val Williams, "Fragile Innocence," *British Journal of Photography*, October 15, 1992, 10; Val Williams, "Women: The Naked Truth," *Guardian*, September 22, 1992, 17; Aletti 1992, 106; Hagen 1992; and Richard Woodward, "The Disturbing Photography of Sally Mann," *New York Times Magazine*, September 27, 1992, 29–32, 52.

10 Alfred Corn, "Photography Degree Zero," *Art in America* (January 1998): 89; David Pagel, "Art Review," *Los Angeles Times*, October 10, 1997.

11 Hilton Als, "The Unvanquished: Sally Mann's Portrait of the South," *New Yorker*, September 27, 1999, 101.

12 Mann has repeatedly uttered these words throughout her career: see, for example, "A Conversation with Photographer Sally Mann," *Mount Holyoke College Art Museum Newsletter* (Spring 1999), 1, and Mann 2015, 240.

13 Sally Mann, as quoted in Susan Piperato, "Sally Mann Gives 'Family Pictures' a New Focus," *Popular Photography* 95 (February 1988): 18.

14 "Sally Mann: By the Book," *New York Times*, June 28, 2015, BR 10.

15 "By the Book," 2015, BR 10; see also John Stauffer, "Introduction and Reflections," in *Southern Landscape*, ed. John Wood (Cape Cod, MA, 2013), who points out that some of the titles of Mann's books have been drawn from literary sources, such as *Matter Lent* (2001), which was drawn from lines written by the seventeenth-century theologian Jacques-Bénigne Bossuet, while *What Remains* was drawn from Ezra Pound's Canto 81. See also John Wood, "Madelines, the Great Periplum, and Sally Mann,' in *Strange Genius: The Journal of Contemporary Photography* (2002): 157–161, who argues that Pound's theory of the periplum, a word implying a voyage of spiritual discovery, is central to Mann's work.

16 Mann, interview by Stephan, in Jena 2007, 39.

17 Mann 2015, 206 and 208.

18 See Robert Hobbs' untitled text in *Fictions in Wonderland* (exh. cat., Reynolds Gallery, Richmond, 2002); see also François Brunet, *Photography and Literature* (London, 2009), for a discussion of how the invention of photography coincided with a redefinition of literature from a broadly descriptive term including all forms of writing to one more exclusively focused on the expression of the creative self and his perceptive analysis of the rise of fiction photography since the 1970s. A.D. Coleman was among the first to identify a "directorial" turn in contemporary photography; see his 1976 "The Directorial Mode: Notes toward a Definition," reprinted in *Light Readings: A Photography Critic's Writings, 1968–1978* (New York, 1979), 246–257.

19 Mann 2015, 208.

20 Sally Mann, as quoted in Dodie Kazanjian, "Nature of Mann," *Vogue*, September 1999, 611. Sally Mann to Sarah Greenough, June 14, 2017, notes that her father was actually twenty-eight when he traveled around the world on his motorcycle.

21 Mann 2015, 100–103. Unless otherwise noted, all biographical information is based on this memoir or derived from conversations with Mann herself.

22 Sally Mann, as quoted in *Hospice: A Photographic Inquiry,* ed. Dena Andre, Philip Brookman, and Jane Livingston (exh. cat., Corcoran Gallery of Art, Washington, 1996), 84.

23 Mann 2015, 245; In "By the Book," 2015, BR 10, she recounts that her favorite books as a child were *The Jack Tales* by Richard Chase, *Charlotte's Web* by E.B. White, *The Moonstone* by Wilkie Collins, *My Family and Other Animals* by Gerald Durrell, *The Little Prince* by Antoine de Saint-Exupéry, and *The Prisoner of Zenda* by Anthony Hope, as well as all the Walter Farley horse stories (especially *The Black Stallion*), and all the *Oz* books by L. Frank Baum.

24 Mann 2015, 245, 198.

25 Mann 2015, 243.

26 Mann 2015, 248.

27 Betty Ann Kilby, as quoted in Peter Wallenstein, *Cradle of America: A History of Virginia* (Lawrence, KS, 2007), 353.

28 See Virginia Historical Society, "Passive Resistance," http://www.vahistorical.org/collections-and-resources/virginia-history-explorer/civil-rights-movement-virginia/passive (accessed April 11, 2017).

29 Mann 2015, 31–33.

30 Mann 2015, 35–36.

31 Edward Steichen, as quoted in Eric J. Sandeen, *Picturing an Exhibition: The "Family of Man" and 1950s America* (Albuquerque, 1995), 2, and "By the Book," 2015, BR 10.

32 Edward Steichen, *The Family of Man: The Greatest Photographic Exhibition of All Time—503 Pictures from 68 Countries* (exh. cat., Museum of Modern Art, New York, 1955), 3.

33 Sally Mann, as quoted in Arlene Distler, "Sally Mann, 'Then and Now,' at Putney School," *Brattleboro Reformer,* May 13, 2010, and Mann 2015, 40–42.

34 Sally Mann, "Early Pictures (Part I): Rebirth at Pisa (Part II)" (master's thesis, Hollins College, Roanoke, 1975), which she illustrated with platinum prints.

35 Mann 1975, 2.

36 For further discussion of the development of photographic workshops, see Christopher Burnett, "Photographic Workshops: A Changing Educational Practice—The Modern Workshop, Beginnings of Modernist Workshop: Late 1930s to Early 1950s," http://encyclopedia.jrank.org/articles/pages/1028/Photographic-Workshops-A-Changing-Educational-Practice.html (accessed April 12, 2017).

37 Minor White, "The Way through Camera Work," *Aperture* 7, no. 2 (1959): 73, and Minor White, "The Workshop Idea in Photography," *Aperture* 9, no. 4 (1961): 148.

38 Ansel Adams, "The Workshop Idea in Photography," *Aperture* 9, no. 4 (1961): 162.

39 Mann 2015, 282.

40 Ted Orland, introduction to *Scenes of Wonder and Curiosity: The Photographs and Writings of Ted Orland*, foreword by Sally Mann, (Boston, 1988), 7. In addition to Mann and Orland, the other members of the Image Continuum included David Bayles, Chris Johnson, Robert Langham, and Boone Morrison.

41 Sally Mann to Ted Orland, March 1977, June 1979, April 1977, and June 1979, *Image Continuum Journal* 4 (1979): n.p.

42 Sally Mann, introduction to *Sally Mann: Still Time* (exh. cat., Alleghany Highlands Arts and Crafts Center, Clifton Forge, VA, 1988), 8.

43 Sally Mann, as quoted in *Sally Mann/The Lewis Law Portfolio* (exh. cat., Corcoran Gallery of Art, Washington, 1977), n.p.

44 As quoted in Mark Power, "Iowa in Ohio," introduction to *Iowa*, by Nancy Rexroth (Rochester, NY, 1977), n.p.

45 Introduction to Rexroth 1977, n.p.

46 Mann in Washington 1977, n.p.

47 Linda Connor, as quoted in Mann 2015, 107.

48 Mann in Washington 1977, n.p.

49 Mann in Clifton Forge 1988, 8.

50 For further discussion, see John B. Ravenal, in *Sally Mann: The Flesh and The Spirit* (exh. cat., Virginia Museum of Fine Arts, Richmond, 2010), 90.

51 Sally Mann, *Second Sight: The Photographs of Sally Mann*, introduction by Jane Livingston (Boston, 1983), n.p.

52 Ralph Waldo Emerson, "Essays: Poetry and the Imagination, 1872," as reprinted in *American Transcendental Web*, http://archive.vcu.edu/english/engweb/transcendentalism/authors/emerson/essays/poetryimag.html (accessed April 16, 2017). Roland Barthes, in *Camera Lucida: Reflections on Photography* (New York, 1980), 47, also refers to "second sight": "the photographer's 'second sight' does not consist in 'seeing' but in being there."

53 Mann 1983, n.p.

54 Sally Mann, as quoted in "Hot Shots," *Darkroom* 4, no. 3 (1982): 14.

55 Mann in Clifton Forge 1988, 8.

56 Mann in Clifton Forge 1988, 8, and Mann, as quoted in Piperato 1988, 18.

57 Emmet Gowin, *Emmet Gowin: Photographs* (New York, 1976), 100.

58 Emmet Gowin, as quoted in Martha Chahroudi, *Emmet Gowin: Photographs* (exh. cat., Philadelphia Museum of Art, 1990), 9. See also Keith Davis, "Where Pictures Come From: The Sources of Emmet Gowin's Vision," in *Emmet Gowin* (New York, 2013), 40.

59 "Discoveries: Soft-Focus Subtlety and Fragile Grace," *Photography Year 1982*, (Alexandria, VA, 1982), 172.

60 Sally Mann, *At Twelve: Portraits of Young Women* (New York, 1988), 46.

61 Mann 1988, 46.

62 John Updike, "The Short Story Today," introduction to *The Best American Short Stories* (Boston, 1984), reprinted in Robert M. Luscher, *John Updike: A Study of the Short Fiction* (New York, 1993), 182.

63 Sally Mann, introduction to *Immediate Family* (New York, 1992), n.p.

64 Sally Mann, as quoted in "An Interview with Sally Mann," *Visions of Childhood: Photographs by Barbara Ess, Wendy Ewald, Sally Mann, Nicholas Nixon* (exh. cat., The Center for Curatorial Studies, New York, 1995), 18.

65 Woodward 1992, 52.

66 Mann 1992, n.p.

67 Mann 1992, n.p.

68 A print of Arbus' *Child with toy hand grenade in Central Park, N.Y.C.* currently hangs in Mann's studio in Lexington.

69 Mann, as quoted in Woodward 1992, 36, and as quoted in George Cruger, *Portrait: Faces of the 1980s* (exh. cat., Virginia Museum of Fine Arts, Richmond, 1987), 19.

70 For further discussion, see Andrew Hartman, *A War for the Soul of America: A History of the Culture Wars* (Chicago, 2015), and James Davidson Hunter, *Culture Wars: The Struggle to Control the Family, Art, Education, Law, and Politics in America* (New York, 1991).

71 See Carole Vance, "The War on Culture," *Art in America* 47 (1989): 39–43.

72 See Trudy Wilner Stack, *Family Matters: An Exhibition of Works by Sally Mann, Vince Leo, Melissa Shook and Philip-Lorca diCorcia* (exh. cat., Northlight Gallery, Arizona State University, Tempe, 1993).

73 See Vince Aletti, "Review: Sally Mann," *Village Voice*, October 19, 1995, 9.; A.D. Coleman, "Letter from: New York, No. 36," *New York* 36 (September/October 1992), reprinted in *Critical Focus: Photography in the International Image Community* (Munich, 1995), 146–155; Janet Malcolm, "The Family of Mann," *New York Review of Books*, February 3, 1994, 7–8.

74 Freudenheim 1989. For a summary of the critical responses to these photographs, see Malcolm 1994, 7–8. For a longer analysis of the issues raised by contemporary visual representations of children, see Anne Higonnet, *Pictures of Innocence: The History and Crisis of Ideal Childhood* (London, 1998).

75 Anne Higonnet, "Conclusions Based on Observation," *Yale Journal of Criticism* 9, no. 1 (1996): 14–15. See also Hager 1992; Anna Douglas, review of *Immediate Family* by Sally Mann, *Women's Art* 51 (March/April, 1993), 29; Mary Gordon, "Sexualizing Children: Thoughts on Sally Mann," *Salmagundi* 111 (Summer 1996); Julie Burchill, "Death of Innocence," *Guardian*, November 12, 1997, 2; and Woodward 1992, 36.

76 See Ann Gerhart, "Family of Mann: The Focus of a Controversy; Sally Mann's Photo Art Has Its Share of Critics," *Philadelphia Daily News,* October 29, 1992.

77 See Richard Leppert, "Representing the Young: Innocence, Nakedness, and the Adult Imaginary," in *The Nude: The Cultural Rhetoric of the Body in Art of Western Modernity* (Boulder, CO, 2007); Higonnet 1996, 1–18; Higonnet 1998; and Gordon 1996, 144–145.

78 Mann 2015, 126–127.

79 Mann also gave her children the option to remove any pictures they wanted from *Immediate Family*; the only ones they asked to be deleted were those that made them look like "dorks," not those where they were nude; see "Photography's Top 100 People: Sally Mann," *American Photography* (1994). In Karen Barnes, "Sally Mann: Accepting Contradictions," *Hollins Alumnae Issue* (May 1994), 35–37, Jessie notes (on page 37) "I think some of the pictures Mom takes of me can be scary for me sometimes. But I never connect myself. It's a picture of me, but it's not exactly me. It's not that close to me, it's not my feelings." A few years later, Jessie again reflected on the photographs; see Jessie Mann and Melissa Harris, "Jessie at 18: Daughter, Model, Muse, Jessie Mann on Being Photographed," *Aperture* 162 (Winter 2001): 1–15.

80 See Mann to Harris, July 1, 1994, in "Sally Mann," 1995, 27.

81 Sally Mann, *Mother Land: Recent Landscapes of Georgia and Virginia* (exh. cat., Edwynn Houk Gallery, New York, 1997), 6; Mann 2015, 212.

82 Mann to Harris, July 1, 1994, in "Sally Mann," 1995, 24.

83 Mann to Harris, August 30, 1994, in "Sally Mann," 1995, 28, and Mann to Harris, July 1, 1994, in "Sally Mann," 1995, 24.

84 Mann to Harris, August 30, 1994, in "Sally Mann," 1995, 30.

85 Cy Twombly, *Photographs*, with text by William Katz (exh. cat., Matthew Marks Gallery, New York, 1993).

86 Rainer Maria Rilke, *Letters to a Young Poet*, trans. M.D. Herter Norton (New York, 1954), 34.

87 Mann 2015, 67–68.

88 Mann, to Fleurov and Rifken, February 22, 1996, fax, and Mann 2015, 215.

89 Mann 2015, 221–222.

90 Sally Mann, *Deep South* (New York, 2005), 50; see also Mann 2015, 231.

91 Mann, interview by Stephan, in Jena 2007, 40.

92 Mann 2015, 224, and Sally Mann, in "Place," *Art 21*, season 1, episode 1, aired 2001, www.pbs.org/program/art21.

93 Sally Mann, interview by Malcolm Daniel, January 25–26, 2016, at the Mann home in Lexington, Virginia.

94 Mann 2015, 235, and Mann in Kazanjian 1999, 610.

95 Mann 2015, 234.

96 Sally Mann, as quoted in Mary Panzer, "Master Class: In with the Old," *American Photo* 13, no. 3 (May/June 2002): 36.

97 Mann, 2005, 52, and Mann 2015, 236.

98 See Mary Ann Perkins, "Death and Memory in the Photography of Sally Mann" (master's thesis, California State University Dominguez Hills, 2008), 21.

99 Martin Luther King, Jr., "Loving Your Enemies," *Strength to Love* (Philadelphia, 1963), 53.

100 Mann 2015, 238.

101 Mann, interview by Philip Brookman, in Washington 1996, 76.

102 Mann, as quoted in Washington 1996, 78.

103 Lawrence Osborne, "Crime-Scene Forensics: Dead Men Talking," *New York Times Magazine*, December 3, 2000, 104–108, with photographs by Sally Mann.

104 Mann 2015, 410.

105 Sally Mann, as quoted in Malcolm Jones, "Love, Death, Light," *Newsweek*, September 8, 2003, 56.

106 Mann 2015, 410.

107 "Love, Death, and Light," 2003, 54–56.

108 Union Major General Joseph Hooker, "Unfinished Report to Brigadier General Alpheus S. Williams," November 8, 1862, *The War of the Rebellion: A Compilation of the Official Records of the Union and Confederate Armies*, 70 vols. (US War Department, Washington, 1880–1901), ser. 1, part 1, 19:218.

109 For further discussion, see Ravenal, "Last Measure," in Richmond 2010, 54–55.

110 "Love, Death, and Light," 2003, 54.

111 From *Leaves of Grass,* as quoted in Sally Mann, *What Remains* (New York, 2003), 82.

112 Mann 2014, 411; see also James Christen Steward, "A Recent Museum of Art Acquisition: New Work by Sally Mann," *Bulletin: The University of Michigan, Museums of Art and Archaeology* 15 (2003), http://hdl.handle.net/2027/spo.0054307.0015.110 (accessed May 8, 2017).

113 Sally Mann, "A Conversation with Photographer Sally Mann," *The Charlie Rose Show*, aired November 12, 2003.

114 Pound, as quoted in Mann 2003, 104.

115 Sanford Levinson, as quoted in Mann 2015, 279.

116 Mann 2015, 263.

117 William Faulkner, "The Bear," in *Go Down, Moses* (New York, 1942), as quoted in Mann 2015, 280.

118 Mann 2015, 279.

119 Mann 2015, 235.

120 Mann 2015, 284–285.

121 Henry Wadsworth Longfellow, "The Slave in the Dismal Swamp," in *The Poetical Works of Henry Wadsworth Longfellow* (London, 1860), 137.

122 T.W. Higginson, "Nat Turner's Insurrection," *Atlantic Monthly* 8, no. 46 (August 1861), https://www.theatlantic.com/past/docs/issues/1861aug/higginson.htm; newspapers at the time speculated that Turner was headed for the Dismal Swamp: see *Petersburg Intelligencer* (Virginia), August 26, 1831, as quoted in "Free the Land," https://newafrikan77.wordpress.com/2016/09/06/nat-turner-dismal-swamp-maroons-turner-may-have-wanted-to-establish-a-maroon-colony. For further discussion, see Samuel Warner, "Authentic and Impartial Narrative of the Tragical Scene ..." printed for Warner and West (1831) in Henry Irving Tragle, *The Southampton Slave Revolt of 1831: A Compilation of Source Material* (Amherst, 1971), 296–297; Thomas C. Paramore, "Covenant in Jerusalem," and Douglas R. Egerton, "Nat Turner in a Hemispheric Context," in *Nat Turner: A Slave Rebellion in History and Memory*, ed. Kenneth S. Greenberg (New York, 2003), 62 and 141.

123 For further discussion, see Stauffer in Wood 2013, 11.

124 See David F. Allmendinger, *Nat Turner and the Rising in Southampton County* (Baltimore, 2014), 21–22.

125 Joe Nutt, *Historical Sketches of African-American Churches (Past and Present) of Augusta County, Staunton, Waynesboro, & Vicinity* (Staunton, 2001).

126 Nutt 2001, 11, 53.

127 Sally Mann, "The Two Virginias," *Art 21*, *Extended Play*, aired September 12, 2014, https://art21.org/watch/extended-play/sally-mann-the-two-virginias-short/, and Mann 2015, 249.

128 Toni Morrison, in *World Magazine* (1989), as quoted in "Bench by the Road Project," The Toni Morrison Society, http://www.tonimorrisonsociety.org/bench.html (accessed May 16, 2017).

129 Mann 2015, 250, 262, 259, respectively.

130 All quotations in this paragraph are Mann 2015, 257, 251, 264, 261, 256, 255.

131 Mann 2015, 278.

132 Mann 2015, 267, 278.

133 Bill T. Jones, as quoted in *Fondly Do We Hope ... Fervently Do We Pray*, Bill Moyers Journal, http://www.pbs.org/moyers/journal/12252009/profile.html (accessed May 16, 2017).

134 Jones, as quoted in Mann 2015, 281.

135 Mann 2015, 289.

136 Mann 2015, 267, 292.

137 Mann 2015, 263.

138 John Stauffer, "Introduction: Sally Mann," *Aperture: Vision and Justice* 223 (Summer 2016): 89. See also Cara Parks, "Instill Life: The Dark and Light of Sally Mann," *New Republic*, June 2015, 70–73.

139 Huey Copeland, in conversation with Thelma Golden and Hilton Als, "Looking Back at *Black Male*," Whitney Museum of American Art, December 12, 2014, http://whitney.org/Education/Education-Blog/LookingBackAtBlackMale (accessed May 16, 2017); see also Thelma Golden, ed., *Black Male: Representations of Masculinity in Contemporary American Art* (exh. cat., Whitney Museum of American Art, New York, 1994).

140 This and subsequent quotations in this paragraph are Mann 2015, 292, 293, 289, 293.

141 Mann 2015, 293–294.

142 Mann 2003, 6, and Mann 2015, 416–417.

143 Richmond 2010, 8.

144 Sally Mann, as quoted in Lisa Shea, "Sally Mann Reflects on a Career of Controversial Images," *Elle,* May 11, 2015, 94.

145 Mann 2015, 143.

146 Salman Rushdie, *Midnight's Children* (London, 1992), 292.

147 T.S. Eliot, "Burnt Norton," in *Collected Poems 1909–1962* (Franklin Center, PA, 1979), 177–183.

148 Vladimir Nabokov, *Novels and Memoirs 1941–1951: The Real Life of Sebastian Knight; Bend Sinister; Speak, Memory* (New York, 2008), 369.

149 Ezra Pound, "Canto LXXVI," in *The Cantos of Ezra Pound* (New York, 1970), 457.

150 Michael Bell, *Literature, Modernism and Myth: Belief and Responsibility in the Twentieth Century* (Cambridge, UK, 2006), 143.

Flashes of the Finite:
Sally Mann's Familiar Terrain

1 Sally Mann, *Hold Still: A Memoir with Photographs* (New York, 2015), 111.

2 Mann 2015, 78.

3 Mann 2015, 111.

4 This figure does not include more than eighteen hundred color family pictures that Mann made but has not yet fully edited or printed.

5 Mann 2015, 83.

6 The first exhibition and publication that included works from the *Family* series was *Sally Mann: Still Time* (exh. cat., Alleghany Highlands Arts and Crafts Center, Clifton Forge, VA, 1988). Organized in association with the Virginia Museum of Fine Arts in 1988, the exhibition circulated to eleven venues in Virginia. In 1994, *Aperture* republished the catalogue with additional photographs: see Sally Mann, *Still Time* (New York, 1994). For other exhibitions of family pictures between 1988 and the release of *Immediate Family* in 1992, see the chronology.

7 Susan Freudenheim, "It May Be Art, but What about the Kids?" *San Diego Tribune,* March 29, 1989.

8 Sally Mann, "Sally Mann's Exposure," *New York Times,* April 16, 2015.

9 Leslie Phillips, "Lawmakers Tackle the Funding of Art," *USA Today,* September 12, 1989, cited in Wendy Steiner, *The Scandal of Pleasure* (Chicago, 1995), 24.

10 Melissa Harris, ed., "The Body in Question," special issue, *Aperture* 121 (Fall 1990).

11 Raymond Sokolov, "Critique: Censoring Virginia," *Wall Street Journal,* February 6, 1991.

12 The question of consent and dereliction of maternal duty was raised by Richard Woodward's article, "The Disturbing Photography of Sally Mann," *New York Times Magazine,* September 27, 1992, when he asked: "Can young children freely give their consent for controversial portraits, even if—especially if—the artist is their parent?"

13 Woodward 1992.

14 Roger N. Lancaster in *Sex Panic and the Punitive State* (Berkeley, 2011) described the 1980s as a period in which pervasive anxiety that horrific abuse of children lurked everywhere gave rise to a modern suburban culture of fear. See also Philip Jenkins, *Moral Panic: Changing Concepts of the Child Molester in Modern America* (New Haven, CT, 1998); Mary de Young, *The Day Care Ritual Abuse Moral Panic* (Jefferson, NC, 2004); and Amy Adler, "Photography on Trial," *Index on Censorship* 3 (1996): 141–145.

15 The McMartin case occupied the better part of the 1980s. The first accusations were made in 1983, and the trial, which exonerated all of the defendants from any charges of wrongdoing, lasted from 1987 to 1990. See Richard Beck, *We Believe the Children: A Moral Panic of the 1980s* (New York, 2015).

16 For an excellent summary of the culture wars, see Andrew Hartman, *A War for the Soul of America* (Chicago, 2015). It is worth noting as well that the 1994 Oscar-nominated documentary short by Steven Cantor, *Blood Ties,* focused heavily on the media controversy surrounding Mann's art and fueled the association between Mann's art and the broader culture wars.

17 See Sarah Parsons, "Public/Private Tensions in the Photography of Sally Mann," *History of Photography* 32, no. 2 (Summer 2008): 123–136.

18 In 1999, Mann told photographer Maude Schuyler Clay, who acted as Mann's guide in Sumner, Mississippi, "There is one absolutely inarguable statement you can make about those pictures: they testify to a maternal passion that is not only natural but pretty close to universally experienced. Anyone who finds it dichotomous that a

mother should produce such saturatingly maternal images is beyond reasoning with." For this 1999 interview by Maude Schuyler Clay, see "Sally Mann's Vision," *Oxford American: A Magazine of the South*, May 12, 2015. Helen Molesworth articulated the rise of feminism and the shifts in 1980s art in *This Will Have Been: Art, Love, and Politics in the 1980s* (exh. cat., Museum of Contemporary Art, Chicago, 2012). More recently, Claire Raymond considered Mann's work in relation to feminism in *Women Photographers and Feminist Aesthetics* (New York, 2017).

19 See K.J. Dell'Antonia, "In Debate around Sally Mann's Photography, Too Much is Exposed," *New York Times*, April 16, 2015, https://parenting.blogs.nytimes.com/2015/04/16/in-debate-around-sally-manns-photography-too-much-is-exposed/ (accessed June 5, 2017).

20 Sally Gall, "Emmet Gowin," *Bomb* 58 (Winter 1997), http://bomb-magazine.org/article/2012/emmet-gowin (accessed June 8, 2017).

21 Sarah Moroz, "Emmet Gowin: 'Everyone Thought My Photographs Were Incestuous,'" *Guardian*, May 29, 2014.

22 Chris Wiley, "The Most Intimate Photograph," *New Yorker*, January 10, 2017, http://www.newyorker.com/culture/photo-booth/the-most-intimate-photograph (accessed June 9, 2017).

23 Kathleen Anne McHugh discussed Hollywood's responses to the breakdown of the cultural fantasy of "white bourgeois domestic femininity" in *American Domesticity: From How To Manual to Hollywood Melodrama* (Oxford, 1999), 153–159. See also Sarah Harwood, *Family Fictions: Representations of the Family in 1980s Hollywood Cinema* (London, 1997).

24 Mann's photographs were included in the following exhibitions and catalogues that focused on family life: Peter Galassi, *The Pleasures and Terrors of Domestic Comfort* (exh. cat., Museum of Modern Art, New York, 1991); *Blood Relatives: The Family in Contemporary Photography* (exh. cat., Milwaukee Museum of Art, 1991); *Family Album: Changing Perspectives of Family Portrait* (exh. cat., Tokyo Metropolitan Museum of Photography, 1992); *Visions of Childhood: Photographs by Barbara Ess, Wendy Ewald, Sally Mann, Nicholas Nixon* (exh. cat., Center for Curatorial Studies, Annandale-on-Hudson, 1995). Mann's work was also included in the book *Flesh and Blood: Photographers' Images of Their Own Families*, ed. Alice Rose George, Abigail Heyman, and Ethan Hoffman (New York, 1992).

25 Galassi 1991, 15.

26 Reynolds Price, "Neighbors and Kin," in "New Southern Photography between Myth and Reality," special issue, *Aperture* 115 (Summer 1989): 36.

27 Price 1989, 36.

28 In a review of the exhibition, A.D. Coleman noted that "the show could just as easily be called 'The Art-Educated, (Mostly) White Middle Class of the United States Photographs Itself at Home in the Eighties." A.D. Coleman, "Letter from New York, No. 29," *Photo Metro* 10, no. 95 (December 1991–January 1992), 27.

29 Sally Mann, *At Twelve: Portraits of Young Women* (New York, 1988), 52.

30 Mann in Clifton Forge 1988, 9.

31 Mann in Clifton Forge 1988, 8.

32 Mann in Clifton Forge 1988, 7.

33 Although there was no documented increase in child abuse in the 1980s (indeed, a decrease is more likely), it "represented a period of significant expansion in public awareness of child maltreatment, research on its underlying causes and consequences, and the development and dissemination of both clinical interventions and prevention strategies." See Child Welfare Information Gateway, *Child Maltreatment Prevention: Past, Present, Future* (Washington, 2011), produced by the Department of Health and Human Services, https://www.childwelfare.gov/pubs/issue-briefs/cm-prevention/ (accessed May 28, 2017).

34 Mann 2015, 114.

35 Woodward 1992.

36 Sally Mann, introduction to *Immediate Family* (New York, 1992), n.p.

37 Sally Mann, in Robert Enright, "Questioning Bodies: A Symposium on Censorship and Representation," *Border Crossings* 10, no. 2 (1991): 20.

38 Anne Higonnet, *Pictures of Innocence: The History and Crisis of Ideal Childhood* (London, 1998), 224–205.

39 Mann, as quoted in Annandale-on-Hudson 1995, 18.

40 Mann 1992.

41 Mann 2015, 128.

42 Mann 2015, 128.

43 Don DeLillo, *The Body Artist* (New York, 2001), 9.

44 Quoted in Mann 2015, 149.

45 Interview with Jian Rong originally for the November 2010 issue of *Chinese Photography*, republished as "An Exclusive Interview with Sally Mann—'The Touch of an Angel,'" in *American Suburb X*, January 5, 2013, http://www.americansuburbx.com/2013/01/interview-sally-mann-the-touch-of-an-angel-2010.html (accessed June 8, 2017).

46 See Zoë Lepiano, "Family in Colour: Integrating Colour into Sally Mann's Family Pictures" (master's thesis, Ryerson University, Toronto, 2016). Lepiano noted that Mann made nearly nineteen hundred color transparencies, from which she selected eighty-three to become the subseries Family Color. Five were published in the 1994 edition of *Still Time*.

47 Mann in Lepiano 2016, 77: "I think I was just shooting so freely because I could. Because someone had given me the camera and Agfa was throwing the film at me and it seemed to have less consequence, was less fraught, had less import than black-and-white, because I had established myself and had already started the series had the series well under way, I guess."

48 See David Levi Strauss, "Eros, Psyche, and the Mendacity of Photography," in *Sally Mann: The Flesh and the Spirit*, ed. John B. Ravenal (exh. cat., Virginia Museum of Fine Arts, Richmond, 2010), 179–184.

49 See A.D. Coleman, "The Directorial Mode: Notes toward a Definition (1976)," in *Photography in Print: Writings from 1816 to the Present,* ed. Vicki Goldberg (Albuquerque, 1981), 485.

50 "Photography," *New Yorker*, June 1, 1992, 13.

51 Carol Armstrong discussed Cameron's maternal imagery in "Cupid's Pencil of Light: Julia Margaret Cameron and the Maternalization of Photography," *October* 76 (Spring 1996): 114–141.

52 Jessie Mann and Melissa Harris, "Jessie at 18: Daughter, Model, Muse Jessie Mann on Being Photographed," *Aperture* 162 (Winter 2001): 7.

53 Mann devoted a chapter of her 2015 memoir to her relationship with Gee-Gee. See Mann 2015, 243–271.

54 Charles Hagen, "Review/Art: Childhood without Sweetness," *New York Times*, June 5, 1992.

55 Edward Sozanski, "A Photographer Who Studies Her 3 Children," *Philadelphia Inquirer*, November 15, 1992.

56 Sozanski 1992.

57 According to Woodward 1992. However, *Artforum* published the photograph with an essay by Jeffrey Eugenides in 1994. See Jeffrey Eugenides, "Hayhook," *Artforum* (December 1994): 56–57.

58 In 1991, Stephen Knox was convicted of possessing child pornography. The material in question consisted of films of young girls dancing in bathing suits and other "revealing attire" but did not depict nudity or sexual activity. The case was first argued before the United States Court of Appeals for the Third Circuit in 1992 before going to the United States Supreme Court in 1993, who referred it back to the court of appeals in 1994. For more on this law, see Higonnet 1998, 182–186.

59 Amy Adler, "The Perverse Law of Child Pornography," *Columbia Law Review* (March 2001): 6, https://ccoso.org/sites/default/files/import/PerverseLawofChildPornography.pdf (accessed May 22, 2017).

60 Adler 2001, 2. Lawrence Stanley addressed censorship and child nudity in "Art and 'Perversion,' Censoring Images of Nude Children," *Art Journal* 50, no. 4 (Winter 1991): 20–27. See also Sarah Parsons, "Public/Private Tensions in the Photography of Sally Mann," *History of Photography* 32, no. 2 (2008): 123–136.

61 Henry Giroux has explored the cultural and political manipulation of the concept of the disappearing child in "Nymphet Fantasies: Child Beauty Pageants and the Politics of Innocence," *Social Text* 57 (Winter 1998): 31–53. See also Richard Eder, "The Teenager as Sex Object-Art or Exploitation?" *New York Times*, November 29, 1981.

62 Mann, as quoted in Vince Aletti, "Child World," *Village Voice*, May 26, 1992, 37.

63 A.D. Coleman's admiring review averred that Mann's work "aspires to and attains the status of literature." See A.D. Coleman, "The Entrancing Clarity of a Mother's Vision of Her Young," *New York Observer*, June 8, 1992.

64 Simon Dumenco, "Mother Lode: Sally Mann's Startling Family Photos Expose Childhood," *Baltimore City Paper*, June 18, 1991, 14.

65 Janet Malcolm elaborated on Mann's departure from maternal norms in "The Family of Mann," *New York Review of Books*, February 3, 1994, 7–8.

66 Mann 2015, 137.

67 Luc Sante, "Luc Sante on Photography: The Nude and the Naked," *New Republic*, May 1, 1995, 30–35.

68 Sante 1995, 34.

69 Dell'Antonia 2015.

70 Jane Swigart analyzed the construction of the ideal mother in *The Myth of the Perfect Mother: Parenting without Guilt* (Lincolnwood, IL, 1998). Marianne Hirsch discussed the ways in which Mann presents and challenges maternal identity in *Family Frames: Photography, Narrative and Postmemory* (Cambridge, MA, 1997). Broader explorations of art and motherhood include Rachel Epp Buller, ed., *Reconciling Art and Mothering* (London, 2012) and Myrel Chernik and Jennie Klein, eds., *The M Word: Real Mothers in Contemporary Art* (Ontario, 2011).

71 Emily White, "Danger in Paradise: Sally Mann Exposes the Risks of Childhood," *LA Weekly*, January 22–28, 1993, 39.

72 Mann 2015, 140.

73 Mann 2015, 151.

74 Luc Sante, "Sally Mann," in *Collection in Context: Selected Contemporary Photographs of Hands from the Collection of Henry M. Buhl* (exh. cat., Thread Waxing Space, New York, 1996), 54.

75 "Jane Smiley, The Art of Fiction No. 299," interview by Nicole Rudnick, in *Paris Review* 214 (Fall 2015).

76 In fact, the accident caused a serious concussion. Emmett suffered at least two more concussions as a teen. Together, they very likely caused or contributed to the schizophrenia that he developed as a young man and that would claim his life in 2016.

77 Mann 2015, 117.

78 Mann 2015, 118.

79 Mann 2015, 120.

80 Mann 2015, 126.

81 Sally Mann to Melissa Harris, July 1, 1994, as quoted in "Sally Mann: Correspondence with Melissa Harris," *Aperture* 138 (Winter 1995): 24.

82 Mann 2015, 99.

83 Vince Aletti, "Sally Mann Talks about Her Return to the Land," *Village Voice*, October 21, 1997, 49.

84 Mann to Harris, July 1, 1994, in "Sally Mann," 1995, 30.

85 Susan Sontag, *On Photography* (New York, 1977), 15.

86 Eric Ormsby, "Childhood House," as quoted in Mann 1994, 5.

The Earth Remembers:
Landscape and History in the Work of Sally Mann

1 Law and Lincoln are quoted in Ernest B. Furgurson, *Not War but Murder: Cold Harbor 1864* (New York, 2000), xi, 233–234. See his powerful description of the slaughter on page 3. See also Gordon C. Rhea, *Cold Harbor: Grant and Lee, May 26–June 3, 1864* (Baton Rouge, 2007). Ulysses S. Grant, personal memoirs in *Memoirs and Selected Letters*, ed. Mary Drake McFeely and William S. McFeely (1885; repr., New York, 1990), 587. The battle Pierson described, which is called Gaines Mill, took place in the same location two years before the battle that Law described, which has come generally to be known as Cold Harbor. (And indeed bones and skulls from the 1862 battle were on the field in 1864 when Cold Harbor began.) For Pierson's description, see *Brothers in Gray: The Civil War Letters of the Pierson Family*, ed. Thomas W. Cutrer and T. Michael Parrish (Baton Rouge, 1997), 101.

2 Russell Conwell, as quoted in Furgurson 2000, 258.

3 Sally Mann, as quoted in press materials for the 2003 exhibition *Last Measure*, http://www.houkgallery.com/sally-mann; Sally Mann, *Hold Still: A Memoir with Photographs* (New York, 2015), 416.

4 Fred Mather, as quoted in Furgurson 2000, 140; Mann 2015, 213, 416.

5 Sally Mann, *Deep South* (New York, 2005), 7; Mann 2015, 289. For the classic and iconic treatment of this issue, see C. Vann Woodward, *The Burden of Southern History* (Baton Rouge, 1960).

6 William Faulkner, *Absalom, Absalom!* (1936; repr., New York, 1964), 361, 377.

7 Mann 2015, 80; on Traveller and Little Sorrel see Drew Gilpin Faust, "Equine Relics of the Civil War," *Southern Cultures* (Spring 2000): 23–49.

8 Mann 2005, 5; see James W. Ely, *The Crisis of Conservative Virginia: The Byrd Organization and the Politics of Massive Resistance* (Knoxville, 1976).

9 I have written about my childhood confrontation with segregation in "Living History," *Harvard Magazine* (May–June 2003), harvardmagazine.com/2003/05/living-history.

10 Mann 2015, 259, 262.

11 Mann 2015, 402, 263.

12 Mann 2015, 235; Faulkner 1964, 10; Mann 2005, 49.

13 Mann 2015, 235–237.

14 Mann, as quoted in Hilarie M. Sheets, "Sally Mann on Friendship and Loss," Arts, *New York Times*, September 7, 2016, 2; Mann 2005, 52.

15 Mann 2015, 82; Mann, as quoted in Ann Hornaday, "'Remains' to Be Seen," *Washington Post*, June 6, 2004, N1; Sally Mann, "A Conversation with Photographer Sally Mann," *The Charlie Rose Show*, aired November 12, 2003, https://charlierose.com/videos/13089; Mann 2015, 411.

16 J. David Hacker, "A Census-Based Count of the Civil War Dead," *Civil War History* 57 (December 2011): 307–348; J. David Hacker, "Recounting the Dead," *New York Times,* Opinionator blog, September 20, 2011, https://opinionator.blogs.nytimes.com/2011/09/20/recounting-the-dead/#more-105317; Drew Gilpin Faust, *This Republic of Suffering: Death and the American Civil War* (New York, 2008), xi, xiii; Mann 2005, 89.

17 Faust 2008, 58, 59, 209.

18 Sally Mann, *What Remains* (New York, 2003), 6.

19 Mann 2003, 80. On establishment of the national cemetery system see Faust 2008, chapter 7.

20 James M. McPherson, *Crossroads of Freedom*: Antietam (New York, 2002), 3.

21 Mann 2015, 224; on photography at Antietam in the days after the battle see William Frassanito, *America's Bloodiest Day: The Battle of Antietam, 1862* (London, 1978).

22 "Brady's Photographs: Pictures of the Dead at Antietam," *New York Times*, October 20, 1862.

23 Henry Allen, "The Way of All Flesh," *Washington Post*, June 13, 2004; Mann, *Charlie Rose Show*, 2003.

24 As quoted in McPherson 2002, 4, 6; as quoted in Faust 2008, 66.

25 As quoted in Faust 2008, 67, 68, 69.

26 Oliver Wendell Holmes, "My Hunt after 'The Captain,'" *Atlantic Monthly* 10 (December 1862): 764.

27 Caroline Alexander, "Letter from Vietnam: Across the River Styx," *New Yorker*, October 25, 2005, 44.

28 On the denial of death see Ernest Becker, *The Denial of Death* (New York, 1974); Atul Gawande, *Being Mortal: Medicine and What Matters in the End* (New York, 2014); Mann, as quoted in Hornaday 2004.

29 Mann, as quoted in Hornaday 2004; William Faulkner, *Requiem for a Nun* (New York, 1951), 92.

Abide with Me:
The Color of Humanity in Sally Mann's World

1 Joan Didion, *South and West: From a Notebook* (New York, 2017), 5–6.

2 See Sally Mann, *Hold Still: A Memoir with Photographs* (New York, 2015), 279. For early history in Virginia, including John Rolfe's letter to Sir Edwin Sandys, 1619/1620, see Engel Sluiter, "New Light on the '20. and Odd Negroes' Arriving in Virginia, August 1619," *William and Mary Quarterly* 54, no. 2 (1997): 395–398, http://www.jstor.org/stable/2953279; for the *White Lion*, see John C. Coombs, "Phases of Conversion: A New Chronology for the Rise of Slavery in Early Virginia," *William and Mary Quarterly* 68, no. 3 (2011): 332–360, http://www.jstor.org/stable/10.5309/willmaryquar.68.3.0332.

3 See Henry Francis Lyte, "Abide with Me," in *Miscellaneous Poems* (London, 1868), 297–299; Mahatma Gandhi to Gulchen Lumsden, February 10, 1933, as quoted in *The Collected Works of Mahatma Gandhi, 13 January, 1933–9 March 1933*, 2nd ed. (New Delhi, 2000), 59:223; and Matthias Range, *British Royal and State Funerals: Music and Ceremonial Since Elizabeth I* (Woodbridge, 2016), 281.

4 See James H. Cone, *God of the Oppressed* (Maryknoll, NY, 1997), xvii, and James Baldwin, "Down at the Cross: Letter from a Region of My Mind," in *The Fire Next Time* (New York, 2013), 41.

5 See Flannery O'Connor, "Some Aspects of the Grotesque in Southern Fiction," in *Mystery and Manners: Occasional Prose*, ed. Sally and Robert Fitzgerald (New York, 1969), 45, and C. Ross Mullins, Jr., "Flannery O'Connor: An Interview," *Jubilee* 11 (June 1963); reprinted in *Conversations with Flannery O'Connor*, ed. Rosemary M. Magee (Jackson, 1987), 104.

6 Mann 2015, 267–268.

7 See Sluiter 1997.

8 See Baldwin 2013, 46; Robert Burns, "The Ordination," in *The Poetical Works of Robert Burns: Carefully Collated with Original Explanatory Notes* (London, 1826), 210; and Anna Bartlett Warner and Susan Warner, *Say and Seal* (Philadelphia, 1860), 2:115. The poem in the novel was later adapted as a Christian hymn by Warner with a melody by William Batchelder Bradbury added in 1862.

9 See Eudora Welty, "Where Is the Voice Coming From?" *New Yorker*, July 6, 1963, and Barbara Lazear Ascher, "A Visit with Eudora Welty," in *More Conversations with Eudora Welty*, ed. Peggy Whitman Prenshaw (Jackson, 1996), 85.

10 Mann 2015, 267.

11 Mann 2015, 303.

12 Mann 2015, 198.

13 For a history of voting in the South, see W.E.B. DuBois, *Black Reconstruction in America: An Essay toward a History of the Part Which Black Folk Played in the Attempt to Reconstruct Democracy in America, 1860–1880* (New York, 1998); Eric Foner, *Reconstruction: America's Unfinished Revolution, 1863–1877* (New York, 1988); Steven Hahn, *A Nation under Our Feet: Black Political Struggles in the Rural South from Slavery to the Great Migration* (Cambridge, MA, 2005); and C. Vann Woodward, *The Strange Career of Jim Crow* (New York, 2002).

14 See "Some Aspects of the Grotesque in Southern Fiction," in O'Connor 1969, 44; Flannery O'Connor, "A Temple of the Holy Ghost," in *A Good Man Is Hard to Find* (New York, 1955); and Mann 2015, 4–5.

15 John O. Killens, "The Confessions of Willie Styron," in *William Styron's Nat Turner: Ten Black Writers Respond* (New York, 1968).

16 Mann 2015, 278.

17 See William Faulkner, "The Bear," in *Go Down, Moses* (New York, 1942), as quoted in Mann 2015, 280.

18 See Baldwin 2013, 29, and Toni Morrison, *Playing in the Dark: Whiteness and the Literary Imagination* (Cambridge, 1992).

19 See "The Regional Writer," in O'Connor 1969, 53–54, and Truman Capote, "New Orleans," in *Portraits and Observations* (New York, 2013), 4.

Torn from Time Itself:
Sally Mann's New Avenues from Old Processes

1 Sally Mann, interview by Malcolm Daniel, January 25–26, 2016, at the Mann home in Lexington, Virginia. Unless specified otherwise, observations by Mann that follow are from this interview.

2 The process is alternately called wet-plate, wet collodion, wet collodion on glass, or simply collodion. All of these commonly used terms refer to the same process, which is summarized on page 250 of this essay and described in Mark and France Scully Osterman, *Basic Collodion Technique: Ambrotype & Tintype* (Rochester, NY, 2012), which updates and expands upon Mark's 1994 self-published manual "The Wet-Plate Process."

3 *Search for Shadows in the West of Ireland*, March 7–April 11, 1997, Pennswood Village Art Gallery, Newtown, Pennsylvania.

4 France Scully Osterman, email message to Malcolm Daniel, March 16, 2017.

5 Sally Mann, *Hold Still. A Memoir with Photographs* (New York, 2015), 96, 216. In *Mother Land: Recent Landscapes of Georgia and Virginia* (exh. cat., Edwynn Houk Gallery, New York, 1997), 6, Mann cited the date 1972 for her discovery of the Miley negatives and numbered them at about ten thousand.

6 See Marshall William Fishwick, *General Lee's Photographer: The Life and Work of Michael Miley* (Chapel Hill, 1954); Richard A. Straw, *Rockbridge County: The Michael Miley Collection* (Charleston, SC, 2013). Portions of the Michael Miley Photographic Collection at Washington and Lee University can be searched online at https://repository.wlu.edu/handle/11021/31249. Part of the Miley negatives are housed at the Sally Mann studio and the remainder are at the Virginia Historical Society, Richmond, where they were reunited with negatives acquired from the Miley family in 1940.

7 Mann 2015, 216–217; John B. Ravenal, *Sally Mann: The Flesh and The Spirit* (exh. cat., Virginia Museum of Fine Arts, Richmond, 2010), 4.

8 Mann 2015, 222.

9 Sally Mann, fax to Ellen Dugan [Fleurov] and Ned Rifken, February 22, 1996, High Museum of Art, Atlanta.

10 Mann 2015, 223.

11 F.S. Osterman to Daniel, March 16, 2017, email.

12 Frederick Scott Archer, "On the Use of Collodion in Photography," *The Chemist*, n.s., 2 (March 1851); Frederick Scott Archer, *Manual of the Collodion Photographic Process* (London, 1852).

13 M. and F.S. Osterman 2012, 6.

14 M. and F.S. Osterman 2012, 7.

15 Gaston Tissandier, *Les merveilles de la photographie* (Paris, 1874), 122; translation by Malcolm Daniel.

16 Mann 2015, 223.

17 J. Towler, *The Silver Sunbeam: A Practical and Theoretical Text-Book on Sun Drawing and Photographic Printing; Comprehending All the Wet and Dry Processes at Present Known, with Collodion, Albumen, Gelatin, Wax, Resin and Silver; as [sic] Also Heliographic Engraving, Photolithography, Photozincography, Celestial Photography, Photography in Natural Colors, Tinting and Coloring of Photographs, Printing in Various Colors, the Carbon Process, the Card-Picture, the Vignette, and Stereography* (New York, 1864).

18 Mann jokes that her sloppy technique has prompted some "collodion purists" to burn her in effigy.

19 Mann 2015, 224.

20 Mann 2015, 220–221.

21 The magnificent ruined columns of Windsor Mansion (pl. 26), the grandest of antebellum plantation houses, completed in 1861, might easily be read as a metaphor for the destruction of high Southern culture in the wake of the Civil War, but the mansion remained intact until a disastrous fire in February 1890.

22 In the rare instances when a solar enlarger was used in the nineteenth century to print photographs on the grand scale of Mann's prints, such enlargements were almost always made to be overpainted.

23 Mann to Fleurov and Rifken, February 22, 1996, fax.

24 Sally Mann, interview by Malcolm Daniel, April 20, 2017.

25 Mann's switch from a substrate of black glass to one of aluminum (from ambrotypes to tintypes in a technical sense) was a practical one, made on August 23, 2011. As she worked in the collodion studio atop the implement shed that afternoon just before 2:00, the whole building began to shake and the line of glass ambrotypes leaning against the wall began to dance on the narrow shelves supporting them. A 5.8 magnitude earthquake, centered less than a hundred miles east-northeast of Lexington, was rattling the East Coast. Miraculously, none of the plates were damaged, but the close call and the recollection that photographers Carleton E. Watkins and Arnold Genthe had both lost a lifetime of work in glass negatives in the 1906 San Francisco earthquake were enough to send Mann looking for alternate materials. The black-coated aluminum plates she now orders from a trophy company are far easier to handle and transport, and are virtually indistinguishable to the eye.

26 Mann, April 20, 2017, interview.

27 Mann's decision to use black glass rather than clear glass backed with black also creates a greater intimacy since not even a sheet of glass lies between the viewer and the photographic material.

28 While experimenting with collodion as a possible varnish, John Parker Maynard found that the substance glued his fingers together rather firmly. "This accidental occurrence at once suggested to me the idea that this fluid, as it suddenly became solid, and seemed to possess an adhesive tenacity unequalled by any known gum, might be made use of as an elegant and effective substitute for the common adhesive plaster, and become an important agent in surgery." John Parker Maynard, "Discovery and Application of the New Liquid Adhesive Plaster," *Boston Medical and Surgical Journal* 38 (1848): 179. Nitrocellulose is still used in liquid bandage products.

29 Sally Mann, email message to Malcolm Daniel, April 23, 2017.

30 Sally Mann, interview by Malcolm Daniel, April 24, 2017.

31 The back cover of Osterman's 1994 manual illustrates the relative color sensitivity of panchromatic Kodacolor film and collodion.

32 Mann, April 24, 2017, interview.

NOTES TO EPIGRAPHS

Pages 3 and 9: John Glenday, "Landscape with Flying Man," from *Grain* (London, 2009), © John Glenday 2009, reproduced with permission of Pan Macmillan through PLSclear.

Page 19: "'I Photograph What I Love but Not Necessarily What I Understand,'" interview with Sally Mann by Erik Stephan, in *Sally Mann: Deep South/Battlefields* (exh. cat., Kunstsammlung im Stadtmuseum Jena, 2007), 39.

Page 22: Sally Mann, *Immediate Family* (New York, 1992), n.p.

Page 37: Marcel Proust, "Overture: Swann's Way," in *Remembrance of Things Past*, trans. C. K. Scott Moncrieff (New York, 1934), 1:97, and *Sally Mann, Hold Still: A Memoir with Photographs* (New York, 2015), 210.

Page 58: Mann 1992, introduction.

Page 76: Mann 1992.

Page 87: *Sally Mann: Still Time* (exh. cat., Alleghany Highlands Arts and Crafts Center, Clifton Forge, VA, 1988), 25.

Page 110: Mann, interview by Stephan, in Jena 2007, 40.

Page 116: Sally Mann, *Deep South* (New York, 2005), 52.

Page 120: Mann 2015, 235–237.

Page 127: Reuben Allen Pierson, July 11, 1862, in *Brothers in Gray: The Civil War Letters of the Pierson Family*, ed. Thomas W. Cutrer and T. Michael Parrish (Baton Rouge, 1997), 101.

Page 142: Abraham Lincoln, "Address at Gettysburg, Pennsylvania," November 19, 1863, in *Speeches and Writings, 1859–1865: Speeches, Letters, and Miscellaneous Writings, Presidential Messages and Proclamations*, ed. Don E. Fehrenbacher and Roy P. Basler (New York, 1989), 536, and Isaiah 40:7 (King James Version).

Page 146: Major General Joseph Hooker, "Unfinished Report to Brigadier General Alpheus S. Williams," November 8, 1862, in *The War of the Rebellion: A Compilation of the Official Records of the Union and Confederate Armies*, 70 vols. (US War Department, Washington, 1880–1901), ser. 1, part 1, 19:218, and John B. Gordon, *Reminiscences of the Civil War* (New York, 1904), 84.

Page 150: C. H., "How a Man Feels in Battle," *Springfield (MA) Daily Republican*, January 26, 1863.

Page 156: Major Sullivan Ballou, Second Rhode Island, died at First Bull Run, to Sarah Ballou, July 14, 1861, in Henry Sweetser Burrage, *Brown University in the Civil War: A Memorial* (Providence, RI, 1868), 107.

Page 161: Joan Didion, *South and West: From a Notebook* (New York, 2017), 5–6.

Page 174: Sally Mann, statement to authors, December 2017.

Page 180: *The Confessions of Nat Turner and Related Documents*, ed. Kenneth S. Greenberg (Boston, 1996), 46.

Page 184: Mann 2015, 263.

Page 192: Frederick Douglass, "What to the Slave Is the Fourth of July?" (speech, Rochester, NY, July 5, 1852), in *My Bondage and My Freedom* (New York, 1857), 444.

Page 204: Henry Francis Lyte, "Abide with Me," in *Miscellaneous Poems* (London, 1868), 297–299.

Page 216: Mann 2015, 249.

Page 224: Mann 2015, 243.

Page 228: Mann 2015, 258–259.

Page 236: James Dickey, "The Traditions Web," in *Jericho: The South Beheld* (Birmingham, 1974), 115; paintings by Hubert Shuptrine.

Page 245: Sally Mann, interview by Malcolm Daniel, January 25–26, 2016, at the Mann home in Lexington, Virginia.

Page 258: Ezra Pound, "Canto LXXXI" in *The Cantos of Ezra Pound* (New York, 1996), 520–521.

Page 270: T. S. Eliot, "Burnt Norton," in *Collected Poems 1909–1962* (Franklin Center, PA, 1979), 177–183.

Page 278: Ezra Pound, "Canto LXXVI," in *The Cantos of Ezra Pound* (New York, 1970), 457.

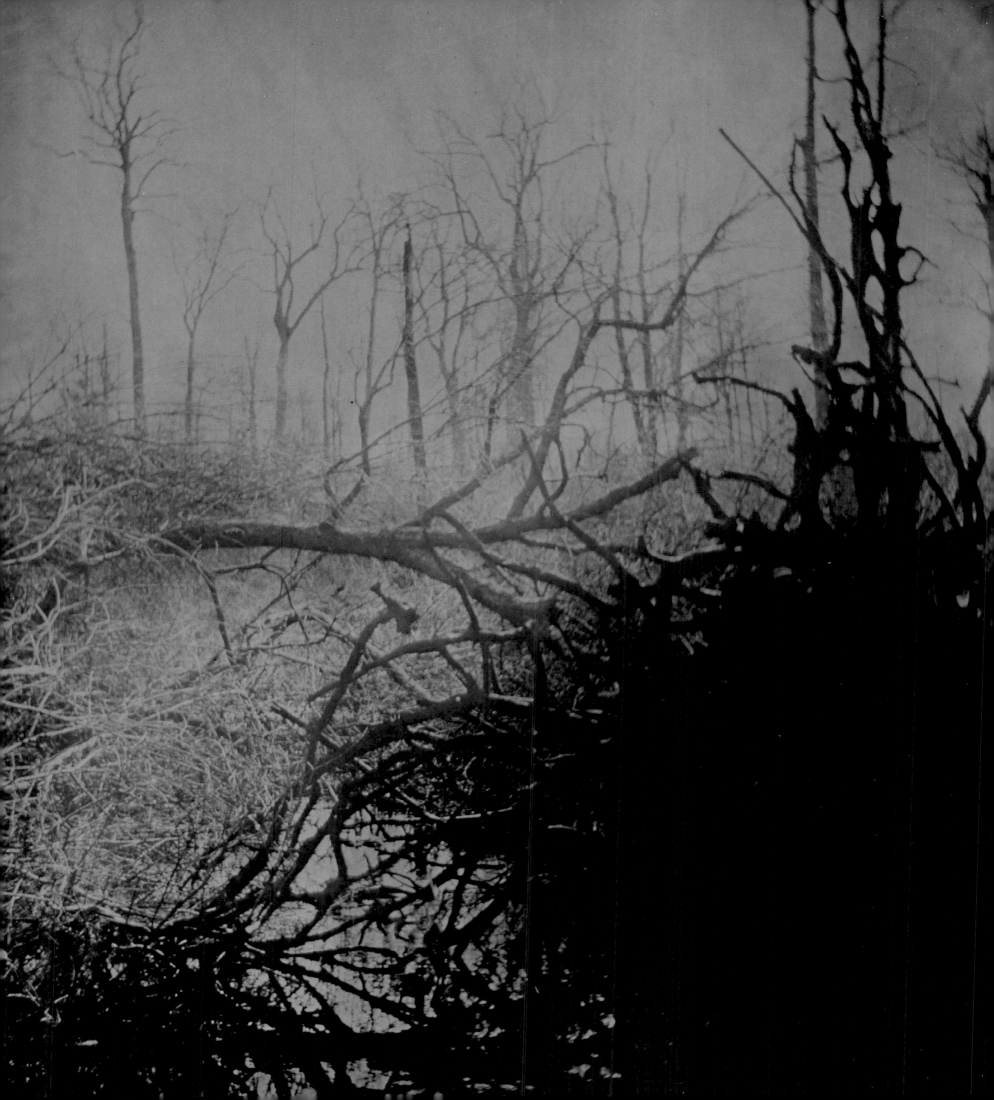

SELECTED BIBLIOGRAPHY

Documentaries

Art 21. Season 1, episode 1, "Place." Directed by Catherine Tatge. PBS, September 21, 2001. www.pbs.org/program/art21.

Blood Ties: The Life and Work of Sally Mann. Directed by Steven Cantor and Peter Spirer. Moving Target Productions, 1993.

Egg: The Arts Show. Episode 301, "Giving Up the Ghost." Produced by WNET. PBS, September 20, 2002.

What Remains: The Life and Work of Sally Mann. Directed by Steven Cantor. Zeitgeist Films, 2005.

Television and Radio Interviews

Mann, Sally. "A Conversation with Photographer Sally Mann." Interview by Charlie Rose. *The Charlie Rose Show*. PBS, November 12, 2003.

Mann, Sally. "From the Lens to Photo: Sally Mann Captures Her Love." Interview by Melissa Block. *All Things Considered*. NPR, February 17, 2011.

Mann, Sally. "Making Art out of Bodies: Sally Mann Reflects on Life and Photography." Interview by Terry Gross. *Fresh Air*. NPR, May 12, 2015.

Mann, Sally. "Sally Mann." Interview by Charlie Rose. *The Charlie Rose Show*. PBS, June 1, 2015.

Mann, Sally. "Sally Mann *Hold Still*." Interview by Ann Patchett. *Thalia Book Club*. Symphony Space, May 13, 2015.

Monographs / Sally Mann

Mann, Sally. *At Twelve: Portraits of Young Women*. New York, 1988.

Mann, Sally. *Deep South*. New York, 2005.

Mann, Sally. "Early Pictures (Part I): Rebirth at Pisa (Part II)." Master's thesis, Hollins College, Roanoke, 1975.

Mann, Sally. *Hold Still: A Memoir with Photographs*. New York, 2015.

Mann, Sally. *Immediate Family*. New York, 1992.

Mann, Sally. *Mother Land: Recent Landscapes of Georgia and Virginia*. Exh. cat., Edwynn Houk Gallery, New York, 1997.

Mann, Sally, Simon Schama, and Edmund De Waal. *Remembered Light: Cy Twombly in Lexington*. New York, 2016.

Mann, Sally. *Sally Mann: Photographs and Poetry*. New York, 2005.

Mann, Sally. *Second Sight: The Photographs of Sally Mann*. Boston, 1983.

Mann, Sally. *Still Time*. New York, 1994.

Mann, Sally. *What Remains*. New York, 2003.

Mann, Sally, and Ted Orland. *Sweet Silent Thought: Platinum Prints by Sally Mann*. Durham, NC, 1987.

Mann, Sally, and C.D. Wright. *Proud Flesh*. New York, 2009.

Livingston, Jane. *Sally Mann / The Lewis Law Portfolio*. Exh. cat., Corcoran Gallery of Art, Washington, 1977.

Ravenal, John B. *Sally Mann: The Flesh and The Spirit*. Exh. cat., Virginia Museum of Fine Arts, Richmond, 2010.

Stephan, Erik. *Sally Mann: Deep South/Battlefields*. Exh. cat., Kunstsammlung im Stadtmuseum Jena, 2007.

General Books, Exhibition Catalogues, and Articles

Aletti, Vince. "Child World." *Village Voice*, May 26, 1992.

Aletti, Vince. "Critic's Notebook: Family of Mann." *New Yorker*, September 21, 2009.

Aletti, Vince. "Sally Mann Talks about Her Return to the Land." *Village Voice*, October 21, 1997.

Aletti, Vince. "We Are Family." *Village Voice*, September 29, 1987.

Aletti, Vince. "What Remains: Life, Love and Death through the Lens of Sally Mann." *Modern Painters*, June 2006.

Als, Hilton. "The Unvanquished: Sally Mann's Portrait of the South." *New Yorker*, September 27, 1999.

Andre, Dena, Philip Brookman, and Jane Livingston, eds. *Hospice: A Photographic Inquiry*. Exh. cat., Corcoran Gallery of Art, Washington, 1996.

Barnett, Lisa. "Sally Mann." *Art Criticism* 14, no. 1 (1991): 28–31.

Bellafante, Ginia. "Sally Mann: Portrait in Which She's the Star." *New York Times*, January 31, 2007.

Black, Emily Rapp. "Review: Sally Mann's Memoir *Hold Still* as Lyrical as Her Photos." *Los Angeles Times*, May 14, 2015.

Boxer, Sarah. "The Maternal Eye of Sally Mann: Two Decades after Her Photographs of Her Children Created a Furor, She Reveals the Curious Logic of Her Art." *Atlantic*, June 24, 2015.

Boxer, Sarah. "Photography Review: Slogging through the Valley of the Shutter of Death." *New York Times*, July 23, 2004.

Bussard, Katherine A. *So the Story Goes: Photographs by Tina Barney, Philip-Lorca diCorcia, Nan Goldin, Sally Mann, and Larry Sultan.* Exh. cat., Art Institute of Chicago, 2006.

Coleman, A.D. "Child Minders: The Work of Sally Mann and Jock Sturges." *British Journal of Photography* 140, April 1993.

Coleman, A.D. "The Entrancing Clarity of a Mother's Vision of Her Young." *New York Observer*, June 8, 1992.

Coleman, A.D. "Sally Mann Heads South to Explore New Landscapes." *New York Observer*, October 20, 1997.

Davis, Leslye. "A Lesson from Sally Mann: 'Just Take the Picture.'" *New York Times*, April 21, 2015.

Dickmann, Katherine. "Landscape and the Suspension of Time." *Village Voice*, October 21, 1997.

Di Prete, Laura. "The Wound That Wounds: Trauma, Subjectivity, and Vision in the Photography of Sally Mann." In *Foreign Bodies: Trauma, Corporeality, and Textuality in Contemporary American Culture*, 23–48. New York, 2006.

Ehrhart, Shannah. "Sally Mann's Looking-Glass House." In *Tracing Cultures: Art History, Criticism, Critical Fiction*, edited by Miwon Kwon, 53–70. New York, 1994.

Eugenides, Jeffrey. "Hayhook." *Artforum* (December 1994): 56–57.

Feeney, Mark. "Landscape Photos Capture Intersection of Man and Nature." *Boston Globe*, August 20, 2006.

Freudenheim, Susan. "It May Be Art, but What about the Kids?" *San Diego Tribune*, March 29, 1989.

Galassi, Peter. *The Pleasures and Terrors of Domestic Comfort.* Exh. cat., Museum of Modern Art, New York, 1991.

Gerhart, Ann. "Family of Mann: The Focus of a Controversy; Sally Mann's Photo Art Has Its Share of Critics." *Philadelphia Daily News*, October 29, 1992.

Glueck, Grace. "Sally Mann." *New York Times*, October 15, 1999.

Glueck, Grace. "Sally Mann: 'Last Measure.'" *New York Times*, October 24, 2003.

Goldberg, Vicki. "Photography Review: Landscapes That Are Steeped in Time." *New York Times*, October 17, 1997.

Goldberg, Vicki. "Photography Review: Looking Straight into the Eyes of the Dying." *New York Times*, March 3, 1996.

Goldstein, Richard. "The Eye of the Beholder." *Village Voice*, March 10, 1998.

Hagen, Charles. "Review/Art: Childhood without Sweetness." *New York Times*, June 5, 1992.

Harris, Melissa. "Sally Mann: Correspondence with Melissa Harris." *Aperture* 138 (Winter 1995): 24–35.

Heartney, Eleanor. "The Forensic Eye: The Latest Work from Sally Mann." *Art in America* 93, January 2005.

Hess, Elizabeth. "The Good Mother." *Village Voice*, October 17, 1995.

Higonnet, Anne. *Pictures of Innocence: The History and Crisis of Ideal Childhood.* London, 1998.

Higonnet, Anne. "The Price of Great Art." *Public Books*, September 1, 2015.

Hochdörfer, Achim, and Sally Mann. *Cy Twombly: The Last Paintings.* Beverly Hills, CA, 2012.

Hornaday, Ann. "'Remains' to Be Seen." *Washington Post*, June 6, 2004.

Jones, Malcolm. "All in the Family." *Newsweek*, October 26, 1992.

Kazanjian, Dodie. "Nature of Mann." *Vogue*, September 1999.

Kazanjian, Dodie. "*Vogue*'s Gallery: Hilton Als Curates a Show Inspired by Sally Mann's Memoir." *Vogue*, December 1, 2015. https://www.vogue.com/article/hilton-als-show-sally-mann.

Lash, Miranda, and Trevor Schoonmaker, eds. *Southern Accent: Seeking the American South in Contemporary Art.* Exh. cat., Nasher Museum of Art, Durham, NC, 2016.

Livingston, Kathryn. "Sally Mann: Second Sight." *American Photographer*, May 1984.

Livingston, Kathryn. "The 12 Year Olds." *American Photographer*, October 1984.

Lloyd, Christopher. *Rooting Memory, Rooting Place: Regionalism in the Twenty-First-Century American South*. New York, 2015.

Lloyd, Robert. "Television Review: Viewing a Thin Line between Art and Exploitation in 'What Remains: The Life and Work of Sally Mann.'" *Los Angeles Times*, January 31, 2007.

MacKenzie, Niall. "Analytique Interviews: Sally Mann." *Chicago Art Journal* 14 (Spring 2004): 85–89.

Mackey, Maureen. "Sally Mann." *Darkroom Photography*, March/April 1982.

Malcolm, Janet. "The Family of Mann." *New York Review of Books*, February 3, 1994.

Mann, Sally. "Sally Mann's Exposure." *New York Times Magazine*, April 16, 2015.

Mann, Sally. "Sally Mann: Photographs from the South." *Creative Camera* 344, February/March 1997.

Mann, Sally. "September 12, 2001." *Blind Spot* 20, Spring 2002.

Mann, Sally. "Untitled." *Aperture* 194 (Spring 2009): 20–29.

Mann, Sally, Royster Lyle, and Pamela Hemenway Simpson. *The Architecture of Historic Lexington*. Charlottesville, VA, 1977.

Marks, Laura. "Minor Infractions: Child Pornography and the Legislation of Morality." *Afterimage* 18, no. 4, November 1990.

Mavor, Carol. *Pleasures Taken: Performance of Sexuality and Loss in Victorian Photographs*. Durham, NC, 1995.

McThenia, Tal. "Apocalyptic Imagination: A Conversation with Sally Mann." *Vanity Fair*, May 7, 2015.

Messud, Claire. "Fierce Attachments: A Renowned Photographer Explores How Family Has Shaped Her Art." *Bookforum*, Summer 2015.

O'Grady, Megan. "Sally Mann on Her New Memoir and the Fate of Art Photography in the Age of Selfies." *Vogue*, May 6, 2015.

Parks, Cara. "Instill Life: The Dark and Light of Sally Mann." *New Republic*, June 2015.

Price, Reynolds. "Best Photographer: Sally Mann." *Time*, July 9, 2001.

Price, Reynolds. "Neighbors and Kin." *Aperture* 115 (Summer 1989): 32–39.

Rexer, Lyle. "The Angel of Uncertainty: An Interview with Sally Mann on the Lure of the Poured Image." In *Photography's Antiquarian Avant-Garde: The New Wave in Old Processes*, 80–83. New York, 2002.

Rexer, Lyle. "Marriage under Glass: Intimate Exposures." *New York Times*, November 19, 2000.

Sante, Luc. "Luc Sante on Photography: The Nude and the Naked." *New Republic*, May 1, 1995.

Schaub, Grace. "Sally Mann." *Photographer's Forum* 14, February 1992.

Schuyler Clay, Maude. "Sally Mann's Vision." *Oxford American: A Magazine of the South*, May 12, 2015. http://www.oxfordamerican.org/item/581-sally-mann-s-vision.

Shea, Lisa. "Sally Mann Reflects on a Career of Controversial Images." *Elle*, May 11, 2015.

Sokolov, Raymond. "Critique: Censoring Virginia." *Wall Street Journal*, February 6, 1991.

Sorlien, Sandy. "The Age of Innocence: Sally Mann." *Photo Review* 16, no. 1, Winter 1993.

Williams, Val. "Childish Pursuits." *Creative Camera*, February/March 1993.

Williams, Val. "Fragile Innocence." *British Journal of Photography*, October 15, 1992.

Williams, Val. "Women: The Naked Truth." *Guardian*, September 22, 1992.

Woodward, Richard. "The Disturbing Photography of Sally Mann." *New York Times Magazine*, September 27, 1992.

Wright, C.D. "Closer." *Harper's Magazine*, October 2009.

Zimmer, William. "Reality and Artifice in World of Contemporary Photographs." *New York Times*, February 6, 1994.

Compiled by Gordon Dearborn Wilkins

CHECKLIST

Family

1 **On the Maury** 1992
gelatin silver print, 25.4 × 20.3 cm (10 × 8 in.)
Private collection

2 **Easter Dress** 1986
gelatin silver print, 47 × 57.8 cm (18 ½ × 22 ¾ in.)
Patricia and David Schulte

3 **Gorjus** 1989
gelatin silver print, 48.3 × 59.7 cm (19 × 23 ½ in.)
Sayra and Neil Meyerhoff

4 **Blowing Bubbles** 1987
gelatin silver print, printed 1995, 47.3 × 59.2 cm (18 ⅝ × 23 ⁵⁄₁₆ in.)
High Museum of Art, Atlanta, Purchase with funds from
Lucinda W. Bunnen for the Bunnen Collection

5 **Larry Shaving** 1991
gelatin silver print, 50.8 × 61 cm (20 × 24 in.)
Alessandro F. Uzielli

6 **The Alligator's Approach** 1988
gelatin silver print, 49.2 × 59.6 cm (19 ⅜ × 23 ⁷⁄₁₆ in.)
National Gallery of Art, Washington, Corcoran Collection
(Gift of David M. Malcolm in memory of Peter T. Malcolm)

7 **Cherry Tomatoes** 1991
gelatin silver print, 47.6 × 59 cm (18 ¾ × 23 ¼ in.)
National Gallery of Art, Washington, Corcoran Collection
(Gift of David M. Malcolm in memory of Peter T. Malcolm)

8 **The Ditch** 1987
gelatin silver print, 47.5 × 58 cm (18 ¹¹⁄₁₆ × 22 ¹³⁄₁₆ in.)
The Art Institute of Chicago, Gift of Sally Mann and
Edwynn Houk Gallery

9 **Jessie at Six** 1988
gelatin silver print, 47.5 × 58.5 cm (18 ¹¹⁄₁₆ × 23 ¹⁄₁₆ in.)
National Gallery of Art, Washington, Corcoran
Collection (Gift of David M. Malcolm in memory of
Peter T. Malcolm)

10 **Last Light** 1990
gelatin silver print, 47 × 58.4 cm (18 ½ × 23 in.)
Joseph M. Cohen Family Collection

11 **Emmett Floating at Camp** 1991
gelatin silver print, 20.3 × 25.4 cm (8 × 10 in.)
Private collection

12 **Emmett and the White Boy** 1990
gelatin silver print, 47.9 × 58.7 cm (18 ⅞ × 23 ⅛ in.)
Solomon R. Guggenheim Museum, New York, Gift,
The Bohen Foundation, 2001

13 **Jessie Bites** 1985
gelatin silver print, 49.7 × 59.4 cm (19 ⁹⁄₁₆ × 23 ⅜ in.)
Lent by The Metropolitan Museum of Art, Purchase,
Ronald A. Kurtz Gift, 1987

14 **Fish Heads** 1991
silver dye bleach print, 49.5 × 50.5 cm (19 ½ × 19 ⅞ in.)
Lent by The Metropolitan Museum of Art, Purchase,
Ronald A. Kurtz Gift, 1991

15 **Bean's Bottom** 1991
silver dye bleach print, 49.5 × 49.5 cm (19 ½ × 19 ½ in.)
Private collection

16 **River Dance** 1991
silver dye bleach print, 48.9 × 52.7 cm (19 ¼ × 20 ¾ in.)
Courtesy Gagosian

17 **Bloody Nose** 1991
silver dye bleach print, 49.5 × 49.5 cm (19 ½ × 19 ½ in.)
Private collection

18 **Trumpet Flowers** 1991
silver dye bleach print, 48.3 × 48.3 cm (19 × 19 in.)
Solomon R. Guggenheim Museum, New York,
Gift, The Bohen Foundation, 2001

19　**Jessie at Nine** 1991
gelatin silver print, 59.4 × 47.3 cm (23⅜ × 18⅝ in.)
National Gallery of Art, Washington, Corcoran
Collection (Gift of David M. Malcolm in memory
of Peter T. Malcolm)

20　**The Last Time Emmett Modeled Nude** 1987
gelatin silver print, 20.2 × 25.2 cm (7¹⁵/₁₆ × 9¹⁵/₁₆ in.)
Addison Gallery of American Art, Phillips Academy,
Andover, Massachusetts, Museum purchase

21　**Picnic** 1992
gelatin silver print, printed 1995, 61 × 50.8 cm (24 × 20 in.)
Courtesy of the New Orleans Museum of Art,
Collection of H. Russell Albright, M.D.

The Land

22　**Virginia, Untitled (Blue Hills)** 1993
gelatin silver print, printed 1997, 77.5 × 97.8 cm
(30½ × 38½ in.)
Lent by The Metropolitan Museum of Art, Purchase,
the Horace W. Goldsmith Foundation Gift,
through Joyce and Robert Menschel, 1998

23　**Virginia, Untitled (Niall's River)** 1994
gelatin silver print, 76.7 × 97.2 cm (30³/₁₆ × 38¼ in.)
Stephen G. Stein Employee Benefit Trust

24　**Deep South, Untitled (Fontainebleau)** 1998
gelatin silver print, printed 2017,
94.9 × 120 cm (37⅜ × 47¼ in.)
Stephen G. Stein Employee Benefit Trust

25　**Deep South, Untitled (Three Drips)** 1998
gelatin silver print, printed 1999, 96.4 × 120.3 cm
(37¹⁵/₁₆ × 47⅜ in.)
National Gallery of Art, Washington, Gift of the Collectors
Committee and the Sarah and William L. Walton Fund

26　**Deep South, Untitled (Valentine Windsor)** 1998
gelatin silver print, 99.7 × 123.2 cm (39¼ × 48½ in.)
Virginia Museum of Fine Arts, Richmond,
Gift of the Massey Charitable Trust

27　**Deep South, Untitled (Stick)** 1998
gelatin silver print, printed 1999, 95.7 × 119.4 cm (37¹¹/₁₆ × 47 in.)
Courtesy of the New Orleans Museum of Art,
Collection of H. Russell Albright, M.D.

28　**Virginia, Untitled (Upper Field)** 1993
gelatin silver print, 76.2 × 96.8 cm (30 × 38⅛ in.)
Alice and Richard G. Tilghman

29　**Deep South, Untitled (Scarred Tree)** 1998
gelatin silver print, 96.5 × 121.9 cm (38 × 48 in.)
National Gallery of Art, Washington,
Alfred H. Moses and Fern M. Schad Fund

30　**Deep South, Untitled (Bridge on Tallahatchie)** 1998
gelatin silver print, 94 × 120.6 cm (37 × 47½ in.)
Markel Corporate Art Collection

31　**Deep South, Untitled (Concrete Grave)** 1998
gelatin silver print, 119.4 × 94 cm (47 × 37 in.)
Private collection

32　**Deep South, Untitled (Emmett Till River Bank)** 1998
gelatin silver print, 99.7 × 123.2 cm (39¼ × 48½ in.)
Peabody Essex Museum, Salem, Massachusetts, Museum
purchase with funds donated by Susan Esco Chandler
and Alfred D. Chandler and Joanie V. Ingraham and
Timothy A. Ingraham.

Last Measure

33　**Battlefields, Manassas (Veins)** 2000
gelatin silver print, 101.6 × 127 cm (40 × 50 in.)
Private collection, New York

34　**Battlefields, Manassas (Airplane)** 2000
gelatin silver print, 101.6 × 127 cm (40 × 50 in.)
High Museum of Art, Atlanta, Purchase with funds
from the H. B. and Doris Massey Charitable Trust
not shown in Washington

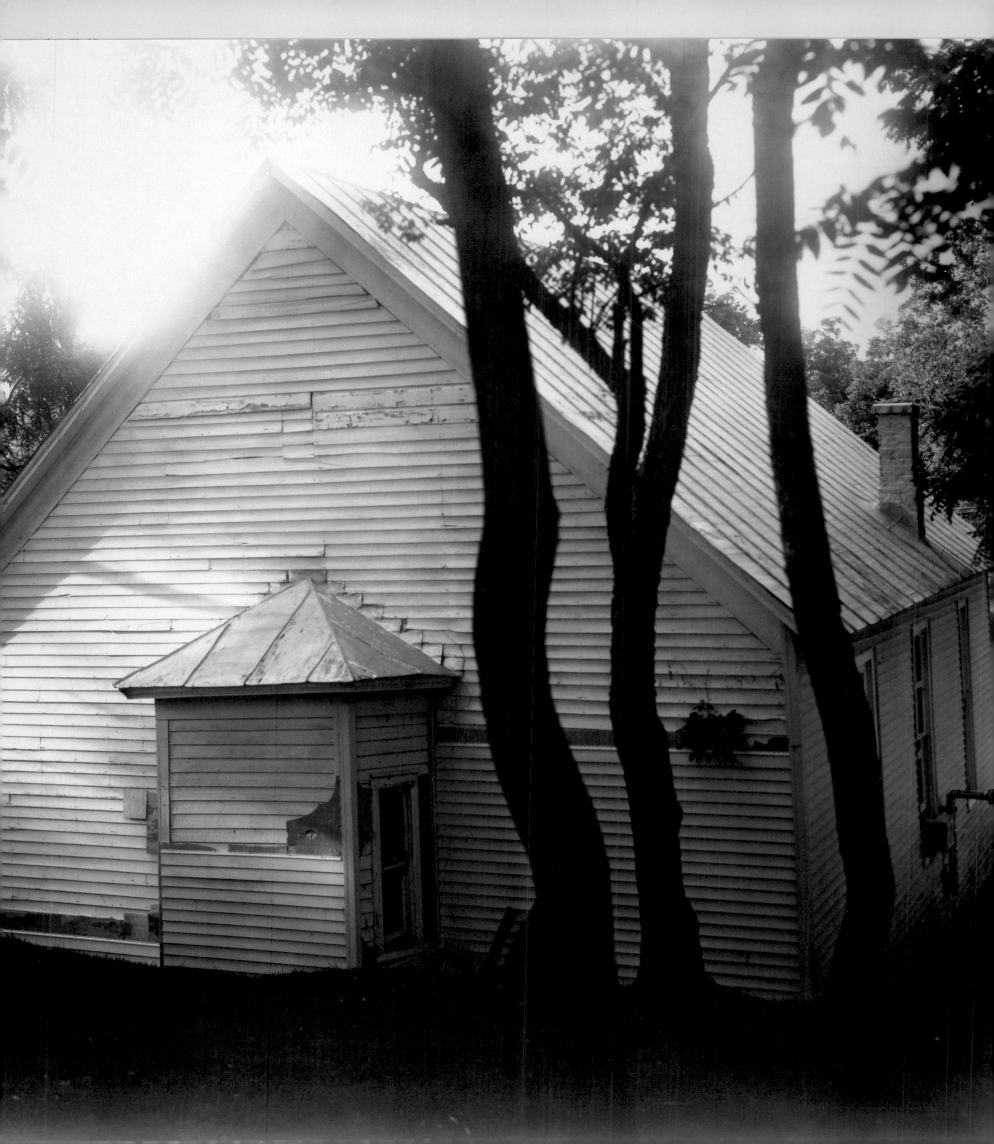

ACKNOWLEDGMENTS

In 2014 when Sally Mann was in the final stages of completing what would become her award-winning memoir, *Hold Still*, we began to talk with her about this exhibition and catalogue. Although she had received considerable attention since her first publications and exhibitions in the late 1980s and early 1990s, no systematic effort had ever been made to explore her relationship to the South nor had any publication analyzed the full spectrum of her art. It seemed a propitious moment to undertake this endeavor, as she had shared so much new information in *Hold Still* about her life, her family, and especially her art and aspirations. Little did we then know how timely and complex our project would become, as many of the issues Mann has addressed in her art—about history and race, place and memory—have since burst onto the national stage.

We owe our largest debt of gratitude to Sally Mann, who has been intimately involved in all aspects of this exhibition and its accompanying catalogue. Throughout our work on this project, she has challenged and inspired us with her deep commitment to her art and her willingness to engage with some of the most important and difficult issues of our time. Welcoming us into her home and studio at a moment in her life when she might have wished to focus on other endeavors, she has given freely and generously of her time, enriching our exhibition and catalogue in innumerable ways. We also wish to thank Mann's assistant Molly Grace Smith for her unfailing dedication to this project and for elegantly and assiduously managing its complex details. Zoë Lepiano and Laura Wiseman also deserve special thanks, as do Mann's husband, Larry, and her daughters, Jessie and Virginia, for the support they have given in the last three years.

While every exhibition and publication is a team effort, *Sally Mann: A Thousand Crossings* has proven to be a particularly rich collaborative venture that has benefited from the ideas and assistance of numerous people. From its inception, the project received the enthusiastic support of Earl A. Powell III, director of the National Gallery of Art, and Dan L. Monroe, the Rose-Marie and Eijk van Otterloo Director and chief executive officer

PHOTOGRAPHY AND
POETRY CREDITS

Every effort has been made to locate the copyright holders for the reproductions used in this book. Any omissions will be corrected in subsequent editions.

Pages 3 and 9

John Glenday, "Landscape with Flying Man," from *Grain* (London, 2009), © John Glenday 2009, reproduced with permission of Pan Macmillan through PLSclear

Writing with Photographs: Sally Mann's Ode to the South, 1969–2017

Fig. 2: © 2017 The Ansel Adams Publishing Rights Trust; fig. 8: photography by Ted Orland; fig. 9: © Emmet and Edith Gowin, courtesy Pace/MacGill Gallery, New York; fig. 10: © RMN-Grand Palais / Patrice Schmidt / Art Resource, NY; fig. 15: The Art Institute of Chicago / Art Resource, NY; fig. 16: Imaging Department © President and Fellows of Harvard College; fig. 17: © Fondazione Nicola Del Roscio; fig. 19: Digital Image © The Museum of Modern Art / Licensed by SCALA / Art Resource, NY

Family

Pls. 6, 7, 19: Image courtesy of the Board of Trustees, National Gallery of Art, Washington, photographer Tricia Zigmund; pl. 8: The Art Institute of Chicago / Art Resource, NY; pl. 9: Image courtesy of the Board of Trustees, National Gallery of Art, Washington, photographer Ric Blanc; pls. 13, 14: © The Metropolitan Museum of Art / Art Resource, NY; pl. 20: Addison Gallery of American Art, Phillips Academy, Andover, MA / Art Resource, NY

Flashes of the Finite: Sally Mann's Familiar Terrain

Fig. 1: © The Estate of Harry Callahan, Courtesy Pace/MacGill Gallery, New York, Image copyright © The Metropolitan Museum of Art / Art Resource, NY; fig. 2: © Emmet and Edith Gowin, Courtesy Pace/MacGill Gallery, New York, Princeton University Art Museum / Art Resource, NY; figs. 3, 7: The Art Institute of Chicago / Art Resource, NY; fig. 8: © 1981 Center for Creative Photography, Arizona Board of Regents; fig. 9: Courtesy of Edwynn Houk Gallery, New York

The Land

Pl. 22: © The Metropolitan Museum of Art / Art Resource, NY; pls. 24, 25, 29: Image courtesy of the Board of Trustees, National Gallery of Art, Washington, photographer Ric Blanc; pl. 26: Virginia Museum of Fine Arts, photographer David Stover

The Earth Remembers: Landscape and History in the Work of Sally Mann

Fig. 2: http://hdl.loc.gov/loc.pnp/pp.print

Last Measure

Pl. 36: Virginia Museum of Fine Arts, photographer David Stover; pl. 40: Image courtesy of the Board of Trustees, National Gallery of Art, Washington, photographer Greg Williams; pls. 41, 43: Image courtesy of the Board of Trustees, National Gallery of Art, Washington; pl. 42: Addison Gallery of American Art, Phillips Academy, Andover, MA / Art Resource, NY

What Remains

Pl. 104: Image courtesy of the Board of Trustees, National Gallery of Art, Washington, photographer Tricia Zigmund; pl. 112: Virginia Museum of Fine Arts, photographer David Stover

Chronology

Fig. 12: © 2005 Len Prince

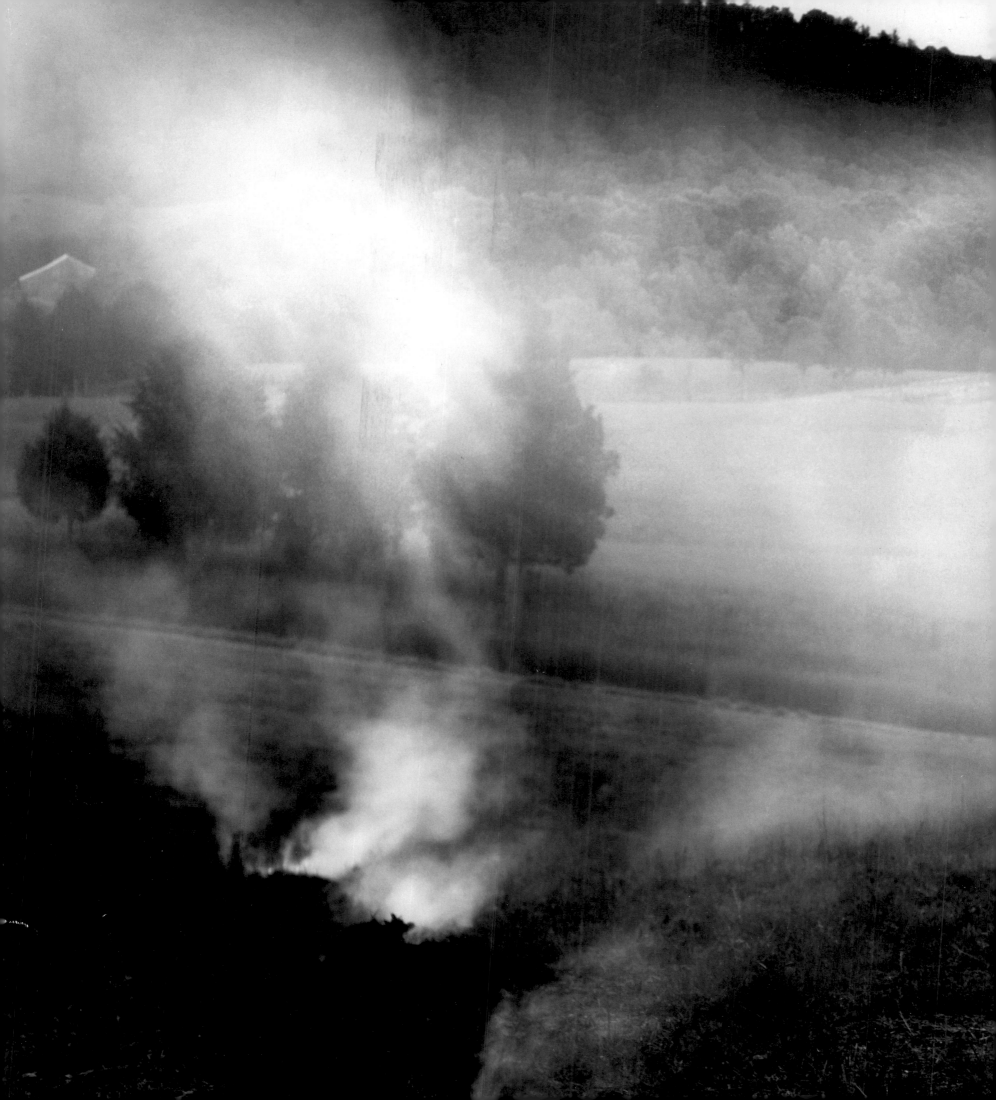